T0395257

THE ANTECHAMBER

Cultural Memory | in the Present

Hent de Vries, Editor

THE ANTECHAMBER

Toward a History of Waiting

Helmut Puff

STANFORD UNIVERSITY PRESS
Stanford, California

Stanford University Press
Stanford, California

© 2023 by Helmut Puff. All rights reserved.

Printed in the United States of America on acid-free, archival-quality paper

Library of Congress Cataloging-in-Publication Data

Names: Puff, Helmut, author.
Title: The antechamber : toward a history of waiting / Helmut Puff.
Other titles: Cultural memory in the present.
Description: Stanford, California : Stanford University Press, 2023. | Series: Cultural
 memory in the present | Includes bibliographical references and index.
Identifiers: LCCN 2023017219 (print) | LCCN 2023017220 (ebook) | ISBN 9781503635418
 (cloth) | ISBN 9781503637023 (paperback) | ISBN 9781503637030 (epub)
Subjects: LCSH: European literature--Themes, motives. | Waiting (Philosophy) in
 literature. | Entrance halls in literature. | Time in literature. | Space in literature.
Classification: LCC PN56.W215 P84 2023 (print) | LCC PN56.W215 (ebook) |
 DDC 809/.93384--dc23/eng/20230508
LC record available at https://lccn.loc.gov/2023017219
LC ebook record available at https://lccn.loc.gov/2023017220

Cover design and etching treatment: Lindy Kasler
Artwork: Salomon Kleiner, *Antechamber*, (Upper Belvedere), Vienna, 1733 (detail)

Contents

Illustrations

Acknowledgments

Without the unwavering support of colleagues and friends, this project would never have left the realm of the antechamber: the place of anticipation, dread, and hope. On my home turf, the University of Michigan, I want to single out for their collegial warmth those without whose encouragement I could not have written this book: Kerstin Barndt, Stephen Berrey, Kathleen Canning (now Rice University), David Caron, Deborah Dash Moore, Dario Gaggio, Andreas Gailus, William Glover, Megan Holmes, Val Kivelson, Teresa Kovacs (now Indiana University), Kenneth Mills, Farina Mir, Anthony Mora, Jennifer Nelson (now University of Wisconsin), Cathy Sanok, Elizabeth Sears, Mrinalini Sinha, Scott Spector, Melanie Tanielian, Johannes von Moltke, Silke Weineck, and Claire Zimmerman. Kathryn Babayan has been a dream friend and intellectual companion. At other institutions, Joel Harrington, Jean Hébrard, Cordelia Hess, Sarah Higinbotham, Nancy Hunt, Hubertus Jahn, Daniel Jütte, Kris Lane, Maren Lorenz, Lyndal Roper, Wolfram Schneider-Lastin, Claudius Sieber-Lehmann, Christoph Singer, Christopher Wild, and Gerhild Scholz Williams all have my deepest gratitude.

Venturing into uncharted spacetimes required getting support from others. Mark Hengerer shared his publications on the imperial court with me. Stephan Kraft first called my attention to the Baroque novel that has made it into the book. He also connected me to Simon Wilkens, who generously supplied me with a reliable guide to this textual universe of several thousand pages. Mara Wade guided me in my exploration of emblems. Jakob Michelsen offered help with his vast knowledge of eighteenth-century Prussia at a crucial moment. Wojtek Jezierski called my attention to a source text. Jill Bepler informed me about women's antechambers. Lynne Tatlock alerted me to the writings of Willibald Alexis. Heinrich Löffler supplied me with great lexicological support at a crucial moment. Birgit Gropp introduced me

to Haus Harkotten in Westphalia. Martin Herzog shared a book with me.

I also want to express my thanks to the undergraduate and graduate students at Michigan who enrolled in several classes on the history, politics, and ethics of times in history. Special thanks to Shai Zamir for sharing fascinating and thoughtful finds with me.

I have been fortunate in that this project found the support of two exceptional institutions where research flourishes, the Historische Kolleg in Munich, Germany, and the National Humanities Center in North Carolina. Of the many wonderful people I met in the light-infused corridors of the NHC, I want to single out my virtual friends—Bryna Goodman, Rivi Handler-Spitz, and Robert Schine—as well as in-person fellows Emily Branagwanath, Michael Johnston, Joan Neuberger, and Saundra Weddle. The conversations Helen Solterer and I had in her backyard meant a lot to me, as did my friendship with Annabel Wharton.

The ensuing pages have been shaped by many audiences. My discovery of waiting as a theme goes back to a talk I delivered at the University of Basel in 2008, long before I entered the antechamber. Yet it was the confluence of the spatial and temporal in the word *waiting* that intrigued me. A foray at a panel organized by the Eisenberg Institute of Historical Studies in the Department of History was followed by many other occasions on campus, in the German Department, and elsewhere. The animated discussions at the Michigan Society of Fellows when Don Lopez directed this institution were a particular pleasure. Other versions were delivered at the following places of learning: Ruhr University Bochum; University of Chicago; University of Freiburg; University of Göttingen; University of Gothenburg; New York University; Paderborn University; Princeton University; University of Tübingen; Washington University; and University of Würzburg. The research nexus Kenneth Mills and Kris Lane created imaginatively, "Horror and Enchantment," allowed me to think further through waiting as a theme, with special thanks to Zeb Tortorici, John Charles, and Heidi Scott. My interview with Bernardo Zacka, "Architectures of Waiting," was one of the most pleasurable activities I could have waited to have happen to me as an academic.

Kathryn Babayan, Will Glover, Stephan Kraft, Rivi Handler-Spitz, Joan Neuberger, and Annabel Wharton read parts of the manuscript; their comments helped its gestation. Val Kivelson, Paolo Squatriti, Sueann Caulfield, Susan Juster, and Hussein Fancy helped me think through the introduction.

Haley Bowen generously researched bibliographical materials. Danielle LaVaque-Manty was a wonderful editor, and the illustrator Matilde Grimaldi is a delight to work with. Erica Wetter amazed me with her amiable dedication to waiting; she helped me steer the project to a temporary conclusion.

Gundula Boveland supplied me with many finds from the shelves of the Herzog August Bibliothek in Wolfenbüttel, Germany. Without her passion, this book would still be waiting to see the light of day.

Among the publications that paved the way for this book are "Architectures of Waiting: Helmut Puff and Bernardo Zacka in Conversation," *Contemporary Political Theory* 21 (2022); "Gay Times: Ein Versuch zur Figur des Wartens," in *Transatlantische Emanzipationen: Freundschaftsgabe für James Steakley*, ed. Florian Mildenberger (Berlin: Salzgeber, 2021); "Bedenkzeit (spatium deliberationis): Timing the Reformation," in *The Cultural History of the Reformation: Theories and Approaches*, ed. Susan Karant-Nunn and Ute Lotz-Heumann (Wolfenbüttel: Herzog August Bibliothek, 2021); and "Waiting in the Antechamber," in *Timescapes of Waiting: Spaces of Stasis, Delay and Deferral*, ed. Olaf Berwald, Christoph Singer, and Robert Wirth (Leiden: Brill, 2019), with thanks to the publishers for the permission to republish materials from the last two publications.

As I am writing, I feel like I am still waiting for the final version of this book. May others complete the many tasks waiting ahead.

THE ANTECHAMBER

Introduction

Waiting means being no stranger to paradox.
—Andrea Köhler, *Passing Time*

The present study is animated by the apprehension that temporalities have frequently been obliterated from social analysis and cultural criticism. With its focus on times operative in a type of room, *The Antechamber* seeks to set an example to the contrary. We will visit societies and spaces of the past through the lens of a particular temporal modality: waiting.

Before we embark on this endeavor, let us take stock of the magnitude of the task at hand. "We necessarily express ourselves by means of words and we usually think in terms of space" is the opening salvo from Henri Bergson's 1888 treatise *Time and Free Will*—a foundational essay on the problem of time's perceptibility.[1] Almost 150 years later, the contemporary geologist Marcia Bjornerud detects "a pervasive, stubborn, and dangerous temporal illiteracy in our society."[2] A conceptual hierarchy that prioritizes the spatial prevents us from recognizing that in late modern societies "temporal norms . . . have become dominant," in the words of another critic.[3] Despite these and other calls to change course, the obstacles to carving out how actions acquire meanings through socially mandated or culturally negotiated temporal protocols remain considerable.

The sociological literature that tackles social time, timing, and timekeep-

ing has for the most part pursued one tagline: acceleration. In a dizzying array of publications, Hartmut Rosa, for instance, has proclaimed our times to be an "Age of Acceleration." The insight that time as a resource is scarce at precisely a moment when human life expectancy has been on the rise (at least for those privileged enough to have access to health care and other services), serves as the linchpin of his social theory.[4] Acceleration's contradictions notwithstanding, this sociologist hypothesizes that Western societies are entering an era that amounts to a dictatorship of speed.

Theorists of modernity have persistently envisioned modern times as ever faster, more mechanized, efficient, attentive only to their own rhythms—a sense of historical progression that necessarily distances us from the past, and quickly so.[5] This focus on speed is such an all-comprehensive theme that it risks swallowing all reflection on speed's other: slow or still times, of which waiting is one.[6] Even in our age of "frantic standstill," interstitial times persist.[7] With regard to technological innovations, Judy Wajcman contends that "the simultaneous production of fast time spaces with those of remarkable slowness" constitutes a temporal pattern in contemporary societies in the West.[8] In fact, the COVID-19 pandemic, with its waves defined by the virus's mutants, has upended restless everyday rhythms on an unprecedented scale, globally.[9] My goal in this study is a modest one: to nudge practices of waiting and letting others wait above the threshold of our perception when studying society and culture.

If "modernity is speed,"[10] as many critics contend with rhetorical verve and an armature of observations, then premodernity must represent its opposite.[11] According to this story line, times before the advent of what passes as modern were everything that contemporary societies are not: slow, steady, predictable. It is said that people back then viewed their existence as part of a cosmologically defined order whose cyclical nature grounded one's life. What is a precious resource today must have been in good supply before industrial production, mass society, the bureaucratic state, and digital devices turned time into a scarce commodity. Whereas today we live for a future we hope to be part of, if not help bring about, people in the past lived in the present. Wherever they lived or live, whether in Africa, Asia, or Europe, "premoderns" and "nonmoderns" were or are little troubled by the irrelevant past or the unknowable future. Thanks to the religious certainties anchoring their communities, these people escaped and escape the mere functionalism of work-related stress in a globalized capitalism run amok.

To be sure, there are a great many versions of this vast terrain of assumptions.[12] At the same time, critics in this vein often treat the past like a projection screen: "Pre-moderns were fated to live in a world in which their existence unfolded in a steady rhythm from birth, to death and beyond. Time was predictable and inescapably infinite, saturated with ideas of singular determination and first cause. . . . In the context of circular time, we waited for fate, that is, determination, or alternatively the intercession of magic or prophesy in order to break or confirm this circle of determination. Waiting for the future was subordinated to, or subsumed by, determination."[13] The author marshals a chorus of luminaries to buttress his claim about premodern restfulness: Marcel Mauss, Stephen Hawking, John Berger, Norbert Elias, and Charles Taylor. Yet no studies of temporizations as experienced trouble a capriccio whose main, if not sole, purpose is to provide a historical backdrop to the apparently ever faster lockstep of modern life.

The author wouldn't have had to look far. The 2009 volume in which John Rundell's contribution appeared features a study of how Tibetan nomads time their existence. Their relationship to time, as Gillian G. Tan demonstrates, is strikingly dynamic: "In their interdependent and attentive interactions with their environment, [social] structures and each other, [the Tibetan nomads] have achieved an attitude that does not attempt to grasp or fix."[14] Different registers—the microclimate, time-honored practices of old, the behavior of neighbors in the present, to name but a few—inform complex decision-making processes about what to do next in an environment where being alert is of the essence because of water, food, and energy scarcities. If there is a commonality to how so-called pre- or nonmoderns in various parts of the globe inhabited or inhabit the temporal dimension of their lives, it is the layered texture of their experience—different from that of "moderns," to be sure, yet tangled, existential, and affectively charged nonetheless.[15]

In this context, focusing on scenarios of waiting offers a chance for us to catch our breath. Let us embark on the task to forge new narratives amid the staccato of an ever faster discourse on acceleration—narratives where past and present temporalities come to resonate in novel ways.

"Waiting" is one temporal modality that makes time—according to Norbert Elias, time eludes the senses—experiential.[16] Waiting portions out the flow of time; its temporal horizon has humans situate themselves in expectation of what is to come. Such an expectation is predicated, at least for routine

social interactions, on a memory of similar experiences one has had or knows about. This strong anticipatory horizon sets "waiting" apart from similar states of the mind, such as tarrying, hesitating, or dithering.[17]

How long and *what* we are waiting for shapes how we, as waiters, experience the time we spend during temporal in-betweens.[18] It matters whether we wait for the birth of a child or the diagnosis of an unknown ailment, whether we are standing at a bus stop to go to work or longing to hear from a lover. A prisoner waits differently for his imminent release than an overworked employee for a long-awaited vacation. Waiting for the Messiah near the end of times is unlike waiting for a person's death to arrive. Still, all these experiences have something in common. No matter what one expects to occur, waiting can be said to be a bounded condition in which time becomes actual. It is a temporal modality tied to the prospect of a future conceived to be within reach—a state different from existential or open-ended waiting.[19] Waiting for something or someone is thus both situational and generative.

What merits consideration, among other things, is the fact that waiting triggers responses in waiters: joyful anticipation, anxious reflection, bored indifference, fledgling tedium, and so on. Why confront the cluster of feelings and states of mind or body that waiting unleashes in those who wait? To answer this question, I turn to Vincent Crapanzano, an anthropologist who, planning to study the "effects of domination on everyday life" in South Africa under apartheid, instead arrived at writing about white South Africans, whose waiting shaped their lives:

> To talk about dread, angst, guilt, or being overwhelmed, all of which are components of the experience of waiting, adds a metaphysical dimension, a melodramatic tension, to the very ordinary experience I am trying to describe. Such terms "elevate" the experience. They give it importance. They permit a sort of moral indulgence, a taking comfort, in it. Symptoms of the ordinary, they mask the ordinary. It is precisely this masking that has to be avoided. Waiting—the South African experience—must be appreciated in all of its banality. Therein lies its pity—and its humanity.[20]

Despite its wealth of emotions, waiting often is considered dead time, "untime," or nontime. To some, this state equals a state of deprivation, namely an inability to act on one's own accord, or a state of dependency, if not a temporary loss of subjectivity. Precisely for this reason, "waiting can be

the most intense and poignant of all human experiences," as W. H. Vanstone proposes.[21]

Although we often like to think otherwise, being human necessarily entails being in need, whether we are children, frail, sick, or elderly. Even if adult and *compos mentis et corporis*, we might join the ranks of those who rely on others at any moment. As "patients," we endure. Where assistance in times of need is a matter of course, we wait for assistance. We hope for support or survival where such infrastructures of collective welfare are lacking. In Vanstone's words, "one is frustrated not because the system constantly fails to deliver" (which, of course, it does) "but because one must constantly wait for it to deliver—because one has no alternative to waiting."[22] For Vanstone, Emmanuel Lévinas, and others, living in time and waiting are inextricable—a form of Heideggerian phenomenology with a theological-temporal twist.[23]

For social scientists, waiting has fewer ontological qualities. Rather than seeing it as indexical of the human condition per se, they interpret interstitial times as politically, socially, and culturally conditioned. Although waiting has to be tolerated individually, it actually forms an integral part of sociability. Whether the wait time one experiences is imposed or someone willingly subjects themselves to it, waiting enlists those who wait in its ranks. Waiters are removed from the activities that would fill their hours ordinarily. Intermittent waiting therefore disrupts routines while reorienting us toward other beings or infrastructures whom we rely on to end this in-between state. In this sense, waiting's characteristics are about more than the strictures put in place by those in a position of power or authority. In many ways, waiting is structured time. An individual child's capacity to calculate potential gains in the immediate future and choose to wait longer in order to be rewarded has been considered an indication of strength of character and, possibly, future educational or professional success, for instance.[24] Waiting is both an activity and an inactivity, a collective and an individual condition (sometimes simultaneously), and these dualities make it a modality worthy of critical attention.

In a study of feminist artworks on women in hospitality, Irina Aristarkhova reminds us that "waiting is not expected equally from all people. . . . Some people (such as those in need of refuge, or approval, or another type of actual or social capital) are expected to spend more time in waiting than

others."[25] Put differently, waiting scenarios reflect the distribution of power in a society. Importantly, these asymmetries concern people on the move: refugees from war zones, areas ravished by climate change, failing states, and other places of deprivation across the globe. They wait for food; they wait for passage; they wait for a visa or a stamp or some other recognition from the authorities; they search for a job; and they wait for friends and family members to join them. For shorter or longer periods of time, they live in a state of latency with high stakes, limited opportunities, and, in some cases, life-threatening risks.[26]

But they are not the only ones who are waiting. Those who stayed behind, be they kin or friends, are often looking for news from those who left, for transfers of money, or for cues about how to follow on the same migratory paths. The children of the Eastern Europeans who work in Western Europe as caretakers, agricultural workers, or in other professions wait for a call or a visit; they grow up getting to see their parents only occasionally.[27]

Modern bureaucracies, in particular, have made waiting an institutional mandate.[28] In a seminal account of how delays shape the workings of businesses, hospitals, publishing houses, and the like, the sociologist Barry Schwartz concluded in the mid-1970s that variations in waiting times reflect the distribution of power in a social system. What is more, how people wait— the time spans they are made to wait, their willingness to wait, their discontent with having to wait, the meaning they attribute to the wait, and how they narrate their waits—varies according to race, class, gender, profession, context, and culture.[29] In this context, Schwartz also touches on the impact of waiting spaces when discussing the "atmosphere of the waiting room" that can be orchestrated to produce a certain effect.[30] In *Beyond Caring* (1986), the photographer Paul Graham famously captured rooms in the UK's social security centers. What we get to see are neglected spaces, filled with rows of plastic chairs, adorned with handwritten signs or posters peeling from the walls: spaces populated with apathetic waiters worn down by their plight (which we can only imagine) and, viewers are led to assume, a long wait.[31]

In a meditation on Blaise Pascal, the sociologist Pierre Bourdieu sees social stratification imbricated with temporizations: "Waiting implies submission."[32] The powerful control time, their own and that of others. As a result, paradoxically, those in positions of power lack time. Because they are in high demand, their schedules are tight. At the opposite end of the spec-

trum are the powerless. The jobless, undocumented, and refugees not only command large quantities of time; their marginality is constituted, in part, by the inability of some of them to partake in temporal and other regimes that would allow them to make economic, political, and other demands to improve their lot. For those who are so powerless that they live apart from the civic horizons that make up the welfare state, restitutions, reparations, and caretaking are hard to come by.

This is why transitory spaces for the privileged sometimes serve as a refuge for the less fortunate. Mehran Narimi Kazeri, for example, lived permanently in the "non-places" of Charles de Gaulle Airport.[33] After having been denied entry into the UK for lack of identification, and with no visa that would have allowed him to enter France, this international traveler without papers was stuck in the airport's departure lounges for eighteen years. Starting August 26, 1988, he lived confined to one particular area—he relocated to another area owing to renovations and other changes—where he slept, ate, washed, read, studied, guarded his belongings, and wrote a diary until he was moved to a hospital to receive medical treatment in 2006; after living in a Paris shelter for many years, he moved back to CDG Airport, Terminal 2F, shortly before his death in November of 2022.[34] Waiting became his life, as his autobiography says:

I am sitting on my red bench from the Bye Bye Bar in the middle of Charles de Gaulle airport, waiting to leave.

I am waiting for a green card so I can go to America. I am waiting for a British passport so I can go to England. I am waiting for my documentation so I can go anywhere.

I have been sitting on my red bench from the Bye Bye Bar in the middle of Charles de Gaulle airport waiting to leave for fifteen years.[35]

It is rare for those who are waiting to address others as waiters while waiting. If their cause enters the public purview, others usually speak in their stead or on their behalf. Insofar as those who wait form a group, they are hardly ever heard. The impermanence of their state, as well as their isolation, even if they wait with others, works against their mobilizing. When those who once waited have moved on, their concerns may no longer be what they were when they were waiting. As a rule, those who have waited speak about what it means to wait, as a rule, only in retrospect, if at all.

In this sense, *The Terminal Man* qualifies as an exception. Sir Alfred Mehran addresses the reader as a *Wartesubjekt*. But the autobiography published under his adopted name transcends waiting's liminality by embracing it as permanent—an outlook that echoes how prominent writers, philosophers, literary theorists, and essayists had cast waiting in the twentieth century (Roland Barthes, Samuel Beckett, Maurice Blanchot, Martin Heidegger, Franz Kafka, Siegfried Kracauer, and Michael Rutschky, to name but a few).[36] As a result, waiting for an identity metamorphoses into waiting as an identity, or so goes the story we get to read.

Judging from the quotations of Mehran's diary that form part of *The Terminal Man*'s textual score, it is likely that his coauthor, Andrew Donkin, took an active part in shaping this waiter's account. What is clear is that Sir Alfred Mehran erased traces of his bureaucratic self that possibly would have allowed him to make a home elsewhere than in a transit area. Whether he actually was Iranian (which he denied) and the identity of his parents were questions the authorities waited to see answered. Ultimately, this migrant turned the tables on those who were ready, if not eager, to right his situation (or simply were worn out by the media attention he received) and had them wait in turn for answers.

Indeed, over the years he was waiting and living in CDG Airport, he became a global celebrity. Journalists interviewed him; he received mail from all over the world; immigration lawyers took up his cause; his fate, it is said, inspired the Steven Spielberg film *The Terminal* (2004) (though no member of the director's team seems to have contacted him); and Sir Alfred Mehran played a role in inspiring the British composer Jonathan Dove to compose *The Flight* (1998), an opera that has become a theatrical success.

If many people were touched by Sir Alfred Mehran's waiting in permanence, it is, in part, because we can relate. Truth be told, we have all been "there." Many of us know the experience of being stuck somewhere for some time, though most of us extricate ourselves from this state.[37] When young, we wait to become grown-ups; adolescence is often experienced as an exercise in extended waiting for something we know will come, though we are unsure what it will be like. In other words, scenarios of waiting invite identification. We are tempted to project our ideas, memories, or affects about waiting onto others whose waiting we learn about, different structures of liminality manifest in different waiting scenarios notwithstanding.

Anthropologists have recently begun to cast the social phenomenon of waiting as multiform. Waiting, it is said, is formative for those who wait. Craig Jeffrey, one of the doyens of critical studies on waiting, excavated its potential as a basis for political formation among young male students from an agricultural background in Meerut, India, in the early 2000s. In defiance of middle-class codes of behavior, these men performed "timepass" near their university's campus—chatting, playing games, and doing nothing—thereby alerting the public to the fact that they lived in limbo against their will. Lacking the job opportunities they once were promised, they mobilized collectively as chronic waiters, brokering negotiations with local officials on occasion.[38] In Argentina's government agencies, those hoping to receive assistance from the state assist each other, exchanging information, stories, food, and childcare.[39]

Rebecca Rotter argues that long-term waiting among asylum seekers in the UK (whom she observed over the course of one year) is not simply lost time, nor is it seen as such among those who hope to be able to stay. Accordingly, waiting qualifies as a state that helps those kept in suspense against their will to home in on horizons of expectations and anticipate what is to come (rest assured, her research is not meant as a blueprint for making people wait, though I cannot guarantee that it won't be used in this way).[40] Similarly, while saying they are "just waiting," people in contemporary Kyrgyzstan achieve a whole range of things, tending to relationships, possessions, and little futures. For post-Soviet Georgia, Martin Demant Frederiksen exposes the precarity of the "politics of hope." A young and rapidly aging generation is haunted by the lingering presence of past conflicts. Without much of an education or a job, these Georgians find themselves unable to partake in their country's national reconfiguration.[41] In sum, anthropologists have discovered multiple and complex forms of agency in waiting, this supposedly passive state. If we follow their findings, waiting's agency is haphazard, momentary, and unstable, though undoubtedly present.[42]

The moment has come to explore the potent ways by which waiting in its different registers and rhythms structures societies and meaning-making, in the present as well as in the past. And what we need, above all, are empirical studies. My goal in these introductory pages has been to turn the reader's attention to an evanescent yet semantically rich mode. Waiting, thus viewed, proves a paradoxical, powerful, and prolific guide to social relations.

But does waiting have a history? This study argues that it does, and it proposes to anchor an exploration in spaces where people waited— "architectures of waiting" like the zones for travelers that we encountered through the eyes of Sir Alfred Mehran.[43] Such built spaces envelop and outlast individual waiters, and they offer a potent heuristic to explore modalities of waiting. They shed light not only on those who wait but also on a gamut of social actors—be they elites, bureaucrats, or architects—who make others wait and are responsible for forging the messages these spaces impart to waiters. In short, rooms designed for those who spend time in limbo have a lot to tell us about what it meant and means to keep others waiting or to be kept waiting. As stations, airports, hospitals, and public agencies show, such in-between areas coordinate human interactions, means of transport, and public services, whether medical, business-related, or governmental. This book explores temporal interstices as part of interactions within a specific architectural infrastructure: the antechamber in late medieval and early modern Europe.

The "structures of waiting" I have in mind for this endeavor invoke the "structures of feeling"—a concept the late Raymond Williams elaborated over many years. As a battle cry for a restorative criticism, this formulation countervails the "reduction of the social to fixed forms," meanings, and values in sociocultural analysis, instead inciting accounts with a focus on processes of becoming and meaning-making.[44] Time, space, and experience are not givens, Williams contends. They are always lived, and as a result, our descriptions ought to strive to capture them in flux and on the move. Situating interstitial waiting in the concrete circumstances of a particular space, *The Antechamber* aims for such history-writing in process.

In fact, the intersection of the temporal and the visual or spatial forms the basis of the word *waiting*.[45] Its root combines the semantic layers of "to watch" and "to lie in wait for."[46] In medieval English and German, the word conjures up turning one's watchful eye to the perils on the horizon.[47] As a temporal-spatial condition, waiting provides those who wait with the opportunity to prepare for what is or may be coming their way. If we are on guard, in other words, we can be ready for those who approach us. Being alert in this fashion entails imagining the immediate future with tense anticipation: Who are the persons moving toward the watchful observer and waiter? What kind of encounter will ensue?

Chronotope, or "space-time," is how the literary theorist Mikhail Bakh-

tin captures the "intrinsic connectedness of the temporal and the spatial."[48] His "historical poetics" traces literary representations of space and of time in texts or genres from antiquity to the present. As Bakhtin acknowledges, this term pays homage to the theory of relativity. According to Albert Einstein, space and time always and everywhere are entwined in the physical world.[49] He speaks of the "space-time continuum," a term the physicist Carlo Rovelli recasts as "spacetime."[50]

New conceptions of spacetime such as Einstein's abounded in early twentieth-century Europe, when scholars, writers, and artists explored afresh the grand question of how humans come to inhabit time and space in new media and with different technologies.[51] Their explorations of temporal-spatial relations shattered mechanistic or monadic conceptions of both.[52] Approaching schizophrenia as a particular engagement of time, space, and, ultimately, reality, the psychoanalyst-phenomenologist Eugène Minkowski coined the term *lived time* (temps vécu).[53] Jean Piaget investigated children's distinct temporal and spatial sensibilities.[54] In a series of exploratory texts, Ernst Bloch uncovered the layered temporalities that engulfed German society on the eve of National Socialism.[55] From a variety of angles, these and other critics discovered spacetime in the social world to be eminently variable, as well as consequential.[56]

While many such approaches commented on space and time as larger-than-life categories of cognition, others attended to spatiotemporal constellations on a human scale. For Walter Benjamin, the urban stroller scans and surveys outmoded spaces of urban commerce, the arcades of nineteenth-century Paris.[57] In this unfinished project, one passage compares the flâneur to the waiter. Their "apperceptions" of time, he suggests, differ—radically so. They are antitypes: the latter fixates on the clock, the former does not; the flâneur has an interest in the past, the waiter looks to the immediate future; the latter's vision is moored to a circumscribed space, the former's gaze reaches far and wide.[58] In addition, the one is privileged in that *flânerie* is an activity engaged in by a member of the leisure class, whereas interpersonal waiting, as a rule, is replete with intentions, strategies, and aspirations of the less privileged, who do not command their time fully. Likewise, in the pages that follow, I examine the small futures that waiting compels us to investigate, pursuing everyday interactions rather than time and space as categories writ large.

This book comprises three chapters: "Times," "Spaces," and "Encounters." Each chapter takes the reader on a journey through continental Western Europe during the early modern period. All three culminate in the eighteenth century, with a focus on the Holy Roman Empire. Its tapestry of territories, the German lands, which boasted many courts and cities, allows us to reconnoiter Europe-wide phenomena.

The first chapter takes its departure from the finding that the early modern period knew no explicit discourse or theory of waiting. "Times" approximates how early moderns conceived of what it meant to live in time. Notions of time often revolved around acting—an ethical field defined by one's situatedness and one's opportunities with regard to one's plans. Through proverbs, poems, maxims, treatises, novels, and visuals, early moderns learned to become aware of what was possible and advisable to do at any given moment. Their temporal present was not so much defined by chronometers. Rather, they lived in an ever-evolving present—a present structured by frames of actions, occasions, and expectations. This expansive present of constant change was a restless, ever-endangered place: an experiential register of hatching plans, waiting for opportunities, and revising these same plans. In other words, it was a present that required being alert, attentive, and ready to act, even if this entailed deferring action until circumstances were more favorable to one's intents.

"Times" sets counterpoints to the burgeoning historiography on time, with its emphasis on technologies of timekeeping as instigating change. How may time have drawn subjects into its ambit? This is one of the questions this chapter seeks to answer. In the process, I muddy the distinction many critics have inferred between the supposed slowness of premodern times and the supposedly fast pace of modern times. Importantly, the pocketed time that is ours to act (in reference to Baltasar Gracián's *Pocket Oracle*) is a temporal sensibility centered on the personal.

The second chapter, "Spaces," pursues the idea that antechambers, as built structures, were anything but neutral. The owners, residents, or their ancestors constructed, furnished, and decorated the spatial vessels where people waited to interact with other people. Through their size, imagery, and accoutrements, these rooms communicated, and as in the case of other architectures of waiting, they shaped and were meant to shape the experience of those who spent time there. What messages did these spaces forge? To be sure, no specific

iconographic programs existed for this type of room. As different examples of anterooms show, they intimidated, impressed, informed, or entertained waiters (if not a combination thereof). Yet the occasionalist ethics readers will encounter in "Times" also ran through these spaces. At times, such images encouraged waiters to seize opportunities or premeditate their actions. Chapter 2 thus traces the historical trajectory of such architectural receptacles from the palatial buildings of late medieval Europe to the antechamber as an architectural standard for members of the elites in the eighteenth century.

Finally, "Encounters." Spending time in anticipation of an encounter was and is an integral part of social life in stratified societies. The temporal intervals imposed on people were a constitutive element in the production of power, status, and authority. Yet in late medieval and early modern societies, interactions between unequals increasingly happened indoors.

How long did people have to wait? What were their chances of being admitted? What could one do to increase the likelihood of getting access? What may have been the sentiments, affects, and emotions that shaped waiting in the antechamber? Was the antechamber a place to bond with or talk to others kept in limbo? What were the codes of behavior operative in the antechamber?

Importantly, interactions on the thresholds between ante- and audience chambers did not simply reflect a rigid hierarchy in a period when everyone knew their place. Given the tussle between lineage, offices, and favoritism, access was contingent on the basis of protocol, precedent, and other factors. Antespaces therefore emerge as a stage where the vagaries of status were enacted as if they were certain. In short, there was great variety in how outsiders were welcomed and treated. To be sure, this type of room brought about a tightening of opportunities to interact with a person of station, as well as a delay in bringing about such an interaction. Thus viewed, the antechamber constituted a key space in a complex social arena.

This chapter sounds out how waiting in the antechamber played out with regard to a number of specific incidents and encounters. Selected court ordinances, images, diaries, memoirs, and letters offer insights into waiting scenarios in the antechamber. During the Enlightenment, one can hear the clocks ticking in the rooms where those who waited roamed. From the vantage point of an industrious society, waiting was time spent unproductively; time that could and should have been put to better uses simply ticked away.

In sum, waiting was part and parcel of early modern sociability. Learning how to bide one's time while hoping for an encounter was an important lesson many people needed to master. So the antechambers, with their amenities and discomforts, were a central site in early modern culture, and this culture endures, as my conclusion shows.

An investigation into the history of waiting necessarily rubs against the limits of archives that, all too often, revolve around outcomes. By contrast, how events acquired meaning as processes is difficult to know. Yet a history of waiting has the potential to disrupt history as we have come to know it; a history of waiting is impossible to conceive in a linear fashion. By necessity, it is episodic. But such episodes are not impossible to piece together from the shards of letters, etiquette manuals, chronicles, prints, and other documents we have mined frequently, though mostly for other ends, without giving attention to how temporal corsets or time-bound routines shaped people's lives. In that sense, waiting's histories—and I hope there will be many—are capable of revealing the structures, strictures, and possibilities of waiting.

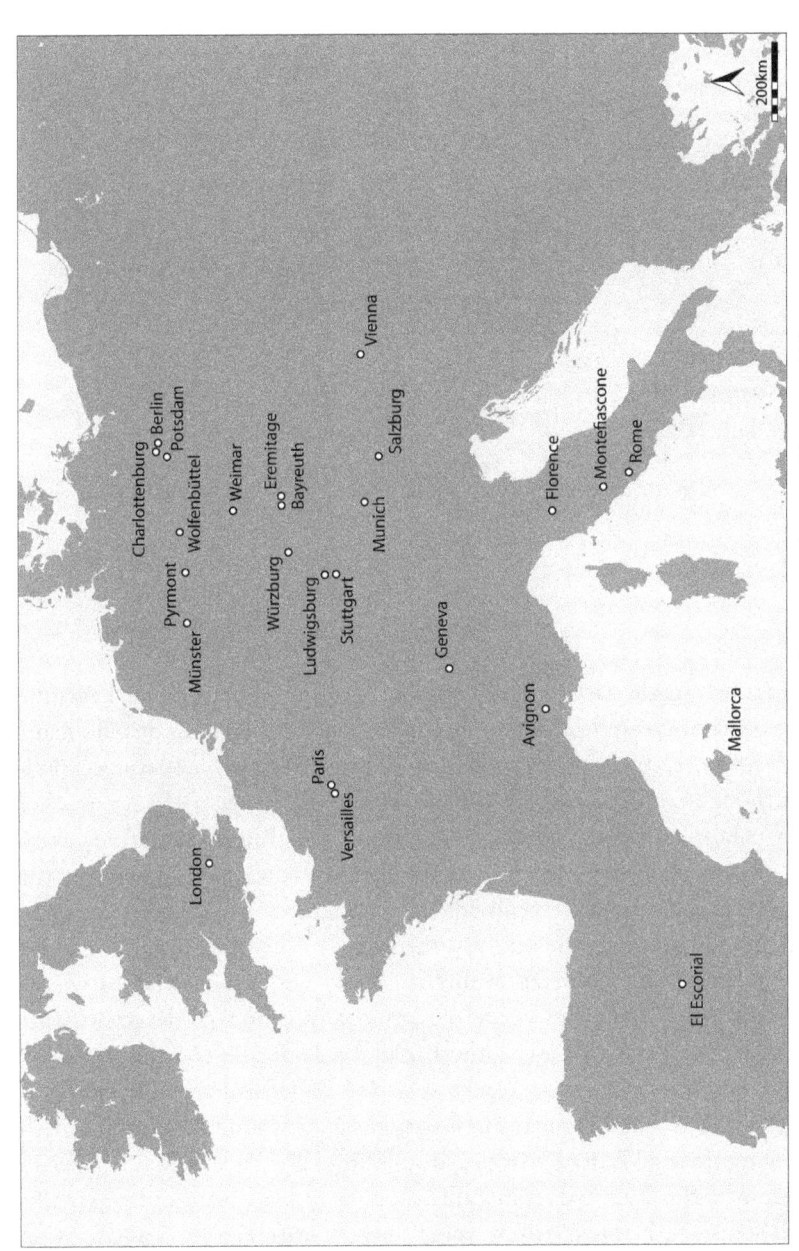

Map of Europe showing placenames mentioned in the book (illustration by Matilde Grimaldi).

Times

Nosce tempus!
"Know time!"
—Erasmus, *Adagia*

For early moderns, time was not a force external to their selves. Learning to know time meant learning to recognize what could pass as due moments to act—something I call occasionalism.[1] To uncover early modern occasionalist thought and practice, we will survey a cache of materials. An array of texts (adages, treatises, manuals, etc.), visuals (paintings, sculptures, etc.), and objects (timepieces, clocks, etc.) provides clues about temporalities as a complex and conflictual domain for early modern actors. Whether engaging in politics, diplomacy, the military, medicine, or rhetoric, taking the workings of time into consideration implied to act with moderation or wisely. Subsequently, we will explore one of the most influential guides to situating one's self as an actor vis-à-vis others: Baltasar Gracián's *Oráculo manual y arte de prudencia* (1647) or "Pocket Oracle." Whereas pocketing time à la Gracián means hatching plans in isolation, the plot of Duke Anton Ulrich of Braunschweig-Wolfenbüttel's capacious novel *The Roman Octavia* opens a window on the fractured temporalities among myriad protagonists. Finally, Enlightenment manuals call on young men to learn the art of modulating time in an occasionalist manner.

As a "social institution," time held possibilities.[2] Yet the most important early modern lesson about time may have been that it was distinct for everyone. People therefore needed to study, gauge, account for, and deploy time. Timing the self required one to act with foresight, increasing the chances to succeed with one's plans.

Sententious Lessons about Time

"Know time!" was Erasmus of Rotterdam's call.[3] But how did and does time, this mysterious force, become knowable? Proverbs provide one answer. They reach us as a "time capsule" from the past.[4]

Tempora tempore tempera is an adage whose minimal syntax mimics time edging forward.[5] Whoever seeks to know what this pithy Latin saying means will likely generate the answer "time heals all wounds."[6] Understandably, the notion that time wields curative power has its adherents. But there also are those who contend that what this postclassical maxim states is incorrect: some wounds remain open, the passing of time notwithstanding.[7] Let us take *tempora tempore tempera* as a point of entry to how early moderns may have known time.

Importantly, unlike the modern translation "time heals all wounds," *tempora tempore tempera* eschews a universal truth about what time *is* or what time *does*. First, time, according to this adage, is not one. Tellingly, the term features twice, once in the plural (*tempora*), a second time in the singular (*tempore*). The former refers to *temporalia* that affect us but largely are outside our control: the "times" of political turmoil, let's say, or of epidemics, economic crises, and similar trials.[8] Invoking times in the plural often entailed thinking of them as perilous or troubled.[9] By contrast, *tempus* singles out the time we may be able to turn to our advantage.[10] Setting these two temporalities in relation to one another, this adage encourages humans to act. Appropriately, *tempera* is an imperative (as is "know time!"):[11] mindful of the context of their actions, humans are called on to soften the impact of the times they live in by acting in time with moderation. What such good measure may mean is left to the one getting to know time. Time in the singular was specific to every individual and every moment.

In an eminently practical sense, the early modern *tempora tempore tempera* is reminiscent of the ancient proverb *festina lente*. Erasmus of Rotter-

dam paraphrases "hasten slowly" as "promptness together with moderation, tempered with both vigilance and gentleness, so that nothing is done rashly and then regretted and nothing useful to the weal omitted out of carelessness."[12] According to his *Adagia*, maxims such as "Know time!" were a fountain of human learning, style, and wit. They were "applicable to every situation in life." *Festina lente* therefore was the perfect tool for conducting one's life well. Its brevity was not a shortcoming. While short, sayings such as this encapsulate what matters most in a memorable way.

Even where time appeared in the singular, its meanings were wide-ranging, however. "Time reveleth [reveals] all thynges" or "Time brings the truth to light," and "Truthe, the doughter [daughter] of tyme" were sixteenth-century translations of *veritas filia temporis*.[13] In early modern times, writers and printers, royals and cardinals, Protestants and Catholics, religious propagandists and courtiers, men and women adopted this ancient adage about truth unveiled over time. They used this saying for mottos, devices, emblems, or artworks. Its message could be made to gesture toward a future free of religious, artistic, and other shortcomings in the present as well as serve as a slippery aside on the mythical nymph Callisto, whose growing womb revealed that Jupiter had assaulted her. Fritz Saxl found the dizzying array of this proverb's messages "disheartening." Yet such diversity stood at the core of early moderns' hands-on understanding of times. The truth invoked here was eminently personal.[14]

In modern criticism, a temporal sensibility that hovers between times in the plural and time in the singular (as in *tempora tempore tempera*) has at times been rendered as Chronos—times as a stretch, inevitably marching forward[15]—versus kairotic time, with its momentary opportunities. The mythological figure of Kairos (Lat. *occasio*) may cross one's path all of a sudden; you need to grab him or her (Occasio) when they pass by at great speed.[16] If one is prepared to act speedily, in other words, one may succeed in seizing an opportunity that comes one's way. To be sure, Father Time's weathered body contrasts with youthful-athletic Kairos or beautiful Occasio. Yet this imagery, with its binarism, fixes all too readily what was a murky terrain of knowing how to live and act in time.

That time was multiple and, to a degree, malleable, as the above adages have it, would not have come as a surprise to late medieval and early modern people. From the vantage point of Christian anthropology, humans essen-

tially had a heterochronic makeup. Late medieval theologians elaborated Augustine's foundational temporal theology by positing that the soul, while not part of eternity, escapes the transitoriness of the human condition.[17] Put differently, time consisted of various registers.

Only recently, historians, social scientists, and cultural critics of various stripes have again started to stress that time is not singular.[18] To address a spectrum of times within time, they speak of varieties of temporal experience,[19] temporal complexity,[20] heterochronicity,[21] plurality,[22] or pluritemporality;[23] others deploy the expression multiplicity,[24] if not diversity,[25] of times; yet others have coined resonant descriptions such as plenitude, fullness,[26] or thickness of time,[27] translating the multilayeredness of time into particular religious, cultural, political, disciplinary, and period-specific frames of understanding.[28] Still, the multiple times they investigate in a variety of contexts are for the most part external to the selves.[29] What has found little attention in the feverishly expanding historiography on time in the plural are "inward notation[s] of time," to cite E. P. Thompson.[30]

Doing Time

For early moderns, time qualified as a force to be drawn on, mulled over, and used. Acting in time required not only attention to time's rhythms but also forethought and attentiveness. Such temporal agency oriented individuals toward the future.[31] This practical take is one of the foundations for "the fascination with time" that "permeated [early modern] European culture."[32] Temporal awareness was a strategic tool, and it was meant to assist individuals in their tribulations, whatever they were. What is more, this approach played out in a variety of fora: religion, politics, diplomacy, the military, law, and medicine, among others. In fact, the royal and other courts were a particularly fertile arena for a conception of time tied to doing and waiting to act.

How does one ready oneself to act in time? After all, doing what *tempora tempore tempera* exhorts us to do, namely scout out possibilities, was and is no easy task. "Hope that is deferred afflicteth the soul," a sentence from the biblical Proverbs (13:12) warns us (Spes quae differtur adfligit animam).[33] Grasping time also was thought to be difficult, because it was elusive to the senses: "Mortals think that Time is sleeping, / When so swiftly unseen he's

sailing. / But he comes, with ruin sweeping, / In his triumph never failing."[34] In other words, while waiting for their turn to act, humans are at risk. They misread the times they live in, miss the opportunities time offers, or miscalculate what lies within reach. Only spiritual rewards were certain, as one seventeenth-century emblem contends.[35]

Still, being mindful about the times we live in was relevant in part on spiritual grounds, as a passage from Luke reminded Christians: "Be you then also ready, for at what hour you think not, the Son of man will come" (Et vos estote parati, quia qua hora non putatis, filius hominis veniet).[36] In a sermon on this New Testament passage, Martin Luther elaborates how arduous it is for believers to maintain hope that they will be saved in light of the never-ending adversities they confront, of which death serves as an example.[37] Waiting—waiting silently for that which God has promised (Hoffnung aber helt stille und wartet des, das jr ist von got zůgesagt)—entails waiting for what one cannot see (warten auff d[a]z ding, das man nicht sihet). Hope therefore requires faith as a foundation, he posits. Without it, waiting is a near impossibility. After all, one cannot picture with precision what will come. But faith alone does not do the trick either. Patience is needed to assist one's hope in this crucial matter. With patience, the "experience" (erfarung) we collect over time will assist us so that we can endure the admittedly difficult wait. Luther's sermon, with its cascading concepts, thus advocates watchfulness as a pious practice of the mind and the senses. Accordingly, one of Luther's biblical mottos was a reminder that "in quietness and hope lies your strength" (In silentio et spe erit fortitudo vestra) (Is 30:15). Though he was known for his temper, portraits of the Reformer offered these words to his followers.[38]

In the early seventeenth century, the Lutheran theologian Daniel Cramer deepened the discussion of *tempora tempore tempera* by linking it to a meditation on time from the book of Ecclesiastes.[39] Evidently, God is not subject to the upheavals people face.[40] Only humans contend with constant change: "All things have their season, and in their times all things pass under heaven" (Omnia tempus habent, et suis spatiis transeunt universa sub caelo).[41] The early modern author's emblematicism, with its word-centered Protestant teachings, pictures the above proverb via a *pictura* of ice-skaters on a frozen canal (fig. 1). As is evident, one may enjoy this pastime in only one season, winter. Even so, one of the ice-skaters has fallen; and everyone else may fall

as well. When this happens, others are bound to witness one's fall, as the urban setting with its onlookers suggests.[42] Accordingly, the epigram accompanying the image advises good judgment in temporal matters: "The wise henceforth moderate times with times" or beat time with its own weapons (Temperat hinc sapiens tempora temporibus), echoing, once again, the message of *tempora tempore tempera*.[43]

At times, this type of argument amounts to spiritual occasionalism. The epistle to the Romans in fact lent itself to such a reading: "The hour has already come for you to wake up from your slumber" (Rom 13:11). A seventeenth-century "useful instruction" aiming to enhance a sermonizer's

FIGURE 1. Daniel Cramer, *Octoginta emblemata moralia nova* (Frankfurt am Main: Lucas Jennisius, 1630), 76–77 (Herzog August Bibliothek, Wolfenbüttel, Germany: Xb 6083).

message from the pulpit exhorted Protestant readers to be attentive and not to neglect (verabsäumen) "the occasion to further one's [spiritual] well-being."[44] Tellingly, this is the exhortation that precedes all other teachings in a volume of thirteen hundred pages.

Time spent waiting more or less patiently for moments suitable to take action, therefore, is anything but empty time. Knowing time (*nosce tempus*) entailed knowing when time was ripe, as the motto of a French diplomat in the service of the Vatican went: *nosce oportunitatem*.[45] This stretch proves crucial not only when preparing for the final truths, as theologians had them, but also for collecting information. At any rate, it would be a mistake to waste this period. Among other things, it allows those on a quest to gain a footing in this barely knowable subject matter, time. Evidently, times of crisis like troubles or wartime required particular attentiveness. Amid atrocities, whether experienced, anticipated, feared, or committed, one's quotidian life persisted. In difficult times, conventional actions or rituals lent themselves to even be recognized as a bellwether, and temporal rhythms assumed the quality of a remarkable, if not nervous, apprehensiveness.

In other words, time was thought to flow unevenly. It made its impact felt all of a sudden, over stretches, or by some rhythm. Its course was punctured. Temporal layers convulsed. The interstices that time's cataclysms necessitated required doing little at times. At certain moments, conditions were conducive for taking charge, however. Time had the ability to thicken and congeal.

Waiting was inherently part of these scenarios. It was less a temporal frame set apart than an essential component of timed lives. Acting in time in this fashion lacked rules. The situations in which one found oneself could not be condensed into sententious exhortations applicable to general rules. Rather, the temporal constituted a field of action where a person needed to be on the alert to what was specific to this person's every moment.

Rhetoric, as a pivotal field in medieval and early modern schooling, taught students to tend to the moment when speaking or writing. They were instructed to approach ancient texts with questions such as *who, what, where, by what means, why, how,* and *when*.[46] Categories of this kind trained literati to account for audience, genre, place, and date, as well as the occasion of an utterance. This attentiveness to particulars is the backdrop for the vast library of early modern occasional literature, poetry, or oratory performed

and published on particular occasions, such as baptisms, anniversaries, weddings, funerals, feast days, civic festivities, and the like. They enhanced the momentary by offering an enduring invocation of an event commemorated in writing.[47]

Importantly, wisely timed utterances or actions were not exclusively about outcomes. They differed from what moderns call "time management." Instead, they were thought to carry moral weight. After all, *temperantia*, or moderation, one of the cardinal virtues, was closely allied with *tempus*, both sharing the same Latin root, *temp-*.[48] Hence *tempora tempore tempera*. On the western facade of the Munich Residenz—the only wing of this palace facing the city in the seventeenth century—the sculpted program encapsulates Duke Maximilian's vision of Bavaria as a bastion of Catholic Christianity.[49] Signaling the nexus of keeping time and exemplary behavior, the allegorical female figure of Temperance holds a four-faced clock (fig. 2).[50] The heraldic lion on the ground near one of the entryways, bearing the motto "Temperato ponderibus motu" (literally, "tempered by weights while moving forward," or "the weights adjust the clock's hands")[51] on a shield, reinforces this message about the nexus between timekeeping and knowing one's place.[52]

Temperantia—Time's twin in the minds of the educated and Latinate— emerged as a preeminent virtue during this period. Her allegorical representations became equipped with inventions of recent vintage: windmills or clocks. For a religious, intellectual, and cultural context in which regularity, order, and discipline mobilized laypeople, clergy, and elites, she was an ideal figurehead. After all, she was malleable, personable, and made to fit one's needs and observations. In Munich she was paired with *Fortitudo* (Strength).

Similarly, portraits of wealthy sitters with timepieces gesture toward moral rectitude.[53] A person's clocked life was meant to resonate with God's universe. Creation and clockwork were often set in a comparative frame. God was the master clockmaker; the created world constituted clockwork.[54] What sounds like a metaphor constituted a web of connections that timepieces allowed humans to make. Given the prominence of clocks in communities, many saw, heard, intuited, and possibly even grasped these connections.[55] At any rate, one can hear the individual quest for harmony with the divine ticking in these invocations.

Timepieces from the period are objects whose bodies signal the mentalities at stake. They helped early moderns to fathom time. Luxurious clock

FIGURE 2. *Temperantia*, western facade of the Munich Residenz of the Dukes of Bavaria, Residenzstrasse, Munich, Germany, Hans Krumpel (ca. 1616) (1960/1970; photograph by Helga Schmidt-Glassner, © Bildarchiv Foto Marburg / Art Resource, New York: fm1556529 / AR 6159465).

designs during the early modern period often featured a case that expressed or even performed movements, spatializing measured time in addition to a clock's moving hands (fig. 3). "Motion must of necessity be associated with time; for time is as it were a measure of it," as Erasmus of Rotterdam states.[56] Some clocks were shaped like ships, associating time ticking forward with travel through space. Yet naval vessels not only traverse the seas to unknown shores; these miniature works of wonder also invoke layovers.[57] Animal designs, as well as mythological, allegorical, and biblical or religious scenes, take up this same theme of mobility.[58] As automata, table carriages drew clock times on an even surface.[59] Some small clocks also doubled as automata, with figural processions on the striking of the hour, just like the spectacular mobile displays on large astronomical clocks.[60] These lifelike animations literally showed time on the move. Importantly, what is at stake in the aforementioned timepieces has little to do with the realm of pure ideas. These clocks are not about space or time in the abstract. Rather, they illuminate a temporal terrain in motion of which humans were thought to be part, as actors.

Such mechanical instruments were made to entertain elites and others who took pleasure in their workings wherever they witnessed them. At the same time, they connected the mundane with the universe by means of mechanics,[61] inciting humans to pause and marvel.[62]

Keeping an eye and ear on time through watches since the late fifteenth century linked timekeeping further with the practical domain of individuals timing themselves.[63] These instruments were not about accuracy exclusively. They connected the time of clocks with the self's designs, aspirations, and hopes. In the early modern mind, there was no contradiction between technology and practical ethics: "the virtuousness of technology," as Lynn White Jr. aptly characterizes this nexus.[64] Instead, such devices helped to bring behavioral possibilities to the fore. With their elaborate mechanisms and complex bodies, clocks were thought to mirror the intricate mechanics of larger entities and to symbolize the supposed beauty of the well-ordered universe. This is why the use of clock metaphors connected semantic fields as diverse as creation and nature with the workings of rulership, state, and ethics.

Chroniclers report that late in the life of Charles V, "his [majesty's] only occupation and his exclusive concern day and night was to care for his clocks and keep them working in unison."[65] The ruler who had reigned over an

FIGURE 3. Gerhard Emmoser, *Celestial Clock with Clockwork*, 1579, once owned by Emperor Rudolf II (New York: Metropolitan Museum of Art, 17.190.636; gift of J. Pierpont Morgan, 1917).

empire where the sun was said to never set spent his waking hours dismembering and reassembling timepieces, of which he had a vast collection. Given the poor precision of such devices at the time, at least compared to modern timepieces, this form of "doing time" was a losing proposition.[66]

Charles's son, King Philip II of Spain, cherished these instruments as well. The two clocks in his apartment also served as lights. While Geoffrey Parker interprets them as an "artificial aid to efficiency," the object itself has us imagine yet another story, that of the Herculean task of shouldering the ticking world.[67]

With their faces and, above all, sounds, clocks and bells on church towers had shaped communities since the high Middle Ages. By comparison, the clocks on castle facades are rarely noted.[68] Yet these timepieces also communicated the hour to commoners and courtiers alike, as in Amalienborg, Dublin, Meersburg, Mexico City,[69] Milan, Münster, Paris,[70] Stettin, and Versailles.[71] Whereas few clocks made it to the exteriors of castles, they became a craze within. One of these castles, Esterháza, a seat of one of the most eminent families in the Habsburg Empire, is said to have contained no fewer than four hundred clocks in the eighteenth century.[72] What a cacophony of ticks and times!

The paradox at the core of early modern lessons about acting timely and well is that temporal awareness was broadly apposite and widely practiced. Its social locus was expansive, including women, subalterns, and others. At the same time, it was said to hold particular lessons in store for people in positions of power. On the one hand, Erasmus celebrates *festina lente* as a teaching nugget that, although ancient, conveyed Christian values efficiently. This proverb is said to be "pregnant," "authoritative," and "wholesome": a sentence for everyone to remember at each and every moment. On the other hand, it is a "royal" proverb. Put differently, this maxim is especially relevant for persons in positions of authority, whatever their station.[73] According to Erasmus, those who have powers at their disposal are given to act rashly. It is a flaw that only they can afford. Their subjects don't have this same luxury to disregard the timing of their actions. "Make haste slowly," therefore, is the adage rulers need to embrace as an antidote to the temptations of their position. After all, reckless and precipitous acts on their part often have disastrous consequences for their subjects. In other words, even if "make haste slowly" is relevant for everybody, as Erasmus insists, *festina lente* addresses

rulers in a critical manner. They ought to learn how to temper their actions in time and train their awareness of the temporal condition of others.

Decision-makers thought of politics as something like the art of the possible—possible despite adverse conditions, limited resources, slow communications, and similar such frames that constrained their ability to act. What was prudent needed to be determined based on the particular constellation of political, military, and other forces at stake. As a result, waiting for the right circumstances to act shaped politics; its corollaries were deferrals and delays that had the advantage of avoiding confrontation or conflict.[74] During an audience with an Italian ally in 1571, Philip II expressed as much: "Contrary to his normal custom, [he] spoke at length and entered into great detail about the means, the place and the men" (contrariamente a lo que en él era habitual, habló extensa y detalladamente sobre los medios, el lugar y los hombres) that would allow Spain to return the English crown to the Catholic faith through military force; "he had wanted and waited for a long time for an occasion and opportunity . . . and . . . he believed the time had now come, and that this was an occasion and the opportunity for which he had waited" (llevaba largo tiempo deseando y esperando una ocasión y oportunidad . . . y que creía que había llegado el momento y que aquella era la ocasión y la oportunidad que había estado esperando).[75] In hindsight, the moment thought to be ripe for the picking was an enormous miscalculation whose losses, once the plan came to fruition, were staggering: only half of the Spanish Armada's naval vessels made it back to Spain from English waters, and fewer than half of the soldiers and sailors survived. At any rate, transferring a practical philosophy centered on individual actors onto groups, communities, armies, and states could result in giant misapprehensions. What may have seemed fortuitous at one moment would inevitably change.

Diplomacy was an arena where temporal awareness of the kind contoured here was particularly relevant. Given the distances involved, nobles, courtiers, and emissaries on a diplomatic mission were removed from their superiors or sovereigns.[76] Absent well-timed instructions and regular updates, the ability to adjust to local conditions was key. In an extensive memorandum to Diego Hurtado de Mendoza, imperial plenipotentiary in Rome and representative at the Council of Trent, Charles V reports with great detail on recent audiences he has held with the representative of the curia in Innsbruck, Austria. Since the speed of epistolary exchange often did not keep up

with evolving circumstances, he instructed this diplomat for some time to come, specifying that "as time and chance must play a part in these matters, we must modify our policy accordingly." In an addendum to the memorandum with instructions to the ambassadors in cipher, he added, "Keep us well posted of all you hear," instructing this ambassador to inform him regularly "so that we may write to you from time to time in the light of other questions telling you all you require to know about general politics."[77]

Living in time differed for early modern women and men. In the pedagogical manuals that instructed women on education, marriage, and the household, male pedagogues put a strong emphasis on countering what they saw as female idleness. They promoted women's diligence, with multiple temptations and lust lurking as dangers. By contrast, men often escaped censure of this kind. Yet women writers of the period occasionally reimagined, corrected, and interrupted patriarchal scripts on time. For the French poetess Louise Labé, writing emerged as a wellspring of "singular satisfaction" (singulier contentement), amplifying possibilities for women in the extensive poetic present.[78] While writing is an act, it is different from the occasions that provided opportunities for men in public life. But it also is important to remember that what is at stake in this context was a temporal practice with a promiscuous range of applications of which women partook.

In the early modern period, taking time's manifold horizons into account passed as sensible medical practice for both patients and experts, for instance. The notion of every body's ability to change in ways that resisted generalization united the eighteenth-century Eisenach doctor Johannes Storch and the women from different classes he treated and whose case studies he published in elaborate volumes on women's diseases. These female patients decided when to seek advice and from whom they solicited such advice at certain moments. Whether servants or members of the middling and noble classes, in Storch's mediation, they come across as acute observers. Their bodies were theirs to sense and observe, or this is what they communicated to Storch. As a rule, they knew or suspected when they had conceived; subsequently, they shared this and other information with their doctor of choice (for many, Storch was not their only doctor). A thirty-year-old woman who had been raised in a peasant family (as Storch writes) let her doctor know in 1724 that she had thought she was pregnant when her body swelled. After the time for giving birth had long passed and there was no fetal movement,

she started menstruating again. For Storch, she was an example "that there are people who live healthily without medication" (daß es auch Leute giebt, die ohne Artzneyen gesund leben) and whose bodies heal by themselves.[79]

In communications with Storch, these women patients narrated bodily phenomena of concern to them. By doing so, they ordered what they had observed with their senses, with an eye to these bodies' time-bound logics, as they saw them. At any rate, the expert's renderings of patients' accounts pay detailed attention to the temporizations of their bodies. As Barbara Duden comments, physical ailments "appeared only as experienced processes," not as deviations from medical standards. What her exquisite study skims over, however, is the disquieting and anxiety-provoking nature of these women's bodies in process.[80] Orphans, servants, and daughters from well-to-do families regularly speak of "horror" (Schrecken), "trepidation" (Bangigkeit), and similar such affects.[81]

When the nineteenth-century neurologist Jean-Martin Charcot researched his thesis on the workings of time in diagnostic medicine, he looked to medical authorities of the seventeenth and eighteenth centuries for inspiration (William Harvey, Georg Ernst Stahl—Storch's inspiration—etc.): "Anticipation is a method" (L'expectation est donc une méthode), he states, adding that it is different from inactivity. Such attentiveness means to observe relevant details against the backdrop of clearly defined goals for one's actions.[82] In some cases, treatment can do more harm than good, he reminds his readers; doctors should not discard the possibility that a patient recovers spontaneously. Yet Charcot's attention to the temporal dimension as a force experts ought to marshal to their advantage in doctor-patient relations was not of its time. Submitted in 1857, his *thèse d'agrégation* was rejected.

Conflicting Times

Some of the richest invocations of the complexities of time's registers in Europe, at least in material-architectural form, are the facades of the eighteenth-century palace for the prince-bishop of Münster in Westphalia. This city serves as a telling example for the contested terrain of time in early modern society. Münster's history, one conjectures, formed the backdrop for the castle's design, with its web of references to time.

In sixteenth-century Münster, the Anabaptist Kingdom had instituted a monolithic temporal regime. Its leaders ruptured the multilayered urban

calendar in order to ready citizens for the end of times the leaders saw as imminent. Stripping "the Lord's church of all its decorations," iconoclasts destroyed the cathedral's late medieval astronomical clock in 1534.[83] When Anabaptists seized power in the city, heavenly time became the standard, and citizens had to dispense with what they owned, timepieces included.[84] The kingdom's bloody demise became a defining moment in the city's history. The cages of the executed Anabaptist leaders remained visible high on the belltower of St. Lamberti Church. Their haunting presence issued a warning against those who were seen to disrupt the flow of urban-liturgical times, adding a strongly diachronic marker to the cityscape (at least for half a century after 1535, though the cages returned at a later moment and can still be seen from across town). Accordingly, the authorities governing this bi-confessional Catholic-Lutheran community had a new clock installed in the cathedral (1540–42). Its construction marked the return of the old calendric order, while keeping the violent conflicts of the past resonant.[85]

Arguably, what came to be installed in Münster's cathedral is one of the most impressive monumental timepieces in a house of worship from this era. It is a veritable "miniature cathedral of its own," as Anthony Grafton describes an even larger example of this genre, the Strasbourg astronomical clock. In the sixteenth century, teams of scientists, artisans, and artists replaced the late medieval clocks in both cases.[86] These clocks reminded residents that the local time their clockfaces indicated, as well as their chimes, zodiac signs, astronomical imagery, and biblical iconography, resonated with the cosmic order and God's creation.[87] The city of Münster thus provides an example of what scholars have called chronocenosis, "a sense that multiple temporal regimes are not merely concurrent but at once competitive, conflictual, cooperative, unstable, and sometimes even anarchic."[88]

When Prince-Bishop Maximilian Friedrich of Königsegg-Rothenfels and the estates of the bishopric carried out a long-harbored plan to build a palace in Münster in the late eighteenth century, the ruler came to be associated with time as a dynamic field of action. Tellingly, in the last phase of construction, the architect Johann Conrad Schlaun added a tambour with a clock to his design (the garden facade also shows a clock—a doubling that is rare in palatial exterior decorations). Representations of the months, the ages of man, the seasons, and the times of the day engulf the facade toward the city as well as its counterpart toward the garden. As envisioned here, time was not an abstract principle or force. Again and again, Saturn, or Chro-

nos, this protean deity with its multiple associations and many attributes,[89] is invoked as a doer, a destroyer, a builder, and so forth. In these representations, time is an agent. Uncovering the fabric of time means to reveal the truth, for example, as one of the reliefs on the garden facade's upper registers illuminates (fig. 4). What is more, the golden age seems within reach. But let us avoid the universalisms often associated with the workings of time in our times. In the early modern conception at stake in this context, time is no equalizer. Yes, the hourglass, usually interpreted as a symbol of death, is invoked. Yet in Münster, Fama, Fortuna, and Tempus appear above all in the facades' upper levels, the register associated with the ruler, where his coat of arms can be detected.[90] Temporal politics and ethics, in other words, map onto social, political, and other hierarchies.

The sensibility that encouraged people to tend to the right moment to act with particular attention to the obstacles, crises, and catastrophes they experienced was, if anything, an individuated approach to time. If every moment was particular, then no person's moment was like another's. At the same time, this temporal praxeology, thought to be serviceable as a means of survival in difficult times, was a way to gauge others.

Where there was awareness about time's doing and one's acting in time, there also was a potential to use one's time in a contrary fashion.[91] Let me zoom in on an example. Martin Luther at the Diet of Worms (1521) is one of the best-known episodes in all of history: a professor at a recently founded, small university, Wittenberg, and someone whom the pope had declared a heretic, challenged his powerful interrogators in the packed bishop's palace where the empire's dignitaries had assembled. Importantly, they had no authority over spiritual matters. That Luther was permitted to speak was the result of negotiations before the diet started.[92]

On April 17, 1521, a cleric from the imperial party confronted Luther with two questions: Had he authored the books on display in the meeting hall? And did he want to recant any of these publications or parts thereof? The questions aimed to give short shrift to Luther's appearance. After all, answering them in whatever form precluded a debate on matters of theology. In response, Luther asked for a "space to consider" his answer to these questions. This request for a *spacium deliberandi* garnered him a pause of one day (he had not asked for a specific amount), courtesy of the newly elected Emperor Charles V, who presided over the meeting. Though the investiga-

FIGURE 4. Johann Ignatius Feill (sculptor), *Chronos Reveals Time and Truth*; below: *Owl with Hourglass*, former palace of the prince-bishop of Münster, garden facade, Münster/Westphalia, Germany (1928; photographer unknown, © LWL-Denkmalpflege, Landschafts- und Baukulture in Westfalen).

tors registered surprise at the unwelcome (from their perspective) request, the gesture showed a ruler's generosity in public dealings with his subjects. As a result, a mere commoner made dignitaries wait for an answer to their questions.[93]

This extra time and Luther's statements before and after (even if we don't know their exact wording) invested his appearances at the diet with significance. It signaled to the assembly, as well as to the crowd waiting outside the hall, the deeper questions at issue from Luther's perspective: God's immutable word and man's salvation. Their weight was such that these questions required careful consideration in a "space to consider."[94] Deliberate timing on his part was not a reflection of personal psychology. Nor did it signal a crisis of faith, of which there is no evidence, despite the plethora of documents about how Luther spent his days in Worms. Instead, this strategy relied on and resonated with available cultural idioms for exchanges between subjects and rulers, temporal protocols at law courts or university debates, and personal strategies in using time as a resource.[95]

Although, as I have stated, Luther at the Diet of Worms may well be one of history's best-known scenes, scholars have rarely explored the temporal registers at stake. At any rate, Luther's request lacked self-evidence; there was no right to "time to consider," especially not in this somewhat unprecedented context (when questions of religious orthodoxy were up for debate, though not on the agenda). Still, other actors would soon follow Luther's example with their own performances of contrary beliefs in and through time: "a hometown reenactment of Martin Luther's legendary confrontation," in the words of David Luebke.[96]

In this case, the notion of time in the plural permits us to delve into the conflicting temporal practices available at particular moments. Luther was made to wait before he entered the hall in the bishop's palace where the meeting took place. Yet he also made others wait for his response to their questions. The interval of one day constituted an efficacious counterpoint to the premeditated script that the imperial party had devised to dispense with "the Luther affair" quickly.

In sum, in early modern Europe, waiting was an integral part of thinking about and acting in time. Importantly, using time well conjured up a field of planning, delaying, and taking action. This approach had to be learned and practiced. *How* early moderns imbibed lessons on inhabiting time is the question I pursue in the next section.

Prudential Times

In early modern Europe, knowing time and knowing how to wait for one's turn were said to be full of rewards. Yet how does one learn to act in due time? A highly influential compendium of practical philosophy in temporal matters was Baltasar Gracián's *The Pocket Oracle and the Art of Prudence* of 1647 (*Oráculo manual y arte de prudencia*). "Bide your time" (Hombre de espera) is one of its maxims.[97]

Waiting needs to be learned, this passage proclaims.[98] "First master yourself and then you will master others" is the path recommended (Sea uno primero señor de sí, y lo serà después de los otros).[99] For Gracián, waiting or hoping (espera), if practiced with prudence, was a powerful tool in working toward one's goals, whatever they may be. Capturing waiting's promise, the author differentiates *espera* from sheer inactivity: "The crutch of time accomplishes more than Hercules' nail-studded club" (La muleta del tiempo es más obradora que la azerada clava de Hércules).[100] In the theater of one's life, unexpected turns offer waiting's practitioners opportunities, the occasions, for acting.[101] Those who have acquired the necessary skills to seize the moment when it has arrived are at an advantage. Appropriately, this maxim closes with future prospects: "Fortune rewards patience with a truly great prize" circles back to the passage's beginning (La misma Fortuna premia el esperar con la grandeza del galardón).[102]

Importantly, for *espera* to wield its force, the goals, intentions, or sentiments one harbors must remain unknown to others. "Not immediately revealing everything fuels anticipation," as the *Pocket Oracle* has it in another passage (El no declararse luego suspende, y más donde la sublimidad del empleo da objeto a la universal expectación).[103] Accordingly, a posture that belies one's inner readiness through an inscrutable outward appearance may make one's exercising restraint in time particularly effective. If one prepares, in other words, one finds oneself in a good position to take advantage of the moment once it has come. There never are, or never seem to be, victims of *espera*, those who had hoped and waited in vain.[104] For Gracián, one strategic calculus cedes to the next; there is no resolution other than the end of one's life.

Here I have mined a passage from the *Pocket Oracle* for clear-cut lessons on waiting. This pointed mode of engagement would have been familiar to

early modern audiences. One may call it selective reading. Yet learning in this fashion only scratches the text's surface. The maxim's, as well as the volume's, epigrammatic, if not brusque, prose styles often border on the incomprehensible. This opacity is calculated. Arguably, it issues an invitation to mull over what Gracián says.

In our maxim, nouns abound—*patience, self-mastery, Hercules, God, opportunity, prudence, fortune,* and *time*—alongside weighty verbs such as *delay, ripen,* and *mature.* How is one to make sense of this semantic web? How does time concatenate with space when the author invokes a "journey through the tracts of time to the centre of opportunity" (hase de caminar por los espacios del tiempo al centro de la ocasión)?[105] Or what does "A great saying: 'Time and I against any other two'" (el tiempo, y yo a otros dos) exactly mean?[106] Syntactic connectors are often missing. It would be a mistake to smooth over these gaps when the precarity of experiencing time is at stake.

Gracián's *Pocket Oracle* performs what it teaches. A text whose enigmas are plainly evident features passages that call on us to veil strategic plans for our own good. Put differently, its elliptic mode of arguing incites engagement in the reader. Readers are advised to ponder its messages to unlock the text's profundities when pocketing time. What follows, then, is that the *Oráculo* is a manual best kept close at hand, be it in one's pocket or within reach, as the title suggests.

In many ways, the poetics of the *Pocket Oracle* both emblematize and exceed the philosophy of time expounded in previous sections. As was to be expected, Gracián ominously invokes "these times" of tribulations as a backdrop to our actions in the opening paragraph to his slim volume.[107] *Occasions* is a key term; they function as decisive points that orient *espera*'s practitioners in the uneven flow of time. The condensed messages contained in the volume seek to maximize one's chances of surviving these challenging times.

In a way, survival *is* the task at hand. Yet unlike some documents we have encountered so far, Gracián's philosophical edifice has an innerworldly quality.[108] This is not to say that the author denies the existence of God; far from it (see maxim 300). To be sure, God is mentioned in "Bide your time." Surprisingly, God does as we ought to do with regard to others—that is, act on us in time or occasionally: "God himself punishes not with the rod, but at the opportune moment" (El mismo Dios no castiga con bastón, sino con sazón).[109] But while our Jesuit author focuses on the complexities and

challenges of the Now, the Godhead is largely left out of the picture. We are left to our own temporal devices. After all, time is the human condition; it is inescapable. But it also is a weapon. Therefore, it is good to master how to use the "act of not acting" by "listening to the circumstances."[110] Life, as Gracián has it, is a rather lonesome and agonistic affair. It equals a fight in a contest, not a battle in which a *persona* can rely on others.

Like Ignacio de Loyola's *Spiritual Exercises*—the text that formed the foundation of the Jesuit order—the *Oráculo* instantiates an *exercitium* in time. But its organization is of an entirely different kind.[111] Gracián's Jesuit pedagogy does not follow a sequential *ratio docendi* or *exercitandi*, where one lesson prepares one for the next level. Sure, certain key themes, terms, and formulations reappear at intervals. At the same time, echoes, frictions, and seeming inconsistencies are meant to trigger in the reader what is useful above all: alertness. After all, mindful attention to the uneven workings of time is crucial for a person's success in a world out of joint. And as readers, we are on constant alert, without the solace of a continuous and well-organized curriculum, as in humanist pedagogy.[112]

The text's difficulty, if not impenetrability, entails that the *Pocket Oracle* is best absorbed over time. Slowness, in fact, is what Gracián extols: "Folly always rushes in, for all fools are audacious.... [G]ood sense undertakes things extremely carefully; vigilance and caution scout ahead so it can move forward without danger" (La necedad siempre entra de rondón, que todos los necios son audaces... Pero la cordura entra con grande tiento. Son sus batidores la advertencia y el recato, ellos van descubriendo para proceder sin peligro.).[113] Engaging the *Oráculo manual*, therefore, means to surrender to a process. What is required of the reader (or should I say adherent?) is commitment: the commitment to make sense, to orient oneself, and to probe the *Oráculo*'s riddles.

Gracián's temporal poetics resonate with the history of time, Achim Landwehr proposes. This historian of time locates the emergence of a capacious present in Europe's seventeenth century. During a period when theological-scientific calculations situated the end of the world in a relatively distant future, contemporaries filled pregnant moments with news from periodicals and newspapers, those novel media;[114] the impact of the exemplary past on the present receded, and the immediate future gained contour in its specificity. As a result, the present morphed into a multiform flow of time, and the temporal fabric of people's lives changed, as the present accommo-

dated it within its ambit.[115] What Landwehr argues for is not a radical shift in the score of lived time but a temporal sensibility that eked out ever more of an existence amid others.

If this is correct, then the rise of the Now would have been conducive to the reception of Gracián's practical philosophy (fig. 5). What is more, the courts, where the author had lived, were an ideal ground for this approach to flourish. These institutions brought together many people from different walks of life; courts were attuned to scientific-philosophical-artistic experiments; and finally, courts prided themselves in spearheading technical and intellectual innovations. As institutions said to suffer from a relentless pace in the philosophical literature of the time,[116] they were the ideal testing ground to apply Gracián's *filosofía cortesana*: a courtly philosophy in, as well as beyond, the courts.

Pocketing Gracián

The *Pocket Oracle*'s lasting influence as a tool of survival for the self in difficult times rests above all on a seventeenth-century French adaptation: Abraham-Nicolas Amelot de La Houssaye's (1634–1706) *L'homme de cour*, or "The Courtier"[117]—an immediate and resounding success (fig. 6). *L'homme de cour* served as the basis, template, and model for subsequent editions in several languages, including English, German, Italian, and Russian.[118] Its title is programmatic. It "expresses not only everything that [the book] discusses but also its usage and for whom it is appropriate," Amelot de La Houssaye claims (son titre exprime non seulement tout ce qu'il traite, mais encore à quel usage, et à quelles gens il est propre). Gracián had been equivocal on the court and the courtier. Neither did he condemn court life wholesale nor did he propagate his *Oráculo* as a manual for this particular way of life. For him, the court represented one forum among others where readers could practice what his maxims held in store.

By contrast, Amelot de La Houssaye's explicit focus on a defined group of addressees, "courtiers," went hand in hand with expanding the text considerably. Through paratexts and additions—frontispiece, dedicatory letter, a preface to the reader, a table of contents, annotations, addenda,[119] as well as a detailed recapitulation of all the precepts found in the three hundred maxims—Amelot de La Houssaye helped his readers come to grips with

FIGURE 5. [Baltasar Gracián], *Obras de Lorenzo Gracian, dividas en dos tomos* (Antwerp: Verdussen, 1702), engraved title by Erasmus Quellin the Younger and Peeter Clouwet. This is the frontispiece of the fourth edition, Herzog August Bibliothek, Wolfenbüttel, Germany, LI 110:1 (formerly in the library of Duke Ludwig Rudolph of Braunschweig-Lüneburg).

Quis tot sustineat, Quis tanta negotia solus?

FIGURE 6. Frontispiece (King Louis XIV as courtier) from Abraham-Nicolas Amelot de la Houssaye, *L'homme de cour, traduit de l'Espagnol de Baltasar Gracian ... avec des notes* (Paris: La Veuve-Martin & Jean Boudot, 1684), engraved title by Pierre Lepautre (or Le Pautre), Herzog August Bibliothek, Wolfenbüttel, Germany, LI 4° 5 (formerly in the library of Duke Ludwig Rudolph of Braunschweig-Lüneburg).

Gracián's calculated opacities. His edition's font, layout, numbering, and format turned *L'homme de cour* into an object different from the sparsely designed original editions; editions of Gracián's *Oráculo* follow some of the same principles to this day.

Amelot de La Houssaye recommends the text's "temporisement raisonnable" (temporization based on reason):[120] mastery through self-discipline within time. One of the adepts of *L'homme de cour* was Ludwig Rudolph of Braunschweig-Lüneburg (b. 1671, r. 1707/1731–35). This Protestant prince's interest in the Spanish Jesuit's work stands in for other aristocratic readers across Europe. In addition to a fashionable leather binding and an elegant ex libris, he made the book his own by adding two inscriptions in his hand. Both showed his having absorbed central tenets of Gracián's program. The one in Latin, "occasione et prudentiâ" (with occasion and prudence), ingeniously summarizes the temporal poetics of Gracián, with its attention to caution and slowness when inwardly preparing for the favorable moment to act. The one in French strikes a different tone: "My motto is that love is foolish" (Je tiens pour ma devise, que l'amour n'est que sottise).[121] Indeed, interpersonal love, whatever we may associate with the term, lies beyond Gracián's philosophical vision, with its focus on individual actors, though an outright rejection of this kind strikes me as somewhat un-Graciánesque.

Ludwig Rudolph became something of a Gracián aficionado. Over the years, he would add volumes by the author to his library.[122] Some were in Spanish, a language he did not command, as far as we know; others were in French, Italian, and German.[123] With approximately fifteen thousand volumes, his library, by the end of his life, amounted to one of the largest aristocratic book collections in his day. Yet this bibliophile aristocrat from a line of other bibliophiles started his career as a reader of modest ambitions. He was not a scholar-aristocrat, much to the chagrin of his father, Duke Anton Ulrich (who had a doctorate in theology), but was interested in books of practical value above all. Journals of his bookish exploits bear witness to his labors as a reader. He studied Gracián's *El Criticon* in French and in German, together with Blaise Pascal's *Pensées* (which he found ingenious).[124] Ludwig Rudolph's reception is emblematic of the praxis-oriented and occasionalist aristocratic reader.

The professor of philosophy Christian Thomasius cast Gracián in a light different from *L'homme de cour*. Unlike Amelot de La Houssaye, he advocated the *Pocket Oracle* (which he knew from Amelot de La Houssaye's edi-

tion) as a guide for everyone. At the University of Leipzig (1687–88), he taught a "collegium on Gracián's basic rules on how to live sensibly, prudently and well" (Collegium über des GRATIANS Grund-Reguln / vernünfftig / klug und artig zu leben). His class is known as the first academic lecture held in the German language (at a time when Latin was the standard academic language). In this context, the *Pocket Oracle* was a most meaningful choice. It made a case for access to knowledge not only linguistically but also in terms of an eminently practical education. Numerous translations into German followed from this affront, as some contemporaries saw it. The intense reception of Gracián in the modern German-speaking world in the works of Arthur Schopenhauer, Friedrich Nietzsche, Werner Krauss, and others arguably dates back to this moment: Johann Leonhard Sauter in 1686, with further prints in 1687; Christian Weißbach [pseudonym Selintes] in 1711, with another print in 1715; as well as the translation by August Friedrich Müller from 1715, where the title page mentions Amelot de La Houssaye, though Müller's text is advertised as translated from Spanish.[125]

The Thomasius-inspired translator Müller (1684–1761), lecturer in philosophy at the University of Leipzig, explains "Bide your time" thus:[126]

This maxim concerns . . . the prudence to wait for the right and most convenient times for one's undertakings. [This] is the right time to carry out something, the one in which on the one hand the ability and power that is required for such an undertaking has grown to a satisfactory and ideal degree, but on the other hand the circumstances for the successful execution of such a project are most favorable. So where these two parts come together at a time, there is no reason to wait, but rather, according to the common saying, to forge the iron, when it is hot.[127]

In this version, "Bide your time" argues that thinking strategically with and in time is eminently useful.[128] Occasion, caution, watchfulness, and expectation were promoted as having universal value.

In a similar vein, another Gracián-inspired theory of prudence from the early Enlightenment seeks to render concrete the concept of preparing to act in every moment. Julius Bernhard von Rohr calls on his reader to invest one's life, time, and talent in God's honor and the service of others, avoiding idleness. Unlike in the *Oráculo*, worldly success and religious norms are said to work in tandem, if not harmony. Every action one plans ought to be investigated to determine whether the intent and the means to achieve

it would please God. From then on, how to bring one's plans to fruition is what every individual ought to pursue. To ensure outcomes, the author takes into account principles based in human psychology. A matrix of reasons for and against a particular design ought to structure decision-making processes. Procrastination is to be avoided, to be sure. Visualizing one's immediate future should help one's designs to become actual. The metaphor of the theater of life appears here as a strategy individuals can deploy to ensure positive results: "Imagine standing on a theatrical stage where everyone sees and observes your actions," as one is enjoined to do (Bilde dir ein / daß du auff einem theatro stündest / da dich alle Welt anschauen / und deine actiones observiren könnte).[129] Also, one ought to imagine a difficult task as easy to avoid being bogged down by its difficulty. Caution, constancy, focus, desire, and gaining experience are among the guiding principles when assessing one's progress, while using discretion when sharing one's plans with others. What emerges is a temporal sensibility different from the one outlined above: less adversity and more doability, less personhood and more subjectivity, less caution and more action, less practical ethics and more instruction in how to lead a good life.

As we have seen, in the history of the reception of Gracián's *Oráculo*, two contradictory developments competed with each other. On the one hand, there was a tendency to pinpoint the sententious reflections this momentous yet aphoristic volume contained for specific groups of readers, such as courtiers. On the other hand, time, as a predicament for every human, allowed for a wider reach of the author's practical philosophy. Yet this basic tension informs the history, ethics, and politics of time during the early modern period more generally.[130]

The *Pocket Oracle* had wide appeal and was widely disseminated, with its hands-on yet difficult to grasp maxims. But it was not the only text to be part of the curriculum on waiting as part of a wider approach to living in time.

Novel Times

What was it like to live in the expansive present with its ever-changing possibilities of anticipating occasions to act? If delaying, waiting, and scheming were essential to one's timed existence, what were the sentiments associated with spending time suspended in a series of anticipatory horizons? Thinkers à la Gracián are not likely to give answers to these and similar questions. Novels, however, might introduce readers to the temporal conditions, if not predicaments, of individuals in a web of relations with other individuals. While philosophical manuals in the wake of Gracián often address readers in isolation, narrative texts help us imagine groups or, rather, protagonists. Tellingly, the "experience, knowledge and practice" of timing pervades the following narrative about the most difficult of times.[131]

There are few novels like *The Roman Octavia*, even in the Baroque—an age with a penchant for cavernous plots.[132] Duke Anton Ulrich of Braunschweig-Wolfenbüttel's opus is a colossus of seven thousand octavo pages and more, since the author's later but unfinished reworkings exceeded the first version's page count. Its intermittent gestation spanned more than four decades. Even though it is not the duke's only publication, *The Roman Octavia* is the work of a lifetime. The travels and missions of this scion of one of Europe's preeminent dynasties, the Guelphs (Welfs), intervened.[133] Such an expansive literary undertaking defies conventional notions of textual genesis. While without a doubt Duke Anton Ulrich was the novel's prolific master creator, ultimately, it is the work of many: secretaries, scholars, printers, and others were involved in its production.[134] One of these cocreators, Gottfried Alberti, was tasked with finishing the opus after the duke's death in 1714 but failed to complete this mission; Anton Ulrich's successors showed little interest in a *finis operis*.

The Roman Octavia maps what it depicts—the courts.[135] In the preface to his earlier novel of five volumes, *Aramena* (1669–73), the author describes his fiction as a "mirror of the court and of the world" (Hof- und Weltspiegel).[136] This description is also apropos regarding *The Roman Octavia* (which lacks a prefatory statement of this kind). As we have already seen with regard to Gracián, the courtly sphere was heralded as a reflecting image of the social order. Yet *mirror*, as the preface has it, invokes more than a reflection. The

term conjures up the novel as a guide to courtliness, not unlike the "mirror of princes" as a genre.

Set in the Roman Empire during the tumultuous years CE 68 to 71, *The Roman Octavia* is neither a historical novel nor a roman à clef in historical disguise. Rather, its panoramic monumentality interlaces different periods, as well as different regions of the world, faiths, and political sensibilities, to create one whole. We are dealing with a "zone of maximal contact with the present (with contemporary reality) in all its open-endedness," to quote the theorist of novelistic chronotopes or time-spaces, Mikhail Bakhtin.[137]

These pasts, presents, and imagined futures in a vast geographic space could form one nexus because the most fundamental rule of life, constant change, was thought to be unchanging.[138] As one narrator in the novel puts it succinctly, though with a theological bent atypical of most other parts, "Divine wisdom punishes countries. It exalts one people above another so that from such daily fluxes we recognize the mutability of all temporal things and in the midst of our greatest fortune we are reminded of its decrepitude or impermanence" (Es verhänget ja die Göttliche Weißheit diese und dergleichen Landstraffen und erhebt ein Volck über das andere / damit wir aus solcher täglichen Abwechselung die Unbeständigkeit aller zeitlichen Dinge erkennen / und mitten in unserm grössesten Glück an dessen Hinfälligkeit und Unbeständigkeit gedencken sollen).[139] Constant change is what never changes. "Daily experience" (tägliche Erfahrung) is said to teach this lesson, and so does Anton Ulrich's novel.[140] Within the novel, a quotidian temporality as constantly changing shapes history, politics, religion, and heroism.

The novel's first sentence catapults the reader into the turbulent final period of Nero's reign: "Rome now hovered between fear and hope" (Rom schwebte nun zwischen Furcht und Hoffnung).[141] This condition of living in suspense becomes a pressing reality in subsequent volumes. Their openings often resonate with the first: "Rome hovered between such great outrage and great joy," another volume commences (Rom schwebet in ja so grossem Entsetzen als Vergnügen).[142] At the plot's outset, King Tyridates of Armenia, the main hero, has arrived in the city of Rome, waiting to be received by no other than Nero. When he meets the person he believes to be the emperor, that person offers to make him his successor. Tyridates harbors reservations and plays for time. As the main hero, Tyridates is the champion of a circle committed to restoring virtues to political life. His love for Neronia, Nero's

first wife (her real name is Octavia), a secret Christian during years when their faith was persecuted, complicates this plan; many amorous and political machinations ensue. The transitions of power, as well as this impossible love, cause perilous moments for the protagonists, and a seemingly endless chain of events unfolds.

Every protagonist lives in the Now, a Now defined by an expansive present of constant upheaval.[143] Yet for every person, this fluctuating Now takes on different contours. After all, their ranks, ages, genders, associations, religious beliefs, and schemes differ. In response to the times they live in, they concoct plan after plan, creating temporary and sometimes even lasting bonds in the pursuit of their plans. As a result, everyone is in need of associates and friends. Confidantes provide advice. Men and women give each other counsel. Yet again and again, a mishap, a turn of events, or a new and unexpected piece of information requires additional communications or yet another change of plan. The protagonists await news in order to devise their next steps. But these same plans also make them vulnerable to exposure and counterplots, if not punishment, violence, exile, or execution.

Interactions make up much of the plot. What we witness is not the psychology of the dramatis personae, however. Rather, what unfolds is the theatrics of sociality in the midst of a political crisis. After all, the protagonists' visions, as well as the actions they perform to realize their goals, are prone to falter in light of subsequent revelations. Importantly, not everything is what it seems. Nero has doppelgängers. Some figures pretend they are someone else. People believed dead are, in fact, alive. These dissimulations and simulations notwithstanding, the immediacy of personal encounters is what pushes the plots and subplots forward, with their potential for one momentary truth after another. As with Gracián, the theater serves as an apt metaphor for this multilevel plot of foes and friends, simulators and dissimulators.[144] The complications seem infinite, yet making plans and waiting for the propitious moment to act on them persists.

In this novel, awareness about the workings of time does not hinge on timepieces. Rather, the annalistic linearity of narrated time is such that it is possible for the reader to chronicle what happens. Calendric references mark the temporal flow. Nights are especially apt for carrying out clandestine plans in times of tyrannical rule, as well as political or religious persecution. Shared temporal horizons, among other things, hold this narrative universe together.

This "chronicle" in the form of a novel is countenanced by backstories. The textual fabric of these self-contained narratives differs from the novel's labyrinthine plot.[145] Such retrospections are contrapuntal insertions into the novel's forward movement. These circumscribed narratives contrast with the lifelike mimicry of the workings of time in the novel's main plot. In a way, the closure of these inserts is a preview of the finale that the omniscient master narrator Anton Ulrich keeps his readers in suspense of.

All along, waiting signals anything but stagnation. Importantly, waiting is marked as different from tarrying. Once Nero's reign is overthrown, Nero shows his true character by delaying the inevitable, his suicide. One of his successors, Emperor Otto, does not dither when defeated. Though beloved by his followers, he ends his life, as would an exemplary leader on whom the gods have conferred an unfortunate fate.

Diegetically, waiting means, above all, gaining time until favorable circumstances arise. Characters persevere in their extended present while seeking additional information, confirming alliances, or waiting for things to take a promising turn. At other times, protagonists wait to receive a missive; the reliability and loyalty of messengers prove a constant concern. When interacting with others, these characters regularly withhold information, even if their interlocutors are intimates (sometimes, the authorial voice alerts readers when this is the case).[146] The fact that servants and chamberlains are present during some of these conversations recommends discretion.[147] People literally take or rather claim time to respond when confronted with new information.[148] In this same spirit, characters will also ask (like Martin Luther) for "time to consider" (Bedenkzeit) with regard to a decision they need to make or an action they need to perform, making others wait and taking charge in this way.[149] The protagonists establish interstitial time with purpose, even when this requires extra effort. By doing so, they assert their status or gain a measure of control when things are stacked against them.

Importantly, the protagonists are not waiting per se. As a rule, they *wait for something*. Waiting in this manner is rarely a bore or an imposition. To be sure, potentates who make interaction difficult for courtiers, militaries, or members of their circle are prone to be evildoers.[150] When Norondabates is told to wait for an audience in the imperial antechamber during the time when the empire's secret council meets, several hours pass, and the wait begins to wear on him.[151] This sentiment, however, is an exception; his inactivity simply serves as a trigger to leave and direct his attention elsewhere,

where he is immediately received. Be that as it may, for those who wait, waiting fails to evoke the dread, anxiety, and fears that modern critics have associated with waiting. Rather, waiting resembles a form of cathexis; it means holding on to what is possible and what is meaningful; waiting, in other words, is what the protagonists expect.

To be sure, doubts arise in moments of uncertainty. Yet it is not the state of waiting itself that is worrisome. Rather, the protagonists fear that things may take a turn for the worse. Suffering may be the result. The expansive present of this narration is therefore different from the "Now of warmth," to return to Landwehr's notion of the discovery of the present in the seventeenth century. Rather, it is the multilayered Now of urgency that allows for or rather necessitates the extended consideration of possibilities and impossibilities.[152] In this sense, the modality of waiting brings multiple times to the fore.[153]

What are the spaces that match this novel's temporal expanse? The author speaks little of specific layouts, interiors, or furnishings. Even if Duke Anton Ulrich once traveled to Rome from Venice, this is not a text suffused with archaeological knowledge. The rooms are presented as generic architectural constellations in which antechambers figure prominently. The foreign word *antechamber* does not make an appearance, however. Instead, its German synonyms *vorzimmer*, *vorgemach*, or *vorsaal* are used.[154] Anton Ulrich was a member of one of the foremost societies promoting a reform of the German language, the *Fruchtbringende Gesellschaft* (Fruit-Bearing Society); in keeping with these efforts, the author excised foreign words from the text.[155]

The novel's antechambers are where the reader encounters guards and people of lower rank.[156] The emperor's "before-chambers" are said to be populated.[157] They are a space where news circulates: a forum where one encounters people casually.[158] It is where one hangs around to collect information.[159] Emperor Otto, after a night of ominous dreams, meets an augur in his antechamber whom he asks to tell his future.[160] When the chamberlain controlling access to King Vologeses denies Norondabates, a Parthian prince, access, even though this loyal subject states that "his eagerness for [the king's] well-being motivates him more than that for his own life" (Der Eifer für dessen Wohlfahrt triebe ihn / daßer selbige mehr als sein Leben beachtete), the latter forces his way into the ruler's bedchamber.[161]

For those who progress to the audience hall, who is present during their encounter matters.[162] Embodied comportments supposedly say much about

the moment when such a meeting occurs. One may observe what an inter-
locutor went through since they last saw each other, as Tyridates and his
brother find out.[163] Being perceptive is crucial; attentiveness is warranted:
Who knows whom? Who interacts with whom? What are their affects? Is
someone greeted with great joy?[164] Soldiers march through the anterooms
but do not enter the hall where an audience takes place; their warmongering
shouts can be and are meant to be heard through the walls, however. Like
the emperor, a mayor sits down, but others do not during such a meeting.[165]
When it is over, the emperor returns to the antechamber and speaks to the
crowd, addressing his supporters in fiery oratory. Spaces like the antecham-
ber and the chamber are stages where emotions and affects are on display. As
a result, they lend themselves to astute observations.[166]

At the same time, caution is warranted. Walls are thin. A commotion
in the antechamber in the middle of the night announces troubles to come.
One hears a person crying in a different room while in the antechamber.[167]
After a lost battle in the remote Roman province of Dacia, for instance,
Emperor Otto's antechamber offers a despondent sight where "everything
looked sad and frightened" (sahe alles traurig und erschrocken aus). When
a summoned informer, Antonius Honoratus, is led into the room where the
emperor awaits his report, he finds the ruler visibly distressed (gantz ver-
stöhrt), who is facing away from the door and looking out a window, his head
resting in one of his arms, while others are in the room: signs that things
are in disarray.[168] What is more, since Antonius Honoratus is loath to start
speaking to the overlord before he is given a sign that he ought to, silence
ensues, until someone from the emperor's entourage starts to say something.
After revelations and deliberations, Otto decides that in order to end the civil
war, he will ask Nero (who, it turns out, is said to be still alive) to resume his
reign. Here and elsewhere, the *Roman Octavia* seeks to portray and sharpen
the reader's perceptions for living at court and in time.

The banality of court life, with its pettinesses and pointless busyness,
was an early modern topos directed at courts and disseminated through
proverbs, philosophical treatises, and the like. Anton Ulrich's novel is so en-
compassing that it incorporates criticisms of this kind. If the courtly novel
reflects the world, then praise and censure of the court can coexist in such
a text. Dishonesty and sycophantry, falseness and meanness abound in the
Roman Empire Anton Ulrich has us imagine as a mirror to courts in his own
era, with the French and the imperial court as constant points of reference.

At the same time, the political tribulations of the empire necessitate never-ending preparedness and planning, as it did in Anton Ulrich's time.

How did readers approach this textual panorama with its mixture of different temporal-historical layers? There are indications that the novel's audience formed part of a community that was literally waiting for new installments after the first volumes had appeared in print between 1677 and 1679.[169] Christian Thomasius (whom we encountered in the previous section) speaks of the "incomparable Octavia whose final elaboration the gallant world awaits with great anticipation while in the meantime they take solace in the pleasures of hope."[170] Patience, in other words, is what the heroes in the novel display, what the reader needed, and what the novel's protracted gestation may have taught the audience. One printer in Braunschweig in 1713–14 acknowledged as much, asking the audience to "content" themselves for the moment. But he held out the prospect that the novel's final installment was soon to appear.[171] In the preface to his earlier novel, *Aramena*, Anton Ulrich circumscribed his narration of the main character's "magnificent variety of tribulations" (vicissitudinumque mirificam varietatem)[172] as a "school of patience" (Gedult Schule).[173]

This expression sheds some light on a feature of the Baroque novel that has often exasperated critics: its expanse. A novel such as Anton Ulrich's, in fact, mimics living in time. In a dialogue on *The Roman Octavia*, one of the interlocutors praises the novel for its utility; he states that usually he doesn't appreciate reading novels, yet *The Roman Octavia* is excepted.[174] At the same time, the school-of-patience metaphor takes up philosophical discourses and advice literature critical of the courts, in which they were described as schools of vice.[175]

In fact, as Stephan Kraft reminds us, the novel's unreadability, often assumed today, was not a sentiment expressed at its time. He cites the reading practice of Elisabeth Charlotte of the Palatinate, wife of Monsieur, King Louis XIV's brother, who writes in one of her letters that she read some pages every day, interlacing her life with the novel's time, adding: "The novel [RO] reminds one of eternity, since it does not end" (Der Roman macht ahn die ewigkeit gedencken, den er nimbt kein endt).[176] At the same time, she fears that the novel will never be brought to a conclusion.[177]

The School of the Court

If every moment lends itself to thinking strategically, how do individuals turn time to their advantage? How to summarize what to do when the court as an arena, as the practical philosophy of a Gracián and the novelistic universe of Duke Anton Ulrich showed, unfolded in the immediacy of one personal encounter after another? This is the task that one cameralist took on in the early eighteenth century.[178] In several volumes dedicated to the "science of ceremonies" (*Zeremonialwissenschaft*), Julius Bernhard von Rohr synthesized the representational practices at European aristocratic residences and their underlying logic to inform about these institutions. Europe, with the Holy Roman Empire of the German Nation at the center, was the focus of his thinking. The author acknowledges in passing that court life in other parts of the inhabited world in Asia and elsewhere merited systematic treatment of this kind. Yet cameralism prided itself on its utility and training for future bureaucrats. Von Rohr's volumes on this subject matter deserve attention because they flourished at the interstices of conduct books, court ordinances, travel guides, histories, cameralism, and political theory.

The "science of ceremonies teaches one how . . . to act appropriately according to the circumstances of location, person, and time" (Die Ceremoniel-Wissenschaft lehret, wie man . . . seine Handlungen nach den Umständen der Oerter, Personen und Zeiten . . . einrichten soll).[179] Von Rohr's definition amounts to nothing less than a rejection of books of etiquette.[180] In the preface, he concedes that there are textbooks aplenty on particular subjects such as dance, diplomacy, and the like. What is lacking, however, are practical guides to social and political life. As a representative of an occasionalist outlook, von Rohr contends that this arena is not identical for individual actors. As a result, he divides the field of what he calls "ceremonies" between people who approach others above their own station and people who are in positions of authority. In other words, the "science of ceremonies" amounts to a synthesis of occasionalism.

What is the court, according to this writer? "Court life is an association of many judicious people who adjust their acts according to the wishes of their lords; [it is] a studio of politesse, a school of patience, a form of slavery that appears magnificent, and a breeding ground of envy and resentment"

(Das Hof-Leben ist eine Versammlung vieler kluger Leute, die ihre Handlungen zum Vergnügen ihrer Herrschafft einrichten wollen, eine Werckstat der Politesse, eine Schule der Gedult, eine prächtig scheinende Sclaverey und ein Sammel-Platz des Neids und der Mißgunst).[181] How to survive under these circumstances is the task at hand. As defined by history, geography, local traditions, and "different individual mentalities of the great and their ministers and favorites" (Sentimens der grossen Herren, oder ihren Staats-Ministren und ihrer Favorita), courts differ, von Rohr contends.[182] He recognized that the quest to distinguish oneself stood at the heart of early modern aristocratic culture. His insistence that practices had evolved and would continue to do so, as well as his recognition of differences between courts, defied the quest for standards. French claims to politesse, in particular, became the target of his critique.[183]

This cameralist's insistence on variety, therefore, encouraged readers "to experience for themselves and observe" firsthand (selbst erfahren und observiren).[184] He encouraged young men (and only men) who had acquired a basic education to tour different courts in a *Bildungsreise*, as their financial and other abilities allowed, to imbibe firsthand what courts had to offer. As to this apprenticeship in public affairs, as we may call it, he recommends where to start and how to introduce oneself at a new place. It is important that one learn how to assess the personality of a prince or superior; their character needs to become part of one's planning over time. He also advocates moderation in self-presentation and all interpersonal dealings. Verbal, gestural, financial, and similar excesses are to be avoided. Learning by observing others trumps being exposed in risqué interactions, especially when one is inexperienced and young. In general, he sees courts as institutions "where intelligent people get wiser and refine their manners but the simple-minded and unintelligent can become more daft than before" (eine solche hohe Schule, bey der gescheite Leute noch klüger und politer, die einfältigen und unverständigen aber noch viel thörichter werden können, als zuvor).[185]

If the court is a school, it is an institution of learning that lacks clearly defined teacher-student relations or a curriculum. As a consequence, students are in charge of their own learning processes; they need to read up on court ordinances and the like; they need to continuously observe and, if possible, expand their horizons by getting to know different courts; and they need to practice moderation when pocketing time. Ultimately, self-advancement

was the goal, though professional chances were scarce. Therefore, one ought to calculate one's chances to get promoted before renewing one's service at a particular court, for instance.[186] In these and similar practical ideas, the science of ceremonies is different from a virtue-centered ethics or politics.[187]

After all, the courts were more than residences of princes and courtiers. They were centers of administration, government, and politics. Significantly, one way the courts impressed their formative qualities on others was through their material presence. Von Rohr paid attention to these edifices as political architecture, and this is where we will turn in the next chapter.

If the reader were to choose adjectives about how early moderns experienced time on the basis of the current historiography, what would they be? Among the many descriptions such a thought experiment may generate, I posit that two would figure prominently: slow and collective. I am singling out these conventional descriptors about living in time between 1500 and 1800 because they rub against this chapter's findings. "Time has the power to separate us," as the novelist Jenny Erpenbeck introjects in a speech.[188]

As it appeared above, time as a plane of action has qualities that are centrifugal. This offers a counterpoint to how premoderns are often seen, as antipodes to our own lives and tied to a cyclical, not a linear, conception of time, a time without troubles or tribulations. Whether such *stabilitas temporis* characterized early moderns' lives is beyond the scope of this study; as a backdrop to the mobile elites or the rushed pace of modern times, commoners often were made to serve as paragons of permanence in the anthropologically inflected literature of the early modern world.[189]

As I have sought to show here, the individuation of temporal scripts in early modern Europe was staggering, the nervousness of court life a commonplace.[190] Today, when we stand nervously before "impending emergencies"—in an age that, as Kristin Sampson reminds us, has been termed Neo-Baroque—occasionalism may emerge once again, this time as a response to a climate and other crises; Sampson recommends Baltasar Gracián as a guide.[191]

In the early modern period, antechambers were a factor and forum in these anxious scenarios. Let us turn next to these spaces.

Spaces

Far from being a coincidental by-product of power ... control
of time comes into view as one of its essential properties.

—Barry Schwartz, "Waiting, Exchange, and Power"

The nexus of space and time runs deep in architecture.[1] We are unable to experience a built space in its entirety.[2] Humans unlock, map, or get a sense of built spaces in and through time. Although often unacknowledged, these movements, rhythms, or temporizations are part of architecture's presence. That architecture becomes experiential in a processual manner is particularly palpable in antespaces.[3] There, time and place conjoin. In fact, the prefix *ante* or "before" has a spatial and a temporal register. An antechamber is where mobility and immobility converge. One traverses spatial configurations to arrive at a space in which to linger.

Anterooms are "transitional, symbolic, and functional" spaces: they are located in between, they anchor social relations, and they invite significa-tion.[4] This confluence of spatial, temporal, and social parameters within the walls of a room is why the antechamber has been singled out as the architec-tural locus *par excellence* for premodern societies. Norbert Elias proposes as much in his influential study of aristocratic culture, *The Court Society* (1933; 1969): "This room, the antechamber, is the symbol of good court society in the *ancien régime*."[5] According to the historical sociologist, the rooms where

domestics waited to attend to their masters or where others waited to interact with people in residence encapsulated "the co-existence of constant spatial proximity and constant social distance, of intimate contact in one stratum and the strictest aloofness in the other," a statement Elias highlighted by italicizing it.[6] Since his seminal study on Versailles under Louis XIV, the dynamism of aristocratic culture and the architectural variations with their respective spatial-temporal practices has come to the fore.[7]

Even if such rooms often had other functions in addition, antechambers were spaces where people of various stripes—servants, courtiers, merchants, clients, petitioners, job seekers, travelers, diplomats, and many others—spent time. How to design a space to contain people for a while? How to make them realize who they were in relation to those whose threshold they had crossed? How to ease their plight or occupy their minds?

Patrons and designers endowed these structures with messages that made occupants present by architectural means.[8] The anterooms' qualities, adornments, and furnishings spoke of their lineage, wealth, status, or distinction. Yet buildings with antechambers were not simply built manifestations of a preexisting political or social order. Their exteriors and interiors actively shaped social interactions. In other words, they solicited responses, guided people, and encouraged certain comportments, imposing a particular gait or affect on those who spent time in them or passed through them.[9] They also conjured up visions of a world of riches and luxuries beyond the closed doors the waiters were hoping to see opened.

In fact, the rendering of the Italian *anticamera* as *antichambre* in French—*anti* means "against"—suggests a contrast. This was the spelling that entered the vocabulary of many European languages. Until the end of the eighteenth century, English also used the French orthography. The eighteenth-century British lexicographer Samuel Johnson bemoans that the term is "generally written, improperly" or "corruptly" as *antichamber*, defining it as the "chamber that leads to the chief apartment."[10]

Put differently, the antechamber is a room defined by its relation to other rooms. A space designated as antechamber forms part of a sequence of at least two, if not more, rooms, separated by walls. It orders the flow of people in multiroom edifices, protecting residents from unwanted intrusions and allowing them or their staff to control visitors' access. Antespaces thus were instrumental in timing intramural encounters between people.

In Europe, rooms defined as transitory both spatially and temporally first emerged in palaces of the late medieval period. The spaces then appeared in sixteenth-century royal residences and emerged as a standard feature of the dwellings of the elites and the middling classes in the seventeenth and eighteenth centuries. While surviving antechambers from the early modern period often date to the eighteenth century, those rooms are what we have, at least at times, and their spatial logic has much to tell us about the moments of containment and coercion they helped shape.

In this chapter, I approach waiting in time through the spaces constructed for this purpose in residences of the elites—above all, by focusing on spaces newly designed for first occupants. The emergence of antespatiality in the European context, in the first section, leads to a comparison between indoor waiting and outdoor waiting. From the sixteenth century on, as we will see, anterooms became *de rigueur* in residences of the elites, whether aristocrats or members of other ranks and classes. Indoors, whether in the German palaces of Pyrmont, Bayreuth, or Charlottenburg, we find that the décor in antespaces was meant to instruct, impress, or entertain.

Viewed thus, the anteroom offers a supreme vantage point from which to explore architecture as formative of social, especially timed, interactions. Focusing on the antechamber permits us to invert traditional approaches to the study of buildings that typically favor attention on the most luxuriously furnished spaces. Studying antespatiality also means reversing our usual focus on festive rituals and ceremonies by refocusing on seemingly mundane interactions between unequals. Finally, from the antecameral viewpoint, we can inquire into how spatiality intersected with temporality.

Antecedent, Avignon

In a classic study on the nexus between the emergence of capitalism and early European society, the sociologist Werner Sombart muses that "perhaps Avignon was the first modern 'court.'" There, "the Grand Seigneurs of almost all of Europe gathered around the head of the church."[11] Others have since elaborated on these suggestive lines.[12] Even within Europe, such a tale of origins is hard to substantiate.[13] Questions of historical precedence aside, the complexity of the papal *palatium* in the late Middle Ages is well established.[14] One critic describes this court as a "mix of castle, monastery, and

manor."[15] Prelates, clerics, potentates, lords, ladies, ambassadors, and their entourages, as well as guests, messengers, and other people, crossed paths, interacted, or spent some time on its premises, in addition to various office-holders, some of whom lived in the palace.[16] In this context, anteroom-like spaces surface in the architectural record.

Great palaces in the late Middle Ages were divided into parts where councils, festivities, and banquets took place, as well as other parts where the pope or prince withdrew to rest.[17] While the latter chambers were not strictly private,[18] fewer people had the privilege to enter.[19] Subjects ordinarily approached rulers in a great hall or when they passed by, sometimes aided by intermediaries.[20] The *leges palatinae* by King Peter III of Aragon list an officer who was well paid "to greet, admit, and discharge any strangers, as well as house them and bring them before the lord king, and have them do as the lord king wishes."[21] At the late medieval papal court, chamberlains (*cubicularii* or *camerarii*) were tasked to collect supplications presented to the pope in person; another official, the *elemosinarium ecclesiasticus*, was called on to intercede on behalf of those in need.[22] On certain occasions, a great many people would have surrounded the powerful. Such gatherings instantiated power and communicated a person's elevated status to those present.[23]

The hustle and bustle of persons of different rank, station, and office at a court like Avignon made it a suitable venue to steer both visitors and residents. Officeholders in the entourage of the powerful played a role in this regard. At the same time, architectural features like courts, gates, corridors, passageways, and stairs shaped communication and encounters with others.[24] They reduced friction or conflict, eased passage, and defined access. This set of architectural strategies is what layouts from large fourteenth- and fifteenth-century palaces evidence.[25] In this context, the *antecamera* became an integral component of architectural settings.

Far from the Eternal City, the Holy See in Avignon, the "new Rome," embarked on transforming what had been the residence of a bishop.[26] Growing administrative needs and ever greater numbers of people, both residents and visitors, necessitated changes to the palace.[27] Benedict XII (r. 1334–42) was the first pope to expand the existing *claustrum* of four wings.[28] This addition extended outward from parts associated with the conclave, consistory, or other sections and culminated in the *camera pape*, the pope's chamber. Indicative was the so-called *studium pape* (pope's study), a *retrocamera* or rear

chamber. Satellite to the *camera pape*, it offered seclusion (even though there likely was a door to the chamber that lay before it). There, the pope would have consorted with associates; this also was where he spent the night, as the inventoried furniture shows.[29] Architectural features underlined this new wing's importance: the tower-like edifice where these chambers were located could be seen from afar. Staircases connected the pope's *camere* (the *camera* and the *studium*) vertically to rooms such as the large and small treasury (*thesauraria*, also *thesauraria secreta*), the wardrobe (*vestiarium*), as well as to a library,[30] and the pope's quarters overlooked a walled-in garden.[31]

Among the architectural additions during the mid-fourteenth century were two rooms in front of the pope's chamber. They were of similarly rect-angular shape and roughly equal size.[32] Located between the papal chamber and the rest of the palace, this bicameral space served multiple functions. One of the two, the so-called *camera paramenti* (vestment chamber), was named for the ceremony in which the pope vested ecclesiastical dignitaries with their offices. Its importance can be gleaned from the fact that a second *camera* was added ca. 1338–39.[33] This *tinellum parvum* served similar func-tions to the first. In this second anteroom, meals were served, as the word *tinellum* indicates. People close to the pope guarded his dwelling in these two rooms (fig. 7).[34]

Significantly, both the *camera paramenti* and the *tinellum parvum* al-lowed the *cubicularii* and others to control access to the pope. This is where those who had advanced to the threshold of his chambers "had to wait for their audience" (which could have taken place in either the *camera pape*, the *studium*, or the rooms where people waited).[35] Remarkably, not only did it take time to arrive at the threshold to the pope's inner sanctum from other parts of the edifice; the space also enabled officeholders to first stop and then grant access to people who had come to see the bishop of bishops. This interspace thus expressed the pope's authority and social elevation by architectural means with temporal consequences. The *camera paramenti* and *tinellum parvum* elevated the head of Christianity by removing *suas cameras* from parts in the same palace with more foot traffic. As a result, the pope's quarters became a unit distinct from other parts in the building.

During the same period, the pope withdrew from public view and ex-trapalatial functions. The *palatium*, with its many spaces, including chapels and windows, became the foremost setting for the vicar of Christ's liturgical

1. *Camera pape*
1a. *Studium pape*
1b. *Coquina secreta*
2. *Camera paramenti*
2a. *Tinellum parvum*
3. *Tinellum magnum*
3a. *Capella parva*
3b. *Dressatorium*
4. Sacristy
5. *Capella magna*
6. *Vestiarium*

40m

FIGURE 7. Ground plan of the Papal Palace in Avignon, upper floor (illustration by Matilde Grimaldi).

and other ceremonies, rituals, or appearances. Similarly, when people of distinction hosted the pope, they sought to replicate some of the splendors of his quarters in Avignon, as was the case when, in 1343, cardinals welcomed Benedict's successor, Pope Clement VI, to their residences.[36]

What we know about the *palatium*'s layout, therefore, is key to understanding routine interactions, as well as religious or other ceremonies at the papal court.[37] The hierarchization of spaces was somewhat analogous to the ranking of palatine officials. The highly positioned among them commanded greater proximity to the pope.[38] Yet the social hierarchy, the ceremonial order, and the spatial sequence were different "idioms"; there was overlap but little equivalence. After all, rooms were not reserved for single persons or particular functions. Rather, considerable flexibility in their use was the norm. Nonetheless, the pope's wing testifies to a dynamic in which offices, functions, and rooms in the service of the powerful became differentiated. As a result, a person's distinction manifested itself through spatial distances and temporal intervals before an encounter. At the same time, walls and rooms not only distanced the head of Latin Christianity from others but also shielded him from intrusion, noise, and smells. Against the backdrop of what we know about ordinary life in residences during this period, the spatial-temporal arrangement in Avignon's papal palace is nothing short of remarkable. It manifests a social hierarchy by spatial means.

As Gottfried Kerscher argues, the structural innovations at the papal court in Avignon may have been inspired by models in the kingdom of Aragon, especially in Majorca,[39] where the word *antecamera* shows up in the medieval record.[40] At any rate, importantly, subsequent popes retained the architectural conception evident in Avignon.[41] Montefiascone near Rome, seat of the papal legate and residence of the pope for a while in the fourteenth century, as well as other residences on the territory of the papal state, reproduced the spatial disposition of the Avignonese *palatium*, with two small rooms "guarding" a *camera* and a *studium* (*camera paramenti, tinellum parvum*).[42] What is more, the same spatial schema surfaces in the Vatican, where the Holy Father began to dwell after the interlude in Avignon.

Potentates and popes are not the only ones to have expanded the variety of spaces in their residences during this period. Fifteenth-century palaces of prominent merchants, ecclesiastical dignitaries, and powerful nobles show evidence of antespaces. As a rule, the houses of the great in Renaissance Italy,

for instance, featured a ceremonial hall (*sala* or *salone*) as well as a chamber (*camera*). But the wish for occasional intimacy and the need to accommodate different kinds of visitors led to extended floor plans with additional rooms. Spaces satellite to the chamber were distinguished from the former by their smaller size. Such rooms often lacked a clearly designated function. For practical reasons, for instance, they regularly served as dining halls. Yet they also offered places to interact with intimates, and they were therefore sometimes sumptuously furnished. If we follow Giorgio Vasari's *Lives of the Artists* (1550), Giovan Maria Benintendi, a Florentine banker, commissioned several of the greatest local painters in 1523 to equip his palazzo's *anticamera* with an iconographic program chosen to convey a well-calculated message about his pro-Medici leanings.[43]

Significantly, however, the layout of rooms did not follow a certain order, as it would in the *enfilade*, the axial progression of rooms in the seventeenth century and thereafter. Still, the fifteenth-century Palazzo Medici in Florence (1445–47) was a multifloor building with self-contained units for different members of this highly prestigious family. It is possible to speak of apartments in this case. This term designates a clearly defined, separate portion of a larger building (*a parte* or apart) with a suite of rooms for a particular person or household.[44] Thanks to floor plans, inventories, and account books, we know that every residential apartment included an *antecamera*.[45] Even if the room's function was not identical with that in dwellings of the elites in later times, as in-between or next-to rooms, they offered spaces to differentiate household functions, to limit access, or to interact with visitors.[46] They also provided spaces where servants, audience seekers, petitioners, suppliers, friends, and members of the *familia* would bide their time. In sum, this before-chamber allowed for making distinctions among people, including determining who received access in the first place.

As these examples demonstrate, the *antecamera* has no clear-cut genealogy. We can assume polygenesis. Antespaces were also not an exclusive feature of residences for European elites. Spaces of this kind existed in Asian courts. To be sure, the spatial and other arrangements in Ottoman Istanbul, Safavid Isfahan, and Ming Beijing varied from what we find in Whitehall in England, Versailles in France, or the Hofburg in Vienna. Still, they are strikingly similar in function.[47] Through sequential arrangement, architectural design, and interior furnishings, the palace of the shōgun in Edo (Tokyo),

Nijō Castle, intimidated those who were discomfited in its anterooms. Only after having spent time there were visitors allowed to enter the grand audience hall.[48] The multiplication of political, administrative, and other functions at a given court—with its corollary, a great many outsiders requesting access—triggered the creation of anteroom-like structures.

Waiting in the Open

Spending time in anticipation of a meeting or an encounter was and is an integral part of sociality in stratified societies, whether at court or in urban communities. The temporal intervals imposed on people seeking interactions with the powerful were a significant element in the production of power, status, and authority. In late medieval and early modern cities, encounters between unequals would not always have happened indoors, as seems to have become the rule in Avignon. Open-air spaces also functioned as social arenas. Having to wait, making someone wait, or choosing to wait took place in settings such as squares, gardens, courtyards, and the like.

In Florence, whose history as a city was marked and marred by competing clans, people gathered in front of the houses of the powerful—the Bardi, the Strozzi, the Medici, and others. These families patronized civic networks of associates and "friends." Groups of men—women would have been the exception—loitering near urban palazzi signaled the preeminence of certain houses to the urban public. So-called *familiari* or clients sought proximity to their actual or potential patrons. Some of those who would have gathered in front of these residences came to do business or perform a particular task. Others simply showed up and lingered. While marking their presence or paying respect, they may have remained silent, chatted, gossiped, or argued, striking up conversations or mingling with others like them, always ready to address a passerby or intervene in a fracas. "The flip side of wait was haste," as Avner Wishnitzer suggests.[49]

A father in quattrocento Florence advised his sons to ply their social skills on the streets in order to make themselves pleasant to potential patrons, offer their services to them for free, and wait outside their homes in order to get noticed: their opportunity for making connections beneficial to their potential future advancement.[50] After an attempt on the life of Lorenzo de Medici, to pick an example, thirty-some "young lads" (giovani e garzoni)

from a small square near the family's palazzo documented their actions as an ad hoc militia in defense of the oligarch, signing a letter to Lorenzo as "servers and lovers of the house of Medici" (servidori et amatori dell chasa de' Medici).[51] To make a particularly compelling case for themselves, they put in writing what often escaped the record.

Social relations, in other words, "played out in the physical spaces of the city: the streets, street corners, outdoor benches, and loggias, family palaces," and similar areas.[52] Socializing in public was a popular pastime. For this purpose, seating arrangements were set up, temporarily or permanently.[53] Clans added to these settings by having stone benches installed in front of their homes or in the *anditi* (vestibules) of their palaces.[54] Benches had been a "vernacular element" of urban architecture in many a city, in Italy as elsewhere.[55] Yet their integration into the stone facades of palazzi in fifteenth-century Florence monumentalized this urbanistic feature.

These benches were more than acts of philanthropy. They functioned as spatial-temporal extensions of a great family's urban stronghold. Architectural elements of this kind (of which some survive) projected their influence into thoroughfares, streets, and squares.[56] After all, "bench-sitters" occupied a space identified with influential families. As such, the *panche* invited urbanites to survey the neighborhood. To be sure, Florentines often associated these *pancaccieri* with lowlifes, idlers, and smart alecks. Still, the panche became a physical feature of urbanism. Their social-temporal modalities signaled power in an oligarchy. What is more, they had the potential to bestow massive buildings with a social-spatial aura. At the same time, these benches defined a threshold: one of many such thresholds for homes, including a gate or courtyard, as well as thresholds within the edifice or in individual apartments such as the *antecamera*. Thus viewed, the antechamber is just one such liminal space in a nexus of several.

A mix of formalities and informalities shaped asymmetrical interactions in late medieval and early modern Europe. Neither the space nor the temporality of such encounters was clearly defined. Such interactions flourished in the interstices between casual communication and actual meetings, between what was said and what was left unspoken. But they also hinged on temporal protocols. In this context, antespaces offered a solution to the interconnected demands of aristocratic or ecclesiastic representation, administration, and communication between unequals.

What is the significance of devoting space to where people linger before they meet (or do not meet) the person they came to see? The answer lies, in part, in endowing encounters with formal qualities. An increased formality in the antechamber does not mean that contacts before their emergence or in other spaces were informal. There were codes of respectful behavior that regulated interactions between superiors and inferiors, no matter where they occurred. Greetings, address, clothing, gestures, and the like come to mind. There was, however, no firm etiquette. In general, the greater the person with whom one wanted to interact, the more elaborate the preparations required to make an encounter happen. In this context, waiting in an anteroom had the potential to contour interactions between unequals through means of an architectural setting.

Royal Antechambers

As an innovation, the antechamber as a room type surfaced in the royal architecture of the Louvre in Paris, as well as other French chateaux (Anet, Saint Germain, Fontainebleau, etc.) under King Henri II (r. 1547–59). Yet it was his son, Henri III (r. 1574–89), who sought to elevate his royal status by architectural and other means (though the spatial arrangements do not survive). The court *règlements* of 1578, 1582, and 1585 speak eloquently of this exaltation.

On twenty-one printed pages, the 1585 ordinance proclaims the king's honor (honneur), as well as the "reverence" and "respect" owed him ad nauseam; no longer is *sire* the address expected of a subject or visitor, but *majesté*. Yet how to signal a king's stature? How to instruct others so that they show deference when interacting with a royal? The king's sovereignty needed to become evident in every interaction, "the very human process of making majesty."[57] To gain currency, this novel version of a familiar notion, the king's superior status, had to be translated into conduct. Spatial arrangements (including barriers around the king's dining table), rituals, and temporal protocols offered themselves as measures to signal elevation. Distance, aloofness, and removal were this concept's principles. What was an ancient idiom manifested in novel ways during this period. Among other things, the antechamber between hall and chamber increased the distance to the ruler.[58]

In other words, the king's prominence in every setting was specified.

The *règlement* mandated gestures of respect whenever the king was present or when he could have been present, even when he was, in fact, physically absent.[59] First, interactions with the king became rare and thereby valued. Second, the monarch's status gained definition by restricting access to the rooms he occupied. Third, certain mandatory gestures signaled the king's social elevation when he shared the same space with others. Henri prescribed how those who encountered the king in person or were in his proximity had to comport themselves: courtiers were expected to moderate their voices or be silent and to be impeccably dressed. They were to make space for the king should he walk by, performing distance with their bodily movements—a distance that dynamically unfolded as the king moved through indoor spaces filled with people. They also were prohibited from sitting down, unless asked, or from touching objects in the royal residence.[60] The chairs in the royal apartment could be used in the king's absence only, though never the king's own.

Subsequently, the royal apartment became a stage for the king's grandeur, and encounters with the king became more choreographed than before. Arrangements of this kind hinged on rooms as stages. As a result, interactions with the king happened increasingly in indoor settings (something we also saw with regard to the papal palace in the fourteenth century); Paris became the capital, and the court became more sedentary than it had been before. Simultaneously, chance encounters were discouraged or minimized. Courtiers—the king's household and members of court had grown significantly[61]—were barred from approaching or speaking to the king unless the king himself asked, spoke to, or approached them. When the king retired to his cabinet to attend to affairs of state, for instance, only those who assisted him in these affairs or were called in were supposed to enter; others, "whatever their station," had to leave, as this ordinance mandated.[62]

This stacked arrangement of spaces became evident during encounters with diplomats and ambassadors: an officer (*lieutenant des gardes*) would have welcomed dignitaries and guided them through the hall to the chamber, where soldiers lined the visitor's course, until lords whom the king had delegated greeted the person in the antechamber; the doors to the king's chamber remained open during this welcoming ceremony.[63] The *appartement*, with its suite of rooms (*salle*, *antichambre*, *cabinet*, and *guarderobe*) and the distance one had to traverse, as well as the time it took to do so,

projected the king's authority. Not accidentally, the hierarchization of spaces during the reign of the last Valois king coincided with bringing court protocol into writing.[64] The complexity of social interactions with members of the royal household made it requisite to specify and keep track of behavioral standards.

Importantly, the king's elevation also became manifest in that he could do what his subjects and courtiers could not do without the risk of censure—namely, depart from these same protocols. His sovereignty may not have been above the law, as suggested by the famous formula Jean Bodin took up from Roman theorists in 1576.[65] But he definitely was above the *règlement* he had issued. The very decorum that mandated the comportment of royal subjects, aristocrats, and diplomats simultaneously freed the sovereign. He could select long-term associates, single out individuals, or bestow favors by volition, for others at court to see. This was another forum where royal superiority demonstrated its symbolic distance from others. As a sovereign, he acted as he pleased. A "court nobility" emerged as a result.[66] Intimacy with "friends"—favorites, one may say, or, to cite the virulent polemical discourses of the period, "minions" (mignons)[67]—became a widely noted and harshly criticized phenomenon during Henri's reign. These alliances were meant to fortify the monarchy in the midst of religious-political divisions.[68] Billed as a restitution of splendors of old, the *règlement* was in fact a breach with the king's accessibility; many courtiers left the court during the confusion that resulted.[69]

These interlocking political, architectural, behavioral, and sartorial strategies may have been inspired by other courts the king had gotten to know in the course of his travels through Europe. Yet this etiquette also responded to the many and vocal critics in the kingdom who maligned the king's masculine prowess—he produced no heir—as well as his consorting with members of the lower nobility or foreigners.[70]

Not surprisingly, the rise of the antechamber and the protocols that came with it provoked critical responses. In France, this novel phenomenon was coded as Italian. The term *antichambre* in French (from which both the English and German terms derive) was a mid-sixteenth-century loan translation of the Italian *anticamera*.[71] Viewed as a foreign intrusion, the word and what it captured signaled an undue elevation of the ruler to contemporary critics: a departure from giving royal subjects, especially aristocrats from

France's preeminent families, access to their king.[72] In effect, revering the monarch in his grandeur also left royalties vulnerable; the security of the ruler became a cause for concern.

The spatial arrangement at the Bourbon court followed its Valois predecessors. At Versailles, the king and the queen inhabited their respective *appartements* with their duplicate *enfilade* of rooms and the requisite anterooms—a symmetry that was to become a feature of courtly residences across Europe. The antechamber to the *appartement* of Queen Marie-Thérèse and the Dauphine between the *Salle de Garde* and the *Salle des Nobles* was where King Louis XIV of France and members of the royal family dined together between 1673 and 1690.[73] These festive suppers were public in the sense that commoners could attend, at least if they had connections to the guards overseeing access and if they wore appropriate clothing. At these occasions, the courtiers stood surrounding the table where the Sun King and his family were seated.[74] Yet, given that sightseers and strangers had access even to the king's bedchamber, there was less pressure on antechambers as quasi-public spaces for visitors.[75]

Once the antechamber emerged in the residences of the powerful, it was only logical that, in a socially stratified society, their number multiplied to distinguish between visitors of different status. The *Palazzo Ducale* (today Palazzo Vecchio), residence of the Grand Duke Cosimo I of Tuscany, featured two *anticamere* in the middle of the sixteenth century.[76] In early seventeenth-century Rome, cardinals inhabited apartments with two anterooms.[77] Similarly, in England, "by 1700, the State Apartment . . . consist[ed] of a Chamber of Audience, preceded by two ante-rooms, one of which [was] reserved for the more important courtiers."[78] In the early eighteenth century, the *Hoff-Auffwartungs-Instruction* (1717) specified no fewer than six waiting areas for the Archbishop of Cologne's residence in Bonn during gala days or court festivities. On such occasions, when attendance was required, nuns, artisans, and burghers were expected to wait in areas close to the general entrance. By contrast, nobles waited in rooms that were part of the suite of rooms leading up to the prince-bishop's more private rooms on the *piano nobile* (main floor). It follows, then, that social status correlated with spatial proximity to the elector.[79]

At the seventeenth-century French court, where the whole royal apartment with its *enfilade* of rooms was included in various public functions,

hierarchies were defined less by spatial access than by the length of time one got to spend with the king and similar such aspects. As a result, "not more than two places of waiting were necessary in French royal apartments—the antechamber for courtiers and the guard chamber for liveried servants."[80] That there was so little distinction between those who waited was a source of concern for foreigners from other parts of Europe and Asia. (When Louis married the Marquise de Maintenon later in life, he withdrew into her apartment, where others had no access, while his royal apartment remained the site of courtly entertainments and events.)[81]

As these arrangements show, where people of station waited depended on the occasion, whether the everyday, a court festivity, or a diplomatic reception. While the Munich residence under Elector Karl Albrecht in the middle of the eighteenth century boasted two antechambers, four circumscribed groups gathered in a total of four rooms on festive days; in addition to the two antechambers, the upper strata of courtiers had right of access to the audience hall (Grosses Audienz Zimmer) and the great cabinet (Grosses Cabinet). On ordinary days, however, only the actual antechambers were to be populated. Accordingly, the lower ranks were to gather in the first, the highest ranks in the second.[82]

"The closer the antechamber is to the apartment of the ruler, the more magnificent the furnishings," is how Julius Bernhard von Rohr synthesized the practices at different residences.[83] Yet this general principle barely masks the considerable casuistry of local conditions that even general treatises on ceremonies (Zeremonialwissenschaft) such as von Rohr's failed to capture.

So far, our tour has explored the emergence of the antechamber as a room type in Europe from late medieval palaces to eighteenth-century chateaux. In order to explore the effects of built spaces on people moving through them, let us enter in the following three sections three antechambers whose pictorial decorations or records thereof survive. The greatest residences, be it in Versailles, Vienna, or other places, were frequently redesigned or reappropriated. Therefore, we turn to examples in the eighteenth-century Holy Roman Empire, where interior design and décor of the antechambers can be reconstructed or are recorded.

My three examples with their respective focuses on lessons, histories, and entertainment stake out a spectrum of decorative possibilities. They also exemplify courts of different stature: a tiny summer residence (Pyrmont),

a summer residence in a small territory (Bayreuth), and one of Europe's larger courts (Berlin). These rooms also, in different ways, reflected their owners: a well-educated prince, a woman aristocrat of royal descent, and a philosopher king.

EMBLEMATIC ANTEROOM

In the early eighteenth century, Count Friedrich Anton Ulrich (r. 1706–28) of Waldeck-Pyrmont used the limited resources at his disposal to transform a small Renaissance fortress into a modest summer residence.[84] During the season, Pyrmont attracted members of the elites from near and far to its spa.[85] One memorable year, a generation before the architectural overhaul gave birth to the castle's anteroom, forty to fifty nobles had gathered in this small town.[86]

In the new edifice, one antespace provided access to the *piano nobile*. Its door opened to the grand hall that in turn gave access to the garden. From the sala at the center of the chateau's floor plan, the chambers of the prince and the princess branched off in opposite directions. In other words, the Pyrmontese layout was a condensed version of the *appartement double*.

As an indoor entryway to the architectural ensemble, the antechamber received a décor distinct from that of other rooms in Pyrmont Castle. Its walls were covered with painted wallpaper featuring "beautiful landscapes and leafwork."[87] While this decoration does not survive (its current décor invokes what is impossible to recover), the wood paneling below the wallpaper has been restored (ca. 1987), featuring nine emblems throughout the room.[88] Emblems are "imagetexts" that must be decoded to reveal the maxims they aim to impart.[89] In Pyrmont's antechamber, these painted cartouches on the wainscots with their mottos and images had the potential to occupy those lingering in the space designated for waiters (fig. 8).

In early modern Europe, the verbal-pictorial genre of emblems proved malleable for diverse ends. In architectural settings, they enhanced a space's impact in time. Observers were invited to puzzle, combine, amplify, adapt, guess, etc. They were called on to relate icon (image) and motto. "Profiterò del mio ingegno" (I will benefit from my inventiveness),[90] to pick an example, shows a cunning bird filling a vase with pebbles so that the liquid spills and it may drink what the vessel contains (fig. 9). According to the source, the bird in question was a crow and the liquid oil.[91] Such an imagetext may

FIGURE 8. Antechamber, Pyrmont Castle, Bad Pyrmont (2016; photograph by Markus Schwier; © Bildarchiv Foto Marburg / Art Resource, NY; fmd498197 / AR6153301).

FIGURE 9. "Profiterò del mio ingegno," emblem, antechamber, Pyrmont Castle (2016; photograph by Markus Schwier; © Bildarchiv Foto Marburg / Art Resource, NY; fmd498215 / AR 6153302).

be said to conjure up any number of things. Yet forethought, strategy, and tenacity—time-related comportments—figured prominently among them. Importantly, the emblem in question may have reminded waiters that hatching plans, whatever they may be, requires patience.

How may emblematicism in a room of this kind have functioned? Observers would have been expected to apply this emblem's message, however they understood it, to their own situation.[92] There are, evidently, numerous possibilities to make sense of generalities of this kind in the changing circumstances of one's life. Such playful open-endedness of combination, interpretation, and application is intrinsic to the fascination with emblems: an aleatory quality that connoisseurs valued as distilling useful lessons from memorable amalgams. In other words, anteroom thinking in Pyrmont proved porous to life outside the room's walls; and this is where the two decorative registers in this antechamber connect, the landscapes and the emblems. In different ways, they radiate from the room's confined space to the external world: in the case of the painted wallpaper, scenes of the natural world; in the case of the emblems, one's behavior in the extended present, while waiting for the door to the hall to swing open.

For people able to decode the messages in this antespatial anthology, the room figures as a forum where those present were interpellated as persons of ability and agility. Virtue,[93] fate, and ingenuity figure among the cues. "Be watchful, the enemy is near"—the motto whose icon shows a goose on a watchtower (Prenez garde l'ennemi est proche)—issues a warning to the waiter to be on guard,[94] though the emblem fails to specify against whom or what such caution is warranted. This cautionary lesson notwithstanding, individuals were also reminded that they have something in common. Like the bees with their beehive, "we all work at the same thing," another emblem states (Non travagliamo [travagliano], che alla medema cosa).[95] Whatever the "same thing" we all work on may be, the potential for a turn or change in one's life features prominently in this room. It is telling that fate or destiny are invoked in several emblems.[96] The time for change, it is suggested, may be near. "Always forward!" (Giammai in dietro, literally "Never backward!"), one emblem signaled, adequately positioned next to the door to the *sala*, with an open landscape and a sun as a pictura (from the sala one would have looked out over the garden) (fig. 10).[97]

The Pyrmont antechamber caters to visitors with linguistic versatility. Remarkably, four languages appear: Italian (4), Latin (2), French (2), and

FIGURE 10. Door in the antechamber, Pyrmont Castle (2016; photograph by Markus Schwier; © Bildarchiv Foto Marburg / Art Resource, NY; fmd498198 / AR6153304).

German (1). Only one of the cartouches features the local vernacular, calling on people to be moderate in all affairs ("Halte Mahs in allen Dingen"); temperance invokes time, in part because, as I noted in chapter 1, the root for Latin *temperantia* and *tempus, temp-*, is identical.[98] Emblems are like riddles; they are meant to engage observers over time. But pondering a motto in a language possibly not one's own added to the challenge of decoding their messages. As a result, this space may have sparked conversations among those present (assuming one wasn't alone), although the message to be on guard also suggests caution in this regard. Be that as it may, this polyglot emblematicism speaks of a cosmopolitan outlook at a provincial court.[99]

The antechamber's emblems construed people as actors in time, no matter what their circumstances, encouraging them to take action or stay on course, even under adverse circumstances. Still, these nine emblems do not form a program. They rather resemble a maze as depicted in the pictura for "Ma destinée m'en fera sortir" (My fate will help me escape from this) (though its tentlike appearance makes one wonder whether the painter had ever seen a maze).[100]

To be sure, emblems in architectural settings functioned and figured as extensions of the owners' selves. To the waiter, an antechamber's emblematicism promised to shed light on the space's masters (whether they had taken an active part in selecting the emblems in this room or not). Anyone visiting might speculate about why the counts had selected certain emblems, interpret these imagetexts as signs, or look for clues to the court's or the prince's character. Arguably, they made their presence palpable even when they were absent.[101]

In this emblem-enhanced antespace, the conceivers—whether members of the count's family, the architect, or the artists whose names are not known—went by the book. The source for the emblems painted on the wainscots was a particular collection, printed in Augsburg shortly before the décor in Pyrmont went up. With its mottos, each in four languages (as opposed to the monolingual emblems in the antechamber), the publishers targeted a Europe-wide readership (containing more than seven hundred examples on one hundred pages): the collaborative effort of an engraver, Daniel de la Feuille, and the author of a textbook of English for speakers of German and German for speakers of English, Heinrich Offelen. As the publication's title page has it, the emblems were of "the greatest interest" and "most enjoyable" (*Emblematische Gemüths-Vergnügung Bey Betrachtung Sieben Hundert und funffzehen der curieusesten und ergötzlichsten Sinn-Bildern*)—a description also applicable to Pyrmont's antechamber. Who selected these nine emblems and the languages of the mottos from among the many others in the same volume, however, remains an open question.

Born near Pyrmont, Hermann Korb (1656–1735), architect for the dukes of Braunschweig-Wolfenbüttel, conceived of Pyrmont Castle's redesign (1706–10). He was a bookish builder. He designed the first library building featuring a cupola at its center, following the idea of Gottfried Wilhelm Leibniz, who served as a librarian for the bibliomaniac dukes (see chapter 1).[102] What is more, the ducal court engaged emblems with great sophistication during this same period. Friedrich Anton Ulrich of Waldeck and Pyrmont may have encountered this rich emblem thought while attending the academy of nobles (Ritterakademie) in Wolfenbüttel as a young man.[103] The library of Count Ludwig Rudolph of Braunschweig-Wolfenbüttel (1671–1735) included an edition of *Devises et emblemes*, from which the room's décor was taken. It is even possible that Korb (who had library access) used this copy.[104]

In sum, the space through which one passed or in which one spent time showcased a temporal sensibility centered on occasions. Opportunities or *occasiones* to improve or change one's lot awaited those equipped to decode the emblems' messages about the workings of time and seize the opportunity when the moment was ripe.[105] The belief that one may act within time to one's advantage defined this emblematic community and, arguably, court life more broadly.

SPECULATIVE PLACES

In early modern Europe, aristocratic culture comprised shared horizons. Cultural exchange, as well as competition among different courts, stood at its core. In the Holy Roman Empire, with its tapestry of territories, this dynamic of connection and differentiation was particularly vibrant. A court in a small territory occasionally became the talk, if not the object of admiration, of other seats of power, even when, given the marked hierarchies among aristocrats, it would be difficult to call them peers or a social class. Few residences let one see this potential better than the margravate of Bayreuth in the mid-eighteenth century.

In 1731, Friedrich, heir apparent of the small territory, married Wilhelmine, the oldest daughter of King Friedrich Wilhelm of Prussia and of Sophia Dorothea of Hanover. As a princess, she had been raised to marry a king. But a king her husband was not.[106] In Bayreuth, Wilhelmine established preeminence as a writer, poet, musician, composer, painter, impresaria, collector, inventor, and conceiver of buildings and gardens. Other than the opera house (1748), one structure in particular bears her imprint: the Eremitage near Bayreuth. It had been created as a playground away from the exigencies of court life by Friedrich's uncle in the early eighteenth century, hence the name "hermitage." Gifted with the chateau by her husband in 1735, the year he became margrave, Wilhelmine set out to increase "the beauty and comfort of the place" on a hill at a comfortable distance from the margravate's main residence in town. In her memoirs, written in French but published only decades after her death, she left a description of its buildings and garden, whose redecoration and expansion she oversaw.[107]

The festive hall at the Eremitage gave way to an antechamber and an audience room in each of the separate wings for the margrave and the margravine, followed by a more private suite on either side of a small courtyard

(fig. 11). These official rooms were of modest size yet exquisitely furnished, especially in the margravine's apartment (her husband's wing was never finished), of which much remains *in situ*.[108] Elements of the décor subtly invoke the person who commanded these spaces with an eye to informing outsiders. The colors black and silver in Wilhelmine's anteroom allude to Prussia's coat of arms, reminding visitors of her dynastic lineage as a Hohenzollern princess.[109] The room's somber coloration contrasts with the audience room's friendly and luxurious chromaticism, where a carved crown takes up the theme of royal blood. In these rooms, in other words, the margravine was a presence, whether she herself was present or not. Tellingly, her initial appears in rocailles above the antechamber's doorway. One of her favorite companions, a dog named Folichon, appears in a painting.[110]

In fact, Wilhelmine personalized these rooms through artistic decisions.[111] Over time, she carefully curated her courtly selfhood by selecting furnishings or artwork. In her memoirs, she singles out what the "period eye" (Michael Baxandall) may have found surprising in these rooms—namely, that the paintings painted for the ante- and reception rooms depict historical episodes on ceilings, where such a genre would likely have been considered out of place (as a result, also, one could have no chandeliers in these rooms). Her explanation for having departed from decorative convention may well apply to her artistic-architectural-philosophical vision *in toto*: "I like all that is speculative."[112] In the context of the memoirs, this preference describes what is distinct about her "own invention" in architecture and interior design.[113] Such a statement in her posthumously published memoirs can also be read as an invitation to viewers to speculate, whether in the antechamber, the audience room, or elsewhere in the Eremitage.

In Wilhelmine's apartment, this self-fashioning includes such motifs as social stature (as has already become clear), great women, and moral exemplarity.[114] "Historical facts represent virtues," she states.[115] Acknowledging that, conventionally, virtues were represented as emblems or allegories,[116] she explicates having chosen episodes from ancient history in order to pictorialize virtues in action. Such scenes are "pleasing to the eye," she claims.[117] What are the scenes she commissioned? The antechamber of the margravine's apartment has a "painted ceiling representing the Roman matrons that prevented Rome from being plundered by their enemies," as her own description has it; they offered the conquerors treasures these women owned

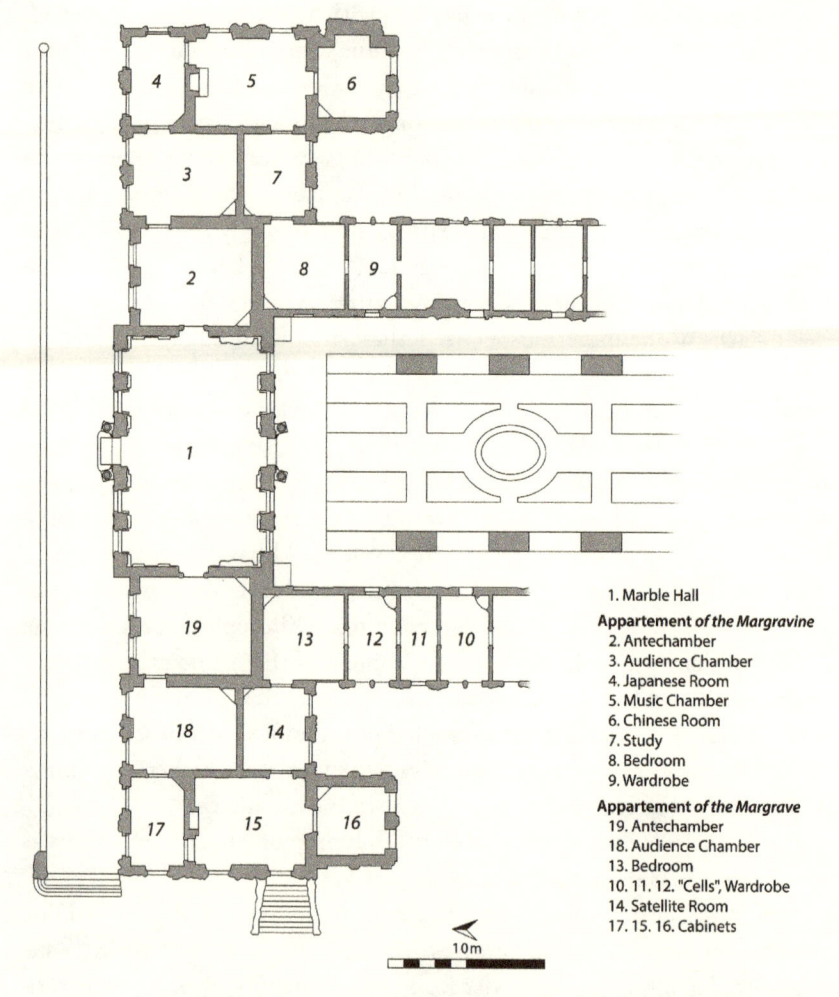

1. Marble Hall

Appartement *of the Margravine*
2. Antechamber
3. Audience Chamber
4. Japanese Room
5. Music Chamber
6. Chinese Room
7. Study
8. Bedroom
9. Wardrobe

Appartement *of the Margrave*
19. Antechamber
18. Audience Chamber
13. Bedroom
10. 11. 12. "Cells", Wardrobe
14. Satellite Room
17. 15. 16. Cabinets

10 m

FIGURE 11. Ground plan, Eremitage, Old Castle, Bayreuth (illustration by Matilde Grimaldi).

as a price for peace (fig. 12).[118] In the audience chamber, the scene on display depicts a virtuous Greek wife, navigating conflicting duties between loyalty to her family and loyalty to her husband.[119] This was a theme that had personal resonances, as many visitors would have surmised, if they recognized the scene. Overdoor paintings continue the theme of women worthies with scenes of Andromache dutifully saying farewell to her husband, Hector (who, they know, will not return alive), the death of Lucretia (who took her own life to preserve her family's honor after she had been sexually violated),[120] and Semiramis interrupting her morning toilette when receiving news about a rebellion in Babylon, the city she ruled.[121] Finally, the scene above the fireplace shows a woman from the Greek city of Thebes, Timocleia, taking revenge on the man who had raped her.[122] With their didactic edge, these for the most part rarely depicted and deliberately chosen scenes exhort beholders to act not only in defense of virtue with strength but also with humility, generosity, and willingness to make sacrifices.[123] Whenever Wilhelmine deploys "historical facts" in her apartment's rooms, where interactions with strangers and familiars were meant to take place, the images represent virtuous wives, exceptional women, and female rulers—women in command or at the top, in other words, who led by example in moments of crisis. It may not be far from the truth that one can read virtue in this context as signaling aristocratic valor. But virtuous behavior also constituted a code open to nonaristocrats, as the philosopher Christian Wolff and other proponents of Enlightenment ethics argued (teachings with which Wilhelmine was familiar). At any rate, one of the earliest editions of Voltaire's anonymously published *Candide* in 1759 included an ode to the late margravine that praised Wilhelmine as "a woman without prejudices, vice and flaw," taking up the theme of virtues she had cultivated in courtly representations, especially in the Eremitage's anterooms but also in the musical performances she produced.[124]

Strikingly, the paintings on the ceilings in the Eremitage appear to tear open the small rooms with their vertiginous perspectives into the painted blue skies. Their illusionistic theatricality draws the viewer into the dramatic reversals depicted. In the margrave's apartment, the antechamber shows the young Alexander the Great as a child listening to his teacher's advice, whereas the audience room features the ancient Greek military leader Themistocles in an audience before the Persian King Artaxerxes.[125] Particularly evocative of its setting, an audience chamber, is King Artaxerxes on a throne

FIGURE 12. Rudolf Heinrich Richter, *The Women of Rome Cause the Enemies to Withdraw from the City*, antechamber, Margravine's apartment, Eremitage, Bayreuth, Old Castle, ceiling painting, ca. 1740. © Bayerische Schlösserverwaltung, Achim Bunz, München (BayEr. II, DI 007979).

atop steep stairs, surrounded by a great many courtiers in colorful orientalized costumes (fig. 13). As Plutarch tells the story, the military leader and Athenian politician Themistocles, who had once masterminded the defeat of the Persian invaders of Greece, fled to Persia after having fallen out of favor in his native Athens. There, he paid obeisance to the king during an audience, turning his fortunes around by impressing the ruler, against considerable resistance at the royal court.[126] Once a powerful enemy of the Persian kingdom, Themistocles is portrayed here as a mere supplicant on a quest for a post; in fact, it is hard to make out his figure. Cognoscenti would have known that Themistocles, the Persians' erstwhile foe, reversed his fate by rhetorical suavity. His daring but well-planned moves at a court whose foreign customs made his success unlikely granted him a post by favor of the king. An appropriate motif for those who had waited in the anteroom.

FIGURE 13. Wilhelm Wunder attr., *Themistocles before the Persian King Artaxerxes*, audience room, Eremitage, Bayreuth, Old Castle, ceiling painting, before 1744. © Bayerische Schlösserverwaltung, Achim Bunz, München (DI008027).

This fiction of reversal through an individual's courageous act during an audience rubs against assumptions that interactions at court were scripted. In fact, such visions of *peripateia* are reminiscent of dramatic-operatic plots, for which Wilhelmine had a passion.[127] It is no accident that Themistocles, as well as Semiramis, featured regularly on the eighteenth-century stage. In 1753, the Bayreuth opera house premiered *Semiramide*, an opera by an unknown composer on a libretto by Wilhelmine, based on Voltaire's tragedy of 1748.[128] (In Wilhelmine's 1740 opera *Argenore*, for which she wrote both libretto and music, these reversals end in tragic suicides of father and daughter, not the happy ending or *lieto fine* one would have expected.)[129]

Encountering a ruler is replete with possibilities for the savvy who play their cards right, it is suggested. There is little evidence that this was the rule in the courts of early modern Europe. The potential to better one's lot may

have been an intriguing discourse to entertain in courtly settings. This idea must have tickled potentates by holding those waiting for an audience with them accountable for the outcomes they achieved or failed to achieve. Still, these paintings also served as reminders to those in power to make such reversals possible. Be that as it may, the asymmetrical distribution of power in waiting scenarios between unequals runs through these depictions.

Bayreuth was not Berlin, Munich, or Versailles.[130] What is more, the enlightened philosophy that Wilhelmine embraced favored a conception of the state different from the one actualized in ceremonies or daily rituals.[131] The Enlightenment sought to set in motion an ideas-fueled machinery toward a better yet distant future: the somewhat lonely business of the like-minded across the continent with whom rulers exchanged letters and discussed ideas, not the embodied notion of statehood that had catapulted courts to the center of political decision-making.

LOVE IN THE ANTECHAMBER

Different impulses were at work in decorating antechambers during the eighteenth century—the period from which some examples survive. On the one hand, the antechamber was a place to impart information to or impress, if not instruct or intimidate, the visitor or waiter. On the other hand, at least on occasion, pictorial strategies were designed to possibly keep those lingering in an antespace engaged, as with the emblems chosen for Pyrmont Castle.

In Charlottenburg, near Berlin, the painted décor of the first antechamber to the king's apartment functioned in yet another way. King Friedrich II of Prussia, Wilhelmine's younger brother, had the castle's new rococo wing designed during the first years of his reign (1740–46).[132] Before Sanssouci Palace in Potsdam was finished, Friedrich resided frequently in Charlottenburg, while Berlin Castle continued to serve as the stately residence.[133]

The frescoes in the first antechamber sought to lessen the woes of servants, visitors, supplicants, officers, and others.[134] Antoine Pesne's studio adorned this small Charlottenburg room during the early 1740s.[135] (As a portraitist, Pesne had painted individual members of the royal family, including a double portrait of Wilhelmine and Friedrich as children.) The light and vivid brushstrokes of these paintings beckoned those who roamed the space into the illusionistic scenes they depicted (they only survive in photographs

taken when they were rediscovered in the 1930s, after having been covered with wooden panels at the end of the eighteenth century, before wartime destruction).[136]

It was as if three walls of the antechamber gave way to a veranda under a portico from where one could stroll into a garden (an opening up of a confined space we already encountered in Pyrmont) (fig. 14).[137] The room thus became a threshold between inside and outside—an in-betweenness that mirrored the antechamber's function as a gate to other rooms. At the same time, those present in the room would not merely have been observers or viewers; given the frescoes' scale, they inhabited the space as actors in a tableau vivant.[138] These scenes exude not a whiff of busyness, military service, or political intrigue. Nor are there mythological pretensions. While lifelike, the figures are not portraits. What viewers become part of are gallant pleasantries in the here and now.

The rules of ordinary life are suspended, as we enter this leisurely world where Amor, the God of Love, rules. Surprisingly, we find ourselves in the

FIGURE 14. Studio of Antoine Pesne, *Court Scenes in a Garden Architecture*, Charlottenburg Castle, Berlin (wartime loss) (1944; photograph by Peter Cürlis; © Bildarchiv Foto Marburg / Art Resource, NY; fmlac8801_04 / AR6153305).

midst of a costume ball. One young couple is seated on a sofa positioned along the western wall. The young woman holds a mask in her lap while her companion has his arm around her shoulders, a moment we are privileged or doomed to witness. In the background, another costumed couple is engaging in what looks like amorous banter. On the wall facing north, a lutenist plucks the strings of his instrument to entertain a female companion while looking in our direction, as if he wants to flirt (fig. 15). A young page in an exotic costume carries a tray while casting a glance over his shoulders. In yet another scene, a cavalier in a foppish red coat makes a gallant gesture toward two women with elaborate dresses. In the garden, we can make out a couple inspecting a sculpture. These scenes revolve around a veritable choreography of glances, moves, and exchanges that envelop us.

Surprisingly, this anteroom conjures up a space where everyone is young and many are sociable or having a good time. A young courtier on the eastern wall even seems to communicate with an animated pet monkey on a banister. Its gilded and ornate shape takes up the ornaments of the stairwell

FIGURE 15. Studio of Antoine Pesne, *Guitarist with Women and a Page* (detail), Charlottenburg Castle (wartime loss) (1944; photograph by Peter Cürlis; © Zentralinstitut für Kunstgeschichte, Photothek; zio600_0026).

we left behind when entering the room.[139] Only one courtier other than the page is depicted as being by himself, though he clearly seems ready to engage in conversation. To be sure, the antechamber in general was a space open to male and female visitors, though women's presence was the exception rather than the rule in Charlottenburg.[140] But the mixing of the sexes could not have been what we catch glimpses of here, a milieu of amorous frisson. Why cover the walls of a small antespace with such enticing, or should I say sleazy, visual theatrics?

Interestingly enough, these representations of courtly pleasures defy the difference of status, rank, and office that more or less defined the court as a sphere. The Charlottenburg scenes promote a vision of happy interpersonal intimacy among the like-minded and young. As imaged in the chateau's anteroom, interactions between the sexes obfuscate hierarchies of rank, office, and station behind a soupçon of court life as theater (fig. 16).[141] Given the omnipresence of favorites, mistresses, and social climbers, if we follow early modern critics, one may well have constructed the court as a place replete

FIGURE 16. Studio of Antoine Pesne, *Gallant Scenes* (detail), Charlottenburg Castle (wartime loss) (1944; photograph by Peter Cürlis; © Bildarchiv Foto Marburg / Art Resource, NY; fmlac8800_18 / AR 6153306).

with amorous and other possibilities. Still, it is precisely the casual effortless-
ness on conspicuous display that exposes love as a code in this case.

In eighteenth-century Europe, gallantries on display in a courtly context
carried strong French overtones. In that sense, this tableau vivant in a spa-
tial setting signaled the court's and the young king's cultural orientation,
as reflected in the French paintings he collected and would soon display in
the king's second apartment on the same floor once it became available after
construction. The room's master artist, Antoine Pesne, had, after all, been
born in Paris and educated in France.[142] Implicitly, this distanced Charlot-
tenburg from the imperial court in Vienna, where Spanish court protocol,
considered somber at the time, was practiced.[143]

To be sure, the court as an institution was the place where the *discourse*
of love, historically and sociologically speaking, had originated in the Euro-
pean context and where it had been practiced in ever-changing forms.[144] In
a hierarchical society where lovers were not necessarily free to consort, let
alone to marry (if they were members of the elite), true love was thought to
thrive in secrecy. As a result, love plots entailed waiting for the right moment
to act on one's desires. Amorous pursuits, in other words, required timely
or well-timed actions. "Lovers both hate to wait and love to wait," as the
architectural theorist Alberto Pérez-Gómez notes.[145] What is more, lovers
plotted, and their plots almost by necessity relied on scenarios of simulation
and dissimulation to enable the union of souls and bodies that love was said
to be about.[146]

In other words, amorous horizons at court never were exclusively about
rapturous passions for the beloved. Love in this setting centered on restrain-
ing, refining, and schooling the affects and desires associated with it. Doing
so proved one's worth to one's lover in and over time. Love as "code of com-
munication" therefore models behaviors that have little to do with romantic
feelings.[147] Rather, love was above all a discipline about discipline. In Char-
lottenburg's antechamber, this facet of eroticism became palpable in the
masks, costumes, and domesticated animals we get to see. Thus viewed, love
resonated with the dynamics of court life, even if uneasily.[148] While enter-
taining, these frescoes alluded in oblique ways to the occasionalist outlook
we have seen at work in Pyrmont Castle or in Bayreuth's Eremitage. The
anticipations and anxieties, strategies and improvisations, boredom and en-
gagement of those who waited there, therefore, may have mapped in complex

ways onto the space's love-centered pictorial decoration. Was sentimental-affective fulfillment, as these scenes suggest, truly within reach?[149] The presence of a monkey in the courtly mix arguably raises questions in this regard.

In sum, the patrons and designers of palatial buildings could draw on many iconographic settings for antespaces. Ideally, the antechambers' imageries honored the space's master or mistress in some way.[150] A field marshal like Prince Eugene, the consort of an aristocrat, or a person of royal lineage conjured up different iconographic horizons. Whether battles or scenes from ancient mythology and history were featured, these reflexes were rarely unequivocal. They lent themselves to be discovered, decoded, and debated.[151]

Yet no imagery may have been more widespread in this contact zone than episodes of encounters, homages, and negotiations. King Darius's family at an audience with Alexander the Great after the defeat of the Persians was a prominent motif, for instance. Its prestige had much to do with the fact that this iconographic coinage followed the example of Versailles. Images of this type offered lessons such as mercy, conciliation, rapprochement, or respectful interaction between unequals that were thought appropriate for the setting. What is more, in particular contexts, such well-known scenes could be tweaked to signal specific messages.[152]

The *appartements* of female members at court showed different themes, such as an allegory of peace, for example.[153] In yet other antespaces, allegorical figures glorified the builders or patrons.[154] Still, variations in the décor of these rooms reigned—variations that themselves invited thoughtful viewing. A closet drama such as *Sodom, or the Quintessence of Debauchery* (printed in 1684)—John Wilmot, Earl of Rochester, is the likely author—reveals this logic. There, the first act is set in "an antechamber hung round with Aretine's postures" (which refers to *I modi* with Marcantonio Raimondi's etchings based on Giulio Romano, as well as Pietro Aretino's sonnets; the latter's name served as a shorthand for erotica in this period). In this inverted palatial space, every visitor not only gets to understand what the Kingdom of Sodom is all about but also has the opportunity to be entertained or instructed publicly in matters of sex.[155]

Spatial Choreographies

The advance from the antechamber to the room where ordinarily an audience took place often resembled an immersion. Tying consecutive spaces together in a shared design reflected on the grandeur of those who had them built and furnished. When these rooms featured one integrated pictorial program, one progressed, once admitted, from an outer to an inner chamber in a succession of sorts. Such a passage came with the potential to surprise visitors as they moved on.

This is what one experienced in San Lorenzo de El Escorial, one of several residences of the kings of Spain (built 1563–84). The sequence of the antechambers and the audience hall conveyed a well-calculated message about the ruler and his realm. Once diplomats or visitors had left the relatively small room and were shown into the great hall, they encountered a grand space adorned with instruments, maps, and images, as well as an impressive view over the expanse of Castile.[156]

In Ludwigsburg, Duke Eberhard Ludwig of Württemberg erected a state-of-the-art *maison de plaisance* (after 1704), which became the main residence after 1718, approximately three hours away from his principal seat of power, Stuttgart.[157] In the main building's two stately apartments (*appartements de parade*), ceiling frescoes united the respective rooms on the *piano nobile* of the central structure (*corps de logis*). Whoever advanced from ante- to audience room in the duke's quarters moved from Venus's realm to Apollo's. The apartment on the opposing side of the *bel étage* sequenced the realms of Diana, goddess of the hunt—Ludwigsburg was the seat of an aristocratic hunting order that the duke had founded—with that of Mars asleep as a symbol of peace.[158]

In Ludwigsburg, like in Bayreuth, love was shown to be treacherous terrain in the ducal antechamber, as tragic episodes depicted on the ceiling demonstrate. Still, in her bodily glory, Venus made for a high-spirited point of departure. Yet the Sun God, Apollo, offered a superior setting for an encounter with the duke. On entering the audience room, a person first notices invocations of nightfall, night, and dream, as well as personifications of different winds, to then, when walking further into the room and turning around, perceive Apollo guiding the chariot of the sun.[159] This unfolding of

images leads the visitor from night to day, associating the ruler with splendor, light, and the divine charioteer. In other words, when passing from one room to another, one experiences, if indeed one seizes the opportunity to scan what there is to see, an ascent. The painter Johann Jakob Stevens von Steinfels mobilized this sequence for paying homage to the sovereign, guiding the visitor to assume a reverential attitude. In a ceremonial setting, the duke would have situated himself in proximity to Apollo, his allegoric alter ego or rather altior (higher) ego on the ceiling. The two rooms thus were interconnected by their painted décor. Similarities and differences structured the rooms' relation as elation. The transition from one to the next was meant to direct, instruct, impress, and affect the visitor.

As becomes evident, anterooms' decorations must be understood as relational in a given "flight of rooms" (fuga di stanze). Often the antechamber was the first interior furnished chamber that visitors would have been exposed to after traversing transient but often expansive spaces such as vestibules, stairs, corridors, and lobbies.[160] A walk through these spaces resembled a journey. As a rule, palatial complexes were fenced in or surrounded by a wall. While fences provided visual access to a building's facade, such lines of demarcation also defined places of power and prestige as distinct from their surroundings. Gaining access was crucial to an outsider's visit. On entering the premises, visitors would have had to pass guards. But these weren't the last checkpoints where entry could be denied or granted.[161] The antechamber itself was part of this staged—that is, theatrical and gradual—progression from threshold to threshold.

Doors played an important role in guiding people through architectural settings of multispace residences. In El Escorial, the entry points to the audience hall from the two antechambers located in parallel wings were accentuated by splendidly carved, gate-like doors constructed of wood.[162] These massive doorways, 407 cm and 345 cm tall respectively, each uniquely designed, resemble festival architecture as it might have been erected for the entry of a notable or prince.[163] Compared to a single door as in El Escorial, double-winged doors had a limited radius. Could one have caught a glimpse of the room beyond? While often splendidly crafted and eye-catching, doors limited visual access to the chamber beyond the anteroom when closed, as would have been the norm on most days (as opposed to feasts and gala days).[164]

As technologies of inclusion and exclusion, doors in early modern times attracted hopes and anxieties, as Daniel Jütte contends.[165] Having many such separators within buildings signaled wealth and status. Such doors transformed a visit into the theatrics of an advance—or thwarted advance—through sequential spaces with requisite stop-and-go movements. In palatial buildings of the seventeenth and eighteenth centuries, doors on the main floors were arranged so that they lined up to make evident, if not highlight, the deep recesses of rooms in a building. The early eighteenth-century encyclopedist Ephraim Chambers specifies that entryways "be opposite to each other, so that one may see from one End of the House to another, which will not only be graceful, but also convenient."[166] Von Rohr echoes the paean to the aesthetic value of doors lined up in a suite.[167] With the exception of festive soirées or audiences for great visitors,[168] this "grace" was not something outsiders could easily explore, however.[169] That doors were closed when their arrangement in fact calls for an unimpeded view across adjoining interiors makes the state of waiters all the more poignant. As a rule, they were stuck in a room and stuck in time.

In the Munich Residenz of the Electors of Bavaria in the mid-eighteenth century, one of the antechambers of the so-called Reiche Zimmer featured false doors. In addition to actual doors, they aggrandized the space through symmetries. Yet they also may have kept those who waited apprehensive.[170]

For an ordinary person on an ordinary day, the antechamber's doors to the next room would have opened only occasionally. These entry points were controlled by those who provided access, be it the chamberlain, servants, or someone else. At Versailles, courtiers were exhorted to close the doors to the king's quarters immediately when moving about.[171] In a large court like Vienna, guards would have secured the doors that connected the antechamber from other parts of the imperial apartment in the Hofburg.[172] Waiters were discouraged, if not prohibited, from opening doors during their waits, unless with permission.[173] When several people waited in the antechamber, the chamberlain, another official, or a servant might have gestured to or announced the next person.[174] Especially those of lower station, von Rohr recommends, should politely ask guards to be let in. Nor would it have been considered decorous to knock; one was supposed to signal one's presence by scratching the door.[175]

By contrast, when King Friedrich II of Prussia received visitors in Rheinsberg Castle in 1740, the doors to the antechamber were left deliberately open

(laissant la porte ouverte) so that those present overheard the king's interactions first with a minister and then others; the Bavarian envoy found such behavior "against all the rules" (contre tous les regles), as he reported in a letter to his father.[176]

According to an early modern observer, disposition was "a new art, unknown to the ancients," defined as "the art of distributing and arranging with taste the different rooms of an apartment."[177] The term *disposition* suggests a spatial arrangement in the sense of architectural placement with regard to a building's external and its internal order. Yet *dispositio* (arrangement) already appears in Vitruvius's treatise on architecture (30–15 BCE) in the sense of "performing . . . a process" and is associated with "the elegant effect" of an edifice.[178] Importantly, the term references textual composition and thereby captures a logical sequence in time. In von Rohr's formulation, "the rooms with their respective antechambers follow one another on the same level so that one can go from one to the other" (Die Zimmer folgen mit ihren besondern Vorgemächern a plein pied hinter einander, damit man aus einem in das andere gehen könne).[179] This conception of an edifice as dynamic reflected a conception of power that pervaded, enabled, and shaped interactions, whether quotidian or festive.[180] Viewed thus, the term *dispositio* establishes an affinity between rhetoric and architecture that signals the embodied movement through space as a process tied to persuasion, one of the goals of rhetoric.[181] "If seeing is believing, then by implication seeing an impressive building is more than halfway to believing what its creators would have us believe," as William Coaldrake proposes.[182]

Today, visitors to an architecture of power often move quickly to rooms more ornate and more luxurious than their spatial overture, the antechamber. By contrast, early modern commoners would have lingered in this room. Visitors might not have advanced to the audience room, let alone the inner chambers. Only on certain occasions, courtiers or high-ranking invitees roamed the entire sequence of rooms, as is the case today. Notably, commentators remarked on differences between different courts in this regard. Accordingly, Versailles was said to welcome visitors, whereas its German equivalents were not.[183]

In sum, during the eighteenth century, the antechamber formed part of a "relational experience of objects"—furnishings, paintings,[184] and spaces. The residence of the prince-bishops of Würzburg, built between 1720 and 1744 (its interior design continued to be carried out thereafter), is a particularly

powerful example. As an ecclesiastical dignitary, the prince-bishop had no wife. Therefore, the symmetrically arranged stately apartments of his residence housed high-ranking visitors and served other functions. The wood paneling, stuccos, tapestries, and stoves linked the sequence of rooms in both *appartements* while differentiating the reception room as an intensification of elements in the antechamber. What connected antespace and audience halls in Würzburg, among other things, was a series of tapestries with scenes from the life of Alexander, based on influential models by Charles Le Brun for King Louis XIV;[185] these wall hangings had already been part of the decoration when the prince-bishops still resided in the Marienberg fortress, above town. What distinguishes the two rooms is the choice of wood—oak in the antechamber, costlier walnut in the audience room. Also, compared to the lavish audience rooms, with their many splendid woodcarvings, there are few woodcarvings in the anterooms. This same logic of amplification— another word that resonates with rhetoric—was at work with other elements as well: stoves, iconographic registers,[186] wall hangings, and so forth that formed a dialectic of connection and climax. In other words, seriality, with its penchant for the semantics of crescendo, worked toward a visual-spatial rhetoric of distinction. Unified interior designs over several rooms communicated the décor's splendors to the discerning eye. Mimi Hellman's observation about the eighteenth-century French interiors is applicable here: they offered "a pre-established setting into which social actors inserted themselves, inscribing their conduct within a given frame, and it was also an array of props susceptible to manipulation, a mutable mise en scène continuously redesigned by its cast."[187]

Wherever there were two consecutive antechambers, as there would have been in the apartments of many grand residences, especially in Central Europe, the second one was bound to be furnished with greater luxuries than the first. In the second half of the eighteenth century, one of Europe's most sought-after painters, Bernardo Bellotto, also known as Canaletto, was commissioned to paint a cycle of three vedute (views) for the second antechamber of the so-called Kurfürstenzimmer (Elector's Chambers) in the Munich Residenz of the Electors of Bavaria—the rococo room, designed in 1763, once again doubled as a dining room.[188] These painted views of scenes in the city and the electoral summer residence in Nymphenburg near Munich fostered an appreciation of the domains in question and their rulers' good gov-

ernment among the high-ranking dignitaries and diplomats who would have had access. At the same time, there was considerable variation. The Neue Palais in Potsdam, constructed between 1763 and 1769, provided lodgings for King Friedrich II and members of his family, though not for his wife—a marked departure from architectural, as well as aristocratic, convention. As a *maison de plaisance*, the palace did not accommodate state functions. But the antechambers to the various apartments of the king and his guests were by now a standard feature of architecture. With their seating arrangements they functioned, among other things, as repositories for the king's extensive collection of paintings.[189]

One of the key questions regarding antechambers is whether there were chairs, benches, and other arrangements to seat those who spent time in these rooms. Accommodations of this kind were *mobilia*. When needed, in other words, they could be brought in. This occurred, for instance, with the tables when a meal was served in the antechamber for the master and his family or close associates, as was frequently the case. In this sense, a chair for someone who was waiting was an act of generosity or recognition.[190] When ambassadors or other dignitaries visited, taborets were expected at the imperial court in Vienna.[191] Over time, however, furniture became more firmly associated with particular rooms, including chairs or benches (*banquettes*). In the eighteenth century, they increasingly matched other components in the same room. Yet even when there were such accommodations available, no chairs with backrests would have been permanently installed, as a rule.[192]

In Munich, the use of individual stools or taborets was prohibited in the antechamber. Practices of having them, the same document laments, had become common, "which have never been customary before nor are [customary] at other courts" (so vor disem nie gebräuchig gewesen, weeder annoch bey anderen Höfen seind).[193] By contrast, banquettes were provided. Unlike chairs and stools, let alone thrones, they offered a seating arrangement for more than one person. Other amenities featured in anterooms were stoves and heating units, as in Würzburg, in Munich, and other places.[194]

A view of an antechamber such as Salomon Kleiner's depiction of one in Prince Eugene's garden palace (Upper Belvedere) makes this room appear largely empty, except for some visitors scattered about, in pairs of interlocutors and as individuals (fig. 17).[195] These male visitors, in their almost identical fashionable garb, are props; other views of interior rooms in this series are

not as "crowded," with the exception of a veduta of the audience hall during a reception. Kleiner populated his visual representations to reflect the rooms' functions. Antechamber and audience chamber were staffed accordingly—the latter with large numbers of people, including women, who encircled a conversation between dignitaries on chairs in the middle of the room at an official occasion.

This vedutista's remarkable vedute appealed to architects, aficionados, and armchair travelers interested in the latest interior designs.[196] They give an uncluttered view of the floors, dados, walls, ceilings, and artwork. By contrast, rooms in use contained stuff. In this sense, the antechamber also served as a room to store things. An eighteenth-century ordinance for an aristocratic residence prohibits inspecting or pilfering letters, writings, supplications, or books, as well as searching the contents of boxes and drawers found in antechambers.[197] Servants, guards, and other residents or employees seem to have occupied themselves by touching, fingering, reading, or

FIGURE 17. Salomon Kleiner, *Antechamber* (Upper Belvedere), print, 1733 (Photo: Belvedere, Vienna; BB_1012-013; © Library of the Belvedere, Vienna).

stealing. In the electoral residence in Munich, a 1769 ordinance therefore asks people to self-discipline what the same document bemoans as bad habits in the antechambers. Tellingly, this passage equates stuff with information one overhears while in this room; one should ignore both.

Antespaces came into existence to allow for differentiating visitors according to status and thereby ensuring a degree of protection for members of the elite. But seclusion did not always hold what it promised; its twin was curiosity. Some waiters responded to these settings with their constraints in a contrarian fashion, leaving signs of their stay such as scratches or graffiti.[198]

The Triumph of Antespatiality

The antechamber as an architectural vessel was not exclusively a feature of aristocratic residences. Spatial configurations of waiting rooms are also attested for the middling classes in Baroque Rome, for example. In the seventeenth century, well-off Romans lived in single-floor apartments.[199] Extant inventories indicate that the *antecamera* or *antecamere*, as a rule, were adorned with paintings and other works of art. By comparison, furniture, including chairs, was rare; items were brought in from other rooms when needed.[200] Eighteenth-century bishops' palaces in England featured waiting areas, though they sometimes had to be retrofitted into already existing structures.[201] In Paris, *antichambres* became common in the *appartements* of the bourgeoisie during the eighteenth century, if not before. If we follow the notarial record, these spaces often fulfilled several functions simultaneously, serving as waiting rooms, reception areas, storage units, lobbies, or a combination thereof. Moreover, there was considerable variation as to their décor and the material objects they contained, including gaming tables.[202]

In city-states like Geneva, Parisian style apartments held great cachet during the same period, though they were often smaller than those of the aristocracy. As a result, reception areas for visitors in Genevan *hôtels particuliers* were often modest by comparison to their models; owners opened their most secluded rooms on festive occasions; and masters lived in close contact with their servants. Yet these urban residences practically never went without one or two *antichambres*.[203]

The above examples lend credence to what one of the foremost experts on architecture of his time, Augustin-Charles Daviler (or d'Aviler), opined

in 1691—namely, that apartments minimally must have four rooms: a main room, a *cabinet* (small chamber), and a *garderobe* (wardrobe), possibly on a different floor, as well as the antechamber.[204] Another commentator, Marc-Antoine Laugier, differentiates antespaces by whom they are for: "the first antichamber for servants, the second for valets."[205] The British encyclopedist Ephraim Chambers echoes this notion while simplifying the components in his own definition: "A compleat *Apartment* must consist at least of a Chamber, an Antichamber, and a Cabinet or Wardrobe."[206] At any rate, architects and observers saw the antechamber as essential to residential quarters in this period.

Those who commissioned edifices lavished considerable attention on these interstitial zones. Johann Wolfgang von Goethe's mansion in Weimar is a case in point. When he became the owner of a house on the *Frauenplan*, which he had rented before, he meticulously planned the construction of a sprawling stairwell, as well as a reception area of several adjoining rooms in the domestic quarters; he even sacrificed residential space to carry out this redesign (1792–95) (fig. 18).

FIGURE 18. Goethe's residence, "Gelber Saal," room 102, Weimar (2018; photograph by Alexander Burzik; © Klassikstiftung Weimar, Bestand Fotothek).

As a rule, the "prince of poets" received the many people who wanted to see him during a particular time slot in the afternoon. A servant would accompany a visitor on his or her ascent. The passageway featured a total of thirty-three steps, several turns, and a staircase with a steep incline leading up to the door to the actual apartment. Before crossing the threshold to the residential quarters with its welcome message, "Salve" (in the form of a wooden inlay), one would detect the copy of an ancient sculpture of two young men, one of whose arms is on the shoulder of the other on the upper landing, arguably the most prominent among several works of art that adorned this hallway. In the eighteenth century, the youths' mythological identity was contested. But no matter who one thought the couple represented, they figured as emblems of friendship and harmony—an auspicious sign for the newly arrived. Depending on the visitor's rank or the interest Goethe took in the guest, he would impose a wait time or join them immediately. If the initial encounter went well, the host might invite them to continue the conversation or show them his collections. This architectural setting with its sequence of spaces, therefore, provided "the opportunity to enact a nuanced welcoming ritual."[207]

Like in Rome, works of visual art were accorded a central role in Weimar. They were part of a carefully designed décor for those who moved from the doorway to the residential sanctuary, for example. As one advanced through the space, the prints, frescoes, reliefs, and sculptures on display offered themselves to be read as symbols of the owner—his status, his education, and his collections. The objects may have occasioned reminiscences on the part of the visitor—reflections that might shorten one's time spent there waiting, if one wasn't too nervous to notice—or provided cues for striking up a conversation with the host. Such spatial and visual arrangements were anything but accidental in a society that turned receiving another person into something of an art form. Occasionally, owners spared no expense to outfit waiting areas with objects that communicated messages to guests who knew how to decipher them. Without a doubt, location, size, and decoration of reception or waiting areas influenced the experiences of those who traversed them or passed time there. Antechambers are therefore a prime example of an affective space—an environment that molds the waiter's mental and physical state.[208]

The rise of the antechamber points to a long-lasting transformation in architecture between 1500 and 1800. In edifices of different kinds, aisles,

corridors, vestibules, and stairs turned chains of rooms into built spaces increasingly divided between service and circulation units, on the one hand, and an inner sanctum accessible to only a few people, on the other hand. The owners' desire to guard their daily life from possible infringements by others was a rationale cited already in the sixteenth century: "purposeful or necessary communication was facilitated while incidental communication was reduced."[209] These arrangements were the province of the domestic. As people of lesser status, servants and maids represented their masters or lords. Oftentimes they acted as go-betweens, moving from space to space, connecting people within the same building, as well as with the outside, and controlling spaces or temporal routines—a contradictory position of considerable influence in the day-to-day operations of a household.[210]

Readers will wonder if those who spent time in the antechamber, whether servants or visitors, subjects or foreigners, were able to accomplish what they came to do, be it business, having a conversation, paying respect, delivering a supplication, or simply killing time. The occasionalist perspective we have detected in antespaces surveyed would have suggested that, if one tackled a particular mission with foresight, intelligence, and patience, and, what is more, acted at an opportune moment, one indeed had a chance to proceed, if not carry out one's plans. There is and was no way to know for sure, however. Waiting, after all, never is far from doubting.

Indeed, we may fear that waiting in the antechamber resembled what the man from the country experienced in Franz Kafka's "Before the Law" (Vor dem Gesetz, 1915), one of the author's most haunting texts.[211] The man's journey toward the law comes to a halt in a before-space from where he hopes to be admitted. This room is but a threshold to things greater than what he already knows, guarded by a gatekeeper (as some interior spaces were). While waiting to be received, the man from the country gathers information on the space beyond through glances, conversations, gifts, and the like, activities not unlike those in which some of the curious waiters in the antechamber might have engaged. As readers of Kafka will remember, the man who came from afar to gain access holds on to the possibility that he might on some future occasion be granted admission.[212] He also harbors and manages anger, fear, and hope. The "not yet" (noch nicht) of his situation becomes his existential temporal condition.[213]

Intriguingly, in Kafka's telling, the uncertainty of topography morphs into the flow of wait-time. Situational waiting, as in the antechamber—that is, waiting with a purpose, the purpose to be admitted—becomes a permanent and poignant condition, with its concomitant range of sentiments: anticipation, anxiety, despair. The existence of the gate itself, as well as of the gatekeeper, reassures the man that what he came to do—what exactly is it?—is worth the temporal investment, and the glow emanating from the interior he sees with his fading eyes reaches him as a confirmation shortly before his death.

In this chapter, we have explored spaces where servants, guards, courtiers, officeholders, artists, businessmen, commoners, and others were meant to linger. The direction of our account has been a form of forward time travel (as is common in historical writings): from early traces of antespatiality on the European continent in the late Middle Ages to the age of revolutions. We have delved into what messages the rooms with their pictorial and other décors communicated to people trapped between the walls of chambers "before another chamber." We have ourselves dared a glance into adjacent rooms beyond the antechamber where audiences were meant to take place.

Let us acknowledge that the man in Kafka's story or legend, as the author called "Before the Law," wields some agency. He could have walked away. But he "decided to wait until he receive[d] permission to enter."[214] If he had left, he would have lost the potentiality tied to his condition, this "not yet" or future prospect. At the same time, the man's agency pales in comparison to that of the gatekeeper. At least in the waiter's imagination, this representative is of a higher authority, though he presents himself as someone at the bottom of a hierarchy.[215]

In the following chapter, we will explore what waiters within the antecameral spacetime may have experienced. Previous chapters, I hope, have equipped us with frames about pocketed times and waiting spaces that help us fathom these encounters. Waiters often approached their time in this space as a moment replete with possibilities and anticipatory thoughts. Yet who they were, what their intent was, and who their interlocutor was mattered.

THREE

Encounters

Suddenly . . . waiting seems . . . like a set of parentheses bracketing everything taking place on the ground.

—Jenny Erpenbeck, *Go, Went, Gone*

Space and time are conjoined. As I have argued, waiting is a spacetime constellation in social life. In one of the incunabula of studies on the sociology of waiting, Barry Schwartz concluded in the mid-1970s that delays consistently shaped social interactions in the businesses, hospitals, publishing houses, and the like that he studied. While waiting for services and appointments was a pervasive phenomenon in the US, its organization, scripts, spaces, and social meanings eluded an analysis focused on cost or efficiency. Rather, social, cultural, psychological, racial, and similar scripts forged waiting scenarios. How people waited—the time spans they were made to wait, their willingness to wait, their discontent with having to wait, and so on— was contingent on race, class, gender, profession, religion, and so forth, in ways that, as Schwartz stated, required further study.

"We know comparatively little about the social organization of time," Schwartz posited in 1975.[1] In 1989, Paul E. Corcoran even claimed that the social sciences had largely ignored the topic of waiting.[2] It "is a temporal region hardly mapped," as the literary critic Harold Schweizer put it.[3] Yet what held true once no longer does. In recent years, researchers in anthropol-

ogy, sociology, philosophy, literary criticism, queer studies, and other fields have uncovered manifold structures of waiting in modern and contemporary society. By contrast, premodern waiting has barely begun to be examined.

But as we saw in chapter 1, in early modern times waiting was formative for taking action in time. The spaces designated for those who waited were the focus of chapter 2. In fact, Schwartz touched on spatial arrangements and their impact when discussing the "atmosphere of the waiting room" in an empirical study on the executive wing in a mortgage company, with its various amenities; they lessened the potential woes of waiters.[4] How spaces and their temporizations manifested in interpersonal encounters is what we will explore in this chapter.

The production of spacetime in interpersonal contacts is an "important means to augment social power."[5] As we will see, waiting scenarios in the antechamber involved not only the waiter and the one the waiter hoped to meet; others participated in making such an encounter possible or impossible. Interactions of this kind were marked and marred by opacity and contingencies—factors that were part of the production of power and authority in spacetime during the early modern period.

Two Tales

What was an appropriate wait time for an audience with a person of high standing in early modern Europe? What constituted an excess in making others wait? How did those who waited spend their time? Following von Rohr's "science of ceremonies," we can speculate that there may not have been straightforward answers to these queries in the early modern period. "Practices differ" or "Each and every case is particular" is what our eighteenth-century expert would have answered. Such answers may not satisfy our curiosity about details regarding the quotidian rhythms of early moderns. Still, the two sixteenth-century tales that inaugurate this chapter offer telling windows on waiting scenarios in the antespaces of the powerful. As narrations, they seek to instill memorable lessons about waiting. Characteristically, these stories do not express clear-cut rules but serve as frames of perception about antecameral spacetimes. As narrations—or histories, as the narrator assures us—they were told to trigger thought, insight, and conversation on the part of listeners and readers.

The first episode in the antecamera is unconventional fare. It culminates in laughter: a surprising end in light of the fact that the story starts with a duke's death. What happened? When Wilhelm IV of Bavaria died in 1550, his successor, Duke Albrecht V, ordered his majordomo, Count Haugen of Montfort, to apprise Emperor Charles V of the sad news on his behalf. On arriving in the Lowlands, this envoy was given a day to appear at the Brussels court. At the appointed time, the duke joined a group of nobles—princes, counts, and aristocrats (Fürsten, Grafen und vom Adel)—waiting in the antechamber (vorgemach). Among these was Christoph of Braunschweig-Wolfenbüttel, archbishop of Bremen. All of a sudden, this cleric became so absorbed with one of the lifelike scenes depicted on the tapestries adorning this antespace that he sprang into action.[6] He assisted Hercules in killing the river god Achelous by scratching: an ecclesiastical dignitary who intervened on Hercules's side when the Greek hero competed with Achelous to marry the daughter of a king.[7] Those gathered in the *vorgemach* burst out laughing in unison when witnessing this sudden attack on a mere image, it is said.[8] Even when relating the message of the duke's passing to Charles in the "inner chamber" (inner gemach), the messenger was unable to reign in his laughter. We are left guessing as to the emperor's reaction to this affective dissonance; the story is told from the vantage point of those who waited in the antechamber.[9]

To be sure, this tale could revolve around the powerful effect magnificent tapestries had on viewers as decoration in the spaces of the imperial and other courts, though no tapestry of this particular motif seems to have survived.[10] Instead, the narration centers on the nobles who actualized themselves as a collective when waiting for an audience with the emperor. In a palatial edifice, their laughter was out of the ordinary, or this is what the story suggests. After all, the waiters' outburst disrupted decorum in the space: relative silence and a subdued gait in anticipation of an audience with the ruler. It is also suggested that, before this rupture in the flow of their waiting together, those who waited were caught up in their own thoughts. While there is no indication of the length of time they spent in Charles's antechamber, the incident in question provided the German nobles with an occasion to bond.

The sixteenth-century *Zimmern Chronicle*, of which this and the following tale form a part, has been called a "Weltbuch,"[11] a book of the world. With his voluminous manuscript, Count Froben Christoph von Zimmern,

an educated aristocrat who had studied at several European universities, sought to forge a dynastic sensibility with current and future family members. Judging from the product of his travails (with the help of others), the count was a gifted storyteller. Humor is the narrative glue to what mostly is a collection of instructive *exempla*, or historical tales. Characteristically, Froben Christoph stitched together stories on the same or a similar theme.[12] One story on waiting, therefore, was followed by another, involving some of the same protagonists. This concatenation allowed the chronicle's audience to deepen their understanding of—in this case—interactions at court that involved waiting.

The second story goes as such: Emperor Charles V got wind that his son Philip had German princes—the aforementioned archbishop among them—regularly wait for an audience for extended periods of time. The time frame given is more than two hours. To teach him a lesson, Charles ordered Philip to see him. After the latter's arrival at court, while letting his son know that he would see him imminently, the emperor had him and his companions wait in the antechamber. After more than two hours, they grew impatient (Die weil wurt dem sone lang, hat ain beschwerdt darab und alle seine Spanier). This was the effect Charles had aimed for. Calling Philip into the audience room, his father inquired whether "he was also displeased about having had to wait for so long" (ob er nit auch ain misfallen darab, das er so lang hat warten muesen). When Philip remained silent and had his father wait for an answer (something left unexplained), Charles, so the story goes, offered a stern "fatherly rebuke" (vätterliche vermanung): "As you complain about having to wait so long you ought to behave against others. You should not let them wait in vain or keep them waiting without a reason and without necessity" (Gleichergstalt als du ein beschwerdt, so lang zu warten, also solltest du gegen andern dich auch erweisen, die nit vergebenlich und ohne not oder sondern ursachen ufhalten und warten lasen).[13] He pleaded with Philip to show respect toward the German nobles by granting them an audience in a timely fashion.

Let us take note. An excess of two hours was unduly long for one aristocrat waiting for another, if we follow the narrator. Possibly, it was particularly egregious between father and son. As Froben Christoph lets us know in a coda, Charles's somewhat heavy-handed intervention in his son's monarchic antics had no noticeable effect. The count indicts Philip for haugh-

tiness, blaming the latter's foreignness—he was, according to the chronicle, unwilling to speak German—and his Spanish associates for having led him to believe that "he [was] much more noble than his father" (er sei vil edler, dann sein vater).[14]

Froben Christoph was well informed. The historical Charles instructed his son in various ways, and, indeed, Philip had a passion for court jesters, as the story mentions. As a king, Philip became known for intimidating visitors when he greeted them with silence during audiences. Yet what this narration projects about Philip's father, the "pious" (fromm) Charles, was a convenient fiction. The emperor's position was less aligned with German nobles than these stories project. With Charles's succession unresolved and Philip's ascension to the throne a possibility, anti-Spanish sentiment was rampant in the empire (in the end, Charles's brother Ferdinand succeeded him while Philip ruled over Spain, the Netherlands, Italy, and the colonies). Importantly, this is a story not about commoners waiting for an audience but about German aristocrats' access to their ruler. In a monarchy that had become a European and global empire, this was anything but a straightforward affair. Habsburg imperial politics elevated the emperor's sovereignty in interpersonal encounters—a story that resonates with what we have learned about European kingdoms in the sixteenth century. Evidently, Froben Christoph was anything but a disinterested narrator. As a representative of a dynasty that had recently been awarded princely status, he was one of the peers who entertained claims of access to "the King of the Romans."

These two stories conveniently bring together tidbits of information about space, furnishing, decorum, and timing. In the following section, we will pursue these themes. We will explore the theme of the collective of waiters in the well-documented context of the Habsburg court in Vienna. In addition, our courtly tales will be complemented with encounters that involve commoners—in Florence, Vienna, and Munich—before we circle back to Weimar. We will cover a whole range of outcomes, from success to delays and failures to achieve one's mission. In every case, however, these encounters communicated asymmetries of power and authority in which social privilege mattered.

The Tyranny of Waiting

In medieval and early modern Europe, excessive waits were associated with unjust rule. This was the case not only in monarchic governments but also in city-states. As we already know, Lorenzo de Medici, the Magnificent, was known to have evidenced his elevation as de facto ruler of Florence by making himself difficult to approach. Commoners needed time to arrange a meeting with the great man.

In December 1490, the spicer Tribaldo de' Rossi sought patronage for a business he planned to launch. While he entertained contacts with other great families such as the Strozzi and Gondi, he homed in on Medicean support for the rights to mine copper. Apparently, this required a strategic plan, which Rossi pursued methodically. He first made contact with a close associate in the cathedral, Piero da Bibbiena, Lorenzo's chancellor (cancellieri), who invited Rossi to see Lorenzo in the Medici palazzo at a certain hour. When Rossi showed up, the associate told him to come back an hour later. On his return, many others were also waiting: "I stayed from the twenty-third hour, after dinner, up till the time I became so uncomfortable about my shop that I left, with the idea of speaking to him at leisure on a feast day."[15] He tried his luck another time, encouraged, if not reassured, by his intercessor to stay close by.

When the first meeting with the political leader occurred, it was interrupted. Lorenzo quickly took up a different matter. The second meeting was also short. Rossi apparently did not have the time to detail what he had in mind. What mattered, however, was that the two had interacted in a friendly manner and that others—mentioned by name—had witnessed their encounter. Rossi's written account firmed up their association. Notwithstanding the mediation of a close associate, it had taken Rossi more than two weeks and several attempts to realize his plan to speak to Lorenzo.

As this episode reminds us, this Medici performed his exalted status in Florence by making himself rare. Associates shielded him from interacting with people outside his inner circle. These practices existed independent of certain designated rooms for waiters, yet antechambers facilitated this kind of delayed or denied interaction with someone of high status. This episode also is a reminder that what was of import in encounters between

unequals was not only what was said or negotiated; what mattered, among other things, was one's association with the great and mighty. As Tribaldo de' Rossi could testify, such access was hard-won and required expenditures of time.

The religious reformer Girolamo Savonarola confirms Lorenzo's remove from ordinary citizens in the urban community. In a sermon during Lent 1496—after the Medici had been toppled (and before their return)—Savonarola delivered a searing portrait of the family's bearings. Without naming Lorenzo (who had died in 1492) or any other Medici, he indicted the family's former grip on the city. In the midst of contestations about the future of Florence, Savonarola discusses a ruler's unapproachability as a sign of "the tyrant." According to the religious reformer, one recognizes such a person in that "it is difficult to get an audience with him; he has citizens and even clerics wait out there for four [!] hours to see him. He remains in his rooms with his friends and with people who share his pleasures, and doesn't care about who is waiting for him. And then when he comes out, he gives brief audiences and his responses are always garbled and ambiguous."[16] This statement and a closely related passage in Savonarola's *Treatise on the Rule and Government of the City of Florence* (*Trattato circa il reggimento e governo della città di Firenze*) of 1498 express a religiously charged republican outlook on accessibility, transparency, and outspokenness—a political order in which plain articulations and clearly audible exchanges carried the day.[17]

By contrast, secrecy, duplicity, fraud, and self-interest predominate in tyranny, Savonarola claims. If good government means, as he contends with an eye to philosophical tradition, "to maintain and increase the common good" and thereby allow citizens to become virtuous and religious, then tyranny is the opposite. This type of government corrodes mutual trust, friendship, and community ties by sewing mistrust, fear, evil, poverty, and resentment. A tyrant avoids open-ended, regular, and meaningful interactions with his subjects. He solicits information from intermediaries, be they spies or others, and exerts control over others' sociability. In other words, he surrounds himself with those who have little stake in the commonwealth. They are dependents: admirers, flatterers, and minions. Tyrants actively prevent open-ended interactions, if we follow this argument. Such interactions are said to be so difficult as to become nearly impossible. For the sake of the polity, simulation, dissimulation, and miscommunication need to be extir-

pated, Savonarola contends. Spatially, socially, temporally, and in every other way, tyrants remove themselves from citizens. Tyrannical rule therefore runs counter to the "acoustic clarity" that Niall Atkinson has carved out as a civic ideal for the Republic of Florence.[18]

Savonarola's phenomenology of what constitutes an unjust form of rule offers a variation on Aristotle's political theory. Yet a discourse about good and bad government describes the specifics of interactions between a ruler and his subjects only rarely. In this case, the sermonizer and the tyrant in question knew each other. But this fact doesn't explain the level of detail. Savonarola may have aimed to mobilize support among fellow citizens who experienced practices of establishing social distinction.

As these considerations suggest, a mix of formalities and informalities shaped asymmetrical interactions in late medieval and early modern Europe. Neither the space nor the temporality of such encounters was clearly defined, yet there were expectations that the above narrations and episodes convey. Importantly, one should have access to the great and mighty. Audiences figured and functioned in urban, as well as in courtly, settings, whether with or without the aid of the antechamber. As has become evident, this ideal included clarity of communication, and access to the ruler was a profoundly political subject. What difference did the antechamber make as a space for an encounter?

Commingling in the Antecamera

Was the antechamber a space where those who waited bonded, if only for a fleeting moment? Occasionally, waiters in anterooms who talked loudly or laughed appear in the written record (as in one of Froben Christoph's tales). As some ordinances suggest, noises penetrated the walls that separated the waiters' architectural container from other rooms in the same building. Such moments, one can assume—inimical as they were to decorum—triggered responses in those who waited. While people who gathered in the antechambers of a courtly residence on a given day waited for different amounts of time, and while some of them were not admitted on the same day or at all, they all waited. In this sense, they formed a collective when waiting.

Whether antespaces invited waiters in the antechamber to bond is a question Johann Michael von Loën takes up in his account of the imperial court

during the reign of Emperor Charles VI (r. 1711–40). According to this observer, the waiting room in the Hofburg, the principal Habsburg residence in Vienna, constituted a space where different stations and ranks commingled, especially around religious holidays: "The high and mighty become lowly here; the princes, counts, and lords mix with the lowliest nobles, officers, scribes, and all kinds of people" (Die Hohen werden hier niedrig und die Fürsten, Grafen und Herren sind mit den geringsten Edelleuten, Offizieren, Schreibern und allerhand Menschen untermischt).[19] Indeed, in a room filled with waiters, social distinction was difficult to maintain. As a result, loss of status, as the above quotation suggests, was a risk for those who waited in this space. Whereas in sixteenth-century Brussels, as the *Zimmern Chronicle* suggests, nobles waited for an audience with the emperor together with other nobles, in eighteenth-century Vienna nobles and nonnobles mixed, von Loën lets us know. The Stuttgart court ordinance of 1730 speaks of "confusions and disorders" that have arisen in anterooms, where servants and officials no longer respect differences of rank or privilege.[20] But according to this commentator, what put those who waited in the antechamber on the same or similar footing was their relation to the ruler, not the modality of waiting itself: the waiters were equal only by dint of the fact that no matter what their social position, they were imperial subjects. To make his point, the author engages in a thought experiment: if the emperor had entered the room, everyone gathered in the imperial antechamber would have shown their respect. In other words, waiters in the antechamber were not equals. Social position, office, gender, age, education, profession, origins, and other such factors divided them.

But did the imperial antespace truly function as a reflecting mirror of the empire's grandeur, with its diversity of nobles, ranks, offices, stations, and peoples?[21] There is good reason to exercise caution on this point. Eric Hassler concludes that "we cannot consider the court of Vienna as a complete world."[22] Notably, many social groups were excluded from von Loën's portrait. No foreigners are mentioned, even though the French journalist Casimir Freschot (ca. 1640–1720) had mentioned their presence in an account of the same space under Emperor Leopold I several years earlier.[23] The absence of women is also striking. The imperial antespaces formed part of a political order, and this order's emphasis on personal interaction accorded women a presence, though not a firmly circumscribed political role (unless they were rulers, as in the case of Maria Theresia, Charles's successor).

Furthermore, the author fails to distinguish between the two *antecamere* in the Hofburg. This may well reflect the fact that the second one was rarely used. Despite the considerable size of the two rooms, 100 square meters—the first antechamber—and 150 (after the new wing under Leopold went up before 1666), the Viennese Hofburg never quite satisfied the representational needs of this distinguished court. Also, renovations and additions notwithstanding, successive rulers preserved spatial arrangements of the past out of respect for tradition. Still, accommodations had to be made with an eye to changing family constellations (with different members of the imperial family each residing in an apartment), not to mention a conflagration that engulfed a newly constructed wing in the seventeenth century.[24]

De facto, wrangling for status in courtly spaces was common at the Habsburg court. Starting in 1637, in an attempt to fix the courtly order spatially, emperors issued ordinances that determined who had access to which parts of the imperial apartments. These efforts notwithstanding, the pyramid of ranks and offices never quite aligned with the courtly hustle and bustle. Officeholders and courtiers were often given privileged access even when members of the upper aristocracy outranked them, to pick one example. To regulate such questions of status in space, individuals were granted permits *de honore* (out of honor). Under Ferdinand III (r. 1637–57), more than 180 such documents were issued.[25] Furthermore, a handwritten ledger, the "Book of the Antechamber" (Buch der Ante Camera), was compiled to record spatial rights and control access (though the book itself has not survived), containing name, title, and type of access with regard to particular persons. This ledger was entrusted to the head chamberlain.[26] Still, "confusion" persisted. In 1717, the unity of diverse waiters may well have been an idea that rubbed against ideas of spatial-social customs.

To be sure, who advanced when someone had made it to the imperial apartment depended to a considerable degree on the officer in charge.[27] He fielded requests, whether in person or in writing, in consultation with the emperor or empress. If necessary, this court official would meet with the person who requested an audience.[28] At any rate, he was the one tasked with managing access to the ruler.[29] He also met visiting dignitaries on the stairs leading up to the imperial apartment, whether at the bottom—a great honor—on a landing, or in the imperial apartment. The status of the person played a role in the decision to grant access and how, but so did factors such as precedence, the nature of a particular supplication, the political context,

and the like. If a request was found to pass muster, the person requesting an audience may have been given a date soon thereafter; others were discouraged or refused access. In general, ambassadors, emissaries on a diplomatic mission, or high-ranking aristocrats were granted an audience soon after their request.

When the archbishop of Salzburg, Franz Anton of Harrach (r. 1709–27), arrived in Vienna for a prearranged official visit on October 25, 1718, he sent a noble from his entourage to request a formal audience with the emperor. The following day, the imperial head chamberlain (Obristkammerer) responded that on consultation with Charles, the scheduled time for a meeting had been set for 6:00 p.m. the same day. On receiving this information, Franz Anton requested additional audiences with Empress Elisabeth Christine and Charles's mother, Eleonora Magdalena. Meeting them in their apartments in the Hofburg after an audience with the emperor was common, if not expected; the empress's mother, Amalia Wilhelmine, was out of town on the day of the request, so he visited her in her apartment at a later date.

At 5:15 p.m., the archbishop embarked on his ride across town, accompanied by some Salzburg canons and courtiers in several carriages. Archers and soldiers, rifles in hand, welcomed him and his cortege in the Hofburg; the head chamberlain greeted the prince-bishop at the door to the antespace and led him to what was called the Ratsstube (council chamber). There, Franz Anton had to wait while the chamberlain informed the emperor of his arrival. Without delay, Charles welcomed Franz Anton at the door of the room where the audience took place.[30] Nobody else was present during their conversation, conducted on matching chairs covered in red velvet with backrests. In a little more than a quarter hour, the two exchanged niceties and discussed a range of topics, though the prince-bishop's journal does not provide details. When the time was up, the emperor escorted him to the room's door; from there the chamberlain led the archbishop to his next appointment with the empress in her quarters.[31] Again, the meeting lasted a quarter of an hour before he moved on to his last audience for the day, of the same duration.[32]

The spatial configuration of a residence, with its sequence of rooms and the various apartments on the same floor, thus shaped protocol.[33] Which people moved through these spaces and how also structured the account of this welcoming ritual. To those involved, these details on the ground

mattered—from the timing of the encounter, to the welcoming ritual, gestures of the imperial family in space, seating accommodations, and so on. On the occasion of this official visit, these signs may have been more important than what was spoken. Records such as the book of ceremonies (Kaiserlicher Hof- und Ehrenkalender) and the archbishop's notes preserved an account for future encounters between them, and, on the occasion, the protocol itself must have been predicated on similar such encounters in the past.[34]

At the same time, the differences between the two accounts we have are informative. The archbishop of Salzburg notes explicitly that the setup in the room where the audience took place was the same as the one used for a visit by the archbishop of Cologne in Vienna, one of the electors of the Holy Roman Empire.[35] But did the head chamberlain welcome the archbishop at the door to the first antechamber, as Franz Anton claimed, or at the second, as the court calendar stated? The latter account also specifies that the emperor greeted his visitor one step into the room (not at the door, as von Harrach's notes say).[36] Whatever the protocol in question, this is evidently not the treatment regular visitors would have received. For people of lesser rank and lineage, access was far from guaranteed and, if granted, was handled differently.

In early modern Europe, the word *audience* did not suggest the formal qualities we may associate with the term today. *Audience* covered a range of encounters, from a highly routinized or scripted interaction to the casual.[37] There were ceremonies that welcomed ambassadors, dignitaries, and high-ranking aristocrats (as in the case of von Harrach). But there also were public occasions when rulers or other high-ranking dignitaries offered ordinary subjects and travelers the chance to meet them. An audience could be little more than a chat; it also could be something that was subject to advance negotiations. The spatial configuration of apartments, residences, and palaces with their antechambers offered a stage for such interactions of different kinds between unequals.

To interact with the emperor, one needed to have access to the court as a physical space. People of status approached those in charge of granting a hearing, whereas lower echelons were at a disadvantage; they were removed from the spaces that mattered and the officeholders who arranged or helped to arrange a meeting.[38] Higher social status, in other words, translated into greater access to the ruler. The social pyramid thus reinforced itself through

spatial-temporal exclusions and delays. Such an argument feeds notions of the court as irrational when, as Norbert Elias and others have shown, there was a logic to these interactions. In the case of the antechamber, ultimately, these arrangements reduced access to the ruler, elevating his stature and favoring people at the top of the social hierarchy.

Guards controlled access to the outer antechamber of the emperor's and the empress's apartments; those in livery had to stop there (unless they were imperial servants), as Johann Basilius Küchelbecker writes; only cavaliers (cavaliers) and people of station (honete Personen) were permitted to proceed.[39] Social hierarchies, hierarchized spaces, and temporizations thus reinforced each other. People with an understanding of the court as an intricate social, cultural, and political institution were at an advantage in finding access.

News from the Antechamber

Systematizing access to the emperor remained a work in progress. What was decreed in writing did not necessarily match what happened on a given day.[40] Lower ranks and servants should not have been in the Ritterstube, for instance.[41] But at many courts, valets and "persons of the chamber" waited for instructions from their masters in the antechamber.[42] Also, different rulers shifted their "policies" ever so slightly. These are just some of the parameters that put pressure on notions of a clear-cut social-spatial-temporal order. The tussle between rank, office, and other distinctions persisted. In fact, when, during the early eighteenth century, the antechambers accommodated more people in audiences for the public, demand rose; access seems to have become more difficult as a result.[43]

During hours for the general public at the imperial court, waiters in the antechamber hoped to be singled out. As accounts and memoirs have it, the antechamber was where those in positions of authority or power favored some individuals over others. Emperor Leopold I (r. 1658–1705), for instance, was known to grant preferential access to foreign officials and members of the clergy in the imperial antechamber during public audiences.[44] Others waited in vain, as Freschot, a foreign observer, noted. According to this commentator, there was no scarcity of opportunities to roam the imperial antechamber. Leopold was in the habit of holding several visiting hours two or

three times a week, when he was in town. As we already know, those who sought a favor of some kind needed to contact the chamberlain beforehand; others did not. If we follow this account, the names of waiters on a given day were collected on a list from which the emperor picked those to whom he wanted to speak. For his part, Leopold was said to be a loquacious interlocutor (as were some of his predecessors and successors). Given the length of the conversations, only three or four waiters usually made it from the list to the imperial chamber on a given day. At any rate, many did not (though how many people frequented the public audience on average is not reported). As a result, few meetings occurred overall on any given day, our journalist claims. The darkness of the evening hours (when such public audiences took place) in the winter months may have deterred those who could not afford to hire a carriage. Yet there was still ample time, the same observer conceded, paired with an "excessive largesse" (liberalité outrée) for the "indigents" (gueux) and "pious idlers" (pieux fainéans) who frequented Leopold's antechamber.[45]

Delays and deferments were the consequence, according to Freschot. After an extended waiting period, an officer in the imperial army who had advanced to Leopold's antechamber on several occasions lost his patience. His frustration was calculated to get the attention of those present. While the sovereign conversed with an ecclesiastical dignitary, he yelled his message loudly and clearly for everyone present to hear, including his ruler: "Cesare chiama li tui officiali, che sianno amazzor per te, non i frati che ti vengono contare feloppe" (Emperor, call in your officers who die for you, not the clerics who tell you tall tales).[46] (Italian was one of the languages spoken at the Habsburg court under Leopold.)

One of Leopold's successors, Charles VI, is said to have given audiences "every day for several hours," welcoming also those at the other end of the social hierarchy; poor citizens and artisans are explicitly mentioned.[47] He had a twenty-year-old jurist from Württemberg, Johann Jakob Moser, called in for a meeting soon after he arrived in the antechamber.[48] For someone without a distinguished pedigree, being singled out in this setting was unusual, or so Moser's memoirs have it: "In late 1721 I traveled [to Vienna] with very little money, poorly equipped . . . without contacts, without anybody having given me advice on what to do or how to behave at such a large court, which resulted in many mistakes" (Ich reiste darauf im Spath-Jahr 1721 mit sehr wenigem Geld, und in schlechter Figur . . . ohne einige Adressen, und

ohne daß ich jemand gerathen hätte, was ich thun, oder wie ich mich an einem so grossen Hof aufführen sollte, dahere es freylich viele Fehler sezte).[49] How did others in the room react to the preferential treatment Moser encountered: Surprise? Envy? Hope? Curiosity? (As a memoirist, Moser does not offer an explanation for why he thought he was admitted.) "First come, first admitted or received" was not what could be expected during public audience hours at the Hofburg.

On second glance, Moser's account of being "distinguirt" (distinguished) at the imperial court appears suspect.[50] He was hardly a nobody. At a young age, he already had frequented the Württemberg court in his native Stuttgart. When he was nineteen years old, Moser received the title of professor extraordinarius of the law at the University of Tübingen (against faculty resistance but with the backing of the ducal administration).[51] At any rate, he took well-advised steps that increased his chances in Vienna (without knowing whether these steps were sufficient). After 1721, he called himself "Moser von Filseck und Weilburg," a dormant title from his mother's family. In addition, he had received the titular honor of state councilor (Regierungsrat) from the duke before his departure for Vienna; he may even have been perceived to be associated with the rising faction at the Württemberg court.[52] What is more, he carried a scholarly paper in his bags that claimed the Grand Duchy of Tuscany had been subject to the emperor since the Middle Ages, a topic that would have been of acute interest to an eighteenth-century Habsburg ruler. Finally, before setting foot in the imperial antechamber, he found favor with Karl Friedrich of Schönborn, the reform-minded imperial vice-chancellor, as well as with clerics and other officials close to court.[53] In sum, he did what he could to be admitted. Still, in his memoirs, he presented himself as someone whose advancement hinged on an unexpected occasion he seized with savvy.[54]

News about goodwill shown to someone in the antechamber traveled, especially if such benevolence rubbed against the perceived or actual status of the person in question, as was the case with Moser. As a young academic and commoner,[55] his preferment seems to have raised questions. In Württemberg, a minister is reported to have let Moser know in no uncertain terms: "It is incomprehensible that a young and undistinguished person was received in this fashion; I must have revealed things that shed a bad light on the Württemberg dynasty" (Man könnte nicht begreiffen, warum mir, als

einem jungen unverdienten Mann, auf diese Weise begegnet worden seye: ich möchte nur Sachen zum Nachtheil des Hauses Würtemberg entdecket oder an Handen gegeben haben).[56] Contrary to the memoirist's hopes, distinction bestowed on a commoner resulted not in increasing his social or professional capital but in minimizing his chances.

As Moser's case exemplifies, information about what happened in Viennese antechambers circulated. This was so especially when it was out of the ordinary. Such news appealed to those interested in the latest from European courts. Antecameral episodes, in other words, at times entered a Europe-wide communicative nexus. In the eighteenth century, stories, rumors, and news from this type of space had the potential to connect those interested in court life, whether they were nobles or nonnobles, across a vast geography. Such tales featured confrontations, infelicities, mishaps, and the like. They often zoomed in on the inverse of the daily humdrum (like Froben Christoph's narratives). In the best of cases, these episodes offered a forum to reflect on standards of behavior by examples.[57] After all, the norms that governed everyday interactions and receptions at court were spelled out only rarely.[58] These tales and bits of news were also how many readers learned about court life.

Wilhelmine of Bayreuth recounts just such an episode from the imperial antechamber. According to her memoirs, a Prussian official put a finger into the mouth of the yawning Duke Francis of Lorraine, the future husband of Empress Maria Theresia. The latter "was a little surprised at the action," she claims (Le duc en fut un peu surpris).[59] It is possible that the official's gesture was aimed at flagging decorum (Do not yawn!), though the memoirist does not mention this possibility. In fact, tellingly, her story is based on hearsay. In Wilhelmine's retelling, this unseemly act turned into a miniature lesson. Remarkably, she refrains from proffering a sententious generality, applicable to all rooms and situations: respect the corporeal integrity of nobles. Rather, her narration focuses on how to calibrate one's reaction with an eye to the courtiers in question.[60] It appears that "[the duke] knew the disposition of [Emperor] Charles VI to be extremely severe on the point of etiquette," she says (conoissant l'humeur de Charles VI, fort rigide sur les étiquettes).[61] As a result, Francis avoided scandal; he classified the incident as an error. Doing so prevented an escalation. In other words, Wilhelmine faults the Prussian for this breach of decorum; according to her telling, he should have known

better. Instead, he showed his true self in a ghastly act. Her account thus issues a call to courtiers to learn about the characters of their interlocutors.[62]

Episodes such as this from the imperial or another antechamber were of great interest. The memoirs of Saint-Simon, Casanova, and others are replete with them. The antechamber comes across as a stage where one observed and was observed. A faux pas was grist for the mill of such tales; it had the potential to unite others in outrage, amusement, or some other affect.[63] If this is right, it is conceivable that people in the antechamber—the actual space, as well as the somewhat fanciful forum of such tales—bonded by laughing not so much in unison, as Christoph Froben had it, but by pointing one's fingers at others in schadenfreude.

Among the people who frequented antechambers were those young men who, like Moser, hoped to find patronage or advancement.[64] Since one could not count on being singled out on the occasion of a public audience, people regularly approached a visit to the space through preparatory steps. In the eighteenth century, one may have checked guidebooks on individual courts, such as one entitled *Antechamber* (*Antichambre*), to come prepared regarding the specifics of the territories, their recent and present rulers, and historical rote information.[65] For large courts in the empire, they could consult printed court calendars.[66] Such materials contained regularly updated listings of members at a particular institution: ministers, officeholders, musicians, messengers, guards, court suppliers, and the like; the organization of these documents was anything but uniform. These periodicals reflected historical, political, and other predilections or specificities. For Salzburg in 1746, for instance, the calendar listed no fewer than thirty-two servants for the prince-bishop's antechamber (not all would have been on active duty).[67] Readers might thus have been able to identify someone with connections to the court in question to learn more about how best to proceed when seeking an encounter.

Frequently, at any rate, another person needed to intervene on one's behalf to make an audience happen.[68] If one had been "distinguished" in this fashion, as Moser was in the antechamber of Charles VI, then others turned to such a person for their own cause.[69] Moser himself had repeatedly visited the antechamber of the vice president at the Imperial Aulic Court without being received, until someone else put in a word for him. Only then was he able to seize the moment to his advantage (though we are left guessing

how). Subsequently, this talented jurist spent many hours conversing with the same official, he claims. No immediate gain or benefit materialized from what were time-consuming discussions of legal matters, though Moser was in monetary need at the time, as he states.[70]

Treatises like von Rohr's recommended that young men—no mention of women—refine their worldly education by visiting antechambers at different courts according to what the economic means at their disposal allowed.[71] Fathers and educators advised their sons to seek out and identify patrons. The antechamber, therefore, was a space where hopes, dreams, and schemes abounded. Yet the open temporal horizon of these agendas had the potential to turn the antechamber into a space of precarity. There, desires and plans had to contend with sometimes harsh financial realities, especially for those who could not rely on family support or other income. Yes, the antechamber was a space for the young to hone their social and other skills. At the same time, it was a space where ambitions contended with existential needs.

Moser proved lucky: even though or because he refrained from voicing the financial straits in which he found himself, he was regaled with a monetary gift after waiting in a Viennese antechamber. News about his economic needs seems to have traveled. Yet the memoirist does not reveal how or why. It may well be that he did not know, although we already know that his account skirts his career moves. Regardless of whoever prompted this turn of affairs, Emperor Charles VI acted as a deus ex machina for the young and talented but less fortunate in this case.

The eighteenth-century antespace thus emerges as an important social node. Many relations crisscrossed there. Significantly, these rooms served as an information relay in a stratified society. What is more, in the eighteenth century, the antechamber formed part of the social imaginary. There may even be reason to talk about the courtly sphere as a public *in statu nascendi*, and the various reports on the imperial antechamber from this period drive home the fact that this space received considerable attention.[72]

At the same time, there is a pattern to these antecameral tales. Their narration constructs what happened through the lens of turning points or reversals in a person's fate. Moser became an interlocutor for several imperial officials, even though he spurned opportunities his patrons extended. They lured him with professional prospects and a good marriage when he was already betrothed in Württemberg.[73] There was only one condition: he, a

Protestant, must convert to Catholicism, the path to a career at the imperial court since the seventeenth century.[74] Moser dates his religious awakening to a later period. Yet either his Protestantism, his origins, his obligations to his family, his commitment to his future wife, his confidence in his own abilities, or some combination of these attributes kept him from seizing this offer.[75]

Importantly, this attempt to recruit an expert to Vienna was a group effort; some patrons acted as intermediaries on behalf of others, though the emperor seems to have been their mastermind in this case. Remarkably, a nexus of people took an interest in this young jurist. His refusal to embark on a career in Vienna did not end his affiliation with the Habsburg court. The principled manner he claims to have upheld throughout his career would haunt him, however, at later stages. A reform-minded administrator and academic throughout his service for different territories, Württemberg and Prussia among them, Moser's eventful life resulted in censorship of his publications, periods without a post, and even imprisonment for more than five years.

Women and Waiting

What about women?[76] Respect for women of high status shored up ideologies about the superiority of European civilization in the eighteenth century. Enlightenment writers saw women as integrated into and integral to what passed as polite society. Indeed, the layout of courtly residences signals symmetry between elite men and elite women since the seventeenth century.[77] After all, a prince's sequence of rooms corresponded with the princess's apartment in what was called *appartement double*, according to built evidence and architectural discourse.[78] Though there are numerous exceptions or variations to this mirroring in edifices, both apartments, as a rule, featured one or two antechambers.[79]

At the same time, these built symmetries, with their symbolism, masked inequities of access, movement, and power. At Versailles, the apartment of the king under Louis XIV was far more accessible than the tightly controlled apartment of the queen.[80] In eighteenth-century Munich, the elector's apartment was well connected to other parts of the residence, as well as the city, the electress's less so (fig. 19).[81] Though mirroring apartments were a feature

FIGURE 19. Floor plan, Elector's chambers, Residenz, Munich, eighteenth century (illustration by Matilde Grimaldi).

of the Swedish royal residence Tre Kronor, King Charles XI of Sweden and his Queen Consort, Ulrika Eleonora, lived on two different floors, the king as administrator on the lower and the mother of their children above.[82]

In Vienna, a corridor connected the emperor's tract with the empress's rooms for those who paid respects to rulers and their consorts; it led directly

to the guards' room (Wartstube) in the women's quarters (Frauenzimmer).[83] Yet the imperial consort and her court maidens faced layers of surveillance unknown to male members of the imperial court.[84] Elaborate measures were taken to shield female courtiers from their male counterparts and men in general, except for clearly defined settings.[85] That the doors and windows in the women's residential sections were locked was an issue of continued concern. To receive visits, women at court were required to inform their superiors ahead of time; the visitors' names had to be recorded. Interactions with others occurred in antespaces, and, in the case of nonresidents, only when another person was present.[86] Unless the entire entourage went on an outing, these upper-class women needed permission to leave their quarters, even for a mission they needed to accomplish on their mistress's behalf. In other words, the daily lives of women aristocrats at the imperial court were regimented and surveilled. Still, from the middle of the seventeenth century, there were reports of card games and reading of censored materials in the apartment of the empress.[87] The princess or empress worked with her head officers, one male and one female, as well as the mistress of maids, to ensure compliance with restrictions of access.[88] Paradoxically, it was precisely their seclusion that turned the women's household into a forum where foreign diplomats and others sought out high-ranking women, especially when other modes of advancing their cause proved difficult. In sum, aristocratic women's high standing and irrefutable influence notwithstanding, the antechambers in the women's quarters were more tightly controlled than their architectural counterparts in the same building.

Additionally, whereas consorts, widows, or close female relatives commanded their own quarters, men outnumbered women in most courts, despite considerable local variation. Strikingly, women households did not benefit from the growth of members during the eighteenth century; their numbers may have increased yet not on par with the courts as institutions overall.[89] Though antechambers were crucial as gateways to women's quarters, they were far from the semipublic space we have encountered in some eighteenth-century residences. The courtly sphere was the sphere of politics, and although women were a preeminent part of it in many ways, their participation was often symbolic, secondary, or stunted.[90]

What about women as visitors to antechambers? To be sure, women visited antechambers for a variety of reasons. Giacomo Casanova reported

that at the eighteenth-century Württemberg court in Stuttgart, people of all classes and sexes were admitted. "Beautiful peasant women," as opposed to lower-class men, found an all-too-eager interlocutor in Duke Karl Eugen, the garrulous memoirist insinuates (though it is hard to say how he could have known).[91]

When Elisabeth Friederike Sophie of Brandenburg-Bayreuth (Wilhelmine of Bayreuth's daughter) tried to intercede with her husband, Duke Karl Eugen of Württemberg, she acted on behalf of a singer, whom the duke, her husband, had arrested after she supposedly had shared details about his affair with a mistress. The duchess decided to wait for an audience with her husband in his antechamber. That a wife chose this course was unusual. Casanova, who expresses high admiration for the Stuttgart court, adds, "Like any other subject, the Duchess asked for an audience." Visiting a reigning duke's antechamber as the duchess was a highly visible affair that others were bound to witness. Yet "the Duke . . . refused her."[92] By choosing this route, Elisabeth put on display wifely devotion and submission for the courtly public. When Karl Eugen humiliated her by not granting what she desired, she took refuge with her father, never to return. Her waiting in the antechamber and subsequent self-imposed exile made the duke's behavior known. He was criticized as what contemporaries called a despot; the singer's incarceration lasted many years.

The episodic descriptions of encounters in the antechamber reflect the nature of the evidence. There are no logbooks that tell us who waited or how long. The reports do allow us to explore the behavioral repertoires at residences where there were one or several antechambers. Such episodes were part of a puzzle in which there may have been rules and codes, though many of them unwritten. The episodic forms an inherent feature of a society and culture where sociability was central. To the courtly sphere, the occasional, incidental, and accidental were essential. These episodes, therefore, matter not only because they index a larger order but also because they indicate how the performance of sociability was tied to political, social, and other parameters.

Courtliness was occasionally celebrated as a feature that distinguished courtly life in Europe from that of other court societies in the world, above all in Asia, favorably.[93] In this antipodal imaginary, a strict protocol was said to operate outside of Europe (or in another part of Europe). By contrast, Eu-

ropean courts saw their distinction in forms of politesse that shaped asymmetrical encounters as a code. King Louis XIV actualized royal sovereignty in rooms crowded with people of different ranks and stations without occupying a spatially elevated position or a throne. He allowed for interactions with ordinary people on the grounds of the gardens of Versailles or in other contexts. The removal of the king's body or complete silence were not essential to staging royalty in this context.[94]

Writing about a culture that actualized itself in interpersonal relations requires that one recognize the personal encounter as a generative feature of early modern society. With an eye to the structures and protocols at stake that grounded this type of interaction, the detailed account of a particular commoner's efforts to find employment will serve as an example to further the themes we have unearthed so far.

The details we know about the following encounter are revealing with regard to routine interactions. Importantly, this instance constitutes one of the rare cases where we know the space where the meeting took place, the time spans involved, and some details about the interaction itself. The waiter in question was none other than the eighteenth-century composer Wolfgang Amadeus Mozart.

A Quest for a Post

After having been let go by the archbishop of Salzburg in 1777, Mozart sought to secure a post as a musician elsewhere.[95] The court of Maximilian III Joseph, Elector of Bavaria, was his first destination on a voyage that would last more than a year and take him and his mother to Augsburg, Mannheim, and Paris (where Anna Maria Mozart died).[96] The Wittelsbach prince was a musician, as well as a composer.[97] Though their musical tastes differed, Mozart's previous visits to the Bavarian capital shored up confidence in what was an ambitious goal for the twenty-one-year-old composer. We know of his evolving plan from letters exchanged between members of his family. During a mission of the greatest importance for the family's prosperity, the relative geographic proximity between Munich and Salzburg allowed for epistolary exchanges in quick succession.[98] Detailed reports from the road and frequent advice from Salzburg were the result.

Why aim for an in-person encounter with the elector? The audience with the prince passed as an "opportunity" (Gelegenheit) in the words of Mo-

zart's father, Leopold.[99] Such a meeting with a potential employer figured as an occasion to demonstrate one's skills. Leopold, who offered relentless counsel from the wings, put it this way, and Mozart would echo: "He [the elector] knows nothing of me. He does not know what I am capable of" (er weis nichts von mir, er weis nicht was ich kan). He added that the great and mighty listened to others' advice instead of applying their own judgment to the matter at hand: "Their lordships will believe anybody, and are not to investigate for themselves. Yes, it is always like that" (das doch die herrn einem jeden glauben. Und nichts untersuchen wollen. Ja das ist allzeit so).[100] As this wording illustrates, breaking through the aloofness that distanced a ruler from a job seeker triggered hopeful horizons. Court life inspired plans to turn fate toward one's favor by means of personal interactions.

This was particularly palpable in Munich, one of the largest courts in the empire. Over the course of the eighteenth century, the Bavarian court experienced considerable growth. Between 1705 and 1781 the household grew from 1,030 to 2,140 members.[101] In the midst of this vast apparatus, a hearing with the ruler was the fulcrum of time, effort, and costs. Such an encounter promised immediacy of access, a promise that held appeal for those removed from the corridors of power.

Between September 24 and 30, 1777, Mozart networked in the city. During the two days after they arrived in Munich, Mozart *fils* and Mozart *mère* interacted with at least nineteen people, as their first letter from the Bavarian capital claims, some among them several times. The number would have been even greater if the mother-son team had succeeded in contacting people who were unavailable when they called on them. "The whole day we have [received and paid] visits," Maria Anna Mozart wrote to her husband, Leopold, about their social calendar (den ganzen dag haben wür visiten).[102]

Mozart sought out and cultivated acquaintances. What is more, he entrusted others with the task of abetting his quest for a post. Doing so would, according to the calculation that emerges from the letters, maximize his chances of success. Details reported permitted insights into how such advocacy ought to have occurred. People were asked to speak in the composer's favor, or, if necessary, to defend him against detractors.[103] Once trusted interlocutors had agreed to put in a word, there was no guarantee that these "friends" would in fact follow through, however. In a way, they found themselves in a position similar to the one Mozart was in. Even if they were close to the elector and electress, or to others at court, they needed to wait for

the due moment. By contrast, a person of high rank might write a letter or seek an unsolicited conversation on a particular matter. The prince-bishop of Chiemsee, Ferdinand Christoph of Zeil and Trauchburg, approached the electress Maria Anna in Nymphenburg Castle, the Wittelsbach summer residence; she remained uncommitted or unconvinced that there was much that could be done to help Mozart's cause.[104]

Only a well-timed communication was thought to make a difference. If a conversation touched on the possibility of hiring a musician, then supporters were supposed to echo, expand, or, if necessary, correct what had been misrepresented, especially when Mozart "was treated unjustly" (etwa unrecht gethan würde).[105] Ascertaining whether such favors in fact happened required that one follow up with those enlisted to help one's cause. Mozart learned from one informant that the elector had developed an alternative plan: Max Joseph wanted the composer to gain stature in Italy before returning to Munich in order to possibly assume a position.[106] This plan conflicted with Mozart's own; for financial and other reasons, the composer was eager to take a post at this time.[107]

During conversations, one gathered relevant information about court life, as well as—in Mozart's case—the theater, the orchestra, and church music. But these exchanges weren't exclusively about fact-gathering. They created a buzz about the composer's "residence" in town. "One must make friends of all people" (man muß sich alle Leute zu freunden machen), as Leopold reminded his son, recommending that he comport himself in a servile manner, that he perform uncompensated labor, and that he tell his interlocutors of station what they wanted to hear.[108] Mozart reassured his father that he was indeed "very popular" in the city, underlining this phrase (ich bin hier sehr beliebt). During the performance of an operetta, he was invited into several boxes, which he proudly reported: "I am of course well-known enough" (ich bin ja bekannt genug).[109] While flattering others constituted the path to success according to "father Mozart," his son preferred to rely on his exquisite talents and considerable charms.[110] At any rate, Anna Maria Mozart summarized these time-consuming activities to advance her son's cause in Munich: "How things will go with us we must wait and see, we have indeed many good friends here who would like to see us remaining here" (wie es mit uns gegen wird müssen wir erwarten, wir haben recht ville gutte freünde hier die gern seheten das wir hier bleiben).[111]

The open-endedness of one's efforts when working toward a hearing at court depended on committing considerable amounts of time. The nonchalance or disinterestedness manuals recommended, such as Gracián's "court philosophy," may have been hard to keep up in the process—especially in light of the fact that the elector and his entourage were known to go on a scheduled tour of Bavaria soon after Mozart's arrival in Munich. Put differently, anxiousness was part of living in the anticipatory mode, at least sans a steady stream of income.

As director of the court theater and a theatrical entrepreneur, Count Joseph Anton von Seeau (1713–99) was a central figure in Mozart's quest to secure employment in Munich.[112] Von Seeau is likely to have commissioned the composer for an opera written for the carnival season of 1775, *La finta giardiniera*, or "The Pretend Garden-Maid" (K. 196).[113] Still, Mozart felt the need to confirm his support at this very moment. Accordingly, he went to see von Seeau on his first morning in town, but the count had already left the premises. "Patience!" (Geduld!) was Mozart's response, recorded in his letter.[114] Indeed, patience was what was needed. Yet time was in short supply. The next day Mozart arrived at von Seeau's home earlier.

In their conversation, von Seeau advised Mozart on how best to be appointed at the Munich court: "He said [Mozart] should request an audience with His Electoral Highness right away" (er sagte ich sollte nur schnurgerade bey S. Churf. Durchl. Audienz begehren). But he added a cautionary note: if Mozart "were not granted a hearing"—which was evidently within the realm of the possible—[he] "should simply present [his] case in writing" (sollte ich aber, im fall nicht zukommen können, so sollte ich meine sache nur schriftlich vorbringen).[115] This was straightforward enough, though it was a comment so general that it could have been issued by almost anyone with some knowledge of courtly affairs. But in von Seeau's case, the advice's value may have rested on the fact that he was someone with intimate knowledge of the Munich Residenz.[116]

In addition to the words proffered, the gestural repertoire of one's interlocutor in such a quest was scrutinized. Observations on demeanor, gestures, and similar such perceptions permitted one to calculate the likelihood of success with regard to one's plan. In his letters, Mozart dutifully reports these reactions with significant attention to detail: the fact that von Seeau had recognized Mozart outside his house at a considerable distance (when

no servant or other person had announced his coming or his name); his initial reaction (he reportedly was happy to see him); his informedness—the fact that von Seeau already knew that Mozart had lost his job in Salzburg; his manner of speaking (courteous, or "höflich"); the place where the conversation took place (upstairs, presumably a privilege); finally, the fact that the two of them spoke with no one else present ("ganz allein"). Mozart even specifies why the intimate setting mattered: one's conversation could be less guarded. This is when one could express that the moment to hire Mozart was opportune: Munich lacked a great composer, and Mozart was ready to fill the bill.[117]

In short, exchanges Mozart had on his search for a post were parsed as portents. In a way, words did not suffice. Embodied affirmation was what he and others in a similar position were on the lookout for. That von Seeau moved his nightcap a tad at a crucial moment during their conversation, Mozart presents as a gesture of support, somewhat tongue-in-cheek. At any rate, as a gratuitous, if not humorous, flourish, this bodily move is hard to take seriously. The mention reflects, however, a basic truth about conversations at court or with courtiers: minutiae regarding comportment, space, timing, medium, and gestures when working toward an audience passed as indicators of one's prospects. Thus viewed, the court resembled a thicket of signs. It was this fact, above all, that necessitated constant reassurance in the context of one's predicament.

Mozart's letters, sent to Salzburg at regular intervals, give a blow-by-blow account of the concerted efforts to advance his cause. Whether exaggerating or not, he surely intended to convey that he and his mother approached the task at hand with the utmost earnestness. The fact that the Mozarts knew the lay of the land from previous visits worked in their favor. Additionally, they were in a good position in that they commanded a network of music-lovers who were familiar with Mozart's compositions.[118]

Whatever the particular circumstances, it is important to acknowledge the group effort we see at work in Mozart's attempt to secure employment. His family participated, be it with advice or with networking, as did friends. Nevertheless, the exact course of action remained murky, even if the desired outcome was not. What was the right amount of money to earmark for his bid? What was the appropriate amount of time to invest? As time passed, doubts were certain to arise. A job seeker was bound to encounter hesita-

tions, reservations, obstacles, and the like. As von Seeau had made clear, the decision about employment rested with the elector alone. The personal encounter thus seemed the appropriate vehicle to promote his cause. But such in-person interactions also came with the risk of inconclusiveness or finality.

As von Seeau had indicated, the antechamber was not without alternatives. The tussle between in-person encounters and written supplications is an underappreciated fact about courts as the center of political life during the *ancien régime*. Paper-pushing sovereigns like Philip II of Spain[119] and Henri III of France,[120] as well as other rulers, preferred handling governmental business in writing.[121] For these rulers, bureaucratic interactions promised, among other benefits, judicious, if not impartial, decision-making as well as some control over the timing of a response. As a corollary, some rulers delimited the frequency of audiences and reduced their availability as rulers in person. At the same time, in-person meetings and audiences never disappeared during the early modern period, whether for diplomats, petitioners, or others. Rather, these different communicative scenarios coexisted throughout.[122] Rulers and their bureaucracies, whether of kingdoms or territories, had to balance the demands of in-person and on-paper forms of governance. In our episode, submitting one's request in writing passed as second-best choice for someone on a mission like Mozart's. One could not be sure who would respond to a supplication or how long it would take until one received a response. Therefore, the audience or personal encounter remained the preferred goal, despite the cost, effort, and time it required in this or other cases.

"Everything will turn out well" (Es wird noch alles gut gehen) was the mantra with which the composer approached his mission to land a position.[123] Still, between September 24 and 30, his mood darkened somewhat, as his letters testify. Initially, Mozart approached what others—prominently among them his father—understood to be an ambitious plan with confidence. In his messages from the road, he joked profusely. His first letter after having arrived in Munich made explicit what the previous one from the road had conveyed in tone: "There is such a feathery lightness about my heart since I got away from that malignity!" (Mir ist so feder leicht ums herz seit dem ich von dieser chicane weg bin) (referring to his position in Salzburg).[124] This optimistic outlook certainly helped him manage a difficult undertaking. Such *leggerezza* in approaching the quest at hand can also be

interpreted as a strategy to win over those he encountered. Yet the longer the efforts lasted, the more difficult it was to uphold unmitigated optimism.[125] Neither results nor an appointment could be cited. To be sure, this was the nature of such a mission. Everything hinged on the moment. A level-headed approach to the task at hand would have taken these challenges over time into account. But this was not simply about a person's awareness regarding the rhythms of courtly comportments. The often drawn-out uncertainty was a structural feature of interacting at court.

After almost a week had passed, the much anticipated "audience," as Mozart and von Seeau called it, with the elector materialized.[126] Such an opportunity was precisely why one needed to be ready to act quickly within the expanse of time. But if the composer's efforts to be granted a hearing were successful, it was because one person intervened: an attempt to save a mission whose momentum was at risk of flagging. This person was Franz Xaver Wotschitka (also Woschitka), an electoral valet and musician.[127] Mozart had shared the discouraging news of the elector's plans for his immediate future in Italy with him. In response, Wotschitka told Mozart to appear at 9:00 the following morning in the Residenz. Mozart added in a letter to his father that even without this intercession, he would have attended the electoral antechamber to clamor for a position. Out of respect for his intercessor, he desisted until the next morning, he said.[128]

When Mozart showed up at the appointed hour on September 30, 1777, the officiating valet, Baron Joseph Anton von Kern, welcomed him on a day when the elector was going to hunt after mass. Having waited an hour in the luxurious first antechamber of the Reiche Zimmer, Mozart was led into a "narrow little room through which His Electoral Highness had to pass" (ein enges zimmerl so, wo S: Ch: Durchleucht durchgehen müssen) (see fig. 19). Time and space had been chosen to accommodate the elector's schedule.[129] But the first person Mozart reported seeing was Count von Seeau. He traversed the room, regaling the composer with a "most friendly" greeting (sehr freündlich)—a display of encouragement directed at the waiter or possibly others who might have been present (even if they go unmentioned); at any rate, Mozart did not fail to mention this gesture to Leopold.[130]

In the letter that captures the encounter, all Mozart says about the space where he met the elector took place is that it was small and narrow. The room where he awaited the prince can be identified with the first antecham-

ber in the elector's wing of the Residenz (Kleine Ritterstube). Its layout was irregular because it connected two wings at an obtuse angle in this vast architectural complex. After twentieth-century wartime destruction, the "zimmerl" was restored. Little remains, however, of its original decorations, furnishings, and wooden wall coverings. The first antechamber's subtle relation to the décor in the elector's and the electress's apartments that had recently been upgraded by François Cuvilliés (1760–63) can no longer be appreciated.[131]

A prewar photograph gives an impression of what this space once looked like (fig. 20). There were no banquettes or benches, as in the antechambers of the Reiche Zimmer, but chairs with backrests. At any rate, Mozart would likely have been standing to be ready at any moment. We see a timepiece on a console table that, if it was sitting there in the eighteenth century, enabled

FIGURE 20. First antechamber, or "Kleine Ritterstube" (Kurfürstenzimmer), Residenz, Munich (before wartime loss) (Unknown, 1889–1914?; photograph by Carl Teufel and Benno Filser; © Bildarchiv Foto Marburg / Art Resource, NY; fm 83552 / AR6153307).

the one who waited to gauge the time spent. A China-themed tapestry, *The Astronomers*, from a series of popular wall hangings woven in eighteenth-century France adorns the room (another one featured a menagerie of exotic animals). The figure at the scene's center was the seventeenth-century German Jesuit Adam Schall. Having served several emperors, he is shown in somewhat fantastical Chinese court attire with the instruments of his science, astronomy, in the midst of experts, talking to Emperor Kangxi (though the historical Schall whose honor Kangxi posthumously restored after his fall from favor would not have met him).[132] Enlightenment Europe abused the Chinese court as an exotic mirror. Yet the interaction between an expert and a ruler also resonated with the function of this anteroom, one of several in use under Max III Joseph. After all, Mozart was an expert musician in search of employment. But in light of the momentous task ahead, there might have been little patience on his part to reflect. Not surprisingly, we hear nothing much about the space from Mozart, though its narrowness resonated with the anxiety he must have felt about a meeting for which he had been preparing for quite some time.

The wait at court was moderate, one hour approximately. Though the object of extensive preparation, the actual meeting with the elector was nothing more than a conversation in passing, as Max Joseph walked through the space on his way to mass. According to his account, Mozart offered his services to the elector with politesse, deference, and references to his considerable credentials: three voyages to Italy; membership in the Bologna Academy (L'Accademia Filarmonica di Bologna), whose entry test he had passed with bravura; and three operas under his belt. These pieces of information addressed the elector's idea that Mozart pursue his musical career south of the Alps; they aimed at reminding Max Joseph that Mozart was already well recognized there.[133] These verbal overtures, with their "mixture of cocksureness and pretended servility," as one biographer puts it,[134] were met with the elector's pointed questions and curt repartees in what, in Mozart's rendering, reads like Bavarian dialect. Max Joseph expressed interest in hearing details about the composer's departure from his Salzburg post. By addressing the twenty-one-year-old as a child and as young, he also signaled Mozart's lack of experience. If this is indeed what was said, these were signs that prudence was called for in this interaction; the composer duly ignored them. At any rate, it is hard to characterize the short conversation as very amiable,

as one critic does.[135] For his part, throwing all caution to the wind, Mozart proceeded to make his desire for a post explicit: "My only wish ... is to serve Your Elect. Highn., who is himself a great—" (Mein einziger wunsch ist aber Euer Churf: Durchl: zu dienen, der selbst ein grosser—). This left the elector little choice but to respond to the request for a post directly. Interrupting Mozart's flow of words, Max Joseph stated abruptly that there was no vacancy at court (es ist keine vacatur da) for Mozart to fill, a sentence he uttered two times and repeated another time "in parting" (gehend) after Mozart reassured him that he was sure to bring "honor" (Ehre) to Munich.[136]

In this asymmetrical exchange between the elector and the composer in late September 1777, different logics were at work. Mozart saw the Munich court as a terrain where the exceptional ought to be possible and his extraordinary talent had every chance to be recognized. By contrast, the elector embraced a vision of the court as the center of a well-ordered state. As a frugal administrator out of necessity, the elector showed himself averse to granting what Mozart was after. At the same time, the two interlocutors shared an idiom, the language of opportunities, or *occasiones*. What seemed fortuitous for one registered as inopportune for the other. Only one was in charge of making decisions, and the other was not.

Throughout his reign, Max III Joseph had to contend with the fallout from his father's *Großmacht* ambitions.[137] As a result, the elector exerted austerity measures. Truth be told, thriftiness in a large territory like Bavaria was confounding, especially from an outsider's perspective. Given Munich's undisputed splendors, it was reasonable to hope for a post in which one could eke out a living.[138]

Today, the composer's bust adorns the room where Mozart waited for and talked to Max Joseph, who died exactly three months later of smallpox.[139] This reminder of Mozart having waited in this space amounts to a rare monument to someone who waited, and waited in vain.

Not surprisingly, Mozart stayed within the logic of wanting to make a living in Munich. Even after having been told in no uncertain terms that there was no opening for a composer at court, he continued to pursue his musical ambitions in the city. He cited the valet who had made the encounter in the antechamber possible; he apparently said that Mozart should return there frequently in order to turn the elector's negative answer to a different outcome. In a similar vein, one of Mozart's interlocutors suggested, "If [he]

could stay here in the meantime, the business would afterwards take off on its own" (wen ich so hier bleiben könte unterdessen, die sache hernach von sich selbst gieng).[140] This may have been straightforward advice to give, but it was not easy advice to accept. What exactly constituted an appropriate time to lend weight to one's cause? There was, to be sure, no general answer to a question of this kind. What this counsel underestimated was that extending one's stay in the hope that things may take an eventual turn also reduced one's coffers and potentially one's chances. Courtiers turned their backs on supplicants who persisted unduly. The notion that waiting had the potential to reduce the honor of the person waiting is applicable here.[141]

After the encounter with the elector in one of the Residenz's antechambers, a barrage of emotions and explanations broke forth in Mozart. There were good friends and bad friends, he wrote, or, as Leopold recast the formula, friends and enemies. Not that it was easy to identify who belonged to the latter group. This was precisely the challenge. They were "secret," a generality that Leopold Mozart contributed to this vision of the court as a cesspit: they "prohibit this out of fear"; that is, they will prevent a compelling appointment because it might have an impact on their own position (die es aus angst verhindern).[142]

Making plans in the present meant changing plans. Scouting out possibilities remained a constant while searching for a post. Mozart's stay in the city, therefore, helped spawn alternative plans. His innkeeper and friend, the music-loving Franz Joseph Albert, concocted a scheme to have a number of patrons finance the composer's existence, something that sounds precarious even in Mozart's own account, despite the projected income figures he supplied in a letter.[143] If there hadn't been a price tag while cultivating contacts and pursuing time-consuming plans, this might have been fine. For his part, Leopold sought to impose a relationship between expenses and realistic expectations—an elusive proposition in the best of circumstances: "You cannot sit there and use up the money and waste time" [without earning money through concerts or other endeavors while there], he concluded, insisting that his son turn his attention elsewhere (so kannst du nicht hersitzen, das Geld verzehren und die Zeit verlieren).[144]

Norbert Elias speaks of Mozart's "one-man revolution" against court musicianship, citing the above episode in the antechamber as evidence.[145] Yet Elias struggles to contain the composer's agency within the historiograph-

ical model of a bourgeois rebellion against aristocratic hegemony, with its Hegelian overtones. As Elias recognizes, there were many factors at work in Mozart's comportment that his sociology of a musical genius is not equipped to address.

How did Mozart, in fact, relate to the aristocracy? The epistolary record cracks open a window on Mozart's views of those above their station.[146] On the road to Munich, Mozart fully embraced the independence from his father and the archbishop: "Viviamo come i principi" (we [mother and son] live like princes) and "like a prince" (wie ein prinz) are the descriptions of this breakaway from home.[147] Anna Maria offered a variation on this same theme. Unlike Wolfgang Amadeus, she casts her son's formula as living "like the children of the prince" (wie die fürsten Kinder). Both expressions convey the delights of living high. Yet her comment exposes this state as untenable. It will last "until the oppressor comes for us" (bis uns holt der schinder).[148] Living grandly meant to have others serve you and be served, I imagine, without delay. Like childhood, this prince-like state of affairs would end, she indicated. A *lieto fine* (happy ending) was anything but certain. The day of accounting was never far. Anna Maria's humor masks the seriousness of the utterance: The "oppressor" could strike any moment. At the same time, the filial imagery also allows for hopes that their time will come.

Social inequity is a recurrent motif throughout the Mozart correspondence. With an anticlerical bent, Mozart had called Archbishop Colloredo a "mufti," the term for the chief jurist in the Ottoman Empire who, as a contemporary encyclopedia has it, issued sentences that one could not appeal.[149] Leopold reprimanded his son for this choice of words, reminding him that such a letter, if it were to fall into the wrong hands, could be used against them.[150]

I agree with Elias that the Mozarts, both father and son, may not have understood court society, even though the wunderkind and his family had gotten to know many a court over the years.[151] Yet this predicament was shared by many. Ultimately, what guided Mozart was not the search for a particular position alone. He sought occasions that would allow him to practice his creative skills. The contradictions that Elias detects with regard to the Mozarts' class as bourgeois (whose tastes had been shaped by the aristocracy, as he notes) make sense if one regards them from the angle of an occasionalism with its hopes, anxieties, and anticipatory horizons.

In sum, encounters with a person in power were predicated on extensive efforts (something we have seen in other cases as well). Even elaborate schemas produced sometimes inconclusive or all-too-conclusive interactions. To protect one's prospects, one needed to act with vigilance and circumspection. Furthermore, as casual as the conversation between the elector and the composer may sound, or is reported to have been in many a Mozart biography, it was the pinnacle of many communicative acts involving many actors. Not accidentally, encounters of this kind came across as acts of grace, even if they yielded little or nothing. At the same time, their seemingly spontaneous immediacy was an important element in the self-fashioning of the ruling class. For his part, Mozart had misinterpreted the signs that were anything but encouraging from the beginning of his Munich stay. Staking everything on one card or occasion proved not to have been the best strategy. Still, it was a response to the scarcity of a particular element—time.

Despite elaborate efforts to turn things in his favor, Mozart thus did not succeed in what had seemed a promising plan given his rising fame, his familiarity with the city, and marked support among a network of musicians and music-lovers.[152] This episode thus exposes the Achilles heel of the occasionalist vantage point in an ever-evolving present that this study has begun to unearth. It reveals much about the frailty of waiting for occasions in time. All too often, political, economic, and other conditions remained in the shadows of a vision that counted on a fortuitous encounter at the right moment. Rulers and aristocrats were better equipped to take such contexts into account than a job seeker or petitioner may have been. The more privilege one commanded, the more information one likely had access to, and the better one's starting position in these asymmetrical encounters.

What if Mozart had been successful? His fellow composer and later friend, Joseph Haydn, secured a post with another music enthusiast, Prince Paul II Anton Esterházy de Galántha. Under contract with an employer, the composer needed to appear on a regular basis in the antechamber to await further instruction. When Haydn became Vice-Kapellmeister, his employer specified that the composer had to show up daily to receive instructions about what kind of musical performance the prince had in mind for the day.[153] Wherever the prince was in residence, whether in Vienna or at another palace, Haydn had to routinely appear in the morning and afternoon to inquire and, in the case that his employer had a musical event in mind, receive orders about what ought to happen, as seen in the stipulation below:

5. Haydn hat sich täglich—sei es zu Wien oder auf den Herrschaftssitzen—vor- und nachmittags in der Anti-Chambre zu melden, um die Hochfürstliche Ordre, ob eine Musik sein soll, abzuwarten. Wer aber zur Musik zu spät kommt oder gar ausbleibt, wird besonders vermerkt.[154]

[5. The said Joseph Hayden shall appear daily in the ante-chamber before and after midday, and inquire whether his Highness is pleased to order a performance of the orchestra. On receipt of his orders he shall communicate them to the other musicians, and take care to be punctual at the appointed time, and to ensure punctuality in his subordinates, making a note of those who arrive late or absent themselves altogether.][155]

This regulation is a reminder that antechambers were architectures of waiting where members of court came to do business, some of them in livery (like Haydn), and where valets de chambre or others waited for orders or tasks.

Waiting and Boredom Conjoining

What were the sentiments that accompanied waiting in early modern Europe? How does the history of emotions intersect with the history of waiting? Finding answers to these questions entails striving for that which often eludes us when we reconstruct particular encounters: affects, sentiments, and emotions. But it also means putting pressure on the assumption that tedium constitutes the essence of waiting. To be sure, waiting for an audience with the great and mighty came with expectations about time frames within which one would be admitted, especially for the privileged. In other words, questions of access intersected with social status. A lord or high-ranking official who flaunted expected temporizations ran the risk of upsetting those who were made to wait.[156]

Yet the "inner notation" of waiting before the end of the eighteenth century remains a conundrum. As we saw in the Baroque novel *The Roman Octavia*, tedium due to wasting time in the antechamber was not commonly expressed. Much evidence points to the fact that waiting was essential to doing business in a stratified society. This does not take away waiting's odiousness, for which there certainly is indication. It just means that tedium is not the sole or preeminent component of waiting scenarios. The temporal sensibility of acting in time allowed for a spectrum of emotions.

There is no need to be surprised. If we follow many cultural critics, boredom emerged in the course of the eighteenth century as a social and moral concern.[157] But being bored and waiting are not synonymous. The former approximates one person's sentiment or affective condition; the latter is a temporal modality that shapes interpersonal actions with its own affective horizon. What the two may have in common, however, is an absence of control over time that both states imply—one's own time that is. The Enlightenment call to make the most of oneself and to pursue happiness, whatever one's sex or station, entailed a commitment to one's advancement and a foreseeable future. One's time was considered profitable when marshalled for educational, professional, personal, and other purposes.[158] From such a vantage point, waiting to interact with another person must have registered as empty time, unless its rewards were clearly circumscribed.

Accordingly, the self-interested practitioners of pocketed time who pursued only their selfish yet secret goals risked moral and social censure when exposed. In Pierre Choderlos de Laclos's epistolary novel *Liaisons dangereuses* (1782), the cunning and conniving protagonist, Madame de Merteuil, though victorious, faces ostracization, if not social death; the deadly consequences of duplicitous performance of virtue have become all too apparent.[159] Exposing the protagonist's depravity means to instruct, to follow the original title, or rather shock readers into opposing this behavior. At least this is one way of interpreting the novel's recommendation: acting openly, publicly, and virtuously.

In this same period, courtiers emerged as exemplars of futility: "I know [courtiers] for whom time passes very slowly in the antechambers of their lords. If life weren't made moderately tolerable by conversation with ladies at court and other ladies, billiards, pleasure rides and riding, and gambling, they would surely die of boredom. It is a bad profession [métier] to be a pillar of the antechamber [pilier de l'antichambre]." (Ich kenne einige [Hof-Leute], denen in den Vorzimmern ihrer Herrschafft die Zeit blutlang wird; und wann die Conversation mit den Hof- und andern Damen, das Billard, das Spatzierenfahren und Reiten, nebst dem Spiel, ihnen die Zeit nicht einiger Massen passiren machte, mögten sie für lange Weile sterben. Es ist ein schlecht Métier, einen *Pilier de l'Antichambre* abzugeben.)[160] Tellingly, however, courtiers are only one example among several groups who do not spend their time well or productively, including soldiers and the like.

Mozart is a case in point for the restlessness that becomes legible in

eighteenth-century waiting scenarios. On an extensive trip that had begun on a somewhat hopeful note in Munich—an ultimately thwarted hope for a position—Mozart increasingly expressed fatigue about the dead time spans of lingering for opportunities. Trying to get a post at the French royal court by making contact in the palace of French aristocrats, he writes: "I had the honor to wait a whole hour" (da hatte ich die Ehre eine ganze stunde zu warten).[161] With biting irony, Mozart recounted what he endured while trying to secure a position in yet another city at yet another aristocratic mansion. In a letter of May 1, 1778, Mozart *fils* shared with his *très cher père* [very dear father],[162] Leopold, the physical discomforts, insults, and boredom[163] that petitioners in aristocratic households experienced while waiting for an audition.

A patron and friend had equipped the composer with a letter of recommendation. When Mozart contacted the Duc and Duchesse de Chabot (Louis-Antoine Auguste de Rohan-Chabot and Elisabeth-Louise de La Rochefoucauld) however, he received no response: "[a] week went by without the least news" (da giengen 8 täg vorbey ohne minderster nachricht).[164] He subsequently made a house call. On arrival, he "had to wait half an hour in a large, ice-cold, unheated room that didn't even have a fireplace" (da muste ich ein halbe stund in einen Eiskalten, ungeheizten, und ohne mit Camin versehenen grossen Zimmer warten).[165] When the duchesse greeted him politely, as is duly noted, Mozart refused to show his musical talent on the only keyboard instrument available. "I'd be only too happy to play something but that it was now impossible," he pleaded, "as my fingers were numb with cold" (ich wollte von herzen gern etwas spiellen, aber izt sei es ohnmöglich, in demme ich meine finger nicht empfinde für kälte). In fact, he "asked her if she'd at least lead me to a room with a hearth and a fire" ([ich] bat sie, sie möchte mich doch aufs wenigste in ein Zimmer wo ein Camin mit feüer ist, führen lassen). Unfazed, the duchesse responded: "'Mais oui, Monsieur, vous avez raison!' [Oh yes, Mister, you are absolutely right!] That was her entire answer" (. . . das war die ganze antwort). Still, nothing much ensued. The duchesse "sat down and started to draw for a whole hour in the company of some gentlemen, who all sat in a circle around a large table" (dann sezte sie sich nieder, und fieng an eine ganze stunde zu zeichnen en compagnie anderer herrn, die alle in einen grossen Circkel um einen grossen tisch herumsassen). How the lady of the house and her entourage were able to draw in a supposedly chilly house during a

Parisian spring with open windows is one of many details Mozart's narration covers over—ellipses that, one surmises, the letter's addressee, his *cher père*, detected.

Our letter writer observes that another hour wasted away during which he suffered great unease in what he describes as a shivering cold. It is, of course, difficult to know whether the time spans punctuating Mozart's account are approximate, factual, or exaggerated. Even though there is no mention of a clock, we know that Mozart owned no fewer than five portable timepieces, as a slightly earlier letter testifies (November 13, 1777): wearing a couple of them visibly might prevent a "great lord" (grossen herrn) from gifting him another, he writes in jest.[166] Putting one's pocket watch on display was evidently fashionable, especially for men. What is more, in this period, synchronizing one's own time with the nascent scientific standard emerged as "a means of social distinction" among elites.[167] That Mozart spent hours at the *Hôtel de Chabot* acutely aware of measured time is, therefore, likely.

When the composer realized that his request for better conditions fell on deaf ears, he made do with "that miserable, wretched Pianoforte" (den miserablen Elenden Pianforte).[168] He played his variations on a minuet by Johann Christian Fischer in C (K. 179), only to interrupt his playing halfway. "The worst," he writes, was not the miserable instrument. "The worst" was that the duchesse and her circle carried on with their drawing while he performed "for the chairs, table and walls," as he lets his father know (was aber das ärgste war, daß die Madame und alle die herrn ihr zeichnen keinen augenblick unterliessen, sondern immer fortmachten, und ich also für die sessel, tisch unnd mäuern spiellen muste): "I had to wait yet another half an hour" (ich muste noch eine halbe stund warten, bis ihr herr kam). When the Duc de Chabot finally appeared, *he*, at last, gave Mozart his undivided attention: "I forgot all about the cold and my headache and, regardless of the wretched piano, played as I play when I'm in a good mood" (ich vergas darüber alle kälte, kopfwehe, und spiellte ungeachtet den Elenden clavier so wie ich spiele wenn ich gut in laune bin)—a surprising turn that gives narrative closure to his account.

Waiting permeates this letter like a *basso continuo*, the bass accompaniment in a piece of eighteenth-century music. On the first two of the autograph's four pages,[169] the word appears no less than five times. Even the ruptures in the epistle's narrative logic give contour to what Mozart recounts

as an excruciating experience. In a prolix narration, Mozart builds his case to his father for not wanting to wait for an audition and waste time again. In fact, the same letter lists additional obstacles such as the muck on the streets of the French capital, the cost of crossing the city in a rented coach, and the recent decline in politesse he claims to have observed among the French.

One can hear the clocks ticking in the eighteenth-century rooms where those who waited roamed. From the vantage point of an industrious society, waiting was time spent unproductively—time that could and should have been put to better uses. The lack of measurable results, therefore, was one of several sources of frustration for those kept in this state. It is easy to imagine how Mozart, condemned to idleness, would have preferred to pass the hours differently; instead, he had to let valuable time simply tick away. Those who found themselves in a position comparable to Mozart's were destined to recognize conditions beyond their control. They were reminded of their position in relation to others. At the same time, they were thrown back on themselves. It is this dual focus that makes waiting such a pregnant phenomenon.

For those who waited, entering into this temporally bounded state opened up the potential for reflection on these asymmetries. A number of hints indicate that a waiter like Mozart found himself in a state of heightened awareness. He not only recorded in detail the many bodily and mental states he was made to suffer, but he also eagerly noted the applause his musical talent earned him. What is more, in a letter that voices tedium over aristocratic philistinism, the composer also developed a best-case scenario: "joy" (Freüde) in unison emerges as the shibboleth for what, in blissful circumstances, connects the performer with the music connoisseur.[170]

In *The Marriage of Figaro* (*Le Nozze di Figaro*) (K. 492), the composer and his librettist, Lorenzo Da Ponte, settled the score. This *opera buffa* offers a poignant satire of aristocratic politics of time in a plot replete with scenarios of waiting, deferrals, and comic reversals. Based on the 1784 scandalous and frequently censored play by the French dramatist Beaumarchais, this 1786 piece takes an enlightened count to task for scheming to delay the marriage of two of his servants because he, a notorious philanderer, had cast an eye on one of them, Susanna. The breathtaking speed of the plot's unfolding in an aristocratic residence (with spaces that at times function like antechambers) exposes the social order as a profoundly unstable and manipulable "dance":

Se vuol ballare (to take up Figaro's biting metaphor about challenging his lord to comply with his wish to tie the knot). Ultimately, through acts of simulation and dissimulation, among other things, Figaro and Susanna succeed in marrying, without further delay.[171]

To be sure, waiting scenarios reflected power structures. That this power was itself volatile became evident at the end of the eighteenth century.

Waiting for Goethe

Did the revolutionary age truly constitute a turning point? After the end of the old regime, whether stately homes were centers of political life was an open question. This did not mean that the antechamber disappeared, however. Architecturally, these spaces persisted, though they decreased in significance, as in the following Weimar encounters.

In the early nineteenth century, few poets in Europe rivaled Johann Wolfgang von Goethe in stature. His celebrity attracted many a visitor. Among those who embarked on a quest to bask in the poet's aura in Weimar, the center of a small territory known for its concentration of literati, was Willibald Alexis (pseudonym for Wilhelm Häring, 1798–1871). Alexis approached Goethe three times: in 1819, 1824, and 1829. The retelling of these occasions in an essay traced the author's journey from veneration to ironic affection, if not iconoclasm.[172]

Like a literary pilgrim, Alexis gauged his own reactions to the writer's hallowed grounds in the first of three visits. To be near the genius and to have met his son in a chance encounter on a Weimar street sufficed to fulfill the mission: an act of veneration. No encounter ensued, nor did Alexis seek one out.

During the second visit, this ecstatic vision of Goethe had to contend with the actualities of an encounter. After having arrived in Weimar on a separate occasion in 1824, he and a friend asked for an audience with the poet. Proffering their names and connections, they did so in writing. They were granted a time for the next day: a common interval in recognizing a meeting deemed rightful. To be sure, anxious anticipation ran high, as Alexis and his travel companion spent the day. Accompanied by a servant, they crossed the threshold to the salon at the hour they had been given, 5:00 p.m., when Goethe—or "His Excellency," as the servant called him—received his visi-

tors. In the telling, the entryway and staircase described in part 2 of Alexis's essay registers as a "homely" (behaglich) version of architectural splendors from a bygone era. Interestingly, Alexis cites the Munich Residenz of the Dukes of Bavaria as a point of comparison.[173]

Seated in the salon (see fig. 18), the two men waited for an unspecified period until Goethe entered. In a novel by the same author that features an audience with the writer, the waiting period is said to have been extensive: an important detail.[174] In this essayistic travelogue, however, there is no mention of a long wait. Rather, Alexis uses his time waiting to decode details about the encounter. The servant had positioned the two young men where visitors were made to sit so that the windows bathed Goethe in sunlight. This carefully thought-out arrangement did not escape notice.

In the end, the two lovers of literature got to meet not the poet but the gentleman (vornehmer Mann); Goethe had dressed the part. Although animated, the conversation never was inspired. Even when the party touched on literary matters of interest to them, the exchange of niceties remained unremarkable. Both visitors had expected meeting a monument of a man. Instead, they encountered a mensch, removed from them by age, status, and appearance.

Alexis not only invokes the architectural settings of stairs and salon as a stage for the poet's well-timed encounters with visitors; he also analyzes the audience itself as a form of curated sociability—a ritual that simultaneously conveyed and produced social asymmetry: "How could the much-visited poet express himself differently vis à vis two totally unknown young men if they had come [to Weimar] only to satisfy their curiosity?" (Wie sollte der mit Besuchen überlaufene Dichter sich anders gegen zwei junge ihm wildfremde Männer äußern, die nur gekommen waren, ihre Neugier zu befriedigen).[175] In other words, the immediacy of Goethe's writings had to contend with the mediatedness of an actual encounter with the author. In the process, the distance that separated an aspiring writer from poetic genius metamorphosed into historical reflections. Alexis's description registers the gulf that separated the political ferment of post-Napoleonic Europe (woven into the narration) from the residential protocols of the previous century. To be sure, the past could be appreciated. But the distance to it could no longer be bridged.[176]

In meeting a person, the social form *was* the message. Spatial distance,

social asymmetry, and temporal deferrals were at the core of this and other audiences in the *ancien régime*. If one looked for brilliance or immediacy, the constraints of convention were all too evident. What becomes obvious in the midst of the essay's abundant ironies is that encounters with a man of importance had long been invaded by competing media: "not knowing whether they [the young men] would print all confidential information in the next morning, evening, or midnight-journal, if he [Goethe] had been inclined to express those" (und von denen er nicht wußte, ob sie nicht im nächsten Morgen-, Abend- oder Mitternacht-Journal alle Vertraulichkeiten abdrucken ließen, falls er sich zu solchen bewogen gefühlt hätte).[177] Though published only after Goethe's death, Alexis's essay adds a chapter to this mediated engagement with the famous writer as a celebrity in printed form. But this second visit was not the last time they met.

When yet another encounter with Goethe occurred in Weimar in 1829, the desire for immediacy itself had lost its allure, or this is what the essay suggests. After the self-imposed distance of a cult-follower (who doesn't dare to approach the revered figure) and the conventionalities of the second meeting, the third encounter was surprisingly informal. It happened in Goethe's garden house, not in his mansion, as the previous one had. No request for a meeting preceded their second in-person conversation. Having knocked on the door, the visitor was greeted by a servant. Goethe appeared without delay, it is said. Tellingly, he wore an informal dressing gown. No wait time heightened the visitor's attention or projected a social distance. Goethe invited his guest to sit on the same sofa. They started talking about acquaintances they shared. To the young writer's surprise, the eighty-year-old Goethe alluded to the fact that he was aware his visitor had published a travelogue.

This amounted to something of an invitation. Alexis could have stayed in Weimar to deepen his connection with the great man. But he no longer was what he had been, a pilgrim and an admirer. The coterie around Goethe emerged as an obstacle. The young writer chose to evade these social entanglements. Writing had taken precedence, his own writing. He refrained from becoming another Johann Peter Eckermann (1792–1854) (explicitly mentioned at the end of the essay), whose published conversations with Goethe became a staple of the Goethe cult in the nineteenth century. From his vantage point, the formalities in the antechamber seemed antiquated. This third time, the occasion to come close arrived, and it was an occasion

to be discarded.

As a rule, early modern elites made themselves available, at least on occasion, to interact with people of other ranks. Individuals of low, modest, middling, or high rank could entertain plans to approach persons above their station. The further they themselves were removed from elite circles by class and experience, the more difficult such an interaction was to initiate; there was no guarantee they would actually be received. Still, there was a possibility they might. The antechamber provided the forum where the principle of elite approachability met the sobering realities on the ground. Its rituals were part and parcel of the production of power and authority. Put differently, the antechamber was not simply an expression of a predetermined power dynamic. It was an agent in social intercourse: the object of anticipatory steps and fantasies under the signum of uncertain outcomes.

The opacity associated with such irregular, momentary, and deferred interactions was the other side of the occasionalist philosophy that grounded one's life in time as action-bound. But acting in time was not only about transactions or outcomes. It was about exhibiting connections that were meaningful in and of themselves. Those who made it into these spaces, it is safe to say, were already privileged in that they possessed the ability to possibly become participants in an encounter.

"One thing I do know for certain, we are waiting! That's our value. Yes, we're waiting, and we are, as it were, listening to life."[178] Waiting confers dignity; it links the one who waits to persons of standing or a higher cause and the "mysterious 'inner chambers.'"[179] Yet Jakob, the protagonist in Robert Walser's *Jakob von Gunten* (1909)—a novel admired by Franz Kafka—is anything but a paragon of obedience. As his diary reveals, he, a runaway from a well-to-do family, is independent-minded. As a student in a school that teaches servility to future servants, he proves resistant to the school's core mission—teaching patience. Waiting, while absorbing, is not itself fulfilling. The stay at the Institute Benjamenta, this dilapidated school of waiting, is unsettling. At the novel's end, Jakob leaves behind this "antechamber to the drawing rooms and palatial halls of life at large" in an adventurous journey to unknown shores with utopian overtones.[180]

Conclusion

The other side of waiting is wanting.
—Carolyn Steedman, *Landscape for a Good Woman*

In recent years, journalists, essayists, and curators have repeatedly hailed waiting as an art form.[1] Writers in this vein advocate temporal "in-betweens" as a path to a good life. In the humdrum of the everyday, when we are pressed for time, waits offer getaway moments, it is said, allowing humans to appreciate where they find themselves, where they once were, and where they hope to be. Rather than wanting to excise waiting from our existence, in other words, these critics invite us to embrace interstitial times that puncture our routines. What keeps us from practicing this art?

Yes, it is difficult to conceive of a life without moments, stretches, and recurrences of temporary stillness or temporal liminality; most of us know the experience. Yet meditations on the art of waiting only touch on the many contexts that animate, shape, or frame liminal scenarios in time. It feels like writers in this vein shoulder waiters with the task of staying in charge while waiting.

But have humans always waited? The American sociologist Barry Schwartz claimed the answer to this question is no. Juxtaposing his own society, the Cold War US, with what he termed "traditional societies," this heinous moniker, he posited that people of the past had "no conception of

what it is to be 'on time' or to 'wait.' "[2] As an expert on the strictures and structures of synchronicity in modern service economies, Schwartz was a pioneer. In the somewhat speculative comment quoted here, however, he merely marshalled a foil to our age, contrasting temporal anxieties in the present with a mythical place where time flowed abundantly. Tellingly, the author offered no chronology. He also says little about the historical forces that turned time into something scarce.

Schwartz's is not an isolated reverie. This same formula about a time and place we moderns can barely imagine lurks in the anthropological literature: "Dowayos [in Cameroon] seldom if ever seemed to *do* anything.... They just existed," to quote one example.[3] Equating measured time with the ticking of clocks risks constructing certain people as timeless: a particular "denial of coevalness," to cite Johannes Fabian's haunting formula.[4] The present study has made a case for a history of time and temporality in which premoderns were, in fact, waiting, as, I am pretty sure, Dowayos do, though in ways that warrant being examined in extenso.

Historians, sociologists, and anthropologists have begun to sound out waiting as a complex and textured condition. As expert narrators, social scientists and scholars in the humanities are chronographers or time-tellers; they organize time through their inquiries and writings. Yet their temporizations have often gone unacknowledged or unnoticed, unless they concerned historical periods and periodization.[5] Put differently, favoring conceptual thinking, critics frequently have elided time-bound phenomena such as waiting and wait times from scholarly visibility.

Dipesh Chakrabarty is among a growing number of commentators to have challenged this state of affairs. As a postcolonial theorist and historian, he exposes the temporal schemas that once structured colonial rule and still linger. By claiming that the colonized were not ready for self-governance, colonizers confined subjects and collectives to a lesser position within overlapping cultural, ethnic, racial, and other hierarchies.[6] The "art of waiting" as a formula requisitioned patience from them. Not surprisingly, what was billed as their long path toward political freedoms ultimately proved elusive. Under this temporal regime, Europeans' "denial of coevalness" resulted in constant deferrals and a deceitful change of hands. "This waiting was the realization of the 'not yet' of historicism," as Chakrabarty contends. By dint of waiting scenarios, in other words, time-bound constructs, concepts, or

narratives such as timelessness, development, modernization, and the like have been complicit with forms of subjection.[7] The losses, or rather pains, were and are immeasurable.

It is one thing to say that historians ought to finally explore what imposing waits and having to wait does to people. It is another matter to argue that waiting itself is historical. In both cases, studying waiting means to say no to discarding waits as lost time. Understanding what it means to wait requires that we investigate the social, cultural, religious, and other contexts in choreographies of waits. In this sense, waiting was and is imbricated with acts, plans, dreams, visions, and fantasies, as well as scenarios of social distinctions, and therefore is meaningful. Put differently, waiting references wanting, and wanting, by necessity, revolves around whatever we deem worth a wait, however short or long these deferrals or delays may be. In sum, waiting helps generate meaning in social life.

In *Watch Meeting—Dec. 31st 1862—Waiting for the Hour*, the nineteenth-century US artist William Tolman Carlton conjures a nocturnal scene before President Abraham Lincoln's Emancipation Proclamation went into effect on January 1, 1863 (fig. 21). Barely lit up by a torch, a gathering of African Americans—men, women, and children—is grouped around someone with a watch in the dark of night. Suspended in the "temporary stillness" immediately prior to monumental change, these enslaved, or soon-to-be formerly enslaved, people eagerly await the acquisition of equal status as citizens—a moment that, in the artist's rendering, engenders a panoply of reactions, gestures, and affects.[8] As this oil-on-canvas drama suggests, certain forms of waiting reorient the frustrations of humans' conditions toward change or betterment.

The preceding pages discussed the modality of interpersonal waiting: waiting for someone of influence, authority, expertise, or power, or—to approach this temporal modality from the other end of the social spectrum—inflicting a wait time on others, usually those below one's rank or status. This form of waiting gains texture by whom and what we are waiting for, as well as a host of other factors, such as where, how often, how long, and with whom one waits. What is more, waiting for another frequently isolates, even if it takes place in a room where others also wait. Although waiters may wait together, the particular wants and designs are the individual's. This individuation has made it difficult to recognize that those who wait sometimes constitute a group (as in Carlton's painting).

FIGURE 21. William Tolman Carlton, *Watch Meeting—Dec. 31st 1862—Waiting for the Hour*, 1863, oil on canvas, 74.6 × 92.1 cm (White House Collection / White House Historical Association).

Waiting in the antechamber in old regime Europe revolved around the conundrum of mutual obligations in societies marked by inequalities and asymmetries. A history of waiting, therefore, casts doubt on the assumption that there were times in history when waiting did not require the forms of endurance many associate with it today. After all, waiting in this sense was and is a physical-mental predicament not, or not entirely, of the waiter's choosing. At the same time, as participants in asymmetrical scripts, waiters and those who have people wait coproduce authority, power, efficiency, and the like.

An icon in an early modern glossary shows the bodily posture of a waiter to illustrate the Latin verb *exspectare* (rendered as to wait or *warten*) (fig. 22 and fig. 23).[9] Appropriately, the waiter stands in isolation. With one hand on a tree trunk and the other akimbo, his arc reflects a bodily tension. His

Schrepffen / Scarificare.

Schneiden Theilen / Secare.

Verschliessen Observare.

Säen Seminare.

Halten Servare.

Pfeiffen Sibilare.

Trocken machen Siccare.

Ziehen Trahere.

Trösten Solari,

Im Elend seyn Exulare.

Verwüsten Desolare.

eine Trauer haben Lugere.

Ausspatziren Exspatiare.

Warten Exspectare

Hoffen Sperare.

Verzweiffeln Desperare.

Athem holen Spirare.

Seuffzen Suspirare.

Berauben Spoliare.

Schaumen Spumare.

Schuppen Desquamare.

Düngen Stercorare.

Triefen Stillare.

Angeloben Stipulari.

Stehen Stare.

Würtzen Cibos aromate conspergere.

Küssen Osculari.

Schwitzen Sudare.

Dar-oder fürstellen Præsentare

Herzulocken Anreitzen Advocare, Allicere.

Nemo desperet meliora lapsus. Niemand verzage / im Fall daß es nicht werde besser werden.

Lang

FIGURE 22. Johann Georg Seybold, *Teutsch-Lateinisches Wörter Büchlein: Zum Nutz und Ergötzung der Schuljugend / Dictionariolum Germanico-Latinum in usum et delectationem scholasticae juventutis* (Nuremberg: J. Hoffmann, 1695), 166 (Herzog August Bibliothek, Wolfenbüttel, Germany: Xb 10435).

FIGURE 23. Johann Georg Seybold, *Teutsch-Lateinisches Wörter Büchlein*, 1695, detail.

stillness is that of someone ready to become active in an instant. In this textbook, waiting as a bodily state becomes legible thanks to icons in proximity: a couple strolling about (*exspatiare* or to go for a walk; *ausspatizeren*); a woman receiving rays from the heavens (*sperare* or to hope; *hoffen*); and the bogged-down figure of a despairing man (*desperare* or to despair; *verzweifflen*): "Nobody shall despair in case there is no change to the better" (*Nemo desperet meliora lapsus* or *Niemand verzage / im Falle daß es nicht werde besser werden*), as the motto on this page has it, as if the author wanted to egg on the waiter in his waiting.

The isolation of the waiter in this case is striking. Yet his waiting is anything but desolate. Rather, it may be read to be about readying oneself to act. Ultimately, waiting encapsulates a "hesitant openness, albeit of a sort that is difficult to explain," as Siegfried Kracauer casts the figure in an essay of 1922.[10] Thus viewed, the waiter offers a model for the historian: alert, perceptive, and active.

In early modern Europe, waiting was part and parcel of lived time. Importantly, timing oneself conjured up a field of planning, ruminating, and delaying action. The aforementioned "art of waiting" thus captures something essential about the ways in which time figured in this period. It was a precious, if not precarious, grid of one's life. Such an art can be studied and exercised, even if we must concede that time is impossible to master.

The present study has anchored waiting in history in a room type designated to house those who waited for various lengths of time, whether they

lived in the same edifice or elsewhere. To be sure, experiencing waiting was not limited to certain spaces (like the antechamber) or to certain social groups (like courtiers or others at court). Yet both played a role in inculcating lessons on time and timing. What was true in the sixteenth century—namely, that waiting was rarely conceived of as a distinct modality—no longer held true to the same degree by the end of the old regime. The antechambers of early modern Europe may have helped give birth to waiting as a distinct temporal state, but this is only the beginning of an answer to why waiting gained contour toward the end of the period under discussion. The long rise of industriousness, as well as the implantation of measured time in quotidian activities, among other changes, helped mark interstitial temporality as particular.[11]

At any rate, the antechambers in early modern Europe were part of a spacetime infrastructure that made manifest and helped bring about the intertwined processes of social differentiation and the buildup of administrative procedures. The period's antespaces reflected a social, political, and cultural order centered on elites, especially the aristocracy, and their residences. Antespatiality was a means to cordon off persons below the patron's station. Those knowledgeable, privileged, or well-dressed enough to advance to the anteroom were given an architectural space in which to linger; they often were accorded certain days and hours to appear; and they were kept at bay waiting. At the same time, however, the presence of waiters in the antechamber, divided only by walls and doors from those above their station, also came with the potential for disrupting routines. In societies where personal encounters occupied a pivotal plain, symbolically and actually, the antechamber therefore was a key forum.

Did waiting in the antechamber end with the end of the old regime? How does this space connect with today's architectures and modalities of waiting? Let me sketch an answer to this terrain of questions on the remaining pages. To be sure, the antechamber survives as a metaphor. Spaces invite metaphorization, and anterooms have us imagine what can be expected to happen. Chakrabarty's waiting room of history is just one manifestation in this metaphor's long trajectory. In addition, as a motif in literature, philosophy, and the performative or visual arts, waiting surfaces as a potent-performative state that allows audiences to consider the deferral of fulfillment within linear-secular conceptions of time. Tellingly, Konstantinos Kavaphes's (C. P. Cavafy's) poem "Waiting for the Barbarians" (1904), one of the incunabula in a modernist poetics of waiting, limns the effects and affects of anticipatory horizons on the waiter (and the reader).[12]

The antechamber also lives on in concrete ways. A newly built manor from the early nineteenth century—a period of aristocratic renewal—Haus Harkotten in Westphalia featured a single antechamber on the main floor, as an old plan reveals. Interestingly, however, this *Vorzimmer* was associated with the work sphere, next to the Freiherr's study, as well as a dining or meeting hall. This is striking since the plan as a whole is reminiscent of the *appartement double*, with its parallel wings for men and women (in this case with dedicated spaces for children).[13] But the sequence of rooms was modified. In this instance, the *enfilade* no longer opened with an antechamber as a gateway but consigned the *Vorzimmer* to the realm of the male household head.

In the age of revolutions, some aristocrats who once had kept people waiting were said to have lingered in antechamber-like vestibules to secure their prerevolutionary pensions and the like.[14] During the same era, the waiting areas in European consulates and embassies became spaces to exhibit one's political allegiance. Portraits of Wellington and Blücher as "Saviors of the World" were on display, much to the dismay of those who harbored hopes for the end of restauration.[15] The French writer and diplomat François-René de Chateaubriand contrasted the open forum he associated with revolutionary change to antecameral politics as it resurfaced after Napoleon's demise.[16]

In fact, after the late eighteenth and early nineteenth centuries, the antechamber became identified with unjust rule: anathema to the rights of free (male) citizens as a collective bound together by a shared credo of equality before the law.[17] This set of ideas echoes the medieval and early modern notion that excessive wait times constituted a sign of tyranny. Subsequently, *antechamber* as a term underwent a change. As a verb, "to antechamber" started to describe not only pursuing one's plans in the halls of the high and mighty but also scheming, fawning, bootlicking, and idling. In the German language, writers saw *antichambrieren* as the residuum of a past that should have vanished long ago. Those who "antechambered" became an object of critique, if not derision. The antichamberer was a person of petty character: someone without convictions; someone engaged in cabals; someone who was unknowable and, therefore, a person who could not or should not be trusted as a citizen among citizens. What is more, wherever indigents, soldiers, lowly bureaucrats, or others roamed the corridors of those above their rank, hoping to be admitted, the hallmark of modern society, a well-oiled administration, was lacking, or so the implication went.[18]

Antechambers—these distinct spaces meant to channel encounters between people of different ranks—increasingly came to signal a lack of po-

litical transparency. Friedrich Schiller's drama *Don Fiesco's Conspiracy at Genoa*, first performed in 1783, looks back to historical events in the mid-sixteenth century. This *Republican Tragedy*, as the subtitle has it, starts with one character taking off her mask and ends with the protagonist's assassination at the very moment when Fiesco's long-term scheme to establish himself as an autocrat in this city-republic has borne fruit. Throughout the drama's many upsets, the power-hungry Fiesco goes rarely, if ever, unmasked; the audience witnesses his covert acts with different political factions; they alone are the ones to grasp the extent of Fiesco's theater of personal deceits, political betrayals, and multiform duplicities.

Intriguingly, Schiller locates this political tale in an array of settings, with the antechamber at one end and the public square at the other. In emplotting space, he takes up his main source, Cardinal de Retz, who, as a member of the old regime's elite, once derided those whose notion of politics derived from the semipublic antechamber and not the inner chambers.[19] In Schiller, the residence with its ante- and other spaces emerges as the epicenter of a form of shadowy politics. The antechamber is where Muley Hassan, "the Moor from Tunis," retreats when Fiesco must hide his bond with this suspicious spy on the arrival of political allies in his residence: "The Moor has done his job, the Moor can go" (Der Mohr hat seine Arbeit getan, der Mohr kann gehen) is Hassan's sardonic response to Fiesco's command to "Wait in the antechamber until I ring." Politics and spatiality emerge as mutually constitutive.[20]

In the end, Fiesco, this winsome manipulator who is ready to sacrifice others for his gain, becomes himself a "victim of artifice and intrigue" (ein Opfer der Kunst und Kabale), as the preface has it.[21] This is no accident. Rather, the finale is the vanishing point of a political logic centered on secret machinations and inaccessible spaces, as opposed to open negotiations and public debate. Thus viewed, Schiller's drama is a historical fable about certain concepts and practices to discard on the garbage heap of history. Theatergoers (or readers) were mobilized to undo privileges of access and work toward a future without antecameral politics.

After 1800, antespatiality persisted. Yet wherever possible, the plight of the waiter was masked or lightened, especially for the well-to-do. As a technology of immediacy, calling cards evolved into cartes de visite photographs in the middle of the nineteenth century. Visitors to a home offered their "portraits with a delicacy of design and a beauty of execution for a ceremo-

nial visit" to increase their chances to be admitted for an in-person encounter: "a legitimization of identity and proof of a certain social standing, even if the claims and titles printed on the card were bogus."[22] On a different note, a waiting room for the upper classes of riders in a large urban station from the mid-nineteenth century bore the name *retirade* (retreat). Interestingly enough, this term looked back to the *enfilade* of rooms in a courtly *appartement*. Yet, importantly, the room where people spent time before boarding a train was advertised as an inner, not an ante-, chamber.[23]

The antechamber had organized access to people of influence; modern architectures of waiting like the *salles d'attente* in railway stations usually control access to means of transportation or other services, as is the case with waiting areas in hospitals, offices, and airports. Today, those who wait are not necessarily walled off; they are mostly free to roam—a strategy postwar architects deployed to unshackle waiters from spatial confinement in designated spaces.[24] When the Soviet satirists Il'ia Il'f and Evgeniĭ Petrov visited the United States in the mid-1930s, their travelogue described Americans as living in a continuous, well-organized present, at the same time as they were said to lack ideas about the distant future that Soviets supposedly felt confident to envision. Americans never waited for an appointment, they said: "No one waits for [the American businessman] in his reception rooms, because an appointment is usually made with absolute accuracy, and not a single extra minute is wasted during the interview."[25] Viewed thus, the process of meeting a functionary or bureaucrat resembled an assembly line in industrial production.

By contrast, waiting in line became a defining feature for consumers in the so-called Eastern Bloc. While economists saw scarcities as a phenomenon that would pass with the maturation of the socialist economy, citizens came to understand lines as a seismograph of the state of economic or other affairs.[26] Typically, the Moscow protagonist in Vladimir Sorokin's experimental novel *The Queue* (1983) lined up without an inkling of what might be on offer at the end of the line. In this telling, waiting with others emerged as an arena of public life with social affordances, ritual temporizations, and possible escapades that instantiated, if not defined, the body social.

In capitalist societies, strategies to undo the tedium associated with waiting abound. The numbers one picks when getting in line signal stacked wait times, according to the principle that those who wait will be received in the order in which they arrived or in the order they called on the phone. David

Maister's "The Psychology of Wait Lines" has emerged as a magisterial guide to contain waiting's unpleasantness by means of clear organization, explicit communication or explication, and various forms of distraction or evasion.[27] Even government agencies for the unemployed have started to follow this model. In Denmark, the United Kingdom, and the United States, administrative entities attempt in different ways to undo the stigma of seeking or receiving support from the state through the design of their waiting areas.[28] In the meantime, fewer and fewer people personally put forward a request in bureaucracies. Online waiting, while hidden from sight, has begun to replace waiting for appointments or phone calls in many cases. What is more, today's powerful, whether financiers or celebrities, do not post hours when ordinary people may seek them out for a meeting. Our elites have become secluded. They live behind walls. They lack antespaces or public emails. Yes, their charitable foundations may reach out to us, yet for the most part, we are unable to interact with them, let alone see them in their own dwellings.

The associational order of civil society has us imagine politics without antechambers, as we saw in Schiller. Still, as an actual space and a technology of power, these rooms continue to exist. The memoirs of Germany's former ambassador to Russia, Rüdiger von Fritsch, speak of the forlorn corridors in the Kremlin. In the palatial halls of the Russian Federation's centers of decision-making, diplomats, businessmen, close associates, and others waited and wait for appointments. President Vladimir Putin had ambassadors and politicians linger, sometimes for hours on end, while at other times they were ushered in (at least before the COVID pandemic).[29] Like in the anterooms of old, the reasons for these discrepancies were rarely communicated to the waiters. Lately, as a consequence of Russia's international isolation after the country's invasion of Ukraine, President Putin is himself made to wait, if only for seconds, when meeting those political leaders who are still ready to meet him, the press reports.[30]

According to von Fritsch, no particular rooms are dedicated to those kept on their toes in anticipation of a meeting. In today's Russia, the temporal protocols and spatial semantics of old regime residences have made way for makeshift arrangements. Yet the political theorist Carl Schmitt is not entirely off the mark when pontificating that corridors and antespaces define politics (though he never seems to have analyzed actual spaces).[31] In sum, waiting in designated spaces for a meeting continues to shape interactions of various kinds.

In contemporary society, anterooms often are poorly attended or ill-defined. Intriguingly, the virtual waiting room on the online platform Zoom functions without the semblance of an architectural setting or a community. While waiting to be admitted, we see a blank screen. Once users are let in, they have choices with regard to how to craft their appearance. When in a meeting (or should I say audience?), one can tailor one's name tags by including preferred pronouns, select virtual backgrounds, or blur one's actual space. Fortunately, we occasionally get glimpses of the lives of others: their books, their furnishings, their children, or their pets. Conversely, for the virtual anteroom, no such design option exists to this date. After all, the meeting's host could prepare waiters by projecting a brand or communicating information about the meeting to occur. It is as if this virtual anteroom lies "ante" or outside Zoom's parameters. Waiting is relegated to a space where users do not "own" it.

As this and other examples indicate, waiting's status has sunk considerably since 1800. In contemporary Western societies, wait times are regularly obfuscated. As a result, we may feel waiting's brunt particularly strongly. Importantly, persistent scenarios of waiting remind us that our social, economic, political, and other aspirations are lagging. Not surprisingly, delays in deliveries to consumers prompt demands for countermeasures. In the news media, waiting in line signals states of exception, such as emergencies, elections, energy crises or scarcities, and so forth. Because we may have never been quite modern, we are still waiting. Likely, we will continue to do so for a while.[32]

The digital age has been heralded as a period in which everything will be only a mouse-click away. Now that most of us no longer use a mouse, we still are waiting to see visions of immediate gratification, general inclusiveness, or widespread accessibility fulfilled. A political candidate in my district who ran in the 2020 primaries crafted the campaign motto "We are done waiting!" The social, political, and racial justice issues for which we should no longer be waiting were left to the voters' imagination.

We may want waiting to end. We are sometimes told its demise is imminent. Still, to quit waiting, we first need to remember what it means to wait wherever and whenever we get to practice what some call an art form. As long as there continue to be wants and needs, there are and will be waits. If you interview those who wait, you will hear that we are waiting too long and too often.[33] During the height of the COVID pandemic, in fact, different

types of wait intersected to trigger a new awareness of interstitial temporalities. We were waiting for information; we were hoping for good news from family and friends; we expected food and other deliveries; we anticipated securing a vaccination; we were anxious about lockdowns or the end of them.

Waiting with the history of waiting in mind means waiting differently, or this is my hope. Let's *wait and see* whether I am right.[34] While waiting, you may want to consider that this eighteenth-century formula connects our world with that of the past. For my part, I will wait and see whether I become a practitioner of the "art of waiting." I doubt it.

Notes

Introduction

1. Henri Bergson, *Time and Free Will, an Essay on the Immediate Data of Consciousness*, trans. Frank Lubecki Pogson (London: G. Allen, 1913), xix; Henri Bergson, *Essai sur les données immédiates de la conscience*, 5th ed. (Paris: Félix Alcan, 1906), vii (Avant-propos): "Nous nous exprimons nécessairement par des mots, et nous pensons le plus souvent dans l'espace." See also Anthony Giddens, "Time, Space, Social Change," in *Central Problems in Social Theory: Action, Structure and Contradiction in Social Analysis* (Berkeley: University of California Press, 1979), 198–233.

2. Marcia Bjornerud, *Timefulness: How Thinking like a Geologist Can Help Save the World* (Princeton, NJ: Princeton University Press, 2018), 7.

3. Hartmut Rosa, *Weltbeziehungen im Zeitalter der Beschleunigung: Umrisse einer neuen Gesellschaftskritik* (Frankfurt am Main: Suhrkamp, 2012), 299.

4. Rosa, *Weltbeziehungen*, 204, 284–85, 316–19, and 205.

5. In *Faster! The Acceleration of Just About Everything* (New York: Pantheon, 1999), James Gleick explores particularly how humans are not necessarily subjected to but are complicit in the acceleration they suffer from. See also Thomas Hylland Eriksen, *Tyranny of the Moment: Fast and Slow Time in the Information Age* (London: Pluto, 2001); William E. Scheuermann, *Liberal Democracy and the Social Acceleration of Time* (Baltimore: Johns Hopkins University Press, 2004); and Judy Wajcman, *Pressed for Time: The Acceleration of Life in Digital Capitalism* (Chicago: University of Chicago Press, 2015).

6. Jason Farman, *Delayed Response: The Art of Waiting from the Ancient to the Instant World* (New Haven, CT: Yale University Press, 2018).

7. Rosa, *Weltbeziehungen*, 196–99; Jonathan Crary, *24/7: Late Capitalism and the Ends of Sleep* (New York: Verso, 2013); Byung-Chul Han, *The Scent of Time: A Philosophical Essay on the Art of Lingering*, trans. Daniel Steuer (Cambridge: Polity, 2017). A history of the various slow movements and their genealogies remains to be written; see, however, Caleb Smith, "Disciplines of Attention in a Secular Age," *Critical Inquiry* 45 (Summer 2019): 884–909.

8. Wajcman, *Pressed for Time*, 173.

9. David Caron, "Waiting = Death: COVID-19, the Struggle for Racial Justice, and the AIDS Pandemic," in *Being Human During COVID*, ed. Kristin Hass (Ann Arbor: University of Michigan Press, 2021), 93–116.

10. Eriksen, *Tyranny of the Moment*, 169.

11. Matthew Champion, "A Fuller History of Temporalities," *Past & Present* 243 (2019): 255–66. See also Daniel Lord Smail and Andrew Shryock, "History and the 'Pre,'" *American Historical Review* 118 (2013): 709–37.

12. As examples, see Rebecca Solnit, "The Annihilation of Time and Space," *New England Review* 24, no. 1 (Winter 2003): 5–19, esp. 15–16; and Oliver Burkeman, *Four Thousand Weeks: Time Management for Mortals* (New York: Farrar, Straus and Giroux, 2021), 17–26.

13. John Rundell, "Temporal Horizons of Modernity and Modalities of Waiting," in *Waiting*, ed. Ghassan Hage (Melbourne: Melbourne University Press, 2009), 39–52, 39.

14. Gillian G. Tan, "Senses of Waiting among Tibetan Nomads," in *Waiting*, ed. Ghassan Hage (Melbourne: Melbourne University Press, 2009), 66–75, 73.

15. Stefan Hanß, "The Fetish of Accuracy: Perspectives on Early Modern Time(s)," *Past & Present* 243 (May 2019): 267–284. See also Arndt Brendecke, Ralf-Peter Fuchs, and Edith Koller, eds., *Die Autorität der Zeit in der Frühen Neuzeit* (Münster: Lit, 2007).

16. Norbert Elias, *Time: An Essay* (Oxford: Blackwell, 1992), 3.

17. See Joseph Vogl, *On Tarrying*, trans. Helmut Müller-Sievers (London: Seagull, 2011).

18. In "Six Types of Waiting in Berlin," *South Atlantic Quarterly* 120, no. 2 (April 2021): 279–83, Christine Sun Kim captures different types of waiting and their temporizations through musical notation.

19. Giovanni Gasparini, "On Waiting," *Time and Society* 4 (1995): 29–45.

20. Vincent Crapanzano, *Waiting: The Whites of South Africa* (New York: Random House, 1985), xii, 43.

21. W. H. Vanstone, *The Stature of Waiting* (Harrisburg, PA: Morehouse, 1982), 83.

22. Vanstone, *The Stature of Waiting*, 49.

23. Emmanuel Lévinas, *Wenn Gott ins Denken einfällt: Diskurse über die Betroffenheit von Transzendenz* [De Dieu qui vient à l'idée] (Freiburg: Herder [1985], 3rd ed. 1999), 93. Among the many relevant essays and texts by Heidegger, see especially Martin Heidegger, "Abendgespräch in einem Kriegsgefangenenlager in Rußland zwischen einem Jüngeren und einem Älteren," in *Feldweg-Gespräche* (1944–45) (Frankfurt am Main: Vittorio Klostermann, 1995), 203–45.

24. See, e.g., Walter Mischel, *The Marshmallow Test* (New York: Brown, 2014).

25. Irina Aristarkhova, *Arrested Welcome: Hospitality in Contemporary Art* (Minneapolis: University of Minnesota Press, 2020), 29.

26. Here are some select titles from a vast bibliography: Alexander Schunka, "Zeit des Exils: Zur argumentativen Funktion der Zeit bei Zuwanderern im Kursachsen des 17. Jahrhunderts," in Brendecke, Fuchs, and Koller, *Die Autorität der Zeit*, 149–68; Salim Lakha, "Waiting to Return Home: Modes of Immigrant Waiting," in *Waiting*, ed. Ghassan Hage (Melbourne: Melbourne University Press, 2009), 121–34; Brenda Gray, "Becoming Non-migrant: Lives Worth Waiting For," *Gender, Place and Culture* 18 (2011): 417–32; Daniel Kazmaier, Julia Kerschner, and Xenia Wotschal, eds., *Warten als Kulturmuster* (Würzburg: Königshausen & Neumann, 2016); Manpreet K. Janeja and Andreas Bandak, eds., *Ethnographies of Waiting: Doubt, Hope and Uncertainty* (London: Bloomsbury, 2018); Christine M. Jacobsen, Marry-Anne Karlsen, and Shahram Khosravi, eds., *Waiting and the Temporalities of Irregular Migration* (London: Taylor and Francis / Routledge, 2020).

27. Andrea Diefenbach, *Land ohne Eltern* (Heidelberg: Kehrer, 2012).

28. Paul E. Corcoran, "Godot Is Waiting Too: Endings in Thought and History," *Theory and Society* 18 (1989): 495–529, 511. The late social theorist and historian Alf Lüdtke worked on a talk about waiting in 2018, based on letters written by the German writer Heinrich Böll and other writings. With gratitude to Helga Lüdtke and Jan Wernicke.

29. Barry Schwartz, *Queuing and Waiting: Studies in the Social Organization of Access and Delay* (Chicago: University of Chicago Press, 1975); Barry Schwartz, "Waiting, Exchange, and Power: The Distribution of Time in Social Systems," *American Journal of Sociology* 79 (1974): 841–70.

30. Schwartz, *Queuing and Waiting*, 140.

31. Paul Graham, *Beyond Caring* (1986; London: Mack, 2021).

32. Pierre Bourdieu, *Pascalian Meditations*, trans. Richard Nice (Stanford, CA: Stanford University Press, 2000), 228.

33. Marc Augé, *Non-places: Introduction to an Anthropology of Supermodernity*, trans. John Howe (London: Verso, 1995). Interestingly, the author doesn't couple his coinage, "non-places," with its twin, "non-times," despite hints in this direction at the outset.

34. Jeffrey Schaeffer, "Iranian Who Inspired 'The Terminal' Dies at Paris Airport," Associated Press, Nov. 12, 2022.

35. Sir Alfred Mehran [Mehran Karimi Nazeri] and Andrew Donkin, *The Terminal Man: The Extraordinary True Story of the Man Who Has Lived in an Airport Terminal for Sixteen Years* (London: Corgi, 2004), 7.

36. Roland Barthes, *A Lover's Discourse*, trans. Richard Howard (London: Penguin, 1990); Maurice Blanchot, *Awaiting Oblivion*, trans. John Gregg (Lincoln: University of Nebraska Press, 1997); Siegfried Kracauer, "Those Who Wait," in *The Mass Ornament: Weimar Essays*, trans. Thomas Y. Levin (Cambridge, MA: Harvard University Press, 1995), 129–40; Michael Rutschky, "Wartezeit," in *Wartezeit: Ein Sittenbild* (Cologne: Kiepenheuer & Witsch, 1983), 227–42.

37. Rana Dasgupta's novel *Tokyo Cancelled* (New York: Black Cat, 2005) imagines passengers stranded at an unspecified airport and spending their time in transit narrating stories.

38. See Craig Jeffrey, *Timepass: Youth, Class, and the Politics of Waiting in India* (Stanford, CA: Stanford University Press, 2010).

39. Javier Auyero, "Patients of the State: An Ethnographic Account of Poor People's Waiting," *Latin American Research Review* 46, no. 1 (2011): 5–29; Javier Auyero, *Patients of the State: The Politics of Waiting in Argentina* (Durham, NC: Duke UP, 2012). See also Lisa Björkman, *Waiting Town: Life in Transit and Mumbai's Other World Class Histories* (Ann Arbor, MI: Association for Asian Studies, [2020]).

40. Rebecca Rotter, "Waiting in the Asylum Determination Process: Just an Empty Interlude?" *Time & Society* 25 (2016): 80–101. The Africans in Jenny Erpenbeck's 2015 novel *Go, Went, Gone* would strongly disagree; their first priority was to end the wait and work, as they let interlocutors know frequently. The characters are based on conversations with refugees the novelist encountered in Berlin in 2014, as the acknowledgments make evident. See Jenny Erpenbeck, *Go, Went, Gone*, trans. Susan Bernofsky (New York: New Directions, 2017). For more information on the novel's background, see "Writers Speak: Jenny Erpenbeck in Conversation with Claire Messud," Mahindra Humanities Center, Harvard University, March 5, 2018, YouTube video (uploaded on June 4, 2018), www.youtube.com/watch?v=Hr6kBmAUic4.

41. Martin Demant Frederiksen, *Young Men, Time, and Boredom in the Republic of Georgia* (Philadelphia: Temple University Press, 2013), 180. See also his "Waiting for Nothing: Nihilism, Doubt, and Difference without Difference in Postrevolutionary Georgia," in *Ethnographies of Waiting: Doubt, Hope and Uncertainty*, ed. Manpreet K. Janeja and Andreas Bandak (London: Bloomsbury, 2018), 163–80.

42. On the concept of temporal agency and the limits of such agency, see Felix Ringel, "Can Time Be Tricked?" *The Cambridge Journal of Anthropology* 34 (2016): 22–31; Laura Baer, "Afterword: For a New Materialist Analytics of Time," *The Cambridge Journal of Anthropology* 34 (2016): 125–29. See also On Barak, *On Time: Technology and Temporality in Modern Egypt* (Berkeley, CA: University of California Press, 2013), 209.

43. The formula is from Ursula Schulz-Dornburg, *Architekturen des Wartens: Bushaltestellen in Armenien, Bahnhöfe der Hejaz-Bahn in Saudi-Arabien*, 2nd rev. ed. (Cologne: König, 2007).

44. Raymond Williams, "Structures of Feeling," in *Marxism and Literature* (Oxford: Oxford University Press, 1977), 128–35, 129.

45. See also Anthony Giddens, *The Consequences of Modernity* (Stanford, CA: Stanford University Press, 1990); David Harvey, *The Condition of Postmodernity: An Enquiry into the Origins of Cultural Change* (Oxford: Blackwell, 1990); Stephen Kern, *The Culture of Time and Space, 1880–1918* (Cambridge, MA: Harvard Uni-

versity Press, 1983); Wolfgang Schivelbusch, *The Railway Journey: The Industrialization of Time and Space in the Nineteenth Century*, trans. Anselm Hollo (1979; Berkeley: University of California Press, 2014).

46. *Oxford English Dictionary*, 2nd ed. (Ann Arbor: University of Michigan Humanities Text Initiative, 1996), s.v. "to wait"; Calvert Watkins, *The American Heritage Dictionary of Indo-European Roots* (Boston: Houghton Mifflin, 2000), 95 (s.v. "weg-²"). In Germanic languages, *wait* replaced *bide*; see "bīdan-" in *Etymological Dictionary of Proto-Germanic*, ed. Guus Kroonen (Leiden: Brill, 2013), 277; "bidda" in *Old Frisian Etymological Dictionary*, ed. Dirk Boutkan and Sjoerd Michiel Siebinga (Leiden: Brill, 2005), 172; Carl Darling Buck, *A Dictionary of Selected Synonyms in the Principal Indo-European Languages; a Contribution to the History of Ideas* (Chicago: University of Chicago Press, 1949), 837.

47. *Oxford English Dictionary* [online], 2nd ed., s.v. "wait"; *Deutsches Wörterbuch von Jacob Grimm und Wilhelm Grimm*, digitalisierte Fassung im Wörterbuchnetz des Trier Center for Digital Humanities, version 01/21, s.v. "warten," vol. 27, cols. 2125–67, www.woerterbuchnetz.de/DWB.

48. Mikhail M. Bakhtin, "Forms of Time and of the Chronotope in the Novel: Notes toward a Historical Poetics," in *The Dialogic Imagination: Four Essays*, trans. Michael Holquist (Austin: University of Texas Press, 1981), 84–285, 84. The first footnote in this essay gives credit to a lecture by the biologist A. A. Uxtomskij in 1925, where the author first encountered the concept of chronotope. On Uxtomskij see Michael Holquist, "Answering as Authoring: Mikhail Bakhtin's Trans-linguistics," *Critical Inquiry* 10 (1983): 307–19, esp. 315–17 and 319n16. On chronotope, see Sue Vice, *Introducing Bakhtin* (Manchester: Manchester University Press, 1997), 200–228.

49. Albert Einstein, *Relativity: The Special and General Theory*, trans. Robert W. Lawson (Gloucester, MA: P. Smith, 1959), 9: "In order to have a complete description of the motion, we must specify how the body alters its position with time"; Albert Einstein, *Über die spezielle und die allgemeine Relativitätstheorie (Gemeinverständlich)*, 20th ed. (Braunschweig: F. Vieweg, 1956), 6: "Eine vollständige Beschreibung der Bewegung kommt aber erst dadurch zustande, daß man angibt, wie der Körper seinen Ort mit der Zeit ändert." The sociologist Helga Nowotny translated Einstein's insight about time and space into the concept of proper time (Eigenzeit): everyone, every activity, every collective has their own time. See Helga Nowotny, *Eigenzeit: Entstehung und Strukturierung eines Zeitgefühls* (Frankfurt am Main: Suhrkamp, 1989); trans. Neville Plaice as *Time: The Modern and the Postmodern Experience* (Cambridge: Polity, 2005).

50. See Carlo Rovelli, *The Order of Time* (New York: Riverhead, 2018), 52. The term is also used in the contemporary social sciences; see Ben Anderson, "Time-Stilled Space-Slowed: How Boredom Matters," *Geoforum* 35 (2004): 739–54.

51. On Bergson, see Mark Antliff, "Creative Time: Bergson and European Mod-

ernism," in *Tempus Fugit, Time Flies*, ed. Jan Schall (Kansas City, MO: Nelson-Atkins Museum of Art, 2000), 36–65.

52. On the contradictions of this change see Vanessa Ogle, *The Global Transformation of Time, 1870–1950* (Cambridge, MA: Harvard University Press, 2015); Oliver Zimmer, *Remaking the Rhythms of Life: German Communities in the Age of the Nation-State* (Oxford: Oxford University Press, 2019); Jean-Michel Johnston, "The Telegraphic Revolution: Speed, Space and Time in the Nineteenth Century," *German History* 38 (2020): 47–76; and Oliver Zimmer, "One Clock Fits All? Time and Imagined Communities in Nineteenth-Century Germany," *Central European History* 53 (2020): 48–70.

53. Eugène Minkowski, *Le temps vécu: Études phénoménologiques et psychopathologiques* (Paris: J. L. L. d'Artrey, 1933); Eugène Minkowski, *Lived Time: Phenomenological and Psychopathological Studies*, trans. Nancy Metzel (Evanston, IL: Northwestern University Press, 1970). With reference to Bergson, the book's translator, Nancy Metzel, speaks of the "irrational nature of time" (xxiii) and adds, "If we attempt to understand the phenomenon of time in purely rationalistic terms, we fail to understand it" (xxiii).

54. Jean Piaget, *Le développement de la notion de temps chez l'enfant* (1927; 1946); Jean Piaget, *The Child's Conception of Time*, trans. A. J. Pomerans (London: Routledge, 1969).

55. Ernst Bloch, *Heritage of Our Times*, trans. Neville Plaice and Stephen Plaice (Oxford: Polity, 1991); Ernst Bloch, *Erbschaft dieser Zeit. Erweiterte Ausgabe* (Frankfurt am Main: Suhrkamp, 1962).

56. Paul Glennie and Nigel Thrift, "Reworking E. P. Thompson's 'Time, Work-Discipline, and Industrial Capitalism,'" *Time & Society* 5 (1996): 275–99, 280–81; Miriam Czock and Anja Rathmann-Lutz, eds., *ZeitenWelten: Zur Verschränkung von Weltdeutung und Zeitwahrnehmung, 750–1350* (Cologne: Böhlau, 2017), esp. the introduction with its bibliography. See also Karl Schlögel, *Moscow, 1937*, trans. Rodney Livingstone (Cambridge: Polity, 2012); and Merry Wiesner-Hanks, ed., *Gendered Temporalities in the Early Modern World* (Amsterdam: Amsterdam University Press, 2018).

57. Walter Benjamin, *The Arcades Project*, trans. Howard Eiland and Kevin McLaughlin (Cambridge, MA: Belknap, 1999), esp. 416–55. See also David Frisby, "The City Observed: The Flâneur in Social Theory," in *Cityscapes of Modernity: Critical Explorations* (Cambridge: Polity, 2001), 27–51.

58. Benjamin, *The Arcades Project*, 855; Walter Benjamin, *Passagen-Werk*, in *Gesammelte Schriften*, vol. 5:2 (Frankfurt am Main: Suhrkamp, 1991), 1023–24.

Chapter 1. Times

1. Peter Burke, "Performing History: The Importance of Occasions," *Rethinking History: The Journal of Theory and Practice* 9 (2005): 35–52, 36. In philoso-

phy, the term designates debates on the question of divine causation, see Sukjae Lee, "Occasionalism," in *The Stanford Encyclopedia of Philosophy* (Fall 2020 Edition), ed. Edward N. Zalta, https://plato.stanford.edu/archives/fall2020/entries/occasionalism. See also Peter Burke, "Reflections on the Cultural History of Time," *Viator* 35 (2004): 617–26; Doris Bachmann-Medick, "The Performative Turn," in *Cultural Turns: New Orientations in the Study of Culture*, trans. Adam Blauhut (Berlin: Walter de Gruyter, 2016), 73–101.

2. Nobert Elias, *An Essay on Time*, in *The Collected Works*, vol. 9, ed. Steven Loyal and Stephen Mennell (Dublin: University College Dublin Press, 2007), 12.

3. Erasmus of Rotterdam, "Nosce tempus (Consider the due time)," in *Collected Works*, vol. 32, ed. R. A. B. Mynors (Toronto: University of Toronto Press, 1989), 108 (I vii 70).

4. Andrew Hui, *A Theory of the Aphorism: From Confucius to Twitter* (Princeton, NJ: Princeton University Press, 2019), 97. Erasmus speaks of an adage as a "sealring"; see Erasmus of Rotterdam, "Festina lente (Make Haste Slowly)," in *Collected Works*, vol. 33, ed. R. A. B. Mynors (Toronto: University of Toronto Press, 1991), 3–17 (II i 1), 3. See also Margaret Mann Phillips, *The "Adages" of Erasmus: A Study with Translations* (Cambridge: Cambridge University Press, 1964), 171.

5. Handwritten motto by the owner ("Hannemann") of a volume now owned by the Herzog August Bibliothek, Wolfenbüttel (Germany), 182.5 Hist. 2°. The two works bound together in this volume are works of history: Flavius Arrianus, *Ad Adrianum Cæsarem Nunc primùm è Græco sermone in Latinum versus* (Geneva: Eustache Vignon, 1577); and Jean du Tillet, *Les Memoires et recherches* (Rouen: Philippe de Tours, 1578). For the inscription on house facades, see Palazza Coppedè, Via Veneto 7, Rome, Italy (Gino Coppedè, architect); a house facade in Novate Milanese, Italy, of a Liberty style residence with a sundial. https://commons.wikimedia.org/wiki/File:Tempore_Tempora_Tempera.jpg.

6. See, e.g., https://mymemory.translated.net/en/Latin/English/tempora, -tempore-,tempera; https://www.exlibris-insel.de/Eingang/lateinische_Texte .html#T. This translation can be traced back to a proverb by the Greek playwright Menander: "Time is the healer of all necessary evils" (Fragments dclxxvii [Kock] πάντων ἰατρὸς τῶν ἀναγκαίων κακῶν χρόνος ἐστίν). See also Chaucer's *Troilus and Criseyde*, v. 350 (As tyme hem hurt, a tyme doth hem cure).

7. See https://grammarist.com/proverb/time-heals-all-wounds/#:~:text=A%20proverb%20is%20a%20short%2C%20common%20saying%20or%20phrase .&text=Time%20heals%20all%20wounds%20is%20a%20proverb%20that%20means%20that,is%20relieved%20as%20time%20passes; see also a quote attributed to Rose Fitzgerald Kennedy: www.goodreads.com/quotes/140515-it-has -been-said-time-heals-all-wounds-i-do; www.griefcounselor.org/2017/11/07/does -time-heal-all-wounds; www.psychologytoday.com/us/blog/the-mourning-after/ 201905/does-time-really-heal-all-wounds.

8. Charlton E. Lewis, *A Latin Dictionary* (Oxford: Clarendon, 1980), 1851: "the state of the times, position, state, condition; in plur. the times, circumstances (esp. freq. of dangerous or distressful circumstances)." The saying "Oh tempora, o mores!" reflects this, and is not unlike "times" in English; see *Oxford English Dictionary*, 2nd ed., s.v. "time."

9. In these adages and similar texts that invoke life's vicissitudes, their precise nature often goes unremarked. By contrast, neostoicism is often quite explicit about what ails or troubles humans.

10. There is a variant of *tempora tempore tempera*: *tempora tempori tempera*. This is the version used in a handwritten motto in a book owned by the Herzog August Bibliothek (see above). Here *tempori* means "the right time."

11. *Temperare* translates as "observe proper measure, be moderate, restrain oneself." On *tempus* and *temperantia*, see Anja Wolkenhauer, *Sonne und Mond, Kalender und Uhr: Studien zur Darstellung und poetischen Reflexion der Zeitordnung in der römischen Literatur* (Berlin: Walter de Gruyter, 2011), 10; and Helen F. North, *Sophrosyne: Self-Knowledge and Self-Restraint in Greek Literature* (Ithaca, NY: Cornell University Press, 1966), 374–78.

12. Phillips, *The "Adages" of Erasmus*, 171.

13. Aulus Gellius, *Noctes Atticae* (Turnhout: Brepols, 2010), 46 (xii.xi.7): "Veritatem Temporis filiam esse dixit." For the English translations, see *A Goodly Prymer in Englyshe* (London: William Marshall, 1535), A1r; Morris Palmer Tilley, *A Dictionary of the Proverbs in England in the Sixteenth and Seventeenth Centuries* (Ann Arbor: University of Michigan Press, 1950), T324, 338, and 580. Here and subsequently, quotations in this book will be rendered with the spelling and punctuation as the cited source has them, unless otherwise noted.

14. Fritz Saxl, "Veritas Filia Temporis," in *Philosophy and History: Essays Presented to Ernst Cassirer*, ed. Raymond Klibansky and H. H. Paton (Oxford: Clarendon, 1936), 197–222, 215. See also Dawn Massey, "*Veritas Filia Temporis*: Apocalyptic Polemics in the Drama of the English Reformation," *Comparative Drama* 32 (1998): 146–75; and Simona Cohen, "*Veritas Filia Temporis*: Time in Cinquecento Propaganda," in *Transformations of Time and Temporality in Medieval and Renaissance Art* (Leiden: Brill, 2014), 245–304.

15. Fritz Graf, "Chronos," in *Brill's New Pauly, Antiquity*, ed. Hubert Cancik, Helmuth Schneider, and Christine F. Salazar, http://dx.doi.org.proxy.lib.umich.edu/10.1163/1574-9347_bnp_e233860; Massimo Ciavolella and Amilcare A. Iannucci, eds., *Saturn: From Antiquity to the Renaissance* (Ottawa: Dovehouse, 1992); Gerhard Baudy, "Kronos," in *Brill's New Pauly, Antiquity*, http://dx.doi.org.proxy.lib.umich.edu/10.1163/1574-9347_bnp_e623640.

16. Brigitte Schaffner, "Kairos," in *Brill's New Pauly*, http://dx.doi.org.proxy.lib.umich.edu/10.1163/1574-9347_bnp_e605280; Raphael Michel, "Occasio," in *Brill's New Pauly, Antiquity*, http://dx.doi.org.proxy.lib.umich.edu/10.1163/1574

-9347_bnp_e827650; North, *Sophrosyne*, 92. Lisa Baraitser, *Enduring Time* (London: Bloomsbury, 2017), 3; Kristin Sampson, "Conceptions of Temporality: Reconsidering Time in an Age of Impending Emergency," *Theoria* 86 (2020): 769–82, 772–77.

17. Alois M. Haas, "Meister Eckharts Auffassung von Zeit und Ewigkeit," in *Geistliches Mittelalter*, ed. A. M. Haas (Fribourg: Universitätsverlag, 1984), 339–69; Norbert Fischer, "Die Zeitbetrachtung des Nikolaus von Kues ('intemporale, unitrinum tempus')," *Trierer Theologische Zeitschrift* 99 (1990): 170–92.

18. Russell West-Pavlov, *Temporalities* (London: Routledge, 2012). See also Jacques Le Goff, "Merchant's Time and Church's Time in the Middle Ages," in *Time, Work, and Culture*, trans. Arthur Goldhammer (Chicago: University of Chicago Press, 1980), 29–42, 38; Peter Burke, "Reflections on the Cultural History of Time," *Viator* 35 (2004): 617–26, 618–20; Gerhard Dohrn-van Rossum, "Time," in *Oxford Handbook of Early Modern History*, vol. 1, *People and Places*, ed. Scott Hamish. Oxford Handbooks Online (Oxford: University of Oxford, 2015), n.p.

19. Michael Jackson, *The Varieties of Temporal Experience: Travels in Philosophical, Historical, and Ethnographic Time* (New York: Columbia University Press, 2018).

20. Felix Ringel, *Back to the Postindustrial Future: An Ethnography of Germany's Fastest-Shrinking City* (New York: Berghahn, 2018), 64–89.

21. Keith Moxey, *Visual Time: The Image in History* (Durham, NC: Duke University Press, 2013), 23. Dipesh Chakrabarty, whose work is cited in Moxey (25), coined the term *heterotemporality*. See Dipesh Chakrabarty, *Provincializing Europe: Postcolonial Thought and Historical Difference* (Princeton, NJ: Princeton University Press, 2000), 239n5.

22. Pierre Bourdieu, *Pascalian Meditations*, trans. Richard Nice (Stanford, CA: Stanford University Press, 2000); Marcus Sandl, *Medialität und Ereignis: Eine Zeitgeschichte der Reformation* (Zurich: Chronos, 2011); Ulrike Kirchberger, "'Multiple Sattelzeiten': Zeitkulturen in der atlantischen Welt 1760–1830," *Historische Zeitschrift* 303 (2016): 671–704.

23. Achim Landwehr, *Die Geburt der Gegenwart: Eine Geschichte der Zeit im 17. Jahrhundert* (Frankfurt am Main: S. Fischer, 2014), 17, 250, 290, passim; Alexander Nagel and Christopher S. Wood, *Anachronic Renaissance* (New York: Zone, 2010), 7 ("plural temporality").

24. Georges Gurvitch, *La multiplicité des temps sociaux* (1958; Paris: Centre de documentation universitaire, 1961); Georges Gurvitch, *The Spectrum of Social Time*, trans. Myrtle Korenbaum and Phillip Bosserman (Dordrecht: Reidel, 1964); Reinhart Koselleck, *Sediments of Time: On Possible Histories*, trans. Sean Franzel and Stefan-Ludwig Hoffmann (Stanford, CA: Stanford University Press, 2018), 9.

25. William H. Sewell Jr., *Logics of History: Social Theory and Social Transformation* (Chicago: University of Chicago Press, 2005), 9.

26. Matthew S. Champion, *The Fullness of Time: Temporalities of the Fifteenth-Century Low Countries* (Chicago: University of Chicago Press, 2017).

27. William Kentridge, *Thick Time*, ed. Iwona Blazwick and Sabine Breitwieser (London: Central Books, 2012).

28. For an overview, see Dan Edelstein, Stefanos Geroulanos, and Natasha Wheatley, "Chronocenosis: An Introduction to Power and Time," in *Power and Time: Temporalities and the Making of History*, ed. Dan Edelstein, Stefanos Geroulanos, and Natasha Wheatley (Chicago: University of Chicago Press, 2020), 1–49.

29. For an approach similar to the one suggested here, see Stefan Hanß, "Timing the Self in Sixteenth-Century Augsburg: Veit Konrad Schwarz (1541–61)," *German History* 35 (2017): 495–524.

30. See E. P. Thompson, "Time, Work-Discipline, and Industrial Capitalism," *Past & Present* 38 (1967): 56–97, 57; see also 59, 60, 95.

31. Felix Ringel, "Can Time Be Tricked?" *Cambridge Journal of Anthropology* 34 (2016): 22–31.

32. Anthony Grafton, "Chronology and Its Discontents in Renaissance Europe: The Vicissitudes of a Tradition," in *Time: Histories and Ethnologies*, ed. Diane O. Hughes and Thomas Trautman (Ann Arbor: University of Michigan Press, 1995), 139–64, 140.

33. Prv 13:12. Quoted after *The Vulgate Bible*, vol. 3, *The Poetical Books*, ed. Swift Edgar and Angela M. Kinney (Cambridge, MA: Harvard University Press, 2011), 606–7.

34. Georg Friedrich Händel (music), Thomas Morell (text), *The Triumph of Time and Truth: An Oratorio* (1757), HWV 71, http://opera.stanford.edu/iu/libretti/triumph.htm. The text is from an aria by Counsel, one of the four allegories in the opera. This is the last English-language version of an oratorio whose two Italian versions are *Il trionfo del Tempo e del Disinganno* (The Triumph of Time and Disillusion), HWV 46a; and *Il trionfo del Tempo e della Verità* (The Triumph of Time and Truth), HWV 46b. As punctuation marks, virgules will be rendered as they appear in early modern texts, unless otherwise noted.

35. Christian Albrecht Meisch, *Neu-erfundene Sinnbilder* (Frankfurt am Main: Ammon and Serlin, 1661), 173: "Zeit bringt Rosen."

36. *The Vulgate Bible*, vol. 6, *The New Testament*, ed. Angela M. Kinney (Cambridge, MA: Harvard University Press, 2013), 386–87 (Lk 12:40). On attentiveness in religious matters, see Moshe Barrasch, "Waking: A Form of Attention in Ritual and Religious Art," in *Aufmerksamkeiten*, ed. Aleida Assmann and Jan Assmann (Munich: Fink, 2001), 227–40; and Daniel Jütte, "Sleeping in Church: Preaching, Boredom, and the Struggle for Attention in Medieval and Early Modern Europe," *American Historical Review* 125 (2020): 1146–74, 1153–55.

37. Martin Luther, "Von der Hoffnung" (Roths Feldpostille), in *Weimarer Ausgabe*, vol. 17.2 (Weimar: Böhlau, 1927), 273–75.

38. Lucas Cranach the Elder, "Portrait of Martin Luther," painting (1532) (Historisches Museum der Stadt Regensburg, Germany). See also Theodor Krüger,

"Portrait of Martin Luther" [metalcut print after Cranach], 1563 (British Museum 1867, 0713.116).

39. Daniel Cramer, *Octoginta emblemata moralia nova sacris literis petita, formandis ad veram pietatem accommodata, & elegantibus picturis aeri incisis repraesentata* (Frankfurt am Main: Lucas Jennisius, 1630), 76–77. See Sabine Mödersheim, *'Domini Doctrina Coronat': Die geistliche Emblematik Daniel Cramers (1568–1637)* (Frankfurt am Main: P. Lang, 1994).

40. Emmanuel Lévinas, *Wenn Gott ins Denken einfällt: Diskurse über die Betroffenheit von Transzendenz* [De Dieu qui vient à l'idée] (Freiburg: Herder [1985], 3rd ed. 1999).

41. Eccl 3:1. Quoted after *The Vulgate Bible*, vol. 3, *The Poetical Books*, ed. Swift Edgar and Angela M. Kinney (Cambridge, MA: Harvard University Press, 2011), 694–95.

42. Mödersheim (*'Domini Doctrina Coronat,'* 227–33) rightly calls attention to the fact that whereas Cramer was an orthodox Lutheran, his moral messages are eclectic and would have been shared across confessions.

43. Daniel Cramer, *Octoginta emblemata moralia*, 76–77. On the publishing venture see Mödersheim, *'Domini Doctrina Coronat,'* 131–39.

44. M. Jacob Daniel Ernst, *Anweisung / Wie Dessen so genantes Historisches Bilder-Hauß / neben denen dreyen Theilen der Historischen Confect-Taffel / bey Erklärung der gewöhnlichen Sonn- und Festtags Episteln und Evangelien nützlich anzuwenden und zu gebrauchen* (Altenburg: Richter, 1688), B1r.

45. Sebastiano del Piombo, "Ferry Carondelet and His Secretaries," painting, oil on canvas (c. 1510–12) (Museo Nacional Thyssen-Bornemisza, Madrid, inv. no. 369). This motto appears on a pedimented doorway in the back of the painting; its text is only partially visible, engaging the viewer in the process of deciphering it.

46. See Rita Copeland, *Rhetoric, Hermeneutics, and Translation in the Middle Ages: Academic Traditions and Vernacular Texts* (Cambridge: Cambridge University Press, 1991), 66–76; A. J. Minnis, *Medieval Theory of Authorship: Scholastic Literary Attitudes in the Later Middle Ages*, 2nd ed. (Philadelphia: University of Pennsylvania Press, 1988), 16–17; Nikolaus Henkel, *Deutsche Übersetzungen Lateinischer Schultexte: Ihre Verbreitung und Funktion im Mittelalter und in der Frühen Neuzeit* (Munich: Artemis, 1988), 12, 49, 59; Stephen M. Wheeler, *Accessus ad auctores: Medieval Introductions to the Authors (Codex latinus monacensis 19475)* (Kalamazoo, MI: Medieval Institute, 2015), 2.

47. Horst Rüdiger, "Göttin Gelegenheit, Gestaltwandel einer Allegorie," *Arcadia* 1 (1966): 121–66; Wilfried Barner, *Barockrhetorik: Untersuchungen zu ihren geschichtlichen Grundlagen* (Tübingen: M. Niemeyer, 1970), 76, 151, 165, 272; Wulf Segebrecht, "Zur Produktion und Distribution von Casualcarmina," in *Stadt, Schule, Universität, Buchwesen und die deutsche Literatur im 17. Jahrhundert*, ed. Albrecht Schöne (Munich: Beck, 1976), 523–35.

48. "Tempus," in *Etymological Dictionary of Latin*, ed. Michiel de Vaan, https: //dictionaries-brillonline-com.proxy.lib.umich.edu/search#dictionary=latin&id= la1647.

49. See Klaus Maurice, *Von Uhren und Automaten: Das Messen der Zeit* (Munich: Prestel, 1968), 40. See also Wolkenhauer, *Sonne und Mond, Kalender und Uhr*, 10.

50. Lynn White Jr., "The Iconography of 'Temperantia' and the Virtuousness of Technology," in *Action and Conviction in Early Modern Europe*, ed. Theodore K. Rabb and Jerrold E. Seigel (Princeton, NJ: Princeton University Press, 1969), 197–219, esp. 207–19; Helen North, *From Myth to Icon: Reflections of Greek Ethical Doctrine in Literature and Art* (Ithaca, NY: Cornell University Press, 1979), 231–38. The sculpture harks back to Ambrogio Lorenzetti's frescoes in the Sala dei Nove in the Palazzo Publico of Siena, Italy, where the allegory of Temperance holds an hourglass in a program dedicated to political virtue (c. 1339).

51. "Das rechte Gewicht / Den Zaiger richt," reads a seventeenth-century German translation. See Ranuccio Pallavicino, *Triumphierendes Wunder-Gebäw der churfürstlichen Residentz zu München*, trans. Johann Schmid (Munich: Straub, 1685), 6.

52. Hans Krumpel was the sculptor (1616). A seventeenth-century description and interpretation of this facade appears in Balthasar de Monconys, *Iovrnal Des Voyages*, vol. 2, *Voyage d'Angleterre, Païs-Bas, Allemagne, & Italie* (Lyon: Horace Boissat & George Remevs, 1666), 351; Pallavicino, *Triumphierendes Wunder-Gebäw der churfürstlichen Residentz zu München*, 6. See also Christian Quaeitzsch, *Residenz München* (München: Bayerische Schlösserverwaltung, 2014), 35–37. The lions with the heraldic devices were originally cast for a planned funerary monument for Duke Wilhelm V in St. Michael (1593/1596; Hubert Gerhard, Carlo Palagio).

53. The first painted portrait to feature a table clock was Hans Holbein's portrait of the Gdansk merchant Georg Gisze (Giese), painted in London in 1532 and now in Berlin, Gemäldegalerie (Ident. Nr. 586). See also Christina Juliet Faraday, "Tudor Time Machines: Clocks and Watches in English Portraits, c. 1530–c. 1630," *Renaissance Studies* 33 (2018): 239–66.

54. Maurice, *Von Uhren und Automaten*.

55. This is the point made by the mathematician who oversaw the construction of the sixteenth-century astronomical clock in Strasbourg cathedral, Conrad Dasypodius, in his *Warhafftige Außlegung des Astronomischen Vhrwercks zu Straßburg* (Strasbourg: Nikolaus Wiriot, 1578), B2r.

56. Erasmus, "Festina lente," 7.

57. Bavarian National Museum, Munich, Germany, L2018/12: Navicula—Sun dial in the shape of a ship (mid-sixteenth century, central European). Chariots offer a different iconography; see, e.g., Bavarian National Museum, 76/22: Mantelpiece clock with the allegories of the four seasons on chariot drawn by two lions

(French, after 1798). See also Jessica Keating, *Animating Empire: Automata, The Holy Roman Empire and the Early Modern World* (University Park: Pennsylvania State University Press, 2018).

58. Klaus Maurice and Otto Mayr, eds., *The Clockwork Universe: German Clocks and Automata, 1550–1650* (Washington, DC: Smithsonian Institution, 1980), 242–44 (nos. 70–71), 106–9, 280–84.

59. Maurice and Mayr, 278–84 (nos. 105–9).

60. Maurice and Mayr, 285–89 (nos. 110–12).

61. Otto Mayr, *Authority, Liberty, and Automatic Machinery in Early Modern Europe* (Baltimore: Johns Hopkins University Press, 1989).

62. Conrad Dasypodius, *Heron mechanicus: Seu de mechanicis artibus, atque disciplinis. Eiusdem horologii atsronomici, Argentorati in summo templo erecti, descriptio. Argentorati 1580*, ed. Bernard Aratowsky and Günther Oestmann (Augsburg: Dr. Erwin Rauner, 2008), 150–51 (Hıv).

63. Thomas Eser, *Die älteste Taschenuhr der Welt? Der Henlein-Uhrenstreit* (Nürnberg: Verlag des Germanischen Nationalmuseums, 2014).

64. White, "The Iconography of 'Temperantia,'" 197–219

65. José A. García-Diego, *Juanelo Turriano, Charles V's Clockmaker: The Man and His Legend*, trans. Charles David Ley (Madrid: Editorial Castalia, 1986), 82, and on collections in general, 19–20. See also Geoffrey Parker, *Emperor: A New Life of Charles V* (New Haven, CT: Yale University Press, 2019), 453, 470, 478, 522.

66. Carlo M. Cipolla, *Clocks and Culture, 1300–1700* (New York: Norton, 2003); David Landes, *Revolution in Time: Clocks and the Making of the Modern World* (Cambridge, MA: Belknap, 1983); Gerhard Dohrn-van Rossum, *History of the Hour: Clocks and Modern Temporal Orders*, trans. Thomas Dunlap (Chicago: University of Chicago Press, 1996); Alexis McCrossen, *Marking Modern Times: A History of Clocks, Watches and Other Timekeepers in American Life* (Chicago: University of Chicago Press, 2013); Avner Wishnitzer, *Reading Clocks, Alla Turca: Time and Society in Late Ottoman Turkey* (Chicago: University of Chicago Press, 2015).

67. Geoffrey Parker, *Imprudent King: A New Life of Philip II* (New Haven, CT: Yale University Press, 2014), 114 (with plate 25).

68. For an early example, see David Rooney, "Faith: Castle Clock, Diyār Bakr, 1206," in *About Time: A History of Civilizations in Twelve Clocks* (New York: Norton, 2021), 26–45.

69. Chapultepec Castle (after 1785).

70. Robert J. Knecht, *The French Renaissance Court, 1483–1589* (New Haven, CT: Yale University Press, 2008), 289.

71. It is uncertain whether all these clocks are original to the early modern period, which is the case in Meersburg, Milan, and Münster.

72. See Hans-Josef Irmen, *Joseph Haydn: Leben und Werk* (Cologne: Böhlau, 2007), 123.

73. Erasmus, "Festina lente," 3–4. See also Phillips, *The "Adages" of Erasmus*, 171.

74. Barbara Stollberg-Rilinger, *Cultures of Decision-Making* (London: German Historical Institute, 2016).

75. Parker, *Imprudent King*, 206; Geoffrey Parker, *Felipe II: La biografía definitiva*, trans. Victoria E. Gordo del Rey and Santiago Martínez Hernández (Barcelona: Planeta, 2010), 551.

76. See William Roosen, "Early Modern Diplomatic Ceremonial: A Systems Approach," *Journal of Modern History* 52 (1980): 452–76.

77. "The Emperor to Don Diego Hurtado de Mendoza," Feb. 27, 1552, in *Calendar of Letters, Despatches, and State Papers, relating to the negotiations between England and Spain, preserved in the archives of Vienna, Simancas, Besançon, Brussels, Madrid and Lille*, ed. Gustav Adolph Bergenroth, Pascual de Gayangos, et al., vol. 10 (London: Hereford Times, 1914; s.l.: TannerRitchie Publishing, 2007), 461, 463.

78. Cathy Yandell, *Carpe Corpus: Time and Gender in Early Modern France* (Newark: University of Delaware Press, 2000), 116.

79. Johann Storch, *Von Kranckheiten der Weiber: Darinnen vornemlich solche Casus, Kranckheiten und Gebrechen, so man der weiblichen Mutter zuschreibet* (Gotha: Mevius, 1753), 341 (case 82).

80. Barbara Duden, *The Woman beneath the Skin: A Doctor's Patients in Eighteenth-Century Germany*, trans Thomas Dunlap (Cambridge, MA: Harvard University Press, 1991), 72–178, 107. On the precarity of women's bodily experiences, see Laura Gowing, *Common Bodies: Women, Touch and Power in Seventeenth-Century England* (New Haven, CT: Yale University Press, 2003).

81. Johann Storch, *Von Kranckheiten der Weiber: Darinnen vornehmlich solche Casus, Welche den Jungfern-Stand betreffen*, vol. 2 (Gotha: Mevius, 1748), 490–91, 491 (case 145) and 503–4 (case 154). Collective fears have been the subject of Jean Delumeau, *Sin and Fear: The Emergence of a Western Guilt Culture, 13th–18th Centuries*, trans. Eric Nicholson (New York: St. Martin's, 1990).

82. Jean-Martin Charcot, *De l'expectation en médecine* (Thèse d'agrégation, 1857). On the biographical context, see Georges Guillain, *J.-M. Charcot: 1825–1893: His Life—His Work*, trans. Pearce Bailey (London: Pitman, 1959), 8–9. Charcot retook the *agrégation* in 1860 on a different subject and passed the exam. Psychoanalysis as a therapeutic approach tends to waiting explicitly; see Patrick J. Casement, *Learning from the Patient* (New York: Guilford, 1985). For Jacques Lacan, see John Forrester, *The Seductions of Psychoanalysis: Freud, Lacan and Derrida* (Cambridge: Cambridge University Press, 1990), 168–218.

83. Heinrich Gresbeck, *False Prophets and Preachers: Henry Gresbeck's Account of the Anabaptist Kingdom of Münster*, trans. Christopher S. Mackay (Kirksville, MO: Truman State University Press, 2016), 507.

84. Anthony Arthur, *The Tailor King: The Rise and Fall of the Anabaptist Kingdom of Münster* (New York: St. Martin's, 1999), 38, 78.

85. For context, see R. Po-chia Hsia, *Society and Religion in Münster, 1535–1618* (New Haven, CT: Yale University Press, 1984); David M. Luebke, *Hometown Religion: Regimes of Coexistence in Early Modern Westphalia* (Charlottesville: University of Virginia Press, 2016).

86. Grafton, "Chronology and Its Discontents," 141. See also Anthony Grafton, *Joseph Scaliger: A Study in the History of Classical Scholarship*, vol. 2, *Historical Chronology* (Oxford: Clarendon, 1993), 1–4; Dasypodius, *Aigentliche Fürbildung und Beschreibung deß Neuen Kunstlichen Astronomischen Urwerckes, zu Straßburg im Mönster, das M.D.LXXIIII. Jar vollendet, zusehen* ([Strasbourg]: Jobin, [after 1574]); and Dasypodius, *Heron mechanicus.*

87. A contemporary description is in Gresbeck, *False Prophets and Preachers*, 115–16.

88. Edelstein, Geroulanos, and Wheatley, "Chronocenosis," 27.

89. Erwin Panofsky, "Father Time," in *Studies in Iconology: Humanistic Themes in the Art of the Renaissance* (New York: Harper & Row, 1972), 69–94; S. Macey, "The Changing Iconography of Father Time," in *The Study of Time III Proceedings of the Third Conference of the International Society for the Study of Time, Alpbach, Austria*, ed. J. T. Fraser, Nathaniel Lawrence, and David A. Park (New York: Springer, 1978), 540–77.

90. Ulrich Schulze, "Das Residenzschloß in Münster," in *Johann Conrad Schlaun, 1695–1773: Architektur des Spätbarock in Europa*, ed. Klaus Bußmann, Florian Matzner, and Ulrich Schulze (Stuttgart: Oktagon, 1995), 342–407; Werner F. Cordes, "Schlaun und Feill: Die Schloßfassade in Münster," in Bußmann, Matzner, and Schulze, 408–21.

91. On Barak, *On Time: Technology and Temporality in Modern Egypt* (Berkeley: University of California Press, 2013), 5 and passim.

92. Theodor Kolde, *Luther und der Reichstag zu Worms 1521* (Halle: Verein für Reformationsgeschichte, 1883–84); Martin Steitz, *Martin Luther auf dem Reichstag zu Worms 1521: Zur 450-Jahrfeier des Wormser Reichstags 1971* (Frankfurt am Main: Evangelischer Presseverband, 1971); Rainer Wohlfeil, "Der Wormser Reichstag von 1521 (Gesamtdarstellung)," in *Der Reichstag zu Worms von 1521: Reichspolitik und Luthersache*, ed. Fritz Reuter (Worms; Stadtarchiv, 1971), 59–154; Martin Brecht, *Martin Luther: Sein Weg zur Reformation*, vol. 1, *1483–1521*, 2nd ed. (Stuttgart: Calwer Verlag, 1983); Marcus Sandl, *Medialität und Ereignis: Eine Zeitgeschichte der Reformation* (Zurich: Chronos, 2011), 177–218.

93. Martin Luther, "Verhandlungen mit D. Martin Luther auf dem Reichstage zu Worms, 1521," in *Weimarer Ausgabe: Schriften*, vol. 7, ed. Paul Pietsch (Weimar: Böhlau, 1897), 814–87.

94. Adolf Wrede, ed., *Deutsche Reichstagsakten unter Kaiser Karl V.*, vol. 2 (Gotha: Perthes, 1896), 569–86, 574 (*Kurzer Bericht über die Verhandlungen mit Luther in Worms mit Einschiebung einer Übersetzung der Rede und Gegenrede Lu-*

thers vom 18. April). Printed in Basel, Hagenau, and other locations as *Die gantz handlung, so mit dem hochgelerten Doctor Martino Luther täglichen, dweil er uff dem Kaiserlichen Reychstag zu Wurmbs gewess ergangen ist, uffs kürtzest begriffen* (VD16 S 7414–7416). Several manuscripts also seem to have circulated at the time (Wrede, 569–72). See also Luther, "Verhandlungen," 867, 881; *Doctoris Martini Luther Acta VVormaciae in Comitiis Imperialibus Principum. Anno salutis nostrae M.D.XXI.* (s.l.e.a.); *Römischer Kai. Mt. Verhörung Rede vnd widerrede Doctor Martini Luthers Augustiner Ordens z(o)u Wittenbergk in gegenwürt der Ch(o)urfürsten / Fürsten vnd Stenden des hailigen Reichs / auff dem Reychstag z(o)u Wurmbs beschehen. MD.21. Jahre* ([Worms: Hans von Erfurt, 1521]), A2v.

95. Peter Johanek, "Zusammenfassung," in *Formen und Funktionen öffentlicher Kommunikation*, ed. Gerd Althoff (Stuttgart: Thorbecke, 2001), 473–86. Yanay Israeli, in "Papers in Disputes: Petitions, Legal Culture and Royal Authority in Castile, 1406–1516" (PhD diss., University of Michigan, 2017), shows how local officials in Spain, when confronted with a royal letter that required action on their part, expressed obedience to the crown but, in some cases, specified a time span to decide whether they wanted to comply or not. On universities, see Alex J. Novikoff, *The Medieval Culture of Disputation: Pedagogy, Practice, and Performance* (Philadelphia: University of Pennsylvania Press, 2013); Olga Weijers, *"Queritur utrum": Recherches sur la "disputatio" dans les universités médiévales* (Turnhout: Brepols, 2009); Olga Weijers, *La "disputatio" dans les facultés des arts au moyen âge* (Turnhout: Brepols, 2002); Marion Gindhart and Ursula Kundert, eds., *Disputatio 1200–1800: Form, Funktion und Wirkung eines Leitmediums universitärer Wissenskultur* (Berlin: Walter de Gruyter, 2010).

96. Luebke, *Hometown Religion*, 1. For an extensive discussion, see Helmut Puff, "Bedenkzeit (spatium deliberationis): Timing the Reformation," in *The Cultural History of the Reformation*, ed. Susan Karant-Nunn and Ute Lotz-Heumann (Wolfenbüttel: Herzog August Bibliothek, 2021), 39–54.

97. [Baltasar Gracián] *Oraculo manval, y arte de prvdencia* (Madrid: Maria de Quinnones, 1653), 29r/v: "Hombre de espera, arguye gran coraçon con ensanches de sutrimiento; nunca apresurarse, ni apassionarse. Sea vno primero señor de si, y lo será despues de los otros; hase de caminar por los espacios del tiempo al centro de la ocasion. La detencion prudente sazona los aciertos, y madura los secretos. La muleta del tiempo es mas obradora, que la azerada claua de Hercules. El mismo Dios no castiga con baston, sino con sazon: gran dezir: el tiempo, y yo á otros dos. La misma Fortuna premia el esperar con la grandeza del galardon." For an introduction to Gracián's life and thought, see Werner Krauss, *Graciáns Lebenslehre* (Frankfurt am Main: Viktorio Klostermann, 1947); and Sebastian Neumeister, "Baltasar Gracián: A Pragmatist between Ethics and Aesthetics," in *Major Jesuit Thinkers*, ed. Janez Perčič and Johannes Herzgsell (Paderborn: Schöningh, [2019]), 19–34.

98. The earliest Spanish editions printed the maxims without numbers.

Abraham-Nicolas Amelot de la Houssaye, with his French translation, introduced them. On this point, see Knut Forssmann, *Baltasar Gracian und die deutsche Literatur zwischen Barock und Aufklärung* (Barcelona: [n.p.], 1977).

99. Baltasar Gracián, *The Pocket Oracle and Art of Prudence*, trans. Jeremy Robbins (London: Penguin, 2011), 21; Baltasar Gracián, *Oráculo manual y arte de prudencia* (Barcelona: Linkgua, 2011), 35. The self-mastery alluded to here is associated with "temperantia."

100. Gracián, *Pocket Oracle*, 22; Gracián, *Oráculo manual*, 35.

101. Barner, *Barockrhetorik*, 124–31.

102. Gracián, *Pocket Oracle*, 22; Gracián, *Oráculo manual*, 35.

103. Gracián, *Pocket Oracle*, 3; Gracián, *Oráculo manual*, 19.

104. The Argentinian novelist Antonio di Benedetto dedicated his novel *Zama* (1956), set in eighteenth-century Paraguay, "To the Victims of Expectation" (A las víctimas de la espera). See Antonio di Benedetto, *Zama: Novela* (Buenos Aires: Ediciones Doble P., 1956), 7; Antonio di Benedetto, *Zama*, trans. Esther Allen (New York: New York Review Books, 2000), 3.

105. Gracián, *Pocket Oracle*, 21; Gracián, *Oráculo manual*, 35.

106. Attributed to King Philip II of Spain.

107. Gracián, *Pocket Oracle*, 3: "All things are now at their peak, above all being a true individual. It takes more today to make one sage than seven in years gone by, and more to deal with a single person than an entire nation in the past."

108. See Reinhart Koselleck, "Historia Magistra Vitae: The Dissolution of the Topos into the Perspective of a Modernized Historical Process," in *Futures Past: On the Semantics of Historical Time*, trans. Keith Tribe (New York: Columbia University Press, 2004), 26–42, 31: "Gracian, who, on the basis of the doctrine of circulation, affirmed the principle of foreknowledge, but emptied it of meaning, rendering it ultimately superfluous by the inevitability inherent in it."

109. Gracián, *Pocket Oracle*, 22; Gracián, *Oráculo manual*, 35.

110. Sampson, "Conceptions of Temporality," 780. Sampson recuperates Gracián's *Pocket Oracle* for our age of impending emergencies.

111. S. Ignatius Loyola, *The Spiritual Exercises of St. Ignatius*, trans. Anthony Mottola, ed. Robert W. Gleason (Garden City, NY: Image Books, 1964).

112. See Helmut Puff, *"Von dem schlüssel aller Künsten / nemblich der Grammatica": Deutsch im lateinischen Grammatikunterricht, 1480–1560* (Tübingen: Francke Verlag, 1995).

113. Gracián, *Pocket Oracle*, 30; Gracián, *Oráculo manual*, 42.

114. Jan Hillgärtner, *News in Times of Conflict: The Development of the German Newspaper, 1605–1650* (Leiden: Brill, 2021).

115. Landwehr, *Die Geburt der Gegenwart*. See also the forum that discusses this thesis: "'Gegenwart' im 17. Jahrhundert: Versuch einer Antwort," in *Internationales Archiv für Sozialgeschichte der deutschen Literatur* 42 (2017): 110–278.

116. Helmuth Kiesel, *"Bei Hof, Bei Höll": Untersuchungen zur literarischen Hofkritik von Sebastian Brant bis Friedrich Schiller* (Tübingen: Niemeyer, 1979), 101, 109, 117, 122, 173–74. Like Gracián, many of the early modern authors critical of life at court do not condemn the court wholesale.

117. Abraham-Nicolas Amelot de La Houssaye, *L'homme de cour* (Paris: La Veuve-Martin & Jean Boudot, 1684). See Forssmann, *Gracian*, 139–215.

118. Amelot de La Houssaye had translated Nicolo Machiavelli's *Il Principe* in the year before the first edition of *L'homme de cour* saw the light of day.

119. The commentaries help recalibrate the text in citing rulers' comments about waiting. This section in maxim 55 is taken from Gracián's *El Discreto*.

120. Amelot de La Houssaye, *L'homme de cour*, 57.

121. Amelot de La Houssaye, inside cover. The volume is held in Herzog August Bibliothek, Wolfenbüttel, Germany, call number: LI 110:1.

122. The Herzog August Bibliothek today owns seventeen volumes by Gracián from the library of Duke Ludwig Rudolph.

123. Baltasar Gracián y Morales, *Obras*, 2 vols. (Antwerp: Verdussen,1702) [Herzog August Bibliothek, Ll 110]; Baltasar Gracián y Morales, *Obras: Ultima impression, mas corregida, y enriquecida de tablas* (Madrid: Redondo; De Val, 1664) [LI 109]. On the duke's library, see Werner Arnold, *Eine norddeutsche Fürstenbibliothek des frühen 18. Jahrhunderts: Herzog Ludwig Rudolph von Braunschweig-Lüneburg und seine Büchersammlung* (Göttingen: Traugott Bautz, 1980).

124. Ludwig Rudolph of Braunschweig-Wolfenbüttel, *Tagebuch* (1701), Herzog August Bibliothek, Cod. Guelf. 278 Blank., 135. This mention is part of a list of the books he read in 1701—a reading diary. ["Allerhand Excerpta und Amerkungen so ich aus denen Büchern gezogen die ich geleßen. Angefangen d. 6. September 1699 zu Wolffenbüttel."] These reading excerpts concern Balthasar Gracián, *Criticon von den allgemeinen Lastern des Menschen: Aus dem Frantzösischen ins Teutsche übersetzet* (Frankfurt u. Leipzig: Zeitler, 1698), fol. 1–153v; Epictetus, *Hand-Büchlein: Aus dem Griechischen mit Hülffe der lateinischen . . . in die deutsche Sprache von neuem übersetzet* (Oels: Bockshammer, 1695). See also Cod. Guelf. 280 Blank.; and Cod. Guelf. 286 Blank.

125. Forssmann, *Baltasar Gracián*, 139–48. See Amelot de La Houssaye, *Maxims Translated from a Book Intitled "L'homme de Cour": Or, The Courtier* ([Oxford:] s.n., 1721); *L'Uomo di corte di Baldassar Graziano tradotto dallo spagnuolo nel francese Idioma, dal Signor Amelot de La Houssaie nuovamente tradotto dal francese nell'italiano dall'abate Francesco Tosques* (Rome: Luca-Antonio Chracas, 1698); *L'Uomo di corte di Baldassar Graziano tradotto dallo spagnuolo nel francese Idioma, dal Signor Amelot de La Houssaie nuovamente tradotto dal francese nell'italiano dall'abate Francesco Tosques. Le même: traduit en Russe, par Serge Wolezkow, Secretaire de l'Academie des Sciences. Imprimé pour l'Academie Imperiale des sciences* ([s.l.: s.n.], 1742).

126. Forssmann, *Baltasar Gracián*, 203–15.

127. August Friedrich Müller, *Balthasar Gracians Oracul* (Leipzig: Eysseln, 1717), 406–407: "Diese maxime enthält . . . die klugheit, zu seinen unternehmungen die rechten und bequehmsten zeiten zu erwarten. . . . [Es] ist die rechte zeit, etwas auszuführen, diejenige, in welcher eines theils die fähigkeit und macht, die zu einem unternehmen erfodert wird, zu gnugsamer vollkommenheit gediehen, andern theils aber auch die umstände des glücks der ausführung eines vorhabens am meisten günstig sind. Wo also diese zwey stücke zu einer zeit zusammen kommen, da hat man keine ursache zu warten, sondern viemehr nach dem gemeinen sprichwort das eisen zu schmieden, da es heiß ist."

128. On Thomasius and Gracián, see Forssmann, *Gracian*, 149–88.

129. Julius Bernhard von Rohr, *Einleitung zur Klugheit zu leben* (Leipzig: Martini, 1715), 29.

130. On "the politics of time," see Elisheva Carlebach, *Palaces of Time: Jewish Calendar and Culture in Early Modern Europe* (Cambridge, MA: Belknap Press of Harvard University Press, 2011).

131. M. M. Bakhtin, "Epic and Novel," in *The Dialogic Imagination: Four Essays*, ed. Michael Holquist (Austin: University of Texas Press, 1982), 3–40, 15.

132. The title page of the first (1677) and second (1685) printings bear the title *Octavia: Römische Geschichte*. Only the 1712 Braunschweig edition renders it as *Die Römische Octavia*. See Anton Ulrich, Herzog zu Braunschweig und Lüneburg, *Die Römische Octavia*, vol. 1, part 1, in *Werke: Historisch-Kritische Ausgabe*, vol. 3 (Stuttgart: Anton Hiersemann, 1993–), lxxv–lxxxvi.

133. Stephan Kraft, "Herzog Anton Ulrich," in *Frühe Neuzeit in Deutschland 1620–1720: Literaturwissenschaftliches Verfasserlexikon*, ed. Stefanie Arend et al., vol. 1 (Berlin: Walter de Gruyter, 2019), cols. 240–58.

134. The name of the aristocratic author is not revealed. See Claudius Sittig, "Überlegungen zu einer Literaturgeschichte des Adels in der Frühen Neuzeit," and Christian Wieland, "Nähe, Distanz und Differenz: Reflexionen über Adel und Wissenschaft im Alten Reich der Frühen Neuzeit," in *Die 'Kunst des Adels' in der Frühen Neuzeit*, ed. C. Sittig and Ch. Wieland (Wiesbaden: Harrassowitz, 2018), 127–46 and 171–203, respectively.

135. Stephan Kraft, *Geschlossenheit und Offenheit der "Römischen Octavia" von Herzog Anton Ulrich: "Der Roman macht ahn die ewigkeit gedencken, den er nimbt kein endt"* (Würzburg: Königshausen & Neumann, 2004).

136. Anton Ulrich Herzog zu Braunschweig und Lüneburg, *Die Durchleuchtige Syrerin Aramena*, vol. 1, *Der Erwehlten Freundschaft gewidmet* (Nuremberg: Hofmann, 1678),)()(iiir.

137. Bakhtin, "Epic and Novel," 11.

138. See Koselleck, "Historia Magistra Vitae."

139. Anton Ulrich, *Die Römische Octavia*, vol. 3, part 1, in *Werke* (Stuttgart: Anton Hiersemann, 1997), 280–81.

140. Anton Ulrich, 280.

141. Anton Ulrich, *Die Römische Octavia*, vol. 1, part 1, in *Werke* (Stuttgart: Anton Hiersemann, 1993), 15.

142. Anton Ulrich, *Die Römische Octavia*, vol. 3, part 1, in *Werke* (Stuttgart: Anton Hiersemann, 1997), 5; Anton Ulrich, *Die Römische Octavia*, vol. 3, part 4, in *Werke* (Stuttgart: Anton Hiersemann, 2000), 3: "Es veruhrsachte in Rom so [vieles] [großes] entsetzen als vergnügen"; Anton Ulrich, *Die Römische Octavia*, vol. 4, part 1, in *Werke* (Stuttgart: Anton Hiersemann, 2009), 5: "Rom hatte nicht so viel Furcht und Schrecken bey dem Auflauff empfunden"; Anton Ulrich, *Die Römische Octavia*, vol. 5, part 1, in *Werke* (Stuttgart: Anton Hiersemann, 2011), 5: "Rom sahe sich durch den Todt des Otto nichtes gebessert"; Anton Ulrich, *Die Römische Octavia*, vol. 6, part 1, in *Werke* (Stuttgart: Anton Hiersemann, 2002), 5: "als auf einmahl die geschöpffte Hoffnung von neuem war darnieder gesuncken"; Anton Ulrich, *Die Römische Octavia*, vol. 7, part 1, in *Werke* (Stuttgart: Anton Hiersemann, 2003), 5 takes up the word *fear* (fürchtend). See, however, Anton Ulrich, *Der Römischen Octavia Zweyter Theyl* (Braunschweig: Johann Georg Zilliger, 1712) [not part of the critical edition], which starts differently yet also with mixed emotions.

143. This formulation echoes Ernst Bloch, "Non-contemporaneity and Obligation to Its Dialectic (May 1932)," in *Heritage of Our Times*, trans. Neville Plaice and Stephen Plaice (Cambridge: Polity, 1991), 97.

144. Anton Ulrich, *Aramena*, vol. 1,)()(iiir/v.

145. See M. M. Bakhtin, "Discourse in the Novel," in *The Dialogic Imagination: Four Essays*, ed. Michael Holquist (Austin: University of Texas Press, 1982), 259–422, 396; and Bethany Wiggin, *Novel Translations: The European Novel and the German Book, 1680–1730* (Ithaca, NY: Cornell University Press, 2011).

146. Anton Ulrich, *Die Römische Octavia*, vol. 5, part 3, 712–13.

147. Anton Ulrich, vol. 5, part 3, 696–97, 711.

148. Anton Ulrich, vol. 6, part 1, 31.

149. Anton Ulrich, vol. 1, part 1, 40: "Was aber seinen König betraffe / das verspahrte er / bis er / sich etwas hierüber zu bedenken / Zeit zu gewinnen möchte." Anton Ulrich, vol. 1, part 2, 325–26, 435, 439, 520, 526, etc.; vol. 4, part 3, 660. On this concept see Puff, "Bedenkzeit (spatium deliberationis)."

150. Anton Ulrich, *Die Römische Octavia*, vol. 5, part 4, 865.

151. Anton Ulrich, vol. 5, part 4, 861: "Wie aber einige Stunden darüber verflossen / und ihme die Weile lang zu werden begunte begab er sich . . ."

152. My formulation here alludes to James Thurber, *The Thirteen Clocks* (New York: Penguin, 2016), 2–3.

153. Landwehr, *Die Geburt der Gegenwart*, 289.

154. Anton Ulrich, *Die Römische Octavia*, vol. 3, part 1, 108; Anton Ulrich, vol. 3, part 3, 981, vol. 6, part 1, 29; Anton Ulrich, vol. 5, part 1, 102, vol. 5, part 3, 609; Anton Ulrich, 648 (Vorgemächer); Anton Ulrich, *Die Römische Octavia*, vol. 5,

part 4, in *Werke* (Stuttgart: Anton Hiersemann, 2013), 861.

155. Hugo Harbrecht, "Verzeichnis der von Zesen verdeutschten Lehn- oder Fremdwörter," *Zeitschrift für deutsche Wortforschung* 14 (1912): 1–81, 72.

156. Anton Ulrich, *Die Römische Octavia*, vol. 5, part 3, 648.

157. Anton Ulrich, vol. 3, part 3, 981.

158. Anton Ulrich, vol. 3, part 1, 108–9.

159. Anton Ulrich, vol. 5, part 3, 609.

160. Anton Ulrich, vol. 3, part 3, 981–82.

161. Anton Ulrich, vol. 5, part 3, 108–9.

162. Anton Ulrich, vol. 5, part 1, 102–7.

163. Anton Ulrich, vol. 5, part 3, 708.

164. Anton Ulrich, vol. 5, part 4, 861.

165. Anton Ulrich, vol. 4, part 3, 668.

166. Anton Ulrich, vol. 3, part 1, 109–10.

167. Anton Ulrich, vol. 6, part 1, 160–61.

168. Anton Ulrich, vol. 4, part 3, 651.

169. Christian Thomasius, *Schertz- und ernsthaffter, vernünfftiger und einfältiger Gedancken über allerhand lustige und nützliche Bücher und Fragen* (Halle a.d.S.: Weidmann, 1688–89), 47.

170. Ibid.: "die Aramena und unvergleichliche Octavie, deren letztere[r] völlige Außarbeitung die GALANTE Welt mit Verlangen erwartet / und sich indessen mit einer vergnügenden Hoffnung tröstet."

171. Anton Ulrich, *Die Römische Octavia*, vol. 5, part 1 (Vorbericht an den Leser, xiv): "Derohalben du deine CURIOSITÄT vorerst hiemiet zu CONTENTIREN ersuchet und daneben zugleich versichert wirst / daß mit nächsten besagtes Ende … ohnefehlbar erfolgen soll."

172. "Octavia, Römische Geschichte," in *Acta Eruditorum Anno MDCCVI* (Leipzig: Grosse & Gleditsch, 1706), 333–35, 334.

173. Anton Ulrich, *Aramena*, preface,)()(iiv.

174. Thomasius, *Schertz- und ernsthaffter*, 45, 49.

175. Kiesel, *"Bei Hof, Bei Höll,"* 101, 117.

176. Elisabeth Charlotte von Orléans, *Aus den Briefen der Elisabeth Charlotte von Orléans an die Kurfürstin Sophie von Hannover*, vol. 2 (Hannover: Hahn, 1891), 145. Cited after Kraft, *Geschlossenheit und Offenheit*, 137.

177. Von Orléans, "Es freüdt [mich], daß die OCTAVIA zum endt ist; es war mir bang, es mögte stecken bleiben," in *Aus den Briefen*, xliii (1707).

178. On the role of cameralists and cameralism, see Isabel V. Hull, *Sexuality, State, and Civil Society in Germany, 1700–1815* (Ithaca, NY: Cornell University Press, 1996).

179. Julius Bernhard von Rohr, *Einleitung zur Ceremoniel-Wissenschafft der Privat-Personen* (Berlin: Johann Andreas Rüdiger, 1728), 1. Facsimile by Gotthardt Frühsorge with a general introduction (Leipzig: Edition Leipzig, 1990). See also

G. Frühsorge, "Vom Hof des Kaisers zum 'Kaiserhof': Über das Ende des Ceremoniells als gesellschaftliches Ordnungsmuster," *Euphorion* 78 (1984): 237–65; G. Frühsorge, "Der Hof, der Raum, die Bewegung: Gedanken zur Neubewertung des europäischen Hofzeremoniells," *Euphorion* 82 (1988): 424–29; and Volker Bauer, *Hofökonomie: Der Diskurs über den Fürstenhof in Zeremonialwissenschaft, Hausväterliteratur und Kameralismus* (Wien: Böhlau, 1997).

180. See, e.g., August Bohse, *Der getreue Hoffmeister adelicher und bürgerlicher Jugend* (Leipzig: Gleditsch, 1703), esp. 415–86. While alerting his readership to the specific circumstances and instilling a sense of caution in interactions of all kinds (which are said to be useful and instructive), the author also supplies concrete formulae for conversation and written communication at court for both aristocrats and nonaristocrats.

181. Von Rohr, *Ceremoniel-Wissenschafft der Privat-Personen*, 221–22.

182. Von Rohr, 7.

183. Von Rohr, preface and passim (see also frontispiece).

184. Von Rohr, 209.

185. Von Rohr, 202.

186. Von Rohr, 243–44.

187. Von Rohr, 3–7.

188. Jenny Erpenbeck, "Time: Berlin Academy of the Arts Induction Speech," in *Not a Novel: A Memoir in Pieces*, trans. Kurt Beals (New York: New Directions, 2020), 42–44, 42: "Time has the power to separate us, not only from others, but also from ourselves."

189. For an excellent example, see Arthur E. Imhof, *Lost Worlds: How Our European Ancestors Coped with Everyday Life and Why Life Is so Hard Today*, trans. Thomas Robisheaux (Charlottesville: University Press of Virginia, 1996).

190. On the need to address early moderns as individuals, see Lyndal Roper, introduction to *Oedipus and the Devil: Witchcraft, Sexuality, and Religion in Early Modern Europe* (London: Routledge, 1994), 1–34; Lyndal Roper, *Witch Craze: Terror and Fantasy in Baroque Germany* (New Haven, CT: Yale University Press, 2004); and Jamie Page, *Prostitution and Subjectivity in Late Medieval Germany* (Oxford: Oxford University Press, 2021), 1–25.

191. Sampson, "Conceptions of Temporality."

Chapter 2. Spaces

1. Marvin Trachtenberg, *Building-in-Time from Giotto to Alberti and Modern Oblivion* (New Haven, CT: Yale University Press, 2010).

2. Joseph Rykwert, *On Adam's House in Paradise: The Idea of the Primitive Hut in Architectural History* (Greenwich, CT: Museum of Modern Art, 1972). See also the hut as an exilic refuge in Dieter Roelstraete, *Machines à penser* (Milan: Fondazione Prada, 2018), based on an exhibition at the 2018 Architecture Biennale, and

"Hutopia," an exhibit at the Neubauer Collegium for Culture and Society, University of Chicago, 2019.

3. Niall Atkinson, *The Noisy Renaissance: Sound, Architecture, and Florentine Urban Life* (University Park: Pennsylvania State University Press, 2016), 1–16, 201–14, and passim. With regard to particular spaces, see Susanne Jany, "Operative Räume: Prozessarchitekturen im späten 19. Jahrhundert," *Zeitschrift für Medienwissenschaft* 7, no. 1 (2015): 33–43; and Susanne Jany, *Prozessarchitekturen: Medien der Betriebsorganisation (1880–1936)* ([Göttingen]: Konstanz University Press, 2019).

4. Henri Lefebvre, *The Production of Space*, trans. Donald Nicholson-Smith (Oxford: Blackwell, 1991), 209.

5. Nobert Elias, *The Court Society*, trans. Edmund Jephcott (New York: Pantheon, 1983), 47; Nobert Elias, *Die höfische Gesellschaft*, 4th ed. (Frankfurt am Main: Suhrkamp, 1989), 76. On Elias's study, see Jeroen Duindam, *Myths of Power: Norbert Elias and the Early Modern European Court*, trans. Lorri S. Granger and Gerard T. Morgan (Amsterdam: Amsterdam University Press, 1994); and Jeroen Duindam, "Norbert Elias and the History of the Court: Old Questions, New Perspectives," in *Hof und Theorie: Annäherungen an ein historisches Phänomen*, ed. Reinhardt Butz, Jan Hirschbiegel, and Dietmar Willoweit (Cologne: Böhlau, 2004), 91–104.

6. Elias, *The Court Society*, 48; Elias, *Die höfische Gesellschaft*, 78. See also Jonathan Dewald, *Aristocratic Experience and the Origins of Modern Culture: France, 1570–1715* (Berkeley: University of California Press, 1993); and Jonathan Dewald, *The European Nobility, 1400–1800* (Cambridge: Cambridge University Press, 1996).

7. Hubert Ehalt, *Ausdrucksformen absolutistischer Herrschaft: Der Wiener Hof im 17. und 18. Jahrhundert* (Munich: Oldenbourg, 1980); Christina Hofmann, *Das spanische Hofzeremoniell von 1500–1700* (Frankfurt am Main: Peter Lang, 1985); Aloys Winterling, *Der Hof der Kurfürsten von Köln 1688–1794: Eine Fallstudie zur Bedeutung 'absolutistischer' Hofhaltung* (Bonn: L. Röhrscheid, 1986); Gotthard Frühsorge, "Der Hof, der Raum, die Bewegung. Gedanken zur Neubewertung des europäischen Hofzeremoniells," *Euphorion* 82 (1988): 424–29; Volker Bauer, *Die höfische Gesellschaft in Deutschland von der Mitte des 17. bis zum Ausgang des 18. Jahrhunderts* (Tübingen: Niemeyer 1993); Nicholas Henshall, "Early Modern Absolutism, 1550–1700: Political Reality or Propaganda?" in *Der Absolutismus—ein Mythos: Strukturwandel monarchischer Herrschaft in West- und Mitteleuropa (ca. 1550–1700)*, ed. Ronald G. Asch and Heinz Duchhardt (Cologne: Böhlau 1996), 25–52; Volker Bauer, *Hofökonomie: Der Diskurs über den Fürstenhof in Zeremonialwissenschaft, Hausväterliteratur und Kameralismus* (Vienna: Böhlau, 1997); Andreas Pečar, *Die Ökonomie der Ehre: Höfischer Adel am Kaiserhof Karls VI.* (Darmstadt: Wissenschaftliche Buchgesellschaft, 2003); Rudolf Schlögl, "Der frühneuzeitliche Hof als Kommunikationsraum: Interaktionstheoretische Perspektiven der Forschung," in

Geschichte und Systemtheorie: Exemplarische Fallstudien, ed. Frank Becker (Frankfurt am Main: Campus, 2004), 185–225; Mark Hengerer, *Kaiserhof und Adel in der Mitte des 17. Jahrhunderts* (Constance: Universitätsverlag Konstanz, 2004); Leonhard Horowski, *Die Belagerung des Thrones: Machtstrukturen und Karrieremechanismen am Hof von Frankreich 1661–1789* (Ostfildern: Jan Thorbecke, 2012).

8. Lewis Mumford, *The City in History: Its Origins, Its Transformations, and Its Prospects* (San Diego, CA: Harcourt, 1961), 368. See also Jürgen Habermas, *The Structural Transformation of the Public Sphere: An Inquiry into a Category of Bourgeois Society*, trans. Thomas Burger (Cambridge, MA: MIT Press, 1989), 5–12; Hedda Ragotzky and Horst Wenzel, eds., *Höfische Repräsentation: Das Zeremoniell und Zeichen* (Tübingen: Niemeyer, 1990), 1–9.

9. Duncan Bell and Bernardo Zacka, eds., introduction to *Political Theory and Architecture* (London: Bloomsbury Academic, 2020), 1–17.

10. Samuel Johnson, *A Dictionary of the English Language*, 6th ed. (London: Rivington etc., 1785), s.v. "antechamber" and "antichamber." See also Monique Chatenet, "Architecture et cérémonial à la cour de Henri II: L'apparition de l'antichambre," in *Henri II et les arts: Actes du colloque international: École du Louvre et musée national de la Renaissance—Écouen. 25, 26 et 27 septembre 1997*, ed. Hervé Oursel and Julia Fritsch (Paris: École du Louvre, 2003), 355–80; William Jervis Jones, *A Lexicon of French Borrowings in the German Vocabulary (1575–1648)* (Berlin: Walter de Gruyter, 1976), 103–4.

11. Werner Sombart, *Der Moderne Kapitalismus: Historisch-systematische Darstellung des gesamteuropäischen Wirtschaftslebens von seinen Anfängen bis zur Gegenwart* (Munich: Duncker & Humblot, 1924–28), vol. 1.2, 721.

12. Gottfried Kerscher, *Architektur als Repräsentation: Spätmittelalterliche Palastbaukunst zwischen Pracht und zeremoniellen Voraussetzungen: Avignon, Mallorca, Kirchenstaat* (Tübingen-Berlin: Wasmuth, 2000), 17.

13. Elias, *The Court Society*, 39; Randolph Starn and Loren Partridge, *Arts of Power: Three Halls of State in Italy, 1300–1600* (Berkeley: University of California Press, 1992), 3; Gottfried Kerscher, "Privatraum und Zeremoniell im spätmittelalterlichen Papst- und Königspalast: Zu den Montefiascone-Darstellungen von Carlo Fontana und einem Grundriss des Papstpalastes von Avignon," *Römisches Jahrbuch der Bibliotheca Hertziana* 26 (1990): 87–134, 103; Kerscher, *Architektur als Repräsentation*, 445–46.

14. Kerscher, *Architektur als Repräsentation*, 220, speaks of complexity. The term *palatium* was first used in regard to the residence of Roman Emperor Domitian (r. 81–96) on the Palatine hill. See Starn and Partridge, *Arts of Power*, 1.

15. Stefan Weiß, *Die Versorgung des päpstlichen Hofes in Avignon mit Lebensmitteln (1316–1378): Studien zur Sozial- und Wirtschaftsgeschichte eines mittelalterlichen Hofes* (Berlin: Akademie, 2002), 322. Kerscher, *Architektur als Repräsentation*, 169, takes issue with the description of the Avignon palace as a monastery.

16. Stefan Weiß, "Die Rolle der Damen am päpstlichen Hof von Avignon," in *Das Frauenzimmer: Die Frau bei Hofe in Spätmittelalter und früher Neuzeit*, ed. Jan Hirschbiegel and Werner Paravicini (Stuttgart: Jan Thorbecke, 2000), 401–9.

17. Starn and Partridge, *Arts of Power*, 2 (with literature).

18. The Latin word would have been *secreta*.

19. Gary M. Radke, "Form and Function in Thirteenth-Century Papal Palaces," in *Architecture et vie sociale: L'organisation intérieure des grandes demeures à la fin du moyen âge et à la Renaissance: Actes du colloque tenu à Tours du 6 au 10 juin 1988*, ed. Jean Guillaume (Paris: Picard, 1994), 11–24.

20. Diane Wolfthal, "When Did Servants Become Men?" in *Rivalrous Masculinities: New Directions in Medieval Masculinity Studies*, ed. Ann Marie Rasmussen (Notre Dame, IN: Notre Dame University Press, 2019), 174–208.

21. Marta Van Landingham, *Transforming the State: King, Court and Political Culture in the Realms of Aragon (1213–1387)* (Leiden: Brill, 2002), 170, 211 ("First Ordinances of Pere the Great"). The date is 1277, though likely it was a living document.

22. Marc Dykmans, *Le cérémonial papal de la fin du Moyen Age à la Renaissance*, vol. 3 (Bruxelles: Institute Historique Belge de Rome, 1983), 421, 439 (the published document with the offices at the papal court dates to 1409, though it is best to see it as a living document). See also Kerscher, *Architektur als Repräsentation*, 100n302.

23. In times of the plague, when the pope took refuge elsewhere, the throngs were missing, as a papal official noted in 1406. "Le diaire de François de Conzié," in Dykmans, *Le cérémonial papal*, 356–408, 380.

24. Kerscher, *Architektur als Repräsentation*, 220–22.

25. For the court of Aragon during the same period, the account books enable us to estimate how many people were employed at court in the 1340s (which is not to say they lived at court): 220 in Barcelona, 150 in Majorca. See Marcel Durliat, "La importànca numérica de la cort de Jaume III," in Jaume III Rei de Mallorca, *Lleis Palatines*, ed. Llorenç Pérez Martinez et al., vol. 1 (Palma de Mallorca: José J. de Olañeta, 1991), 49–53; Joan Domenge I Mesquida, preface to James III, King of Majorca, *Leges Palatinae* (Bloomington: Indiana University Press, 1994; in association with José J. de Olañeta, 1994), 10. For Avignon, Kerscher (*Architektur als Repräsentation*, 103) speaks of 240 familiares, an unknown number of milites, and 76 scutiferi in the year 1333, that is, before a marked expansion; he estimates 150–300 employees.

26. Maureen C. Miller, *The Bishop's Palace: Architecture and Authority in Medieval Italy* (Ithaca, NY: Cornell University Press, 2000). Avignon was Jacques Arnaud Duèse's bishopric between 1310 and 1313, before he was elected pope in 1316 (John XXII). His predecessor on the Holy See, Pope Clement V, took residence in Avignon occasionally.

27. Kerscher, *Architektur als Repräsentation*, 21–22. Weiß, *Die Versorgung*, 450–515, lists those who enjoyed the popes' hospitality.

28. An overview is in Kerscher, *Architektur als Repräsentation*, 99–162.

29. Kerscher, 147.

30. Kerscher, 144–45, 220.

31. Kerscher, 110. In fact, the garden was one of the first changes, ca. 1335.

32. The width would have been ca. three meters.

33. According to Kerscher, *Architektur als Repräsentation*, 262, the word first appeared in Catalan in the early thirteenth century. See also Bertrand Jestaz, "Étiquette et distribution intérieure dans les maisons royales de la Renaissance," *Bulletin monumental* 146 (1988): 109–20, 109. On this word, see Kerscher, *Architektur als Repräsentation*, 16; Christoph Luitpold Frommel, *Der Römische Palastbau der Hochrenaissance*, vol. 1 (Tübingen: Ernst Wasmuth, 1973), 82–84 (on the history of the word in the sixteenth century when it came to designate where servants in the household had their meals).

34. Jestaz quotes François Conzié's diary regarding the *camera paramenti* that one did not sleep there.

35. Kerscher, *Architektur als Repräsentation*, 103. Other episcopal palaces from the medieval period do not seem to have this feature; see, e.g., David Rollason, ed., *Princes of the Church: Bishops and Their Palaces* (London: Routledge, 2017).

36. Kerscher, *Architektur als Repräsentation*, 480–83 and 199–205.

37. Bernhard Schimmelpfennig, "Der Einfluss des avignonesischen Zeremoniells auf den Vatikanspalast seit Nikolaus V.," in *Functions and Decorations: Art and Ritual at the Vatican Palace in the Middle Ages and the Renaissance*, ed. Tristan Weddigen, Sible de Blaauw, and Bram Kempers (Turnhout: Brepols, 2003), 41–45.

38. This included the question of whether officeholders were living in the palatium or elsewhere.

39. Certain elements in the room décor such as tiles and frescoes substantiate this connection on stylistic grounds. See Kerscher, *Architektur als Repräsentation*, tables 5 and 6; see also his discussion of these structures as a whole (225–337).

40. Marcel Durliat, *L'art dans le royaume de Majorque: Les débuts de l'art gothique en Roussillon, en Cerdogne et aux Baléares* (Toulouse: Privat, 1962), 220; Kerscher, *Architektur als Repräsentation*, 263, 332. Kerscher (*Architektur als Repräsentation*, 123–25) also uses the term *anticamere* to describe this built ensemble (with further literature in note 431).

41. Kerscher, *Architektur als Repräsentation*, 219.

42. On the question of how Avignon shaped the Vatican Palace, see Weddigen, Blaauw, and Kempers, *Functions and Decorations*; and Kerscher, *Architektur als Repräsentation*, 335–444.

43. Cécile Beuzelin, *L'anticamera' Benintendi: Morale et politique dans la peinture domestique à Florence vers 1523* (Florence: Leo S. Olschki, 2015).

44. See Jestaz, "Étiquette et distribution," 111–12, on the genesis of the term in Italy and its introduction in France.

45. See Wolfger Bulst, "Uso e trasformazione del Palazzo Mediceo fino ai Ric-

cardi," in *Palazzo Medici Riccardi*, ed. Giuseppe Cherubini (Florence: Giunti, 1990), 98–129; Katja Kwastek, *Camera: Gemalter und realer Raum der italienischen Frührenaissance* (Weimar: VDG, 2011), 174–81.

46. Monique Chatenet, "Architecture et cérémonial," 355–80.

47. See Tülay Artan, Jeroen Duindam, and Metin Kunt, eds., *Royal Courts in Dynastic States and Empires: A Global Perspective* (Leiden: Brill, 2011); and Sheila S. Blair and Jonathan M. Bloom, *The Art and Architecture of Islam* (New Haven, CT: Yale University Press, 1994), 37–54.

48. William H. Coaldrake, *Architecture and Authority in Japan* (London: Routledge, 1996), 138–56.

49. Avner Wishnitzer, *Reading Clocks, Alla Turca: Time and Society in Late Ottoman Turkey* (Chicago: University of Chicago Press, 2015), 41.

50. Richard Trexler, *Public Life in Renaissance Florence* (Ithaca, NY: Cornell University Press, 1992), 170.

51. Dale V. Kent and F. W. Kent, "Two Vignettes of Florentine Society in the Fifteenth Century," *Rinascimento* 23 (1983): 237–60, 252–60. See also Lauro Martines, *April Blood: Florence and the Plot against the Medici* (Oxford: Oxford University Press, 2003).

52. Kent and Kent, "Two Vignettes," 90.

53. Atkinson, *The Noisy Renaissance*, 133.

54. Frommel, *Der Römische Palastbau*, 54.

55. Yvonne Elet, "Seats of Power: The Outdoor Benches of Early Modern Florence," *Journal of the Society of Architectural Historians* 61 (2002): 444–69; Fabrizio Nevola, *Siena: Constructing the Renaissance City* (New Haven, CT: Yale University Press, 2007); Fabrizio Nevola, "Home Shopping: Urbanism, Commerce, and Palace Design in Renaissance Italy," *Journal of the Society of Architectural Historians* 70 (2011): 153–73.

56. During processions and similar urban rituals, the panche offered a heightened position from which bystanders could follow a spectacle, as a sixteenth-century painting of the Via Larga (now Via Cavour) with the Palazzo Medici shows. See Giovanni Stradano, "Via Larga with the Play of the Joust of the Saracens, ca. 1561–62," in Elet, "Seats of Power," 457.

57. Janette Dillon, *The Language of Space in Court Performance, 1400–1625* (Cambridge: Cambridge University Press, 2010), 79.

58. *Ensuyvent les reglemens faicts par le roy, le premier iour de Ianvier mil cinq cens quatre vingts cinq* ([Paris: n.p.,] 1585), 20: "Sa Majesté declare qu'elle veut qu'il soit porté tel respect en ses antichambre, chambres et cabinets, qu'encores que les portes soyent ouvertes, nu n'y entre que suivante le reglement sur ce fait." For England, see Hugh Murray Baillie, "Etiquette and the Planning of the State Apartments in Baroque Palaces," *Archaelogia or Miscellaneous Tracts Related to Antiquity* 101 (1967): 169–99, 175–76.

59. *Reglements faicts par le roy*, 21: "toute modestie, tant en gestes, qu'en parolles,

et nul aussi ne portera de chappeau aux antichambre, chambres, et cabinets de sa Majesté, ains des bonnets."

60. *Reglements faicts par le roy*, 20: "SA Majesté ordonne aussi que nul ne s'assoyera en sa presence, en ses salle, antichambre, chambre et cabinets, si elle ne les commande ou permet."

61. Robert J. Knecht, *The French Renaissance Court, 1483–1589* (New Haven, CT: Yale University Press, 2008), 286.

62. Jestaz, "Étiquette et distribution," 112: "et quand il voudra se retirer en sondit cabinet pour regarder aux affaires de son royaume, que nul, quel, qu'il soit, n'y entre que ceux qu'il fera appeller particulièrement." Knecht portrays Henri III as an avid worker who rose early to work; see *The French Renaissance Court*, 284. That this idiom was not unique to the French court is evidenced from the detailed regulation preserved for sixteenth-century Graz, where access to the inner chambers of the prince were reserved for the head chamberlain, state councilors, the head equerry, and "cammerpersonen." See Mark Hengerer, *"Verzaichnus, wie [...] durch die cammerpersonen gediennt würdet*: Edition einer Beschreibung des Kammerdienstes am Grazer Hof des 16. Jahrhunderts aus dem Bayerischen Hauptstaatsarchiv München," *Zeitschrift des Historischen Vereines für Steiermark* 105 (Graz 2014): 45–91, 72–73.

63. Jestaz, "Étiquette et distribution," 118 (1585); Dillon, *Language of Space*, 76–102.

64. In the French case, the first surviving document of this kind dates to 1567. See Jestaz, "Étiquette et distribution," 113.

65. Jean Bodin, *Les six livres de la république* [edition Paris, 1583] (Aalen: Scientia, 1961), 122–61, 211–51 (book 1, chaps. 8 and 10). "Princeps legibus solutus" is a principle first formulated by the Roman jurist Ulpian.

66. Knecht, *The French Renaissance Court*, 19, 76, 106, 122–23.

67. On the word, see Nicolas Le Roux, *La faveur du roi: Mignons et courtisans au temps des derniers Valois* (Paris: Champ Vallon, 2001), 263–66.

68. Jestaz, "Étiquette et distribution," 112. See also Le Roux, *La faveur du roi*; Katherine B. Crawford, "Love, Sodomy, and Scandal: Controlling the Sexual Reputation of Henry III," *Journal of the History of Sexuality* 12 (2003): 513–42; Ronald G. Asch, "'Lumine solis': Der Favorit und die politische Kultur des Hofes in Westeuropa," in *Der zweite Mann im Staat: Oberste Amtsträger und Favoriten im Umkreis der Reichsfürsten in der Frühen Neuzeit*, ed. Michael Kaiser and Andreas Pečar (Berlin: Duncker & Humblot, 2003), 21–38, 29–31.

69. Knecht, *The French Renaissance Court*, 297.

70. Knecht, 280–304; Monique Chatenet, "Henri III et 'L'ordre de la cour': Evolution de l'étiquette à travers les règlements généraux de 1578 et 1585," in *Henri III et son temps*, ed. Robert Sauzet (Paris: Librairie Philosophique J. Vrien, 1992), 133–39; Le Roux, *La faveur du roi*; Una McIlenna, "'A Stable of Whores'? The 'Flying

Squadron' of Catherine de Medici," in *The Politics of Female Households: Ladies-in-Waiting across Early Modern Europe*, ed. Nadine Akkerman and Birgit Houben (Leiden: Brill, 2013), 181–208, 205–8.

71. Françoise Boudon and Monique Chatenet, "Les logis du roi de France au XVIe siècle," in *Architecture et vie sociale: L'organisation intérieure des grandes demeures à la fin du moyen âge et à la Renaissance: Actes du colloque tenu à Tours du 6 au 10 juin 1988*, ed. Jean Guillaume (Paris: Picard, 1994), 65–82, 73–74.

72. Mary Whiteley, "Royal and Ducal Palaces in France in the Fourteenth and Fifteenth Centuries: Interior, Ceremony and Function," in *Architecture et vie sociale: L'organisation intérieure des grandes demeures à la fin du moyen âge et à la Renaissance: Actes du colloque tenu à Tours du 6 au 10 juin 1988*, ed. Jean Guillaume (Paris: Picard, 1994), 47–63, 50; Pauline M. Smith, *The Anti-courtier Trend in 16th C. French Literature* (Geneva: Droz, 1996); Le Roux, *La faveur du roi*, 199–204, 622–27, 650–70.

73. Peter Thornton, *Interior Decoration in England, France and Holland* (New Haven, CT: Yale University Press, 1978), 282.

74. Nicolas Milovanovic, *L'Antichambre du Grand Couvert: Fastes de la table et du décor à Versailles* (Montreuil: Gourcuff Gradenigo, 2010), 18.

75. Samuel John Klingensmith, *The Utility of Splendor: Ceremony, Social Life, and Architecture at the Court of Bavaria, 1600–1800*, ed. by Christian F. Otto (Chicago: University of Chicago Press, 1993), 115.

76. Peter Thornton, *The Italian Renaissance Interior, 1400–1600* (New York: H. N. Adams, 1991), 294.

77. Patricia Waddy, "The Roman Apartment from the Sixteenth to the Seventeenth Century," in *Architecture et vie sociale: L'organisation intérieure des grandes demeures à la fin du moyen âge et à la Renaissance: Actes du colloque tenu à Tours du 6 au 10 juin 1988*, ed. Jean Guillaume (Paris: Picard, 1994), 155–66, 160; Jeffrey Collins, "Europe, 1600–1750," in *History of Design: Decorative Arts and Material Culture, 1400–2000*, ed. Pat Kirkham and Susan Weber (New York: Bard Graduate Center, 2013), 230–76, 234.

78. Baillie, "Etiquette and the Planning of the State Apartments," 180. For the different terminology used in England, in keeping with the tradition of royal households, and its evolutions, see 172–81.

79. Winterling, *Hof der Kurfürsten*, 79–80.

80. Klingensmith, *The Utility of Splendor*, 12.

81. Baillie, "Etiquette and the Planning of the State Apartments," 182–93.

82. Klingensmith, *The Utility of Splendor*, appendix 4, 216–17.

83. Julius Bernhard von Rohr, *Einleitung zur Ceremoniel-Wissenschafft der großen Herren* (Berlin: Johann Andreas Rüdiger, 1733), 73.

84. Magnus Backes, *Julius Ludwig Rothweil: Ein Rheinisch-Hessischer Barockarchitekt* (Baden-Baden/Strasbourg: Heitz, 1959), 16–17; Jens Friedhoff, "'Mag-

nificence' und 'Utilité': Bauen und Wohnen," in *Geschichte des Wohnens*, ed. Ulf Dirlmeier (Stuttgart: Deutsche Verlagsanstalt, 1998), 591–98. Pyrmont was an enclave, not contiguous with the territory of Waldeck. See Dieter Alfter, *Schloss Pyrmont* (Munich: Schnell & Steiner, 1988); Hans Härtel, *Schloss Pyrmont* (Berlin: Deutscher Kunstverlag, 1962); Hans-Henning Grote, "'Grosser Herren Palläste . . .': Schlösser im Fürstentum Braunschweig-Wolfenbüttel," in *Hermann Korb und seine Zeit: 1656–1735: Barockes Bauen im Fürstentum Braunschweig-Wolfenbüttel*, ed. Museum im Schloss Wolfenbüttel (Braunschweig: Appelhans, 2006), 77–124, 82–83, 89.

85. Johann Philipp Seipp, *Neue Beschreibung der Pyrmontischen Gesund-Brunnen* (Hanover: Förster, 1717). See also Reinhold P. Kuhnert, *Urbanität auf dem Lande: Badereisen nach Pyrmont im 18. Jahrhundert* (Göttingen: Vandenhoeck & Ruprecht, 1984), 94–145; and Mary Lindemann, *Liaisons dangereuses: Sex, Law, and Diplomacy in the Age of Frederick the Great* (Baltimore: Johns Hopkins University Press, 2006), 63.

86. Lindemann, *Liaisons dangereuses*, 38.

87. StAM [Staatsarchiv Minden] 118/3315, "Tapete über alle mit ohl farbe mit hübschen Landschaften und Laubwerck gemählet."

88. Dieter Alfter, ed., *Festung und Schloß Pyrmont: Restaurierung und neue Nutzung: Anläßlich der Eröffnungsfeier 29. Mai–1. Juni 1987* (Bad Pyrmont: Museum im Schloß, 1987), 28–29.

89. As applied emblems, the emblems in Pyrmont consist only of mottos and picturae; they lack epigrams that would have deepened the themes they tackle. But this was common. See W. J. T. Mitchell, *Picture Theory: Essays in Verbal and Visual Representation* (Chicago: University of Chicago Press, 1994), 5, 83, 152.

90. [Heinrich Offelen and Daniel de La Feuille], *Devises et emblemes Anciennes et Modernes tirées des plus celebres Auteurs Oder: Emblematische Gemüths-Vergnügung Bey Betrachtung Sieben Hundert und funffzehen der curieusesten und ergötzlichsten Sinn-Bildern / Mit ihren zuständigen Teutsch-Lateinisch-Französisch- und Italianischen Beyschrifften*, 4th ed. (Augsburg: Kroniger & Göbel, 1699), 23, emblem 9. The other languages offered are "Ingenio experiar" (Latin); "J'en profiterai par mon esprit" (French); and "Durch List und Verschlagenheit" (German).

91. *Devises et emblemes*, 23, emblem 9: "Eine Krehe läßt in ein mit Oel gefülltes Gefäß Steine fallen / Damit das Oel überlauffen und sie trincken könne" (A crow drops stones into a vessel filled with oil, so that the oil runs over and she may drink). This is the explanation offered.

92. Ingrid Höpel and Simon McKeown, eds., *Emblems and Impact: Von Zentrum und Peripherie der Embleme* (New Castle upon Tyne: Cambridge Scholars Publishing, 2017).

93. *Devises et emblemes*, 39, emblem 6: "La virtù m'ha inalzata": "Evexit at aethera virtus" (Lat.); "La vertu m'a élevée" (Fr.); "Die Tugend erhebt biß in den Himmel" (Ger.).

94. *Devises et emblemes*, 21, emblem 15. In other languages "Hostis adest"; "Guardatevi, il Nemico è vicino"; and "Der Feind ist vorhanden." The explanation simply says "Eine Gans auf einem Thurn" (A goose on a tower).

95. *Devises et emblemes*, 23, emblem 11. In other languages "Labor omnibus unus"; "Elles travaillent qu'à la même chose"; "Sie verrichten alle einerley Arbeit." The explanation offered is "Ein Immen-Korb zusamt den Bienen" (A beehive with bees).

96. In addition to the one cited below, also *Devises et emblemes*, 24, emblem 8. "Fatis contraria fata" or fate generates its own opposition, a quote from Vergil's *Aeneid*, see *P. Vergili Maronis Opera*, ed. R. A. B. Mynors (Oxford: Clarendon, 1969), 1.238–39: "hoc equidem occasum Troiae tristisque ruinas / solabar fatis contraria fata rependens." The pictura with a phoenix rising from the ashes clarifies what this emblem implies, a radical reversal of fates as in rebirth and renewal. The German translation in *Devises et emblemes* has it as "Life out of death" (Aus dem Tod das Leben).

97. *Devises et emblemes*, 19, emblem 3. In other languages "Neque retrogradior, neque devio"; "Je ne recule point, et ne sourvoye point"; "Ich gehe weder zuruck noch auf die Seite."

98. *Devises et emblemes*, 32, emblem 13. "Est modus in rebus"; "Il en faut user sobrement"; "Bisogna usarne sobriamente"; "Halte Maaß in allen Dingen." The pictura shows a table on which three glasses are arranged in an orderly fashion, placed on a tree-lined avenue in a park. The nexus of *temperantia* (measure) and *tempus* (time), evident to speakers of Latin, was explored in the previous chapter. The three chalices probably refer to the mixing of wine with water, an attribute of the allegory of Temperance.

99. Sabine Mödersheim, *'Domini Doctrina Coronat': Die geistliche Emblematik Daniel Cramers (1568–1637)* (Frankfurt am Main: P. Lang, 1994), 124–27.

100. *Devises et emblemes*, 33, emblem 3. In other languages "Fata viam invenient"; "Il mio destino mene farà uscire"; "Gott wird mich schon leiten."

101. In the German context, Henriette Adelaide of Savoy (1636–76), wife of Elector Ferdinand Maria of Bavaria, had her rooms in the Munich Residenz adorned with emblems on marital themes, whereas rooms used for public functions invoked love, loyalty, and virtues. See also Gerhard Strasser and Mara R. Wade, *Die Domänen des Emblems: Außerliterarische Anwendungen der Emblematik* (Wiesbaden: Harrassowitz, 2004); Sabine Mödersheim, "The Emblem in the Context of Architecture," in *Emblem Scholarship: Directions and Developments*, ed. Peter M. Daly and Gabriel Hornstein (Turnhout: Brepols, 2005), 159–75.

102. Geoffrey Tyack, "Round Reading Rooms: The Architecture of the Herzog August Bibliothek and the Radcliffe Camera" (2019), https://hab.bodleian.ox.ac.uk/de/blog/blog-post-9.

103. Grote, "'Grosser Herren Palläste,'" 82.

104. Korb traveled to Italy at least twice, which is mentioned on his tomb-

stone in St. Johannis Church, Wolfenbüttel ("Italien machte ihn in seiner Kunst vollkommen"—Italy made him perfect in his art). If he was involved in the selection of emblems' languages in Pyrmont, this may have something to do with the selection of Italian mottos. It also reflects the status of Italian as a language of courtly interaction. See Simon Paulus, "'Dass solche Bestallung auff seine Lebenszeit . . .': Zur Biographie Hermann Korbs," in *Hermann Korb und seine Zeit: 1656–1735: Barockes Bauen im Fürstentum Braunschweig-Wolfenbüttel*, ed. Museum im Schloss Wolfenbüttel (Braunschweig: Appelhans, 2006), 51–62, esp. 57–60.

105. Tintoretto, "The Dreams of Men" (mid-16th century) (Detroit Institute of Arts, inv. 23.11). This painting with Saturn, the god of time, his son *Occasio*, and allegories of wealth, love, and fame captures this ethics well. It once decorated the ceiling of the palace of the Barbo family in Venice.

106. Merry E. Wiesner-Hanks, "Female Rule in the Courtly States of the Early Modern World," in *Women—Books—Courts: Knowledge and Collecting before 1800*, ed. Volker Bauer, Elizabeth Harding, Gerhild Scholz Williams, and Mara R. Wade (Wiesbaden: Harrassowitz, 2018), 175–84; Annegret Huber and Benjamin Meyer, *Wilhelmine von Bayreuth (1709–1748): Kunst als 'Staatsgeschäft': Vorträge des Wiener Symposiums aus Anlass des 300. Geburtstags / 250. Todestags der Markgräfin* (Vienna: Mille Tre, 2014).

107. Wilhelmine, *Mémoires de Frédérique Sophie Wilhelmine, Margrave de Bayreuth, Soeur de Frédéric-Le-Grand, Depuis l'année 1706 Jusqu'à 1742, Écrits de Sa Main*, ed. Pierre Gaxotte and Gérard Doscot (Paris: Mercure de France, 1967), 332: "plans pour embellir et rendre cet endroit commode"; Wilhelmine, *Memoirs*, trans. Christian of Schleswig Holstein (New York: Harper & Bros., 1888), 382. The description in Wilhelmine's memoirs captures a snapshot. Her artistic vision was never fully carried out and changed until 1758, the year of her death. An overall assessment of Wilhelmine's projects in Bayreuth in Gerhard Hojer and Peter O. Krückmann, *Anton Raphael Mengs: Königin Semiramis erhält die Nachricht vom Aufstand in Babylon* (Munich: Bayerische Verwaltung der Staatlichen Schlösser, 1995).

108. Peter O. Krückmann, Johannes Erichsen, Kurt Grübel, and Cordula Mauss, *Die Eremitage in Bayreuth* (Munich: Bayerische Schlösserverwaltung, [2019]), 33–42.

109. In the New Residence (Neue Residenz) in the town of Bayreuth, the seat of the territorial administration, erected after 1753, the margrave and the margravine's apartments each had two antechambers as was common. Wilhelmine's first antechamber featured sixteen portraits of members of her family, the royal Hohenzollern, whereas Friedrich's first antechamber featured sixteen portraits with imperial connections (Kaiser-Familienzimmer). See Erich Bachmann and Alfred Ziffer, *Neues Schloss Bayreuth* (Munich: Bayerische Verwaltung der Staatlichen Schlösser, 1995), 65, 90.

110. Stefano Torelli, "Chilonis und Kleombrotos gehen ins Exil," 1740.

111. Cordula Bischoff, "Zur Kunstpolitik der Wilhelmine von Bayreuth," in *Wilhelmine von Bayreuth (1709–1758): Kunst als 'Staatsgeschäft': Vorträge des Wiener Symposiums aus Anlass des 300. Geburtstags / 250. Todestags der Markgräfin* (Vienna: Mille Tre, 2014), 73–99. See also Lorenz Seelig, *Friedrich und Wilhelmine: Die Kunst am Bayreuther Hof 1732–1763* (Munich: Schnell und Steiner, 1982).

112. Wilhelmine, *Mémoires*, 347: "j'aime tout ce qui est speculatif"; Wilhelmine, *Memoirs*, 401.

113. Wilhelmine, *Mémoires*, 346: "j'ai trouvé l'invention"; Wilhelmine, *Memoirs*, 400.

114. The Grand Appartement of the queen at Versailles had a comparable focus. See Nicolas Milovanovic, *L'Antichambre du Grand Couvert: Fastes de la table et du décor à Versailles: Splendours of Table and Décor at Versailles* (Montreuil: Gourcuff Gradenigo, 2010), 60.

115. Wilhelmine, *Memoirs*, 401.

116. The English translation renders this as "allegories."

117. Wilhelmine, *Mémoires*, 347: "réjoui la vue"; Wilhelmine, *Memoirs*, 401. Many of the scenes depicted can be traced back to Plutarch's *Lives*, "Alexander," vol. 1 (Cambridge, MA: Harvard University Press, 1914), 224–25.

118. Wilhelmine, *Mémoires*, 345: "une chambre, dont la peinture représente au plafond les dames romaines lorsqu'elles arrachèrent la ville de Rome au pillage des ennemis"; Wilhelmine, *Mémoires*, 399. It is not entirely clear which historical event this refers to. There are several possibilities. If it is Plutarch (Plut. Cam. xxx), then women are mentioned in this context in passing (390 BCE). But they are not given the role as brokers of peace that is accorded them here. See Plutarch, *Lives*, vol. 2, *Themistocles and Camillus* (Cambridge, MA: Harvard University Press, 1914), 169.

119. See Plutarch, *Lives*, vol. 10, *Agis and Cleomenes*, ed. Bernadotte Perrin (Cambridge, MA: Harvard University Press, 1988), chaps. 16–18, pp. 36–43. (Chilonis and Cleombrotus with their child leave for exile after Chilonis has begged her father, Leonidas, for a commutation of her husband's sentence.)

120. Both paintings by Georg Gläser.

121. Wilhelmine had a particular affinity for the story of Semiramis. On a trip to Rome, she commissioned a painting of the same theme as in the Eremitage for a supraporte in the Neue Residenz, Bayreuth, by Anton Raphael Mengs, after having authored a libretto for an opera with the same main character. See Hojer and Krückmann, *Anton Raphael Mengs*, 19–20; and Michael Eissenhauer and Hans-Werner Schmidt, eds., *3 x Tischbein und die europäische Malerei um 1800* (Munich: Hirmer, 2005), 70–71.

122. Plutarch, "Alexander," in *Lives*, vol. 7, ed. Bernadotte Perrin (Cambridge, MA: Harvard University Press, 1919), 254–57 (xii).

123. As to possible sources, see Bischoff, "Kunstpolitik," 78.

124. [Voltaire], *Ode sur la mort de son altesse royale Madame la Markgrave de Bareith* (London: [n.p.], 1759), 5, 10: "O Bareith! o vertus! o graces adorées! / Femme sans préjugés, sans vice et sans erreur"; "première des vertus"; Wilhelmine, *Memoirs*, 13–14. Voltaire had visited Bayreuth for two weeks with King Friedrich II of Prussia, Wilhelmine's brother, in 1743. Her music room in the Neue Residenz in Bayreuth contained a pastel portrait of the writer, among others of musicians, singers, and dancers. Voltaire and Wilhelmine exchanged letters. Wilhelmine's opera *L'Huomo*, of 1754, took up the theme of virtue and vice. See Thomas Betzwieser, ed., *Opernkonzeptionen zwischen Berlin und Bayreuth: Das musikalische Theater der Markgräfin Wilhelmine: Referate des Symposiums anlässlich der Aufführung von "L'Huomo" im Markgräflichen Opernhaus in Bayreuth am 2. Oktober 2009* (Würzburg: Königshausen & Neumann, 2016), especially the contributions by Oswald Georg Bauer, Ruth Müller-Lindenberg, Sabine Henze-Döhring, and Thomas Betzwieser.

125. Rudolf Heinrich Richter, "The young Alexander" (Alexander streut Weihrauch ins Feuer und wird deshalb von seinem Lehrer gerügt, also attributed to Wilhelm Wunder); Wilhelm Wunder, "Themistocles before Artaxerxes." Both paintings had to have been painted before 1744, the date when it is assumed that Wilhelmine authored her memoirs. See Plutarch, "Alexander," 296–99 (xxv). The wallpapers are lost, but they also showed scenes from the life of Alexander the Great, based on a cycle by Charles Le Brun.

126. Plutarch, "Themistocles," in *Lives*, vol. 2, ed. Bernadotte Perrin (Cambridge, MA: Harvard University Press, 1914), 62–81 (xxiii–xxix). See, e.g., 73 (xxvii) (A speech by Artabanus, the Persian Grand Vizier). See also Plutarch, "Artaxerxes," in *Lives*, vol. 11, ed. Bernadotte Perrin (Cambridge, MA: Harvard University Press, 1926). This is not the King Artaxerxes who welcomed Themistocles but his grandson, though the latter is compared to his grandfather, characterized as being known for "gentleness and magnanimity" (i, 128–29; iv, 134–35).

127. A database at Stanford University (Opening Night! Opera and Oratorio Premieres) lists twenty-one different operas for the eighteenth century on this figure, including by Nicola Porpora and Johann Christian Bach—operas that treated the theme of Themistocles in exile; Semiramis was the subject of forty-nine operas performed in the eighteenth century; see https://exhibits.stanford.edu/operadata/catalog?utf8=%E2%9C%93&exhibit_id=operadata&search_field=search&q=Temistocle.

128. Steffen Voss, "Voltaire—Wilhelmine—Villati: Zur Genese des Librettos zu Carl Heinrich Grauns Dramma per musica *Semiramide* (Berlin 1754)," in *Opernkonzeptionen zwischen Berlin und Bayreuth*, ed. Thomas Betzwieser (Würzburg: Königshausen & Neumann, 2016), 71–88. Voltaire's drama did not contain the scene painted in the Eremitage. Wilhelmine wrote the libretto in French, which then was translated into Italian.

129. The opera may never have been performed, though there are resonances of

its score in Berlin. The year 1740 was ten years after tragic events at the Prussian court, where her brother Friedrich and his friend Katte tried to escape but were apprehended; Katte was executed; Wilhelmine and Friedrich were under house arrest. These events have resonances in this opera. See Wolfgang Hirschmann, "Von der Zuständigkeit der Dilettantin: Wilhelmines Argenore (1740) und die Musikgeschichte des 18. Jahrhunderts," in *Opernkonzeptionen zwischen Berlin und Bayreuth*, ed. Thomas Betzwieser (Würzburg: Königshausen & Neumann, 2016), 41–55.

130. Thomas Rainer, *Markgräfliches Opernhaus Bayreuth* (Munich: Bayerische Schlösserverwaltung, 2018), 20–23; Peter O. Krückmann, *Sanspareil: Burg Zwernitz und Felsengarten* (Munich: Bayerische Schlösserverwaltung, 2012), 13–16.

131. Daniela Harbeck-Barthel and Gisela Schlüter, "'Meine Bibliothek ist jetzt geordnet': Der Aufbau von Wilhelmines französischer Bibliothek," in *Wilhelmine von Bayreuth heute: Das kulturelle Erbe der Markgräfin*, ed. Günter Berger (Bayreuth: Historischer Verein für Oberfranken, 2009), 151–72 (with illustrations).

132. Today, this room is called the First Hautelice room—a word that refers to textile wall hangings, though conventionally spelled haute-lisse. In 1796, Friedrich's successor, King Wilhelm Friedrich II, did away with the rococo design, covering it up with wooden panels and tapestries. The paintings were rediscovered in the 1930s before they were destroyed in a 1943 air-raid. During the castle's postwar reconstruction, the original design was not restored. See Tilo Eggeling, *Die Wohnungen Friedrichs des Großen im Schloß Charlottenburg* (Berlin: Verwaltung der Staatlichen Schlösser und Gärten, 1990), 19–23.

133. Note the absence of dynastic emblems and emblems of statehood in Friedrich's apartments.

134. The larger second antechamber, adorned with scenes from Ovid's Metamorphoses, a painting of Apollo and the Nine Muses, and equipped with marbled walls and stuccoed ornaments with musical themes, probably served as a room for playing music. See *Amtlicher Führer Schloss Charlottenburg*, ed. Stiftung Preußische Schlösser und Gärten Berlin-Brandenburg, 9th ed. (Potsdam: Stiftung Preußische Schlösser und Gärten Berlin-Brandenburg, 2002), 198.

135. Margarete Kühn, *Schloss Charlottenburg* (Berlin: Deutscher Verein für Kunstwissenschaft, 1955), 66. According to an archival document, the name of the painter is Seidel. Whoever he was, he must be located among Pesne's close collaborators. See Eggeling, *Die Wohnungen*, 20–21.

136. Heinz Ladendorf, "Das Vorzimmer des jungen Königs: Neuentdeckte Wandbilder im Stile Pesnes," *Die Kunst: Monatshefte für freie und angewandte Kunst* 71 (1935): 16–17. See Alfred P. Hagemann, *Wilhelmine von Lichtenau (1753–1820): Von der Mätresse zur Mäzenin* (Cologne: Böhlau, 2007), 173–74. The three painted walls in this room are oriented toward or parallel to the garden of Charlottenburg Castle. It is unclear how the room was furnished, since Charlottenburg Castle was looted in 1760.

137. The room's windows face south; its opposite wall with this imagined opening to a garden faces north.

138. Such illusionism was all the more striking since it was rare in Prussian castles or in Charlottenburg; see Marina thom Suden, *Schlösser in Berlin und Brandenburg und ihre bildliche Ausstattung im 18. Jahrhundert* (Petersberg: Imhof, 2013), 152.

139. Kühn, *Charlottenburg*, ill. 64.

140. The homosocial makeup of Friedrich's court is well documented, though in Charlottenburg, unlike in his other residences, his wife, Elisabeth Charlotte, had her own apartment on the ground floor.

141. Kühn, *Charlottenburg*, 65–66; Helmut Börsch-Supan, *Der Maler Antoine Pesne: Franzose und Preuße* (Friedberg: Podzun-Pallas, 1986), 6. On the court as theater, see Janette Dillon, *The Language of Space in Court Performance, 1400–1625* (Cambridge: Cambridge University Press, 2010), 10, 76, and passim.

142. Pesne's paintings and frescos tied the decorations in the new wing together. See Suden, *Schlösser in Berlin*, 127–29.

143. At the same time, the exemplarity of the French court did not extend to the disposition of the king's apartment. The bedroom was not a space where official functions took place.

144. The best introduction is in Joachim Bumke, *Courtly Culture: Literature and Society in the High Middle Ages*, trans. Thomas Dunlap (Woodstock, NY: Overlook, 2000), 360–415. See also William M. Reddy, *The Making of Romantic Love: Longing and Sexuality in Europe, South Asia and Japan, 900–1200* (Chicago: University of Chicago Press, 2012).

145. Alberto Pérez-Gómez, *Built upon Love: Architectural Longing after Ethics and Aesthetics* (Cambridge, MA: MIT Press, 2006), 65.

146. When Friedrich Wilhelm II, Friedrich's successor on the throne, had this room redecorated, the decorative program revolved around Don Quijote–themed tapestries. For the ceiling, Johann Christoph Kimpfel painted the errant knight riding out to fight a windmill, including an inscription on the painting: "Don Quichotte conduit par la Folie et Embrasé de l'amour extravagant de Dulcinée sort de chez luy pour estre Chevalier Errant."

147. Niklas Luhmann, *Love as Passion: The Codification of Intimacy*, trans. Jeremy Gaines and Doris L. Jones (Stanford, CA: Stanford University Press, 1998), 20.

148. Jonathan Dewald, *Aristocratic Experience and the Origins of Modern Culture: France, 1570–1715* (Berkeley: University of California Press, 1993), 120–45.

149. Christopher Clark, *Time and Power: Visions of History in German Politics from the Thirty Years' War to the Third Reich* (Princeton, NJ: Princeton University Press, 2019), 72–117. On the second apartment, see Eggeling, *Die Wohnungen*, 19, 44. Eggeling sees the paintings in the antechamber as a statement about Friedrich as a collector of the artwork of the French painters Antoine Watteau, Nicolas Lancret, and Jean-Baptiste Pater. He argues that Seidel, the putative painter, cited a

Lancret portrait. See also Henriette Graf, "Der Friderizianische Schlossbau und sein Ausstattungsprogramm" (Friedrich 300—Repräsentation und Selbstinszenierung Friedrichs des Großen), https://perspectivia.net/receive/ploneimport_mods_00000118.

150. David R. Coffin, *The Villa in the Life of Renaissance Rome* (Princeton, NJ: Princeton University Press, 1979), 297–98.

151. In Schleißheim (Bavaria), the antechamber showed the fight between Hector and Achilles on a ceiling fresco by Jacopo Amigoni; military themes were shown on four tapestries by Jodocus de Vos; on designs by Philippe de Hondt (Brussels, 1715–24), see Ernst Götz and Brigitte Lenger, *Schlossanlage Schleißheim* (Munich: Bayerische Verwaltung der staatlichen Schlösser, 2009), 108–11. Tapestries from Brussels were also shown in the antechamber in Rastatt; see Sandra Eberle, Ulrike Seeger, and Karolin Böhm, *Residenzschloss Rastatt* (Petersberg: Michael Imhof, 2018), 73 (on designs by Lambert de Hondt).

152. Ulrike Seeger, *Schloss Ludwigsburg und die Formierung eines reichsfürstlichen Gestaltungsanspruchs* (Vienna: Böhlau, 2020), 400–402. Georg Friedrich von Forstner made his career as a favorite at the court of Duke Eberhard Ludwig von Württemberg until his downfall in 1716; he played a key role in the construction of Ludwigsburg castle. A relief by the stuccoist Donato Giuseppe Frisoni in the corps de logis, c. 1713, is based on the Pieter van der Gunst print of a work by Charles Le Brun. At the same time, it changes certain elements to highlight von Forstner's role.

153. In Schleißheim, Amigoni's ceiling fresco in the apartment of the Electress showed an allegory of peace. See Götz and Lenger, *Schlossanlage Schleißheim*, 125.

154. The antechamber in Rastatt contained a representation of night, and princely virtues such as fortitude, justice, moderation, and wisdom. See Sandra Eberle, Seeger, and Böhm, *Residenzschloss Rastatt*, 73.

155. [John Wilmot, Earl of Rochester], *Sodom, or the Quintessence of Debauchery*, ed. Patrick J. Kearney (s.l., 1969), 1. On *I modi* see Bette Talvacchia, *Taking Positions: On the Erotic in Renaissance Culture* (Princeton, NJ: Princeton University Press, 1999).

156. The extraordinary status El Escorial has been given as a key to Spanish culture has recently been interrogated; see Henry Kamen, *The Escorial: Art and Power in the Renaissance* (New Haven, CT: Yale University Press, 2010); and Conrado Morterero Simón, ed., *El Escorial: Octava maravilla del mundo* (Madrid: Patrimonia Nacional, 1987), 339, 348.

157. The following section relies on the excellent study by Seeger, *Schloss Ludwigsburg*, 118–28. See also Paul Sauer, *Musen, Machtspiel und Mätressen: Eberhard Ludwig—württembergischer Herzog und Gründer Ludwigsburgs* (Tübingen: Silberburg, 2008); Sybille Oßwald-Bargende, *Die Mätresse, der Fürst und die Macht: Christina Wilhelmina von Grävenitz und die höfische Gesellschaft* (Frankfurt am Main: Campus, 2000), 20–27; Sybille Oßwald-Bargende, "Der Raum an seiner

Seite: Ein Beitrag zur Geschlechtertopographie der barocken Höfe am Beispiel von Schloß Ludwigsburg," in *Das Frauenzimmer*, 205–31, esp. 212; Catharina Raible, *Rangerhöhung und Ausstattung: Das Staats- und Privatappartement König Friedrichs von Württemberg in Schloss Ludwigsburg* (Stuttgart: Kohlhammer, 2015), 67–122 (on Ludwigsburg ca. 1800, especially the antechamber and audience hall).

158. Ulrich Schulze discusses the antechamber in a hunting lodge or castle, Clemenswerth (Lower Saxony), built 1737–39. See Ulrich Schulze, "Jagdschloß Clemenswerth," in *Johann Conrad Schlaun, 1695–1773: Architektur des Spätbarock in Europa*, ed. Klaus Bußmann, Florian Matzner, and Ulrich Schulze (Stuttgart: Oktagon, 1995), 298–341, 326–27. Schulze features a related iconographic program: fauns, satyrs, and maenads reign in the antechamber whereas the ruler, the prince-bishop Clemens August, is presented as the one to reign in nature, with a room dedicated to Apollo.

159. In Versailles under Louis XIV, the centrality of the sun as an iconographic program was only realized after 1701; see Henriette Graf, "Das Kaiserliche Zeremoniell und das Repräsentationsappartement im Leopoldinischen Trakt der Wiener Hofburg um 1740," *Österreichische Zeitschrift für Kunst- und Denkmalpflege* 51 (1997): 571–87, 574.

160. Some antechambers were serviced by stairs from the outside, though this was not always the case.

161. Von Rohr, *Einleitung zur Cerermoniel-Wissenschafft der grossen Herren*, 65. On the park at Versailles, see Doris Kolesch, "Flanieren im Park: Zur emotionalen und politischen Bedeutung von Bewegung im 17. Jahrhundert," in *Performing Emotions: Interdisziplinäre Perspektiven auf das Verhältnis von Politik und Emotion*, ed. Claudia Jarzebowski and Anne Kwaschik (Göttingen: V&R unipress, 2013), 115–28.

162. Albrecht Altdorfer, "Projet pour un portail," in *Albrecht Maître de la Renaissance allemande*, ed. Hélène Grollemund, Séverine Lepape, and Savatier Sjöholm (Paris: Louvre, 2020), 266f.

163. Ulrich Schütte, "Stadttor und Hausschwelle: Zur rituellen Bedeutung architektonischer Grenzen in der frühen Neuzeit," in *Zeremoniell und Raum*, ed. Werner Paravicini (Sigmaringen: Thorbecke, 1997), 305–24; Starn and Partridge, *Arts of Power*, 168–229.

164. Ulrike Seeger, *Stadtpalais und Belvedere des Prinzen Eugen: Entstehung, Gestalt, Funktion und Bedeutung* (Vienna: Böhlau, 2004), 92–95, 417–30.

165. Daniel Jütte, *The Strait Gate: Thresholds and Power in Western History* (New Haven, CT: Yale University Press, 2015). While his study treats doors that separated a building's inside from the outside, this approach also speaks to indoor gateways.

166. Ephraim Chambers, *Cyclopædia, or, An Universal Dictionary of Arts and Sciences* (London: James and John Knapton, et al., 1728), 1:241.

167. Von Rohr, *Ceremoniel-Wissenschafft der großen Herren*, 73: "Die Zimmer folgen mit ihren besondern Vorgemächern a plein pied hinter einander … [so dass] die Thüren alle nach perspectivischer Ordnung, in gleicher Ordnung und Symmetrie gesehen werden"; Ulrich Schütte, "Stadttor und Hausschwelle: Zur rituellen Bedeutung architektonischer Grenzen in der frühen Neuzeit," in *Zeremoniell und Raum*, ed. Werner Paravicini (Sigmaringen: Thorbecke, 1997), 305–24.

168. See, e.g., Klingensmith, *The Utility of Splendor*, 217.

169. Von Rohr, *Ceremoniel-Wissenschafft der großen Herren*, 76.

170. Christian Quaeitzsch, *Residenz München* (Munich: Staatliche Verwaltung, 2014), 122.

171. Graf, "Das Kaiserliche Zeremoniell," 573.

172. Mark Hengerer, *Kaiserhof und Adel in der Mitte des 17. Jahrhunderts* (Constance: Universitätsverlag, 2004), 244.

173. Von Rohr, *Ceremoniel-Wissenschaft der großen Herren*, 67: "Ein bey Hofe unbekandter, zumahl wenn er von geringerer Extraction, muß, die Thüren nicht leichtlich von selbst öffnen, sondern selbige durch die Garden öffnen lassen, nachdem er ihnen mit Höflichkeit angezeigt, daß er gerne wollte hineingelassen seyn."

174. Frank Druffner, "Gehen und Sehen bei Hofe: Weg- und Blickführungen im Barockschloß," in *Johann Conrad Schlaun, 1695–1773: Architektur des Spätbarock in Europa*, ed. Klaus Bußmann, Florian Matzner, and Ulrich Schulze (Stuttgart: Oktagon, 1995), 542–51, 545–46.

175. Von Rohr, *Ceremoniel-Wissenschafft der großen Herren*, 77; Jütte, *The Strait Gate*, 140.

176. Henriette Graf, "Der Friderizianische Schlossbau und sein Ausstattungsprogramm" (Friedrich 300—Repräsentation und Selbstinszenierung Friedrichs des Großen) https://perspectivia.net/receive/ploneimport_mods_00000118.

177. Mimi Hellman, "Furniture, Sociability and the Work of Leisure in Eighteenth-Century France," *Eighteenth Century Studies* 32 (1999): 415–45, 420.

178. Robert L. Scranton, "Vitruvius' Art of Architecture," *Hesperia* 43 (1994): 495–99, 496. See Vitruvius, *On Architecture*, ed. Frank Granger (Cambridge, MA: Harvard University Press, 1970), 24 (I.2.1): "architectura autem constat ex ordinatione quae graece *taxis* dicitur, et ex dispositione, hanc autem Graeci *diathesin* vocitant, et eurythmia et symmetria et decore et distributione quae graece *oeconomia* dicitur"; (I.2.2): "effectus operis." Interestingly, *dispositio* as a concept does not structure much of the rest of the treatise. In *De re aedificatoria*, Leon Battista Alberti used the word *partitio* and stressed the self-contained nature of individual rooms by comparing them to a building; see Leon Battista Alberti, *On the Art of Building in Ten Books*, trans. Joseph Rykwert, Neil Leach, and Robert Tavernor (Cambridge, MA: MIT Press, 1988), 23 (I.9).

179. Von Rohr, *Ceremoniel-Wissenschafft der großen Herren*, 73 (cited in Friedhoff, "'Magnificence' und 'Utilité,' " 671).

180. Foreign visitors were sometimes allowed to visit a palace, though the number of "tourists" avant la lettre was small, and a fee or a letter of introduction would likely have been required. On Prince Eugen's palaces, see Seeger, *Stadtpalais*, 373.

181. For an overview, see Robert Kirkbride, "Rhetoric and Architecture," in *Oxford Handbook of Rhetorical Studies* (Oxford: Oxford University Press, 2017), 506–22.

182. Coaldrake, *Architecture and Authority*, 1.

183. Von Rohr, *Ceremoniel-Wissenschafft der großen Herren*, 76.

184. Mimi Hellman, "The Joy of Sets: The Uses of Seriality in the French Interior," in *Furnishing the Eighteenth Century: What Furniture Can Tell Us about the European and American Past*, ed. Dena Goodman and Kathryn Norberg (New York: Routledge, 2006), 129–53, 145.

185. Wolfgang Brassat, *Tapisserien und Politik: Funktionen, Kontexte und Rezeption eines repräsentativen Mediums* (Berlin: Mann, 1992), 41, 199–200.

186. Seeger, *Stadtpalais*, 381: "die Blumenstilleben der Antichambre, denen im Konferenzzimmer die eine Stufe höher stehenden Blumen- und Früchtestilleben folgten" (on the sequence of rooms in the Upper Belevedere).

187. Hellman, "Furniture, Sociability and the Work of Leisure," 419. See also Barry Bergdoll, *European Architecture, 1750–1890* (Oxford: Oxford University Press, 2000), 37–40, on Robert Adam's Syon House (1760s), which experiments with a stylistic eclecticism inflected by historicist ideas. There the antechamber proved an explosion of chromaticism after the cool neoclassical idiom of the entrance hall.

188. Julia Thoma, "Geschaffen für Dining Room, Antichambre, Galerie: Auftraggeber und Funktionen von Bellottos Veduten," in *Canaletto: Bernardo Bellotto malt Europa*, ed. Andreas Schumacher (Munich: Hirmer, 2014), 46–71. Canaletto also painted vedute for the castle of the King of Poland in Warsaw.

189. Henriette Graf, "Das Neue Palais—Funktion und Disposition der Appartements," in *Friederisiko: Friedrich der Große*, vol. 2, *Die Essays*, ed. Stiftung Preußische Schlösser und Gärten Berlin-Brandenburg (Munich: Hirmer, 2012), 294–303, 296–98, 302–3.

190. In the case of Sophie of Hanover's visit to the French royal court the seating arrangement, whether a chair with a backrest or a taboret, was the matter of concern at a formal dinner; see Robert Geerds, ed., *Die Mutter der Könige von Preussen und England: Memoiren und Briefe der Kurfürstin Sophie von Hannover* (Munich: W. Langewiesche-Brandt, 1913), 159.

191. Graf, "Das kaiserliche Zeremoniell," 581–82.

192. In the new castle in Schleißheim (Bavaria), built in the early eighteenth century under Elector Max Emmanuel, chairs were the only pieces of furniture in the

antechamber and audience room; they had to be replaced under his successor Max III Joseph. See Götz and Lenger, *Schlossanlage Schleißheim*, 111.

193. Klingensmith, *The Utility of Splendor*, appendix 4, 217.

194. Louis de Jaucourt, "Poële," in *Encyclopédie ou dictionnaire raisonné des sciences, des arts et des métiers*, vol. 12, ed. Jean Le Rond d'Alembert and Denis Diderot (Neuchâtel: S. Faulche, 1765), 811. See also Seeger, *Stadtpalais*, 49.

195. *Residences memorables de l'incomparable heros de nôtre siecle ou representation exacte des edifices et jardins de son Altesse Serenissime Monseigneur Le Prince EUGENE FRANCOIS duc de Savoye et de Piemont . . . schloss belvedere und die dazugehörigen gärten* (Augsburg: Jeremias Wolff Erben, 1731–40). See also Johann Conrad Schlaun's drawings of the antichambre in the Münster Residenz; Schulze, "Das Residenzschloß in Münster," 342–407, 386–87.

196. Seeger, *Schloss Ludwigsburg*, 251–422, discusses media of representation as a source of dissemination for garden and architectural designs.

197. Klingensmith, *The Utility of Splendor*, 219–20.

198. Gertrude Aurenhammer, "Geschichte des Belvedere seit dem Tod des Prinzen Eugen," *Mitteilungen der österreichischen Galerie* 13 (1969), 103. This concerns the Lower Belvedere, part of the garden palace Prince Eugen of Savoy had erected outside Vienna (1712–16), where the Grand Hall served as a waiting area for the *appartement de parade* in this building.

199. Frommel, *Der Römische Palastbau*, 72–73; Waddy, "The Roman Apartment."

200. Renata Ago, *A Gusto for Things: A History of Objects in Seventeenth-Century Rome*, trans. Bradford Bouley, Corey Tazzara, and Paula Findlen (Chicago: University of Chicago Press, 2013), 65–93.

201. Richard Pears, "Auckland and Durham Castles in the Eighteenth Century," in *Princes of the Church: Bishops and Their Palaces*, ed. David Rollason (London: Routledge, 2017), 304–18.

202. Thornton, *Interior Decoration*, 60; Annik Pardailhé-Galabrun, *The Birth of Intimacy: Privacy and Domestic Life in Early Modern Paris*, trans. Jocelyn Phelps (Cambridge: Polity, 1991), 55, 65. A letter by Elisabeth Charlotte of the Palatinate dated December 6, 1682, mentions that one of the antechambers in the Château de Versailles also contained King Louis XIV's billiard table (Liselotte von der Pfalz, 39). See Henriette Graf, "Hofzeremoniell, Raumfolgen und Möblierung der Residenz in München um 1700–um 1750," in *Zeichen und Raum: Ausstellung und höfisches Zeremoniell in den deutschen Schlössern der Frühen Neuzeit*, ed. Peter-Michael Hahn and Ulrich Schütte (Munich: Deutscher Kunstverlag, 2006), 303–24, 316.

203. Anastazja Winiger-Labuda, "De l'antichambre à l'arrière-cabinet: L'influence parisienne dans la distribution des maisons genevoises du XVIIIe siècle," in *Génève—Lyon—Paris: Relations artistiques, réseaux, influences, voyages*, ed. Leïla el-Wakil and Pierre Vaisse (Geneva: Georg, 1994), 51–62.

204. Augustin-Charles Daviler, *Cours d'architecture qui comprend les ordres de Vignole* (1691; Paris: Mariette, 1720), 179.

205. Marc-Antoine Laugier, *Observations sur l'architecture* (Paris: Desaint, 1765), 219: "d'une premiere antichambre pour le service, d'une seconde antichambre pour les valets de chambre."

206. Ephraim Chambers, *Cyclopædia, or, An Universal Dictionary of Arts and Sciences* (London: James and John Knapton et al., 1728), 1:114.

207. Wolfgang Holler and Kristin Knebel, eds., *Goethes Wohnhaus* (Weimar: Klassik Stiftung Weimar, 2011), 40; Walter Schlief, *Goethes Diener* (Berlin: Aufbau, 1965), 214; W. Daniel Wilson, *Goethe, Männer, Knaben: Ansichten zur "Homosexualität,"* trans. Angela Steidele (Frankfurt am Main: Insel, 2012), 301–14.

208. Derek P. McCormack, *Refrains for Moving Bodies: Experience and Experiment in Affective Spaces* (Durham, NC: Duke University Press, 2013), 1–37.

209. Robert Evans, *Translations from Drawing to Buildings and Other Essays* (London: Architectural Association, 1997), 79; Alan Bray, *The Friend* (Chicago: University of Chicago Press, 2003), 208–12; Mark Jarzombek, "Corridor Spaces," *Critical Inquiry* 36 (2010): 728–70 (see esp. his discussion of Evans on [766–70]); Stephan Trüby, *Geschichte des Korridors* (Munich: Fink 2018).

210. Markus Krajewski, *The Server: A Media History from the Present to the Baroque*, trans. Ilinca Iurascu (New Haven, CT: Yale University Press, 2018).

211. Franz Kafka, "Vor dem Gesetz," in *Kritische Kafka-Ausgabe: Drucke zu Lebzeiten*, ed. Jürgen Born, Gerhard Neumann, Malcom Pasley, and Jost Schillemeit (Frankfurt am Main: S. Fischer, 1996), 267–69; Franz Kafka, "Before the Law," trans. Ian Johnston, www.kafka-online.info/before-the-law.html. The word *experiences* (Erfahrungen) shows up in the text toward the end (269).

212. Kafka, "Vor dem Gesetz," 267: "Es ist möglich" (It is possible) is the gatekeeper's response to the man's question whether he will be admitted in the future.

213. Kafka, 268. This expression itself takes up the "jetzt aber nicht" (but not now), which is the gatekeeper's response during their first encounter.

214. Kafka, 268.

215. Ulf Abraham, "Mose 'Vor dem Gesetz': Eine unbekannte Vorlage zu Kafkas 'Türhüterlegende,'" *Vierteljahrsschrift für Literaturwissenschaft und Geistesgeschichte* 57 (1983): 636–50.

Chapter 3. Encounters

1. Barry Schwartz, *Queuing and Waiting: Studies in the Social Organization of Access and Delay* (Chicago: University of Chicago Press, 1975), 1. See also Barry Schwartz, "Waiting, Exchange, and Power: The Distribution of Time in Social Systems," *American Journal of Sociology* 79 (1974): 841–70.

2. Paul E. Corcoran, "Godot Is Waiting Too: Endings in Thought and History," *Theory and Society* 18 (1989): 495–529, 516.

3. Harold Schweizer, *On Waiting* (New York: Routledge, 2008), 1.

4. Schwartz, *Queuing and Waiting*, 140.

5. David Harvey, *The Condition of Postmodernity: An Enquiry into the Origins of Cultural Change* (Oxford: Blackwell, 1990), 233.

6. *Zimmerische Chronik*, ed. Karl A. Barack. Bibliothek des Litterarischen Vereins in Stuttgart, vol. 94 (Tübingen: Laupp, 1869), 48. The question of authorship was settled by Beat Rudolf Jenny, *Graf Froben Christoph von Zimmern: Geschichtsschreiber, Erzähler, Landesherr: Ein Beitrag zur Geschichte des Humanismus in Schwaben* (Lindau: Thorbecke, 1959).

7. Hercules was frequently depicted on tapestries in Burgundy and the Lowlands from about the mid-fifteenth century. Raoul Lefèvre's popular "Receuil des histoires de Troie" (ca. 1460) was a source. The text covers the confrontation between Hercules and Achelous (I/41).

8. The story echoes the attack on images or iconoclasms in confessionalizing Europe, though all the players mentioned in these tales were Catholic, and this echo is not made explicit.

9. *Zimmerische Chronik*, 48.

10. Thomas P. Campbell, ed., *Tapestry in the Renaissance: Art and Magnificence* (New Haven, CT: Yale University Press, 2002). See also Wolfgang Brassat, *Tapisserien und Politik: Funktionen, Kontexte und Rezeption eines repräsentativen Mediums* (Berlin: Mann, 1992), 39–42 and 186–87 (examples of Hercules-themed tapestries); Birgit Franke, "Tapisserie als höfisches Ausstattungsmedium: Zwischen Allgemeingültigkeit und Individualität," in *Zeichen und Raum: Ausstattung und höfisches Zeremoniell in den deutschen Schlössern der Frühen Neuzeit*, ed. Peter-Michael Hahn and Ulrich Schütte (Munich: Deutscher Kunstverlag, 2006), 265–79.

11. Gerhard Wolf, *Von der Chronik zum Weltbuch: Sinn und Anspruch südwestdeutscher Hauschroniken am Ausgang des Mittelalters* (Berlin: Walter de Gruyter, 2002), 364–415. See also Erica Bastress-Dukehart, *The Zimmern Chronicle: Nobility, Memory and Self-Representation in Sixteenth-Century Germany* (Aldershot: Ashgate, 2002); and Judith J. Hurwich, *Noble Strategies: Marriage and Sexuality in the "Zimmern Chronicle"* (Kirksville, MO: Truman State University Press, 2006).

12. Elsbeth Wiemann, "Die Freiherren und Grafen von Zimmern: Archivalien und Memorabilien," in *Der Meister von Meßkirch: Katholische Pracht in der Reformationszeit*, ed. E. Wiemann (Stuttgart: Hirmer, 2017), 267–71, 290–92.

13. *Zimmerische Chronik*, 49.

14. *Zimmerische Chronik*, 49.

15. Tribaldo de' Rossi, "Ricordanze," in *Delizie degli Eruditi Toscani*, vol. 23, ed. Ildefonso da San Luigi (Florence: Gaetano Cambiagi, s.a. [ca. 1779]), 258–61, 260: "insino a ore 23. vi stetti da dopo desinare insino alora dove istando tanto adisagio per amore de la bottegha mi partj chon pensiero di parlarli in dì di festa per agio." English translation in Richard C. Trexler, *Public Life in Renaissance Florence* (Ithaca, NY: Cornell University Press, 1980), 448.

16. Girolamo Savonarola, "Predica viii (Mercoledì doppo la prima domenica di

quaresima)," in *Prediche sopra Amos e Zaccaria*, vol. 3, ed. Paolo Ghiglieri (Rome: Belardetti, 1971), 226: "Il tiranno è molto difficile a l'audienzia, e fa stare e' cittadini là quattro ore per aspettarlo, e così anche e' religiosi; e lui si sta nelle sue camere con li amici e con compagni nelle sue voluttà e non si cura di chi l'aspetta. E poi quando el viene fuora dà brieve audienzia, e sempre dà risposte mozze e ambigue."

17. Girolamo Savonarola, "Trattato circa il reggimento e governo della città di Firenze," in *Scelta di Prediche e Scritti di Fra Girolamo Savonarola*, ed. Pasquale Villari (Florence: Sansoni, 1898), 368–82, 376:

> E per tenersi piú in reputazione è difficile a dare udienza, e molte volte attende a' suoi piaceri e fa stare i cittadini di fuori e aspettare, e poi dà loro udienza breve e risposte ambigue, e vuol essere inteso a cenni, perché pare che si vergogni di volere e chiedere quelle che è in sé male o di negare il bene: però dice parole mozze che hanno specie di bene, ma vuol essere inteso. E spesso schernisce gli uomini da bene con parole, o con atti ridendosi con i suoi complici di loro.

> [To uphold his reputation he rarely gives audiences, and many times he attends to his own pleasure and makes the citizens stand outside waiting for him and when he does come, he gives them short shrift and ambiguous responses. He wants to be understood by gestures because it seems that he is ashamed to want and to ask for things which are evil in and of themselves or to reject the good, and he speaks in clipped phrases which have the appearance of good but he wants their underlying meaning to be understood. Often he sneers at respectable people both with words and actions and laughs at them with his cronies.]

(Girolamo Savonarola, "Treatise on the Rule and Government of the City of Florence," in *Selected Writings of Girolamo Savonarola: Religion and Politics, 1490–1498*, trans. and ed. Anne Borelli and Maria Pastore Passaro [New Haven, CT: Yale University Press, 2006], 176–206, 193).

18. Niall Atkinson, *The Noisy Renaissance: Sound, Architecture, and Florentine Urban Life* (University Park: Pennsylvania State University Press, 2016), 156.

19. Johann Michael von Loën, "Der Kayserliche Hof im Jahr 1717," in *Gesamlete kleine Schriften*, ed. Johann Caspar Schneider, vol. 1, sec. 3 (Frankfurt am Main: Philipp Heinrich Huttern, 1750), 22. Comparing Vienna and Paris, Loën claims that the former exceeds the latter in the bustle on the streets. At the same time, he distinguishes Vienna from large port cities such as London or Amsterdam, where one encounters people from other parts of the world (Loën, 21). See also R. J. W. Evans, "The Austrian Habsburgs: The Dynasty as a Political Institution," in *The Courts of Europe: Politics, Patronage and Royalty, 1400–1800*, ed. A. G. Dickens (New York: McGraw-Hill, 1977), 121–45.

20. "Confusiones und Unordnungen, dergestalten einzuschleichen beginnen . . . in denen Antichambres . . . vor Unßerer fürstl[ich]en Person alles untereinander lauffe und weder respectus personarum noch distinctiones von charges und Bedien-

ten gemacht werden." Cited in Sybille Oßwald-Bargende, *Die Mätresse, der Fürst und die Macht: Christina Wilhelmina von Grävenitz und die höfische Gesellschaft* (Frankfurt am Main: Campus, 2000), 29.

21. John P. Spielman, *The City and The Crown: Vienna and the Imperial Court 1600–1740* (West Lafayette, IN: Purdue University Press, 1993); Grete Klingenstein, "Der Wiener Hof in der Frühen Neuzeit: Ein Forschungsdesiderat," *Zeitschrift für Historische Forschung* 22 (1995): 237–42; Markus Reisenleitner, "Vienna," *Court Historian* 2 (1997): 9–12.

22. Eric Hassler, "Measuring Regular Noble Presence at Court: The Example of Vienna, 1670–1740," *Court Historian* 22 (2017): 38–52, 51.

23. See Casimir Freschot, *Mémoires de la cour de Vienne: Contenant les remarques d'un voyageur curieux sur l'état présent de cette cour* (Cologne: Étienne, 1706), 89. For Emperor Leopold I, Freschot delivers a different image, mentioning the many foreigners—Hungarians, Italians, Spaniards, and others—who frequented the antechamber of this polyglot ruler. See also John P. Spielman, *Leopold I of Austria* (New Brunswick, NJ: Rutgers University Press, 1977).

24. Christian Benedik, "Die Herrschaftlichen Appartements: Funktion und Lage während der Regierungen von Kaiser Leopold I. bis Kaiser Franz Joseph I.," *Österreichische Zeitschrift für Kunst und Denkmalpflege: Wiener Hofburg: Neue Forschungen* 51 (1997): 552–570; Christian Benedik, "Die Repräsentationsräume der Wiener Hofburg in der ersten Hälfte des 18. Jahrhunderts," *Das Achtzehnte Jahrhundert und Österreich* 2 (1997): 7–22. According to Benedik, the large second antechamber barely had ceremonial functions; it served as a space where theatrical and similar performances occurred, especially under Emperor Leopold I. For a general introduction to the Viennese court and its organization, see Jeroen Duindam, "Versailles, Vienna and Beyond: Changing Views of Household and Government in Early Modern Europe," in *Royal Courts in Dynastic States and Empires: A Global Perspective*, ed. Tülay Artan, Jeroen Duindam, and Metin Kunt (Leiden: Brill, 2011), 401–31.

25. See Mark Hengerer, *Kaiserhof und Adel in der Mitte des 17. Jahrhunderts* (Constance: Universitätsverlag Konstanz, 2004), 225–30.

26. Hengerer, 233. It went missing in the seventeenth century.

27. Hassler, "Measuring Regular Noble Presence," 41.

28. Hengerer, *Kaiserhof und Adel*, 244.

29. Freschot, *Mémoires*, 113–14.

30. When the same archbishop was invited to an audience on the occasion of the empress's name day on November 19, 1718, he appeared in the antechamber at the appointed hour, 10:00 a.m. Elisabeth Christine was not yet ready to receive visitors. She sent her head chamberlain, Princess Auersberg, to apologize for the delay and had her daughter, the future Empress Maria Theresia (the "little"), sent in to keep Franz Anton entertained.

31. When discussing the visits of ambassadors in the empress's quarters in 1719, one cameralist claims that the reception for them in the second antechamber of the women's quarters was "a bit more solemn than with the emperor" since the female entourage of the empress was present, while the empress stood under a dais on a carpet near a fautueil. See Katrin Keller, *Hofdamen: Amtsträgerinnen im Wiener Hofstaat des 17. Jahrhunderts* (Cologne: Böhlaum, 2015), 232–34, 234 (Tafelzeremoniell).

32. Christoph Brandhuber and Werner Rainer, "Ein Fürst führt Tagebuch: Die 'Notata' des Salzburger Fürsterzbischofs Franz Anton Fürsten von Harrach (1665–1727)," *Salzburg Archiv* 34 (2010): 205–62, 218. A meeting duration of fifteen minutes between dignitaries at official functions was widespread. See, e.g., *Das frolockende Berlin, Oder Historische Nachricht* (Berlin: Rüdiger, 1728), 12, on the reception of Augustus the Strong of Saxony, King of Poland, by Friedrich Wilhelm I, King of Prussia, in Berlin 1728.

33. Benedik, "Die Repräsentationsräume," 9–20.

34. Irmgard Pangerl, Martin Scheutz, and Thomas Winkelbauer, eds., *Der Wiener Hof im Spiegel der Zeremonialprotokolle (1652–1800): Eine Annäherung* (Innsbruck: StudienVerlag, 2007).

35. Brandhuber and Rainer, "Ein Fürst führt Tagebuch," 218.

36. Brandhuber and Rainer, 228.

37. Hengerer, *Kaiserhof und Adel*, 252.

38. Hengerer, 244.

39. Johann Basilius Küchelbecker, *Allerneueste Nachricht vom Römisch-Kayserlichen Hofe nebst einer ausführlichen Beschreibung der Kayserlichen Residenz-Stadt Wien und der umliegenden Örter. Theils aus den Geschichten, theils aus eigener Erfahrung zusammen getragen und mit saubern Kupffern ans Licht gegeben* (Hanover: n.p., 1730), 621.

40. The matter was different in the case of diplomatic protocol, which had to be followed to the letter.

41. Hengerer, *Kaiserhof und Adel*, 233–34.

42. Mark Hengerer, *"Verzaichnus, wie [. . .] durch die cammerpersonen gedienntwürdet*: Edition einer Beschreibung des Kammerdienstes am Grazer Hof des 16. Jahrhunderts aus dem Bayerischen Hauptstaatsarchiv München," *Zeitschrift des Historischen Vereines für Steiermark* 105 (Graz 2014): 45–91, 72–73.

43. Hengerer, *Kaiserhof und Adel*, 245–46.

44. Freschot, *Mémoires*, 113.

45. Freschot, 84–85. This practice of admitting people of all classes was common, apparently; see Jacques Casanova de Seingault, *Histoire de ma vie suivie de textes inédits*, ed. Francis Lacassin, vol. 2 (Paris: Robert Laffont, 1993), 275: "elle donnait audience à tous ceux qui se présentaient, don't la plus grande partie était des paysans durs, sots, obstinés qui ayant des griefs, croyaient de n'avoir besoin que de parler

au souverain pour qu'on leur fit raison dans la minute. Mais n'y avait rien de plus comique que cette audience que le duc donnait à ses pauvres sujets. Il enriageait pour leur faire entendre raison, et ils sortaient de sa présence épouvantés et désespérés." Giacomo Casanova, *History of My Life*, trans. Willard R. Trask [1966] (Baltimore: Johns Hopkins University Press, 1997), 6:3.68: "he gave audience to all comers, who for the most part were thick-headed, ignorant, obstinate peasants with grievances, who thought they need only speak with their sovereign for a moment to have him right their wrongs on the spot. But nothing was more comical than these audiences which the Duke granted to his poorer subjects. He became furious trying to make them listen to reason, and they left his presence in terror and despair."

46. Freschot, *Mémoires*, 79.

47. Küchelbecker, *Allerneueste Nachricht vom Römisch-Kayserlichen Hofe*, 251: "Wo findet man zu ietzigen Zeiten einen Monarchen welcher wie Kayserl. Maj. alle Tage etliche Stunden Audientz giebt, und zwar nicht nur vornehmen, oder mittlern Standts-Personen, sondern so gar auch armen Bürgern und Handtwerks-Leuten?"

48. Johann Jakob Moser, *Lebens-Geschichte Johann Jacob Mosers Königlich-Dänischen Etats-Raths von ihm selbst beschrieben*, vol. 1, 3rd ed. (Frankfurt am Main: Meyersche Buchhandlung, 1777), 34–35. Additions and explanations to this volume in Johann Jakob Moser, *Lebens-Geschichte Johann Jacob Mosers Königlich-Dänischen Etats-Raths von ihm selbst beschrieben: Nebst einem Register über alle 4 Theile*, vol. 4, 3rd ed. (Frankfurt am Main; Leipzig: n.p., 1783). On Moser see Arthur Nussbaum, *A Concise History of the Law of Nations* (New York: Macmillan, 1947), 163–70; and Mack Walker, *Johann Jakob Moser and the Holy Roman Empire of the German Nation* (Chapel Hill: University of North Carolina Press, 1980).

49. Moser, *Lebens-Geschichte*, 1:30.

50. Moser, 1:46.

51. Moser, 1:22–28.

52. Moser, 1:1–2, 28–30.

53. Küchelbecker, *Allerneueste Nachricht vom Römisch-Kayserlichen Hofe*, 303.

54. Walker, *Johann Jakob Moser*, 30–38.

55. Moser, *Lebens-Geschichte*, 1:20. A biography of the emperor is a desideratum; see Charlotte Backerra, "Intime Beziehungen Kaiser Karls VI. in Historiographie und überlieferten Quellen," in *Homosexualität am Hof: Praktiken und Diskurse vom Mittelalter bis heute*, ed. Norman Domeier and Christian Mühling (Frankfurt am Main: Campus, 2020), 53–75.

56. Moser, *Lebens-Geschichte*, 1:24.

57. See, e.g., Balthasar de Monconys, *Iovrnal des Voyages*, vol. 2, *Voyage d'Angleterre, Païs-Bas, Allemagne, & Italie* (Lyon: Horace Boissat & George Remevs, 1666), 382.

58. Andreas Pečar, *Die Ökonomie der Ehre: Höfischer Adel am Kaiserhof Karls VI. (1711–1740)* (Darmstadt: Wissenschaftliche Buchgesellschaft, 2003).

59. Wilhelmine of Bayreuth, *Mémoires de Frédérique Sophie Wilhelmine, Margrave de Bayreuth* (Leipzig: H. Barsdorf, 1889), 237; Wilhelmine, *Memoirs*, trans. Christian of Schleswig Holstein (New York: Harper & Bros., 1828), 1:210.

60. Küchelbecker, *Allerneueste Nachricht vom Römisch-Kayserlichen Hofe*, b1v–b2v. In his introduction, he commits to focus on the facts, not on secret knowledge.

61. Wilhelmine, *Memoirs*, 1828, 210–11; Wilhelmine, *Mémoires*, 237.

62. Moser (*Lebens-Geschichte*, 4:11) provides precisely such a portrait in general and during audiences; Charles apparently looked elsewhere until those who had come spoke up.

63. Küchelbecker criticizes accounts of court life for feeding this curiosity about human failures; instead, the author adopts a descriptive tone.

64. Sharon Kettering, "Patronage in Early Modern France," *French Historical Studies* 17 (1992): 839–62; Sharon Kettering, *Patrons, Brokers, and Clients in Seventeenth-Century France* (New York: Oxford University Press, 1986).

65. Johann Georg Erbstein, *Antichambre der vornehmsten Höfe Europens oder kurtze Histor- und Genealogische Verfassung der höchsten Potentaten in Europa, von zweyen Seculis her* (Leipzig: Kayser, 1718).

66. Küchelbecker, *Allerneueste Nachricht vom Römisch-Kayserlichen Hofe*, a4. The author explains his publication with the fact that so far only court calendars informed an interested public about the imperial court, with the exception of a few unnamed accounts that lacked quality. On the genre, with a focus on Munich, see Samuel John Klingensmith, *The Utility of Splendor: Ceremony, Social Life, and Architecture at the Court of Bavaria, 1600–1800*, ed. Christian F. Otto and Mark Ashton (Chicago: University of Chicago Press, 1993), 8.

67. *Hochfürstlich-Salzburgischer Kirchen- und Hof-Kalender* (Salzburg: Duyle, 1746), 114–17.

68. Moser, *Lebens-Geschichte*, 1:27; see also Hengerer, *Kaiserhof und Adel*, 245.

69. Moser, *Lebens-Geschichte*, 1:29–30.

70. Moser, 1:27.

71. Julius Bernhard von Rohr, *Einleitung zur Ceremoniel-Wissenschafft der Privat-Personen* (Berlin: Johann Andreas Rüdiger, 1728).

72. Küchelbecker, *Allerneueste Nachricht vom Römisch-Kayserlichen Hofe*, a2r–v, starts the preface of his guide to the imperial court under Charles VI with a penetrating critique of a previous report regarding the court of Leopold I, Freschot's (the name is not mentioned, however).

73. He had already spurned a different match. He refused to marry the daughter of a professor at the University of Tübingen.

74. Moser, *Lebens-Geschichte*, 1:23; see also Hengerer, *Kaiserhof und Adel*, 228, 626.

75. Moser, *Lebens-Geschichte*, 1:30–31.

76. Nadine Akkerman and Birgit Houben, introduction to *The Politics of Female*

Households: Ladies-in-Waiting across Early Modern Europe, ed. Nadine Akkerman and Birgit Houben (Leiden: Brill, 2013), 1–27.

77. This is true also for buildings like the imperial castle in Vienna, where the double apartments had not been part of the original architecture; see Keller, *Hofdamen*, 117.

78. Nobert Elias, *The Court Society*, trans. Edmund Jephcott (New York: Pantheon, 1983), 49–51. On late medieval and early modern models, see Jan Hirschbiegel and Werner Paravicini, eds., *Das Frauenzimmer: Die Frau bei Hofe in Spätmittelalter und früher Neuzeit* (Stuttgart: Jan Thorbecke, 2000).

79. Küchelbecker, *Allerneueste Nachricht vom Römisch-Kayserlichen Hofe*, 621.

80. Nicolas Milovanovic, *L'Antichambre du Grand Couvert: Fastes de la table et du décor à Versailles: Splendours of Table and Décor at Versailles* (Montreuil: Gourcuff Gradenigo, 2010), 58. The original symmetry between the two Grands Appartements of the king and queen was changed with subsequent modifications of the castle's layout.

81. Britta Kägler, "Rückzugsort oder Anlaufstelle? Das 'Frauenzimmer' als Institution und Handlungsraum am Münchner Hof der Frühen Neuzeit," https:// perspectivia.net/publikationen/discussions/5-2010/kaegler_frauenzimmer; Cordula Bischoff, "Le 'Frauenzimmer-Ceremoniel' (cérémonial des femmes) et ses conséquences pour la distribution des appartements princiers des dames vers 1700," in *Versailles et l'Europe: L'appartement monarchique et princier, architecture, décor, cérémonial*, ed. Thomas Gaehtgens et al. (Heidelberg: Arthistoricum.net, 2017), 149–73, https://doi.org/10.11588/arthistoricum.234.3092017.

82. Fabian Persson, *Women at the Early Modern Swedish Court: Power, Risk, and Opportunity* (Amsterdam: Amsterdam University Press, 2021), 253–64.

83. Benedik, "Die Herrschaftlichen Appartements," 561.

84. "Instruktion für den Obersthofmeister Franz Christoph Khevenhüller," April 11, 1631, in Keller, *Hofdamen*, 222–31, 224, 230. See also Hengerer, *Kaiserhof und Adel*, 266–76; and Katrin Keller, "Ladies-in-Waiting at the Imperial Court of Vienna from 1550 to 1700: Structures, Responsibilities, and Career Patterns," in *The Politics of Female Households: Ladies-in-Waiting across Early Modern Europe*, ed. Nadine Akkerman and Birgit Houben (Leiden: Brill, 2013), 77–97.

85. Keller, *Hofdamen*, 92.

86. Keller, 90–91. See also "Tafelzeremoniell" [1719], in Keller, 232–34, 233.

87. See Hengerer, *Kaiserhof und Adel*, 269–70. Similar infractions and instructions are reported for the court of the electors of Bavaria in Munich; see Britta Kägler, *Frauen am Münchener Hof (1651–1756)* (Kallmünz: Michael Laßleben, 2011), 320, 415–16.

88. Keller, "Ladies-in-Waiting."

89. Kägler, *Frauen am Münchener Hof*, 7, 22, 30, 50–116; Keller, *Hofdamen*; Oßwald-Bargende, *Die Mätresse*, 36.

90. Ute Daniel, "Zwischen Zentrum und Peripherie der Hofgesellschaft: Zur biographischen Struktur eines Fürstinnenlebens der Frühen Neuzeit am Beispiel der Kurfürstin Sophie von Hannover," *L'Homme* 8 (1997): 208–17. See also Oßwald-Bargende, *Die Mätresse*, 31, 35. A more sensationalistic account appears in Lucy Worsley, *Courtiers: The Secret History of the Georgian Court* (London: Faber and Faber, 2011), 121–83. See also Hannelore Helfer, *"Kein wurm so sich nit krömt als man ihn tritt": Das Leben der Charlotte von Hessen-Kassel Kurfürstin von der Pfalz (1627–1686)* (Ubstadt-Weiher: Verlag Regionalkultur, 2021), 75 and passim.

91. Casanova, *Histoire*, 275: "Il examinait leurs griefs tête-à-tête et malgré qu'il ne leur accordât rien elles sortaient cependant consolées"; Casanova, *History*, 68: "He examined their grievances in private, and though he granted them nothing they went away satisfied."

92. Casanova, *History*, 68–69, 296; Casanova, *Histoire*, 276: "la duchesse sollicita une audience de son époux, comme un quelconque de ses sujets, mais elle fut mal reçue." Casanova's *Histoire* wants to represent historical reality. Despite his memoirs' sensationalism, Casanova is considered by most scholars now to be a reliable source. See Rives Childs, *Casanova: A New Perspective* (New York: Paragon House, 1988); Ivo Cerman, Susan Reynolds, and Diego Lucci, eds., *Casanova: Enlightenment Philosopher*, no. 9 (Oxford: Voltaire Foundation, 2016). On Duke Karl Eugen, see Karlheinz Wagner, *Herzog Karl Eugen von Württemberg: Modernisierer zwischen Absolutismus und Aufklärung* (Stuttgart: Deutsche Verlags-Anstalt, 2001), 55–56.

93. Travelogues such as Adam Olearius's of his 1633–39 trip as part of a diplomatic mission to Russia and Persia played a part in these sets of perception; see A. Olearius, *Des welt-berühmten Adami Olearii colligirte und viel vermehrte Reisebeschreibungen: Bestehend in der nach Mußkau und Persien* (Hamburg: Hertel, 1696). At the Qing court, appearances of foreign envoys were strictly regulated, including appropriate gifts, gestures, and wait times. See "A Complete Translation of Tribute Regulations as Outlined in the Daqing Huidian" (with gratitude to Daniel M. Greenberg for having shared this unpublished document with me). See also David M. Robinson, "The Ming Court," in *Culture, Courtiers, and Competition: The Ming Court (1368–1644)*, ed. D. M. Robinson (Cambridge, MA: Harvard University Press, 2008), 21–60; and Beatrice S. Bartlett, *Monarchs and Ministers: The Grand Council in Mid-Ch'ing China, 1723–1820* (Berkeley: University of California Press, 1991).

94. Ruth Schilling, "Wandel durch Annäherung? Französisch-siamesische Audienzen 1684–1686," in *Die Audienz: Ritualisierter Kulturkontakt in der Frühen Neuzeit*, ed. Peter Burschel and Christine Vogel (Cologne: Böhlau, 2014), 247–63; Ellen R. Welch, *A Theater of Diplomacy: International Relations and the Performing Arts in Early Modern France* (Philadelphia: University of Pennsylvania Press, 2017).

95. Robert W. Gutman, *Mozart: A Cultural Biography* (New York: Harcourt

Brace, 1999), 360–68. Initially, both Leopold and Wolfgang Amadeus Mozart were cashiered. The son had requested another leave from his post in early August of 1777. On September 1, Leopold learned that they were let go. On the archbishop's part, this decision was the culmination of many years of discontent with the Mozarts' lack of dedication to what their positions required. On his request, Leopold was reinstated on September 26, when Mozart and his mother had already left for Munich on September 23. Otherwise, Leopold likely would have traveled with Wolfgang Amadeus. See Norbert Elias, *Mozart: Zur Soziologie eines Genies* (Frankfurt am Main: Suhrkamp, 1993).

96. Klingensmith, *The Utility of Splendor*, 174; Robert Münster, *"Ich würde München gewis Ehre machen": Mozart und der kurfürstliche Hof zu München* (Weißenhorn: Anton H. Konrad, 2002). Münster lists 1762, 1763, 1766, 1774–75, and 1777. Thereafter he visited two more times, 1778–79 and 1780–81. See also Ludwig F. Schiedermair, *Deutsche Oper in München: Eine 200jährige Geschichte* (Munich: Langen Müller, 1992), 13–24; and Robert Münster, "Maximilian III. Joseph, Kurfürst von Bayern," in *Das Mozart Lexikon*, ed. Gernot Gruber and Joachim Brügge (Laaber: Laaber-Verlag, 2005), 420–21.

97. In a move to advance his own cause, Mozart expressed discontent with the quality of music life, which he found deplorable, as he reports in a letter.

98. Leopold Mozart to Anna Maria and Wolfgang Amadeus Mozart, Sept. 27, 1777, gives a detailed account; see https://dme.mozarteum.at/DME/briefe/letter .php?mid=898&cat=. For this and subsequent citations of correspondence among the Mozart family, I have used the Digital Mozart Edition of the Mozarteum Salzburg (dme.mozarteum.at).

99. Leopold Mozart to Wolfgang Amadeus Mozart, Sept. 28 and 29, 1777; see https://dme.mozarteum.at/DME/briefe/letter.php?mid=900&cat=.

100. Wolfgang Amadeus Mozart to Leopold Mozart, Oct. 2 and 3, 1777; see https://dme.mozarteum.at/DME/briefe/letter.php?mid=905&cat=.

101. Klingensmith, *The Utility of Splendor*, 13–14. As Eric Hassler ("Measuring Regular Noble Presence") points out, the absolute numbers say little about actual presence.

102. Anna Maria Mozart, postscript to a letter from Wolfgang Amadeus Mozart to Leopold Mozart, Sept. 26, 1777; see https://dme.mozarteum.at/DME/briefe/let ter.php?mid=896&cat=.

103. Wolfgang Amadeus Mozart to Leopold Mozart, Oct. 2 and 3, 1777.

104. Wolfgang Amadeus Mozart to Leopold Mozart, Sept. 26, 1777.

105. Wolfgang Amadeus Mozart to Leopold Mozart, Sept. 26, 1777. One of the people the composer asked to make a case for him, Reichsgraf Joseph Ferdinand von Salern, stated that he was in no position to do much but was ready to speak when the moment was right. See Münster, *"Ich würde München gewis Ehre machen,"* 82.

106. Anna Maria and Wolfgang Amadeus Mozart to Leopold Mozart, Sept. 29,

1777: [Count Zeil hat] "heimlich mit den Churfürsten gesprochen. er sagte mir. iezt ist es noch zu früh. er soll gehen, nach italien reisen, sich berühmt machen. ich versage ihm nichts. aber iezt ist es noch zu früh" (spoke privately with the Elector. He said to me, It is still too early at the moment. He should go, travel to Italy and make himself famous. I am not refusing him anything. But it is too early at the moment).

107. In addition to identifying those thought to be in a position to advance one's cause, one also seized the opportunity of chance encounters, especially with those who were privy to potentially relevant information.

108. Leopold Mozart to Wolfgang Amadeus and Anna Maria Mozart, Sept. 27, 1777.

109. Wolfgang Amadeus Mozart to Leopold Mozart, Oct. 3, 1777.

110. Leopold Mozart to Wolfgang Amadeus and Anna Maria Mozart, Sept. 27, 1777.

111. Anna Maria Mozart to Leopold Mozart, Sept. 29, 1777.

112. See Stephan Hörner, "Joseph Anton Graf von Seeau," *Neue Deutsche Biographie* 24 (2010): 129–30, www.deutsche-biographie.de/pnd131919237.html#ndbcontent.

113. Münster, *"Ich würde München gewis Ehre machen,"* 40–61.

114. Wolfgang Amadeus Mozart to Leopold Mozart (with postscript by Anna Maria Mozart), Sept. 26, 1777. Mozart had a late start on this day, as he writes, because he needed to have his hair done, which meant that he reached von Seeau's premises only at 10:30 a.m.

115. Wolfgang Amadeus Mozart to Leopold Mozart, Sept. 26, 1777. Interestingly, Leopold entreated his son to seek help with formulating a written request, should it come to that; see Leopold Mozart to Wolfgang Amadeus Mozart, Sept. 28 and 29, 1777.

116. In 1755, the court painter Georges Desmarées had produced a double portrait of Elector Max III Joseph and Count von Seeau that was and is on view in the conference or audience chamber of the elector's suite in the Munich Residence. See Münster, *"Ich würde München gewis Ehre machen,"* plate 43. See also the drawn portrait by an unknown artist in Münster, *"Ich würde München gewis Ehre machen,"* plate 27.

117. Wolfgang Amadeus Mozart to Leopold Mozart, Sept. 26, 1777.

118. Franz Xaver Niemetschek, *Mozart: The First Biography* [1798], trans. Helen Mautner, ed. Cliff Eisen (New York: Berghahn, 2007), 20: "He counted the time spent in Munich amongst the pleasantest days of his life, and never forgot the candid friendship which he there enjoyed with so many estimable people."

119. Geoffrey Parker, *Imprudent King: A New Life of Philip II* (New Haven, CT: Yale University Press, 2014), 61–79, 115.

120. Nicolas Le Roux, *La faveur du roi: Mignons et courtisans au temps des derniers Valois* (Paris: Champ Vallon, 2001), 162–204.

121. Cecilia Nubola and Andreas Würgler, *Suppliche e "gravamina": Politica, ammistrazione, giustizia in Europa (secoli XIV-XVIII)* (Bologna: Mulino, 2002).

122. [Johann Christian Lünig], *Theatrum ceremoniale historico-politicum, Oder Historisch- und Politischer Schau-Platz des Europäischen Cantzley-Ceremoniels* (Leipzig: Moritz Georg Weidmann, 1720); Volker Bauer, *Die höfische Gesellschaft in Deutschland von der Mitte des 17. bis zum Ausgang des 18. Jahrhunderts* (Tübingen: Niemeyer, 1993), 30, 44. On the use of print media, see Volker Bauer, "Strukturwandel der höfischen Öffentlichkeit: Zur Medialisierung des Hoflebens vom 16. bis zum 18. Jahrhundert," *Zeitschrift für Historische Forschung* 38 (2011): 585–620.

123. Wolfgang Amadeus Mozart to Leopold Mozart, Sept. 23 and 24, 1777; see https://dme.mozarteum.at/DME/briefe/letter.php?mid=892&cat=.

124. Wolfgang Amadeus Mozart to Leopold Mozart, Sept. 26, 1777.

125. Particularly telling in this regard is the letter Anna Maria and Wolfgang Amadeus Mozart wrote to Leopold on September 29, 1777.

126. On the usage of the term, see Hengerer, *Kaiserhof und Adel*, 253.

127. See Münster, *"Ich würde München gewis Ehre machen,"* 68–72. On September 27, Leopold Mozart had first mentioned his name: "You will no doubt have visited Woschitka and flattered him" (den Woschitka wirst du wohl besucht und ihm geschmeichelt haben). He repeated the message in his next letter, of September 29: "Make a firm friend of Mr. Woschitka for yourself, he always has opportunities to speak with the elector" (mache dir den h. Woschitka recht zum freund, er hat immer Gelegenheit mit dem Churf. zu sprechen). On the same day, Wolfgang Amadeus Mozart wrote a letter to his father from Munich in which he reported that he, his mother, and Wotschitka had two meals together and that they were now "good friends." See Wolfgang Amadeus and Anna Maria Mozart to Leopold Mozart, Sept. 29, 1777.

128. Wolfgang Amadeus Mozart to Leopold Mozart, Sept. 29 and 30, 1777; see https://dme.mozarteum.at/DME/briefe/letter.php?mid=902&cat=.

129. Wolfgang Amadeus Mozart to Leopold Mozart, Sept. 29 and 30, 1777. This was a common way to go about the matter; see Hengerer, *Kaiserhof und Adel*, 252. Such exchanges of greetings, conversations, or passing a petition to someone had to be quick since they had to fit into the ruler's schedule.

130. Wolfgang Amadeus Mozart to Leopold Mozart, Sept. 29 and 30, 1777.

131. Christian Quaeitzsch, "Nutzung und Ausgestaltung der herrschaftlichen Wohnräume in der Münchner Residenz unter Kurfürst Max III. Joseph" [2012] (Friedrich 300—Zeremoniell, Raumdisposition und Möblierung) https://perspectivia.net/receive/ploneimport_mods_00000108.

132. Edith A. Standen, "The Story of the Emperor in China: A Beauvais Tapestry Series," *Metropolitan Museum Journal* 11 (1976): 103–17, 106–9. Fifteen examples are known, among them the Residenz Museum in Munich, Germany. The design is by Philippe Béhagle; see www.getty.edu/art/collection/artists/3018/philippe-behagle-french-1641-1705.

133. Wolfgang Amadeus Mozart to Leopold Mozart, Sept. 29 and 30, 1777. Mozart appeared in Munich with his diplomas that proved his membership in the academies of Bologna and Verona. From the road, he had asked his father to send them. It is possible that Mozart embellished his conversation with the elector. His own statements are somewhat ornate. But this fact would have made his inability to pick up on the signs the elector planted all the more apparent. See Piero Melograni, *Wolfgang Amadeus Mozart: A Biography*, trans. Lydia G. Cochrane (Chicago: University of Chicago Press, 2007), 73: "What he reports reveals a youthful imprudence in the nonchalant way he refers to what he said regarding his rebellion against Colloredo."

134. Hugh Ottaway, *Mozart* (London: Orbis, 1979), 66.

135. See Klingensmith, *The Utility of Splendor*, 152.

136. Wolfgang Amadeus Mozart to Leopold Mozart, Sept. 29 and 30, 1777.

137. Friedrich Prinz, *Die Geschichte Bayerns*, 2nd ed. (Munich: Piper, 1999), 247–53.

138. Eberhard Straub, *Repraesentatio maiestatis oder churbayerische Freudenfeste: Die höfischen Feste in der Münchner Residenz vom 16. bis zum Ende des 18. Jahrhunderts* (Munich: Stadtarchiv München, 1969), 319–37, esp. 332–33; Klingensmith, *The Utility of Splendor*, 16.

139. *Tagebuch von der lezten Krankheit Maximilian des III. Herzogen und Kurfürsten in Baiern [et]c. [et]c.: nebst Beylagen von der rechtmäßigen Succeßion Sr. jetzt regierenden Durchleucht, des Concilii medici, und des Testaments-Extract* (Frankfurt am Main: n.p., 1778).

140. Wolfgang Amadeus Mozart to Leopold Mozart, Sept. 29 and 30, 1777.

141. Hengerer, *Kaiserhof und Adel*, 246–48, esp. 247.

142. Leopold Mozart to Wolfgang Amadeus Mozart, Oct. 4, 1777; see https://dme.mozarteum.at/DME/briefe/letter.php?mid=906&cat=.

143. Wolfgang Amadeus Mozart to Leopold Mozart, Sept. 29 and 30, 1777. On Franz Joseph Albert, the innkeeper of "Zum Schwarzen Adler," see Münster, *"Ich würde München gewis Ehre machen,"* 62–66, and plate 33.

144. Leopold Mozart to Wolfgang Amadeus Mozart, Oct. 4, 1777. Count von Seeau inquired with the prince-bishop of Chiemsee about the finances of the Mozarts, wondering whether he would be able to stay with some additional help: "wissen sie nicht, hat den der Mozart nicht so viell von haus, daß er mit ein wenig beyhülfe bleiben könnte. Ich hätte lust ihn zu behalten." (See Münster, *"Ich würde München gewis Ehre machen,"* 80.)

145. See Norbert Elias, "Mozart: The Sociology of a Genius," in *Mozart and Other Essays on Courtly Art* (Dublin: University College Dublin Press, 2010), 73. After Elias's death, Michael Schröter edited the essay, which was first published in English as a monograph under the title *Mozart: Portrait of a Genius*, trans. Edmund Jephcott (Cambridge: Polity, 1993).

146. This is a recurrent theme in Elias's study, see Elias, *Mozart and Other Essays*, 65, 70–73, 82–84, passim.

147. Wolfgang Amadeus Mozart to Leopold Mozart, Sept. 23 and 24, 1777.

148. Anna Maria Mozart, postscript to letter from Wolfgang Amadeus Mozart to Leopold Mozart, Sept. 26, 1777. I replaced the expression "slave-driver" for "Schinder" in the quote since the word *slave* does not show up in this context.

149. Johann Heinrich Zedler, "Mufti," in *Grosses vollständiges Universal-Lexicon aller Wissenschafften und Künste, Welche bißhero durch menschlichen Verstand und Witz erfunden und verbessert worden*, vol. 22 (Halle: Zedler, 1739), cols. 20–22.

150. Leopold Mozart to Anna Maria and Wolfgang Amadeus Mozart, Sept. 27, 1777.

151. Elias, *Mozart and Other Essays*, 131.

152. Robert Münster, "München," in *Das Mozart Lexikon*, ed. Gernot Gruber and Joachim Brügge (Laaber: Laaber-Verlag, 2005), 487–88.

153. David Wyn Jones, "Joseph Haydn and the Esterházy Court," *Court Historian* 3 (1998): 3–8.

154. Hans-Josef Irmen, *Joseph Haydn: Leben und Werk* (Cologne: Böhlau, 2007), 80.

155. J. Cuthbert Hadden, *Haydn* (New York: AMS Press, 1971), 38.

156. Complaints about the length of time one waited surfaced where the social status of the superior in question was an issue, for favorites such as De Luynes under King Louis XIII or Colbert, to cite two French examples from the seventeenth century. See, e.g., Sharon Kettering, *Power and Reputation at the Court of Louis XIII: The Career of Charles D'Albert, Duc De Luynes (1578–1621)* (Manchester: Manchester University Press, 2017), 105: "Pamphleteers reported that the king's favor had so turned his head that Luynes made his father-in-law and other great nobles wait for hours in the antechamber to his rooms."

157. Patricia Spacks speaks of the "invention of boredom as a concept" in the eighteenth century as a moral issue and social ailment with gendered implications; see Patricia Meyer Spacks, *Boredom: The Literary History of a State of Mind* (Chicago: University of Chicago Press, 1995), 60 and passim. See also Elizabeth S. Goodstein, *Experience without Qualities: Boredom and Modernity* (Stanford, CA: Stanford University Press, 2005), 98–100; Martina Kessel, *Langeweile: Zum Umgang mit Zeit und Gefühlen in Deutschland vom späten 18. bis zum frühen 20. Jahrhundert* (Göttingen: Wallstein, 2001); Peter Toohey, *Boredom: A Lively History* (New Haven, CT: Yale University Press, 2011), 143–69. Daniel Jütte ("Sleeping in Church: Preaching, Boredom, and the Struggle for Attention in Medieval and Early Modern Europe," *American Historical Review* 125 [2020]: 1147–74) has offered a poignant critique of these approaches that identify boredom utterly with modern times.

158. Kessel, *Langeweile*, 55–81.

159. Pierre Choderlos de Laclos, *Les liaisons dangereuses, ou lettres recueillies dans une société, & publiées pour l'instruction de quelques autres* (Amsterdam: Durand, [1782]). As an immediate sensation, the book appeared in German one year later, and in English in 1784, see Pierre Choderlos de Laclos, *Die gefährlichen Bekantschaften oder: Briefe gesammelt in Einer Geselschaft und zur Belehrung einiger anderen bekant gemacht*, trans. Christian von Bonin (Leipzig: Jacobäer, 1783); and Pierre Choderlos de Laclos, *Dangerous Connections, or, Letters Collected in a Society and Published for the Instruction of Other Societies* (Dublin: Printed for Messrs. Sheppard, Moncrieffe, Walker, Jenkin, Wilson, White, Burton, Byrne, and Cash, 1784). See especially letter 81, with its reference to plans or schemes, the weapons of time, "occasions," mastery of the self and of others, and concealing one's plans from others (something contradicted by the letters themselves).

160. Joachim Neimitz, *Vernünfftige Gedancken uber allerhand Historische, Critische und Moralische Materien*, vol. 6 (Frankfurt am Main: Andreä, 1745), 201. Quoted in Friedrich Carl von Moser, *Teutsches Hof-Recht*, vol. 1 (Frankfurt am Main: Knoch and Eßlinger, 1761), 209. On courtiers reporting being bored, see Jütte, "Sleeping in Church," 1173.

161. Wolfgang Amadeus Mozart to Leopold Mozart, May 1, 1778; see https://dme.mozarteum.at/DME/briefe/letter.php?mid=1011&cat=.

162. The address is the one Mozart uses in this letter.

163. The word used is *Langeweile*.

164. Wolfgang Amadeus Mozart to Leopold Mozart, May 1, 1778.

165. Wolfgang Amadeus Mozart to Leopold Mozart, May 1, 1778. For translation of this and subsequent quotations in this paragraph, see Wolfgang Amadeus Mozart, *A Life in Letters*, ed. Cliff Eisen, trans. Stewart Spencer (London: Penguin, 2006), 281–83.

166. Wolfgang Amadeus Mozart to Leopold Mozart, Nov. 13, 1777; see https://dme.mozarteum.at/DME/briefe/letter.php?mid=933&cat=.

167. Michael J. Sauter, "Clockwatchers and Stargazers: Time Discipline in Early Modern Berlin," *American Historical Review* 112 (2007): 685–709, 703.

168. Wolfgang Amadeus Mozart to Leopold Mozart, May 1, 1778.

169. Anna Maria Mozart then added another message before the letter was sent off to Salzburg.

170. It may not be entirely accidental, therefore, that Mozart's letter also reports on a musical enterprise conducive to mutually shared enthusiasm through music, the so-called *concerts spirituels*. These concerts were held in Paris for a paying audience, though the specifics he shares with his father about the concert he had attended seem to belie their excellence.

171. Wolfgang Amadeus Mozart, *Die Hochzeit des Figaro: Texte, Materialien, Kommentare*, ed. Attila Csampai, Dietmar Holland (Reinbek: Rowohlt, 1982).

172. Willibald Alexis, "Dreimal in Weimar," in *Penelope: Taschenbuch auf das*

Jahr 1839 (Leipzig: J. G. Hinrichs, 1839), 324–43. On Alexis, see Lynne Tatlock, *Willibald Alexis' Zeitroman "Das Haus Düsterweg" and the Vormärz* (Frankfurt am Main: Peter Lang, 1984). A visit to Goethe that bears some resemblance to the 1824 visit is also part of the author's 1835 epistolary novel, *Das Haus Düsterweg* (Berlin: Duncker & Humblot, 1835). On Alexis's Goethe criticism, see Tatlock, *Willibald Alexis' Zeitroman*, 110–14.

173. Alexis, "Dreimal in Weimar," 332.

174. Alexis, *Das Haus Düsterweg*, vol 1, 362–63.

175. Alexis, "Dreimal in Weimar," 337.

176. See Peter Fritzsche, *Stranded in the Present: Modern Time and the Melancholy of History* (Cambridge, MA: Harvard University Press, 2004).

177. Alexis, "Dreimal in Weimar," 337.

178. Robert Walser, *Jakob von Gunten*, trans. Christopher Middleton (New York: New York Review Books, 1999), 98; Robert Walser, *Jakob von Gunten: Ein Tagebuch*, in *Das Gesamtwerk*, ed. Jochen Greven, vol. 6 (Frankfurt am Main: Suhrkamp, 1978), 93.

179. Susan Bernofsky, *Clairvoyant of the Small: The Life of Robert Walser* (New Haven, CT: Yale University Press, 2021), 144. Pierre Bourdieu speaks of "delaying without destroying hope, of adjourning without totally disappointing." See Pierre Bourdieu, *Pascalian Meditations*, trans. Richard Nice (Stanford, CA: Stanford University Press, 2000), 228.

180. Walser, *Jakob von Gunten*, 66–67; Walser, *Jakob von Gunten: Ein Tagebuch*, 64–65.

Conclusion

1. Dieter Wellershoff, "Langeweile und unbestimmtes Warten," in *Literarische Utopie-Entwürfe*, ed. Hiltrud Gnüg (Frankfurt am Main: Suhrkamp, 1982), 15–21; Jason Farman, *Delayed Response: The Art of Waiting from the Ancient to the Instant World* (New Haven, CT: Yale University Press, 2018); Craig Jeffrey, foreword to *Ethnographies of Waiting: Doubt, Hope and Uncertainty*, ed. Manpreet K. Janeja and Andreas Bandak (London: Bloomsbury 2018), xiv; Brigitte Kölle and Claudia Peppel, *Die Kunst des Wartens* (Berlin: Klaus Wagenbach, 2019); Timo Reuter, *Warten: Eine verlorene Kunst* (Frankfurt am Main: Westend, 2019); Mark Lilla, foreword to Andrea Köhler, *Passing Time: An Essay on Waiting*, trans. Michael Eskin (New York: Upper West Side Philosophers, 2011), 13.

2. Barry Schwartz, *Queuing and Waiting: Studies in the Social Organization of Access and Delay* (Chicago: University of Chicago Press, 1975), 1.

3. Nigel Barley, *The Innocent Anthropologist: Notes from a Mud Hut* (Long Grove, IL: Waveland, 1983), 66, 78–79.

4. Johannes Fabian, *Time and the Other: How Anthropology Makes Its Object* (New York: Columbia University Press, 1983), 31.

5. Reinhart Koselleck, "Author's Preface," in *Futures Past: On the Semantics of Historical Time*, trans. Keith Tribe (New York: Columbia University Press, 2004), 1–5; Kathleen Davis, *Periodization and Sovereignty: How Ideas of Feudalism and Secularization Govern the Politics of Time* (Philadelphia, PA: University of Philadelphia Press, 2008); Harry Harootunian, *Marx after Marx: History and Time* (New York: Columbia University Press, 2015), 21. On the emergence of linear notions of time, see Daniel Rosenberg and Anthony Grafton, *Cartographies of Time: A History of the Timeline* (Princeton, NJ: Princeton Architectural Press, 2010).

6. For context on postcolonial conceptions of time, see Russell West-Pavlov, "Postcolonial Temporalities," in *Temporalities* (London: Routledge, 2012), 158–74.

7. Dipesh Chakrabarty, *Provincializing Europe: Postcolonial Thought and Historical Difference* (Princeton, NJ: Princeton University Press, 2000), 8; Dipesh Chakrabarty, "The Muddle of Modernity," *American Historical Review* 116 (2011): 663–75. See also On Barak, *On Time: Technology and Temporality in Modern Egypt* (Berkeley: University of California Press, 2013); and Priya Satia, *Time's Monster: How History Makes History* (Cambridge, MA: Belknap, 2020).

8. For the notion of "temporary stillness," see Stephen A. Berrey, *The Jim Crow Routine* (Chapel Hill: University of North Carolina Press, 2015), 37–40.

9. Johann Georg Seybold, *Teutsch-Lateinisches Wörter Büchlein: Zum Nutz und Ergötzung der Schuljugend / Dictionariolum Germanico-Latinum in usum et delectationem scholasticae juventutis* (Nuremberg: J. Hoffmann, 1695), 166. The arrangement of words and topics combines grammatical with semantic categories.

10. Siegfried Kracauer, "Those Who Wait," in *The Mass Ornament: Weimar Essays*, ed. Thomas Y. Levin (Cambridge, MA: Harvard University Press, 1990), 129–40, 138; Siegfried Kracauer, "Die Wartenden," in *Werke*, vol. 5.1, *Essays, Feuilletons, Rezensionen, 1906–1923*, ed. Inka Mülder-Bach (Frankfurt am Main: Suhrkamp, 2011), 383–94, 392.

11. An overview appears in Gerhard Dohrn-van Rossum, "Time," in *Oxford Handbook of Early Modern History*, vol. 1, *People and Places*, ed. Scott Hamish (Oxford: University of Oxford Press, 2015). See also Max Engammare, *On Time, Punctuality, and Discipline in Early Modern Calvinism*, trans. Karin Maag (Cambridge: Cambridge University Press, 2010); and Max Engammare, *L'ordre du temps: L'invention de la ponctualité au XVI siècle* (Geneva: Droz, 2004).

12. There are several translations of this poem into English, among them C. P. Cavafy, *Collected Poems*, trans. Edmund Keeley and Philip Sherrad (Princeton, NJ: Princeton University Press, 1975). Dino Buzzati's 1940 novel *Il deserto dei Tartari* (The Tartar Steppe) is inspired by the poem, as is J. M. Coetzee's 1980 novel by the same title as the poem, though it is also a tribute to Buzzati. Ciro Guerra (dir.) turned Coetzee's novel into a film (2019).

13. Adolph von Vagedes, "Haus Harkotten-Korff" (1807), in *Haus Harkotten auf dem Weg in die Moderne: Adel und Alltag um 1800*, ed. Birgit Gropp (Petersberg:

Michael Imhof, 2022), 431. See also Fred Kasper, "Ein Haus zum Wohnen und Wirtschaften: Grundrisse als Spiegel der Lebensverhältnisse," in Gropp, 214–19.

14. François-René de Chateaubriand, *Mémoires d'outre-tombe*, vol. 4 (Paris: Flammarion, 2004), 18.

15. Alfred de Musset, *A Modern Man's Confession*, trans. G. F. Monkshood (London: Greening, 1908), 6.

16. Chateaubriand, *Mémoires d'outre-tombe*, 559.

17. On this momentous transformation, see William H. Sewell Jr., *Capitalism and the Emergence of Civic Equality in Eighteenth-Century France* (Chicago: University of Chicago Press, 2021).

18. *Deutsches Fremdwörterbuch*, ed. Leibniz-Institut für deutsche Sprache (ongoing project on the basis of the dictionary by the same title, ed. Hans Schulz and Otto Basler, 1913–), www.owid.de/artikel/405404?hi=antichambrieren#b_N10042.

19. Quoted in Jonathan Dewald, *Aristocratic Experience and the Origins of Modern Culture: France, 1570–1715* (Berkeley: University of California Press, 1993), 34–35.

20. Friedrich Schiller, "Die Verschwörung des Fiesco zu Genua: Ein republikanisches Trauerspiel," in *Werke in drei Bänden*, vol. 1 (Munich: Hanser, 1966), 171–262, 222; Friedrich Schiller, *Fiesco's Conspiracy of Genoa*, trans. Flora Kimmich, ed. John Guthrie (Cambridge: Open Books, 2015), 71. See also David Bindman and Helen Weston, "Court and City: Fantasies of Domination," in *The Image of the Black in Western Art*, vol. 3, *From the "Age of Discovery" to the Age of Abolition* (Cambridge, MA: Harvard University Press, 2011), 123–70.

21. Schiller, "Die Verschwörung des Fiesco," 172.

22. Ernest Lacan, "Vues et portraits par M. Edouard Delessert," *La Lumière*, Oct. 28, 1853, 170–71. See also Elizabeth Anne McCauley, *A. A. E. Disdéri and the Carte des Visite Portrait Photograph* (New Haven, CT: Yale University Press, 1985), 30; William C. Darrah, *Cartes de Visite in Nineteenth Century Photography* (Gettysburg, PA: W. C. Darrah, 1981), 4.

23. August Orth, "Görlitzer Bahnhof," Berlin (Längsschnitt, Querschnitte eines Wartesaales und der Retirade), Architekturmuseum der Technischen Universität Berlin, Germany, www.europeana.eu/en/item/08535/item_HXMQJSY2733 BY4P7WHUOTHQNEPISOZZA. See also Carroll L. V. Meeks, *The Railroad Station: An Architectural History* (New Haven, CT: Yale University Press, 1956); Ulrich Krings, *Bahnhofsarchitektur: Deutsche Großstadtbahnhöfe des Historismus* (Munich: Prestel, 1985), 117; and Robin Kellermann, *Im Zwischenraum der beschleunigten Moderne: Eine Bau- und Kulturgeschichte des Wartens auf Eisenbahnen, 1830–1935* (Bielefeld: Transcript, 2021).

24. Christopher Alexander et al., *A Pattern Language: Towns, Buildings, Construction* (Oxford: Oxford University Press, 1977), 119–22.

25. Il'ia Il'f and Evgenii Petrov, *Little Golden America: Two Famous Soviet Hu-

mourists Survey the United States, trans. Charles Malamuth (London: G. Routledge & Sons, 1944), 292.

26. Vladimir Sorokin, *The Queue,* trans. Sally Laird (New York: New York Review Books, 2008), 255. On waiting in line from the vantage point of Soviet economics, see E. G. Liberman, "The Queue: Anamnesis, Diagnosis, Therapy," *Soviet Review* 9, no. 4 (1968–69): 12–16. After the end of communist rule, the Institute for National Remembrance in Poland issued a board game entitled Kolejka (Queue) (2011; international edition in 2012), to teach about everyday life before 1991. The literature on lining up in Eastern Europe is vast; see, e.g., Sheila Fitzpatrick, *Everyday Stalinism: Ordinary Life in Extraordinary Times: Soviet Russia in the 1930s* (Oxford: Oxford University Press, 1999), 40–45, 54–58; and Jarrett Zigon, "Hope and Waiting in Post-Soviet Moscow," in *Ethnographies of Waiting: Doubt, Hope and Uncertainty,* ed. Manpreet K. Janeja and Andreas Bandak (London: Bloomsbury 2018), 65–86.

27. See David Maister, "The Psychology of Waiting Lines," in *The Service Enounter: Managing Employee/Customer Interaction in Service Businesses,* ed. John A. Czepiel, Michael R. Solomon, and Carol F. Surprenant (Lexington, MA: Lexington Books, 1985), 113–23.

28. See Helmut Puff and Bernardo Zacka, "Architectures of Waiting: Helmut Puff and Bernardo Zacka in Conversation," *Contemporary Political Theory* 21 (2022): 1–18.

29. Rüdiger von Fritsch, *Russlands Weg: Als Botschafter in Moskau* (Berlin: Aufbau, 2020), 109–10. In times of COVID-19, people who were scheduled to meet Putin had to quarantine for two weeks (Fresh Air, "How Russia's Invasion of Ukraine Changes the World as We Know It," interview with Anne Applebaum, March 2022). See also David E. Sanger and Anton Troianovski, "US Intelligence Weighs Putin's Two Years of Extreme Pandemic Isolation," *New York Times,* March 5, 2022.

30. See Samantha Lock, "Erdoğan Keeps Putin Waiting," *The Guardian,* July 19, 2022.

31. Carl Schmitt, *Gespräch über die Macht und den Zugang zum Machthaber: Gespräch über den Neuen Raum* (1954; Berlin: Akademie Verlag, 1994).

32. See Bruno Latour, *We Have Never Been Modern,* trans. Catherine Porter (Cambridge, MA: Harvard University Press, 1993).

33. See Scott Briar, "Welfare from Below: Recipients' View of the Public Welfare System," *California Law Review* 54 (1966): 370–85.

34. Daniel Defoe, *Robinson Crusoe* [1719] ([Waiheke Island]: Floating Press, 2008), 406. See also Mozart's mother, Anna Maria, who used the same formula quoted in chapter 3.

Selected Bibliography

Primary Sources

Alberti, Leon Battista. *On the Art of Building in Ten Books.* Translated by Joseph Rykwert, Neil Leach, and Robert Tavernor. Cambridge, MA: MIT Press, 1988.

Alexis, Willibald. *Das Haus Düsterweg.* Berlin: Duncker & Humblot, 1835.

———. "Dreimal in Weimar." In *Penelope: Taschenbuch auf das Jahr 1839,* edited by Theodor Hell, 324–43. Leipzig: J. G. Hinrichs, 1839.

Amelot de La Houssaye, Abraham-Nicolas, trans. *L'homme de cour, traduit de l'Espagnol de Baltasar Gracian.* Paris: La Veuve-Martin & Jean Boudot, 1684.

———. *L'Uomo di corte di Baldassar Graziano tradotto dallo spagnuolo nel francese Idioma, dal Signor Amelot de La Houssaie nuovamente tradotto dal francese nell'italiano dall'abate Francesco Tosques.* Rome: Luca-Antonio Chracas, 1698.

———. *L'Uomo di corte di Baldassar Graziano tradotto dallo spagnuolo nel francese Idioma, dal Signor Amelot de La Houssaie nuovamente tradotto dal francese nell'italiano dall'abate Francesco Tosques. Le même: traduit en Russe, par Serge Wolezkow, Secretaire de l'Academie des Sciences. Imprimé pour l'Academie Imperiale des sciences.* [s.l.: s.n.], 1742.

———. *Maxims Translated from a Book Intitled "L'homme de Cour": or, The Courtier.* [Oxford:] s.n., 1721.

Anton Ulrich, Herzog zu Braunschweig und Lüneburg. *Aramena: Urfassung von die durchleuchtige Syrerin Aramena.* In *Werke: Historisch-Kritische Ausgabe* [unnumbered]. Bibliothek des Literarischen Vereins in Stuttgart 351. Stuttgart: Anton Hiersemann, 2017.

———. *Die durchleuchtige Syrerin Aramena.* Vol. 1, *Der Erwehlten Freundschaft gewidmet.* Nuremberg: Hofmann, 1678.

———. *Die Römische Octavia.* Edited by Rolf Tarot and Maria Munding. In *Werke: Historisch-Kritische Ausgabe.* Vol. 3. Stuttgart: Anton Hiersemann, 1993–.

Bergenroth, Gustav Adolph, Pascual de Gayangos, et al., eds. *Calendar of Letters, Despatches, and State Papers, relating to the negotiations between England and Spain, preserved in the archives of Vienna, Simancas, Besançon, Brussels, Madrid and Lille.* s.l.: TannerRitchie, 2007.

Bodin, Jean. *Les six livres de la république.* Aalen: Scientia, 1961.

Bohse, August. *Der getreue Hoffmeister adelicher und bürgerlicher Jugend.* Leipzig: Gleditsch, 1703.

Casanova, Giacomo [Jacques Casanova de Seingault]. *Histoire de ma vie suivie de textes inédits.* Edited by Francis Lacassin. Paris: Robert Laffont, 1993.

———. *History of My Life.* Translated by Willard R. Trask. Baltimore: Johns Hopkins University Press, 1997.

Cavafy, C. P. *Collected Poems.* Translated by Edmund Keeley and Philip Sherrad. Princeton, NJ: Princeton University Press, 1975.

Chambers, Ephraim. *Cyclopædia, or, An Universal Dictionary of Arts and Sciences.* London: James and John Knapton, et al., 1728.

Charcot, Jean-Martin. *De l'expectation en médecine.* Thèse d'agrégation, 1857.

Cramer, Daniel. *Octoginta emblemata moralia nova sacris literis petita, formandis ad veram pietatem accommodata, & elegantibus picturis aeri incisis repraesentata.* Frankfurt am Main: Lucas Jennisius, 1630.

D'Alembert, Jean Le Rond, and Denis Diderot. *Encyclopédie ou dictionnaire raisonné des sciences, des arts et des métiers.* Neuchâtel: S. Faulche, 1751–72.

Das frolockende Berlin, Oder Historische Nachricht. Berlin: Rüdiger, 1728.

Dasypodius, Conrad. *Aigentliche Fürbildung und Beschreibung deß Neuen Kunstlichen Astronomischen Urwerckes, zu Straßburg im Mönster, das M.D.LXXIIII. Jar vollendet, zusehen.* [Strasbourg]: Jobin, [after 1574].

———. *Heron mechanicus: Seu de mechanicis artibus, atque disciplinis. Eiusdem horologii atsronomici, Argentorati in summo templo erecti, descriptio. Argentorati 1580.* Edited by Bernard Aratowsky and Günther Oestmann. Augsburg: Dr. Erwin Rauner, 2008.

———. *Warhafftige Außlegung des Astronomischen Vhrwercks zu Straßburg.* Strasbourg: Nikolaus Wiriot, 1578.

Daviler, Augustin-Charles. *Cours d'architecture qui comprend les ordres de Vignole.* Paris: Mariette, 1720.

Defoe, Daniel. *Robinson Crusoe.* [Waiheke Island:] Floating Press, 2008.

Dykmans, Marc. *Le cérémonial papal de la fin du Moyen Age à la Renaissance.* Vol. 3, *Les textes Avignonnais jusqu'à la fin du grand schisme d'occident.* Bruxelles: Institute Historique Belge de Rome, 1983.

Ensuyvent les reglements faicts par le roy, le premier iour de Ianvier mil cinq cens quatre vingts cinq. [Paris: n.p.,] 1585.

Epictetus. *Hand-Büchlein: Aus dem Griechischen mit Hülffe der lateinischen . . . in die deutsche Sprache von neuem übersetzet.* Oels: Bockshammer, 1695.

Erasmus of Rotterdam. *Collected Works.* Edited by R. A. B. Mynors. Toronto: University of Toronto Press, 1974–.

Erbstein, Johann Georg. *Antichambre der vornehmsten Höfe Europens oder kurtze Histor- und Genealogische Verfassung der höchsten Potentaten in Europa, von zweyen Seculis her.* Leipzig: Kayser, 1718.

Ernst, M. Jacob Daniel. *Anweisung / Wie Dessen so genantes Historisches Bilder-Hauß / neben denen dreyen Theilen der Historischen Confect-Taffel / bey Erklärung der gewöhnlichen Sonn- und Festtags Episteln und Evangelien nützlich anzuwenden und zu gebrauchen.* Altenburg: Richter, 1688.

Freschot, Casimir. *Mémoires de la cour de Vienne: Contenant les remarques d'un voyageur curieux sur l'état present de cette cour.* Cologne: Étienne, 1706.

Geerds, Robert, ed. *Die Mutter der Könige von Preussen und England: Memoiren und Briefe der Kurfürstin Sophie von Hannover.* Munich: W. Langewiesche-Brandt, 1913.

A Goodly Prymer in Englyshe. London: William Marshall, 1535.

Gracián, Balthasar. *Criticon von den allgemeinen Lastern des Menschen: Aus dem Frantzösischen ins Teutsche übersetzet.* Frankfurt am Main and Leipzig: Zeitler, 1698.

———. *Obras.* 2 vols. Antwerp: Verdussen, 1702.

———. *Obras: Ultima impression, mas corregida, y enriquecida de tablas.* Madrid: Redondo; De Val, 1664.

———. *Oráculo manual y arte de prudencia.* Barcelona: Linkgua, 2011.

———. *Oracvlo manval, y arte de prvdencia.* Amsterdam: Ivan Blaeu, 1659.

———. *Oracvlo manval, y arte de prvdencia.* Madrid: Maria de Quinnones, 1653.

———. *The Pocket Oracle and Art of Prudence.* Translated by Jeremy Robbins. London: Penguin, 2011.

Gresbeck, Heinrich. *False Prophets and Preachers: Henry Gresbeck's Account of the Anabaptist Kingdom of Münster.* Translated by Christopher S. Mackay. Kirksville, MO: Truman State University Press, 2016.

Hochfürstlich-Salzburgischer Kirchen- und Hof-Kalender. Salzburg: Duyle, 1746.

Ignatius, of Loyola, Saint. *The Spiritual Exercises of St. Ignatius.* Translated by Anthony Mottola. Edited by Robert W. Gleason. Garden City, NY: Image Books, 1964.

James III, King of Majorca. *Leges Palatinae.* Bloomington: Indiana University Press, 1994 (in association with José J. de Olañeta, 1994).

Jaume III Rei de Mallorca. *Lleis Palatines.* Edited by Llorenç Pérez Martinez et al. Palma de Mallorca: José J. de Olañeta, 1991.

Johnson, Samuel. *A Dictionary of the English Language.* 6th ed. London: Rivington, 1785.

Küchelbecker, Johann Basilius. *Allerneueste Nachricht vom Römisch-Kayserlichen Hofe nebst einer ausführlichen Beschreibung der Kayserlichen Residenz-Stadt Wien und der umliegenden Örter. Theils aus den Geschichten, theils aus eigener Erfahrung zusammen getragen und mit saubern Kupffern ans Licht gegeben.* Hanover: n.p., 1730.

Laclos, Pierre Choderlos de. *Les liaisons dangereuses, ou Lettres recueillies dans une société, & publiées pour l'instruction de quelques autres.* Amsterdam: Durand, [1782].

———. *Die gefährlichen Bekantschaften oder: Briefe gesammelt in Einer Geselschaft und zur Belehrung einiger anderen bekant gemacht.* Translated by Christian von Bonin. Leipzig: Jacobäer, 1783.

———. *Dangerous Connections, or, Letters Collected in a Society and Published for the Instruction of Other Societies.* Dublin: Printed for Messrs. Sheppard, Moncrieffe, et al., 1784.

Laugier, Marc-Antoine. *Observations sur l'architecture.* Paris: Desaint, 1765.

Loën, Johann Michael von. *Gesamlete kleine Schriften.* Edited by Johann Caspar Schneider. Frankfurt am Main: Philipp Heinrich Huttern, 1750.

Ludwig Rudolph Herzog von Braunschweig-Wolfenbüttel. *Tagebuch* (1701). Herzog August Bibliothek, Cod. Guelf. 28 Blank.

———. *Eigenhändige Exzerpte Herzog Ludwig Rudolphs, 1712/13–1724.* Herzog August Bibliothek, Cod. Guelf. 278 Blank.; 280 Blank.; 286 Blank.; 286a Blank.

Lünig, Johann Christian. *Theatrum Ceremoniale Historico-Politicum, Oder Historisch- und Politischer Schau-Platz des Europäischen Cantzley-Ceremoniels.* Leipzig: Moritz Georg Weidmann, 1720.

Luther, Martin. *Werke: Kritische Gesamtausgabe* (*Weimarer Ausgabe*). Weimar: Böhlau, 1883–2009.

Meisch, Christian Albrecht. *Neu-erfundene Sinnbilder.* Frankfurt am Main: Ammon and Serlin, 1661.

Monconys, Balthasar de. *Iovrnal des voyages.* Vol. 2, *Voyage d'Angleterre, Païs-Bas, Allemagne, & Italie.* Lyon: Horace Boissat, & George Remevs, 1666.

Moser, Friedrich Carl von. *Teutsches Hof-Recht.* Frankfurt am Main: Knoch and Eßlinger, 1761.

Moser, Johann Jakob. *Lebens-Geschichte Johann Jacob Mosers Königlich-Dänischen Etats-Raths von ihm selbst beschrieben.* Vol. 1. 3rd ed. Frankfurt am Main: Meyersche Buchhandlung, 1777.

———. *Lebens-Geschichte Johann Jacob Mosers Königlich-Dänischen Etats-Raths von ihm selbst beschrieben: Nebst einem Register über alle 4 Theile.* 3rd ed. Frankfurt am Main: n.p., 1783.

Mozart, Wolfgang Amadeus. *A Life in Letters.* Edited by Cliff Eisen. Translated by Stewart Spencer. London: Penguin, 2006.

———. *Die Hochzeit des Figaro: Texte, Materialien, Kommentare.* Edited by Attila Csampai and Dietmar Holland. Reinbek: Rowohlt, 1982.

———. Digital Mozart Edition of the Mozarteum Salzburg at dme.mozarteum.at.

Neimitz, Joachim. *Vernünfftige Gedancken uber allerhand Historische, Critische und Moralische Materien.* Vol. 6. Frankfurt am Main: Andreä, 1745.

Niemetschek, Franz Xaver. *Mozart: The First Biography.* 1798. Translated by Helen Mautner. Edited by Cliff Eisen. New York: Berghahn, 2007.

Offelen, Heinrich, Daniel de La Feuille, *Devises et emblemes Anciennes et Modernes*

tirées des plus celebres Auteurs Oder: Emblematische Gemüths-Vergnügung Bey Betrachtung Sieben Hundert und funffzehen der curieusesten und ergötzlichsten Sinn-Bildern / Mit ihren zuständigen Teutsch-Lateinisch-Französisch- und Italianischen Beyschrifften. 4th ed. Augsburg: Kroniger & Göbel, 1699.

Olearius, Adam. *Des welt-berühmten Adami Olearii colligirte und viel vermehrte Reise-Beschreibungen: bestehend in der nach Mußkau und Persien.* Hamburg: Hertel, 1696.

Pallavicino, Ranuccio. *Triumphierendes Wunder-Gebäw der churfürstlichen Residentz zu München.* Translated by Johann Schmid. Munich: Straub, 1685.

Plutarch. *Lives.* Edited by Bernadotte Perrin. Cambridge, MA: Harvard University Press, 1914–1990.

Residences Memorables De l'incomparable Heros de nôtre Siecle ou Representation exacte des Edifices et Jardins de Son Altesse Serenissime Monseigneur Le Prince EUGENE FRANCOIS Duc de Savoye et de Piemont . . . Schloss Belvedere und die dazugehörigen Gärten. Augsburg: Jeremias Wolff Erben, 1731–1740.

Rohr, Julius Bernhard von. *Einleitung zur Ceremoniel-Wissenschafft der großen Herren.* Berlin: Johann Andreas Rüdiger, 1733.

———. *Einleitung zur Ceremoniel-Wissenschafft der Privat-Personen.* Berlin: Johann Andreas Rüdiger, 1728.

———. *Einleitung zur Klugheit zu leben.* Leipzig: Martini, 1715.

Savonarola, Girolamo. *Prediche sopra Amos e Zaccaria.* Edited by Paolo Ghiglieri. Rome: Belardetti, 1971.

———. *Scelta di Prediche e Scritti di Fra Girolamo Savonarola.* Edited by Pasquale Villari. Florence: Sansoni, 1898.

———. *Selected Writings of Girolamo Savonarola: Religion and Politics, 1490–1498.* Translated and edited by Anne Borelli and Maria Pastore Passaro. New Haven, CT: Yale University Press, 2006.

Schiller, Friedrich. *Werke in drei Bänden.* Munich: Hanser, 1966.

Seipp, Johann Philipp. *Neue Beschreibung der Pyrmontischen Gesund-Brunnen.* Hanover: Förster, 1717.

Seybold, Johann Georg. *Teutsch-Lateinisches Wörter Büchlein: Zum Nutz und Ergötzung der Schuljugend / Dictionariolum Germanico-Latinum in usum et delectationem scholasticae juventutis.* Nuremberg: J. Hoffmann, 1695.

Storch, Johann. *Von Kranckheiten der Weiber: Darinnen vornemlich solche Casus, Kranckheiten und Gebrechen, so man der weiblichen Mutter zuschreibet.* Gotha: Mevius, 1753.

———. *Von Kranckheiten der Weiber: Darinnen vornehmlich solche Casus, Welche den Jungfern-Stand betreffen.* Gotha: Mevius, 1748.

Tagebuch von der lezten Krankheit Maximilian des III. Herzogen und Kurfürsten in Baiern [et]c. [et]c.: Nebst Beylagen von der rechtmäßigen Succeßion Sr. jetzt regie-

renden Durchleucht, des Concilii medici, und des Testaments-Extract. Frankfurt am Main: n.p., 1778.

Thomasius, Christian. *Schertz- und ernsthaffter, vernünfftiger und einfältiger Gedancken über allerhand lustige und nützliche Bücher und Fragen.* Halle a.d.S.: Weidmann, 1688–89.

Tilley, Morris Palmer. *A Dictionary of the Proverbs in England in the Sixteenth and Seventeenth Centuries.* Ann Arbor: University of Michigan Press, 1950.

Tribaldo de' Rossi. "Ricordanze." In *Delizie degli Eruditi Toscani.* Vol. 23. Edited by Ildefonso da San Luigi. Florence: Gaetano Cambiagi, s.a. [c. 1779].

Vitruvius. *On Architecture.* Edited by Frank Granger. Cambridge, MA: Harvard University Press, 1970.

[Voltaire] *Ode sur la mort de son altesse royale Madame la Markgrave de Bareith.* London: [n.p.], 1759.

The Vulgate Bible: The Douay-Rheims Translation. Edited by Swift Edgar and Angela M. Kinney. Cambridge, MA: Harvard University Press, 2010-.

Wilhelmine von Bayreuth. *Mémoires de Frédérique Sophie Wilhelmine, Margrave de Bayreuth.* Edited by Pierre Gaxotte and Gérard Doscot. Paris: Mercure de France, 1967.

———. *Mémoires de Frédérique Sophie Wilhelmine, Margrave de Bayreuth, Sœur de Frédéric-Le-Grand, Depuis l'année 1706 Jusqu'à 1742, Écrits de Sa Main.* Leipzig: H. Barsdorf, 1889.

———. *Memoirs.* Translated by Christian of Schleswig Holstein. New York: Harper & Bros., 1888.

[Wilmot, John, Earl of Rochester]. *Sodom, or the Quintessence of Debauchery.* Edited by Patrick J. Kearney. s.l., 1969.

Zedler, Johann Heinrich. *Grosses vollständiges Universal-Lexicon aller Wissenschafften und Künste, Welche bißhero durch menschlichen Verstand und Witz erfunden und verbessert worden.* Halle: Zedler, 1731–54.

Zimmerische Chronik. Edited by Karl A. Barack. Bibliothek des Litterarischen Vereins in Stuttgart. Vol. 94. Tübingen: Laupp, 1869.

Secondary Sources

Ago, Renata. *A Gusto for Things: A History of Objects in Seventeenth-Century Rome.* Translated by Bradford Bouley, Corey Tazzara, and Paula Findlen. Chicago: University of Chicago Press, 2013.

Akkerman, Nadine, and Birgit Houben, eds. *The Politics of Female Households: Ladies-in-Waiting across Early Modern Europe.* Leiden: Brill, 2013.

Alexander, Christopher, et al. *A Pattern Language: Towns, Buildings, Construction.* Oxford: Oxford University Press, 1977.

Alfter, Dieter, ed. *Festung und Schloß Pyrmont: Restaurierung und neue Nutzung:*

Anläßlich der Eröffnungsfeier 29. Mai–1. Juni 1987. Bad Pyrmont: Museum im Schloß, 1987.

———. *Schloss Pyrmont.* Regensburg: Schnell & Steiner, 1988.

Althoff, Gerd, ed. *Formen und Funktionen öffentlicher Kommunikation.* Stuttgart: Thorbecke, 2001.

Aristarkhova, Irina. *Arrested Welcome: Hospitality in Contemporary Art.* Minneapolis: University of Minnesota Press, 2020.

Arnold, Werner. *Eine norddeutsche Fürstenbibliothek des frühen 18. Jahrhunderts: Herzog Ludwig Rudolph von Braunschweig Lüneburg und seine Büchersammlung.* Göttingen: Traugott Bautz, 1980,

Artan, Tülay, Jeroen Duindam, and Metin Kunt, eds. *Royal Courts in Dynastic States and Empires: A Global Perspective.* Leiden: Brill, 2011.

Atkinson, Niall. *The Noisy Renaissance: Sound, Architecture, and Florentine Urban Life.* University Park: Pennsylvania State University Press, 2016.

Asch, Ronald G., and Heinz Duchhardt. *Der Absolutismus—ein Mythos: Strukturwandel monarchischer Herrschaft in West- und Mitteleuropa (ca. 1550–1700).* Cologne: Böhlau, 1996.

Assmann, Aleida, ed. *Aufmerksamkeiten.* Munich: Fink, 2001.

Augé, Marc. *Non-places: Introduction to an Anthropology of Supermodernity.* Translated by John Howe. London: Verso, 1995.

Auyero, Javier. "Patients of the State: An Ethnographic Account of Poor People's Waiting." *Latin American Research Review* 46 (2011): 5–29.

———. *Patients of the State: The Politics of Waiting in Argentina.* Durham, NC: Duke University Press, 2012.

Bachmann, Erich, and Alfred Ziffer. *Neues Schloss Bayreuth.* Munich: Bayerische Verwaltung der Staatlichen Schlösser, 1995.

Backes, Magnus. *Julius Ludwig Rothweil: Ein Rheinisch-Hessischer Barockarchitekt.* Baden-Baden: Heitz, 1959.

Baillie, Hugh Murray. "Etiquette and the Planning of the State Apartments in Baroque Palaces." *Archaeologia: or, Miscellaneous Tracts Relating to Antiquity* 101 (1967): 169–99.

Bakhtin, M. M. *The Dialogic Imagination: Four Essays.* Edited by Michael Holquist. Austin: University of Texas Press, 1981.

Baraitser, Lisa. *Enduring Time.* London: Bloomsbury, 2017.

Barak, On. *On Time: Technology and Temporality in Modern Egypt.* Berkeley: University of California Press, 2013.

Barner, Wilfried. *Barockrhetorik: Untersuchungen zu ihren geschichtlichen Grundlagen.* Tübingen: M. Niemeyer, 1970.

Barthes, Roland. *A Lover's Discourse.* Translated by Richard Howard. London: Penguin, 1990.

Bauer, Volker. *Die höfische Gesellschaft in Deutschland von der Mitte des 17. bis zum Ausgang des 18. Jahrhunderts.* Tübingen: Niemeyer 1993.

———. *Hofökonomie: Der Diskurs über den Fürstenhof in Zeremonialwissenschaft, Hausväterliteratur und Kameralismus.* Vienna: Böhlau, 1997.

———. "Strukturwandel der höfischen Öffentlichkeit: Zur Medialisierung des Hoflebens vom 16. bis zum 18. Jahrhundert," *Zeitschrift für Historische Forschung* 38 (2011): 585–620.

Becker, Frank, ed. *Geschichte und Systemtheorie: Exemplarische Fallstudien.* Frankfurt am Main: Campus, 2004.

Bell, Duncan and Bernardo Zacka, eds. *Political Theory and Architecture.* London: Bloomsbury Academic, 2020.

Benedik, Christian. "Die Herrschaftlichen Appartements: Funktion und Lage während der Regierungen von Kaiser Leopold I. bis Kaiser Franz Joseph I.." *Österreichische Zeitschrift für Kunst und Denkmalpflege: Wiener Hofburg: Neue Forschungen* 51 (1997): 552–70.

———. "Die Repräsentationsräume der Wiener Hofburg in der ersten Hälfte des 18. Jahrhunderts." *Das Achtzehnte Jahrhundert und Österreich* 2 (1997): 7–22.

Benjamin, Walter. *The Arcades Project.* Translated by Howard Eiland and Kevin McLaughlin. Cambridge, MA: Belknap, 1999.

Bergdoll, Barry. *European Architecture, 1750–1890.* Oxford: Oxford University Press, 2000.

Bergson, Henri. *Time and Free Will: An Essay on the Immediate Data of Consciousness.* Translated by Frank Lubecki Pogson. London: G. Allen, 1913.

Berrey, Stephen A., *The Jim Crow Routine.* Chapel Hill: University of North Carolina Press, 2015.

Beuzelin, Cécile. *L'anticamera' Benintendi: Morale et politique dans la peinture domestique à Florence vers 1523.* Florence: Leo S. Olschki, 2015.

Bjornerud, Marcia. *Timefulness: How Thinking like a Geologist Can Help Save the World.* Princeton, NJ: Princeton University Press, 2018.

Börsch-Supan, Helmut. *Der Maler Antoine Pesne: Franzose und Preuße.* Friedberg: Podzun-Pallas, 1986.

Bourdieu, Pierre. *Pascalian Meditations.* Translated by Richard Nice. Stanford, CA: Stanford University Press, 2000.

Brandhuber, Christoph, and Werner Rainer. "Ein Fürst führt Tagebuch: Die 'Notata' des Salzburger Fürsterzbischofs Franz Anton Fürsten von Harrach (1665–1727)." *Salzburg Archiv* 34 (2010): 205–62.

Brassat, Wolfgang. *Tapisserien und Politik: Funktionen, Kontexte und Rezeption eines repräsentativen Mediums.* Berlin: Mann, 1992.

Brendecke, Arndt, Ralf-Peter Fuchs, and Edith Koller, eds. *Die Autorität der Zeit in der Frühen Neuzeit.* Münster: Lit, 2007.

Burke, Peter. "Performing History: The Importance of Occasions." *Rethinking History: The Journal of Theory and Practice* 9 (2005): 35–52.

———. "Reflections on the Cultural History of Time." *Viator* 35 (2004): 617–26.

Burschel, Peter, and Christine Vogel, eds. *Die Audienz: Ritualisierter Kulturkontakt in der Frühen Neuzeit.* Cologne: Böhlau, 2014.

Bußmann, Klaus, Florian Matzner, and Ulrich Schulze, eds. *Johann Conrad Schlaun, 1695–1773: Architektur des Spätbarock in Europa.* Stuttgart: Oktagon, 1995.

Butz, Reinhardt, Jan Hirschbiegel, and Dietmar Willoweit, eds. *Hof und Theorie: Annäherungen an ein historisches Phänomen.* Cologne: Böhlau, 2004.

Carlebach, Elisheva. *Palaces of Time: Jewish Calendar and Culture in Early Modern Europe.* Cambridge, MA: Belknap Press, 2011.

Caron, David. "Waiting = Death: COVID-19, the Struggle for Racial Justice, and the AIDS Pandemic." In *Being Human during COVID*, ed. Kristin Hass, 93–116. Ann Arbor: University of Michigan Press, 2021.

Chakrabarty, Dipesh. "The Muddle of Modernity." *American Historical Review* 116 (2011): 663–75.

———. *Provincializing Europe: Postcolonial Thought and Historical Difference.* Princeton, NJ: Princeton University Press, 2000.

Champion, Matthew S. "A Fuller History of Temporalities." *Past & Present* 243 (2019): 255–66.

———. *The Fullness of Time: Temporalities of the Fifteenth-Century Low Countries.* Chicago: University of Chicago Press, 2017.

Cherubini, Giuseppe. *Palazzo Medici Riccardi.* Florence: Giunti, 1990.

Ciavolella, Massimo, and Amilcare A. Iannucci, eds. *Saturn: From Antiquity to the Renaissance.* Ottawa: Dovehouse, 1992.

Clark, Christopher. *Time and Power: Visions of History in German Politics from the Thirty Years' War to the Third Reich.* Princeton, NJ: Princeton University Press, 2019.

Coaldrake, William H. *Architecture and Authority in Japan.* London: Routledge, 1996.

Coffin, David R. *The Villa in the Life of Renaissance Rome.* Princeton, NJ: Princeton University Press, 1979.

Cohen, Simona. *Transformations of Time and Temporality in Medieval and Renaissance Art.* Leiden: Brill, 2014.

Corcoran, Paul E. "Godot Is Waiting Too: Endings in Thought and History." *Theory and Society* 18 (1989): 495–529.

Crapanzano, Vincent. *Waiting: The Whites of South Africa.* New York: Random House, 1985.

Crary, Jonathan. *24/7: Late Capitalism and the Ends of Sleep.* New York: Verso, 2013.

Daniel, Ute. "Zwischen Zentrum und Peripherie der Hofgesellschaft: Zur biographischen Struktur eines Fürstinnenlebens der Frühen Neuzeit am Beispiel der Kurfürstin Sophie von Hannover." *L'Homme* 8 (1997): 208–17.

Davis, Kathleen. *Periodization and Sovereignty: How Ideas of Feudalism and Secularization Govern the Politics of Time*. Philadelphia: University of Philadelphia Press, 2008.

Dewald, Jonathan. *Aristocratic Experience and the Origins of Modern Culture: France, 1570–1715*. Berkeley: University of California Press, 1993.

———. *The European Nobility, 1400–1800*. Cambridge: Cambridge University Press, 1996.

Dickens, A. G., ed. *The Courts of Europe: Politics, Patronage and Royalty, 1400–1800*. New York: McGraw-Hill, 1977.

Dillon, Janette. *The Language of Space in Court Performance, 1400–1625*. Cambridge: Cambridge University Press, 2010.

Dirlmeier, Ulf. *Geschichte des Wohnens*. Stuttgart: Deutsche Verlagsanstalt, 1998.

Dohrn-van Rossum, Gerhard. *History of the Hour: Clocks and Modern Temporal Orders*. Translated by Thomas Dunlap. Chicago: University of Chicago Press, 1996.

———. "Time." In *Oxford Handbook of Early Modern History*. Vol. 1, *People and Places*, ed. Hamish Scott. Oxford Handbooks Online. Oxford: Oxford University Press, 2015.

Duden, Barbara. *The Woman beneath the Skin: A Doctor's Patients in Eighteenth-Century Germany*. Translated by Thomas Dunlap. Cambridge, MA: Harvard University Press, 1991.

Duindam, Jeroen. *Myths of Power: Norbert Elias and the Early Modern European Court*. Translated by Lorri S. Granger and Gerard T. Morgan. Amsterdam: Amsterdam University Press, 1994.

Eberle, Sandra, Ulrike Seeger, and Karolin Böhm. *Residenzschloss Rastatt*. Petersberg: Michael Imhof, 2018.

Edelstein, Dan, Stefanos Geroulanos, and Natasha Wheatley, eds. *Power and Time: Temporalities and the Making of History*. Chicago: University of Chicago Press, 2020.

Eggeling, Tilo. *Die Wohnungen Friedrichs des Großen im Schloß Charlottenburg*. Berlin: Verwaltung der Staatlichen Schlösser und Gärten, 1990.

Ehalt, Hubert. *Ausdrucksformen absolutistischer Herrschaft: Der Wiener Hof im 17. und 18. Jahrhundert*. Munich: Oldenbourg, 1980.

Elet, Yvonne. "Seats of Power: The Outdoor Benches of Early Modern Florence." *Journal of the Society of Architectural Historians* 61 (2002): 444–69.

Elias, Norbert. *The Court Society*. Translated by Edmund Jephcott. New York: Pantheon, 1983.

———. *An Essay on Time*. Edited by Steven Loyal and Stephen Mennell. Dublin: University College Dublin Press, 2007.

———. "Mozart: The Sociology of a Genius." In *Mozart and Other Essays on Courtly Art*, edited by Eric Baker and Stephen Mennell, 56–179. Dublin: University College Dublin Press, 2010.

Engammare, Max. *On Time, Punctuality, and Discipline in Early Modern Calvinism*. Translated by Karin Maag. Cambridge: Cambridge University Press, 2010.

Eriksen, Thomas Hylland. *Tyranny of the Moment: Fast and Slow Time in the Information Age*. London: Pluto Press, 2001.

Eser, Thomas. *Die älteste Taschenuhr der Welt? Der Henlein-Uhrenstreit*. Nuremberg: Verlag des Germanischen Nationalmuseums, 2014.

Evans, Robert. *Translations from Drawing to Buildings and Other Essays*. London: Architectural Association, 1997.

Fabian, Johannes. *Time and the Other: How Anthropology Makes Its Object*. New York: Columbia University Press, 1983.

Faraday, Christina Juliet. "Tudor Time Machines: Clocks and Watches in English Portraits c. 1530–c. 1630." *Renaissance Studies* 33 (2018): 239–66.

Farman, Jason. *Delayed Response: The Art of Waiting from the Ancient to the Instant World*. New Haven, CT: Yale University Press, 2018.

Fischer, Norbert. "Die Zeitbetrachtung des Nikolaus von Kues ('intemporale, unitrinum tempus')." *Trierer Theologische Zeitschrift* 99 (1990): 170–92.

Forssmann, Knut. *Baltasar Gracian und die deutsche Literatur zwischen Barock und Aufklärung*. Barcelona: [n.p.], 1977.

Frederiksen, Martin Demant. *Young Men, Time, and Boredom in the Republic of Georgia*. Philadelphia: Temple University Press, 2013.

———. "Waiting for Nothing: Nihilism, Doubt, and Difference without Difference in Postrevolutionary Georgia," in *Ethnographies of Waiting: Doubt, Hope and Uncertainty*, ed. Manpreet K. Janeja and Andreas Bandak (London: Bloomsbury, 2018), 163–80.

Fritzsche, Peter. *Stranded in the Present: Modern Time and the Melancholy of History*. Cambridge, MA: Harvard University Press, 2004.

Frommel, Christoph Luitpold. *Der Römische Palastbau der Hochrenaissance*. Vol. 1. Tübingen: Ernst Wasmuth, 1973.

Frühsorge, Gotthardt. "Der Hof, der Raum, die Bewegung: Gedanken zur Neubewertung des europäischen Hofzeremoniells." *Euphorion* 82 (1988): 424–29.

———. "Vom Hof des Kaisers zum 'Kaiserhof': Über das Ende des Ceremoniells als gesellschaftliches Ordnungsmuster." *Euphorion* 78 (1984): 237–65.

Gaehtgens, Thomas, et al., eds. *Versailles et l'Europe: L'appartement monarchique et princier, architecture, décor, cérémonial*. https://doi.org/10.11588/arthistoricum.234.3092017.

García-Diego, José A. *Juanelo Turriano: Charles V's Clockmaker: The Man and His Legend*. Translated by Charles David Ley. Madrid: Editorial Castalia, 1986.

Gasparini, Giovanni. "On Waiting," *Time and Society* 4 (1995): 29–45.

Giddens, Anthony. *The Consequences of Modernity*. Stanford, CA: Stanford University Press, 1990.

Gleick, James. *Faster! The Acceleration of Just About Everything*. New York: Pantheon, 1999.

Glennie, Paul, and Nigel Thrift. "Reworking E. P. Thompson's 'Time, Work-Discipline, and Industrial Capitalism.'" *Time & Society* 5 (1996): 275–99.

Goodman, Dena, and Kathryn Norberg, eds. *Furnishing the Eighteenth Century: What Furniture Can Tell Us about the European and American Past*. New York: Routledge, 2006.

Graf, Henriette. "Das Kaiserliche Zeremoniell und das Repräsentationsappartement im Leopoldinischen Trakt der Wiener Hofburg um 1740." *Österreichische Zeitschrift für Kunst- und Denkmalpflege* 51 (1997): 571–87.

Grafton, Anthony. *Joseph Scaliger: A Study in the History of Classical Scholarship*. Vol. 2, *Historical Chronology*. Oxford: Clarendon, 1993.

Gropp, Birgit. *Haus Harkotten auf dem Weg in die Moderne: Adel und Alltag um 1800*. Petersberg: Michael Imhof, 2022.

Guillaume, Jean, ed. *Architecture et vie sociale: L'organisation intérieure des grandes demeures à la fin du moyen âge et à la Renaissance: Actes du colloque tenu à Tours du 6 au 10 juin 1988*. Paris: Picard, 1994.

Gurvitch, Georges. *La multiplicité des temps sociaux*. 1958. Paris: Centre de documentation universitaire, 1961.

———. *The Spectrum of Social Time*. Translated by Myrtle Korenbaum and Phillip Bosserman. Dordrecht: Reidel, 1964.

Habermas, Jürgen. *The Structural Transformation of the Public Sphere: An Inquiry into a Category of Bourgeois Society*. Translated by Thomas Burger. Cambridge, MA: MIT Press, 1989.

Hage, Ghassan, ed. *Waiting*. Melbourne: Melbourne University Press, 2009.

Hahn, Peter-Michael, and Ulrich Schütte, eds. *Zeichen und Raum: Ausstellung und höfisches Zeremoniell in den deutschen Schlössern der Frühen Neuzeit*. Munich: Deutscher Kunstverlag, 2006.

Han, Byung-Chul. *The Scent of Time: A Philosophical Essay on the Art of Lingering*. Translated by Daniel Steuer. Cambridge: Polity, 2017.

Hanß, Stefan. "The Fetish of Accuracy: Perspectives on Early Modern Time(s)." *Past & Present* 243 (May 2019): 267–84.

———. "Timing the Self in Sixteenth-Century Augsburg: Veit Konrad Schwarz (1541–61)." *German History* 35 (2017): 495–524.

Harootunian, Harry. *Marx after Marx: History and Time*. New York: Columbia University Press, 2015.

Härtel, Hans. *Schloss Pyrmont*. Berlin: Deutscher Kunstverlag, 1962.

Harvey, David. *The Condition of Postmodernity: An Enquiry into the Origins of Cultural Change*. Oxford: Blackwell, 1990.

Hellman, Mimi. "Furniture, Sociability and the Work of Leisure in Eighteenth-Century France." *Eighteenth Century Studies* 32 (1999): 415–45.

Hengerer, Mark. *Kaiserhof und Adel in der Mitte des 17. Jahrhunderts*. Constance: Universitätsverlag Konstanz, 2004.

———. "*Verzaichnus, wie* [. . .] *durch die cammerpersonen gediennt würdet*: Edition einer Beschreibung des Kammerdienstes am Grazer Hof des 16. Jahrhunderts aus dem Bayerischen Hauptstaatsarchiv München." *Zeitschrift des Historischen Vereines für Steiermark* 105 (Graz 2014): 45–91.

Hirschbiegel, Jan, and Werner Paravicini, eds. *Das Frauenzimmer: Die Frau bei Hofe in Spätmittelalter und früher Neuzeit*. Stuttgart: Jan Thorbecke, 2000.

Hofmann, Christina. *Das spanische Hofzeremoniell von 1500–1700*. Frankfurt am Main: Peter Lang, 1985.

Hojer, Gerhard, and Peter O. Krückmann. *Anton Raphael Mengs: Königin Semiramis erhält die Nachricht vom Aufstand in Babylon*. Munich: Bayerische Verwaltung der Staatlichen Schlösser, 1995.

Holler, Wolfgang, and Kristin Knebel, eds. *Goethes Wohnhaus*. Weimar: Klassik Stiftung Weimar, 2011.

Hsia, R. Po-chia. *Society and Religion in Münster, 1535–1618*. New Haven, CT: Yale University Press, 1984.

Huber, Annegret, and Benjamin Meyer, eds. *Wilhelmine von Bayreuth (1709–1748): Kunst als "Staatsgeschäft."* Vienna: Mille Tre, 2014.

Hughes, Diane O., and Thomas Trautman, eds. *Time: Histories and Ethnologies*. Ann Arbor: University of Michigan, 1995.

Imhof, Arthur E. *Lost Worlds: How Our European Ancestors Coped with Everyday Life and Why Life Is So Hard Today*. Translated by Thomas Robisheaux. Charlottesville: University Press of Virginia, 1996.

Israeli, Yanay. "Papers in Disputes: Petitions, Legal Culture and Royal Authority in Castile, 1406–1516." PhD diss., University of Michigan, 2017.

Jackson, Michael. *The Varieties of Temporal Experience: Travels in Philosophical, Historical, and Ethnographic Time*. New York: Columbia University Press, 2018.

Jacobsen, Christine M., Marry-Anne Karlsen, and Shahram Khosravi, eds. *Waiting and the Temporalities of Irregular Migration*. London: Taylor and Francis / Routledge, 2020.

Janeja, Manpreet K., and Andreas Bandak, eds. *Ethnographies of Waiting: Doubt, Hope and Uncertainty*. London: Bloomsbury, 2018.

Jany, Susanne. "Operative Räume: Prozessarchitekturen im späten 19. Jahrhundert." *Zeitschrift für Medienwissenschaft* 7 (2015): 33–43.

———. *Prozessarchitekturen: Medien der Betriebsorganisation (1880–1936)*. Constance: Konstanz University Press, 2019.

Jarzebowski, Claudia, and Anne Kwaschik, eds. *Performing Emotions: Interdisziplinäre Perspektiven auf das Verhältnis von Politik und Emotion.* Göttingen: V&R unipress, 2013.

Jarzombek, Mark. "Corridor Spaces." *Critical Inquiry* 36 (2010): 728–70.

Jeffrey, Craig. *Timepass: Youth, Class, and the Politics of Waiting in India.* Stanford, CA: Stanford University Press, 2010.

Jestaz, Bertrand. "Étiquette et distribution intérieure dans les maisons royales de la Renaissance." *Bulletin monumental* 146 (1988): 109–20.

Jütte, Daniel. "Sleeping in Church: Preaching, Boredom, and the Struggle for Attention in Medieval and Early Modern Europe." *American Historical Review* 125 (2020): 1146–74.

———. *The Strait Gate: Thresholds and Power in Western History.* New Haven, CT: Yale University Press, 2015.

Kägler, Britta. *Frauen am Münchener Hof (1651–1756).* Kallmünz: Michael Laßleben, 2011.

———. "Rückzugsort oder Anlaufstelle? Das 'Frauenzimmer' als Institution und Handlungsraum am Münchner Hof der Frühen Neuzeit." https://perspectivia.net//servlets/MCRFileNodeServlet/ploneimport_derivate_00000485/kaegler_frauenzimmer.doc.pdf.

Kaiser, Michael, and Andreas Pečar, eds. *Der zweite Mann im Staat: Oberste Amtsträger und Favoriten im Umkreis der Reichsfürsten in der Frühen Neuzeit.* Berlin: Duncker & Humblot, 2003.

Kamen, Henry. *The Escorial: Art and Power in the Renaissance.* New Haven, CT: Yale University Press, 2010.

Kazmaier, Daniel, Julia Kerschner, and Xenia Wotschal, eds. *Warten als Kulturmuster.* Würzburg: Königshausen & Neumann, 2016.

Keller, Katrin. *Hofdamen: Amtsträgerinnen im Wiener Hofstaat des 17. Jahrhunderts.* Cologne: Böhlau, 2015.

Kellermann, Robin. *Im Zwischenraum der beschleunigten Moderne: Eine Bau- und Kulturgeschichte des Wartens auf Eisenbahnen, 1830–1935.* Bielefeld: Transcript, 2021.

Kentridge, William. *Thick Time.* Edited by Iwona Blazwick and Sabine Breitwieser. London: Central Books, 2012.

Kern, Stephen. *The Culture of Time and Space, 1880–1918.* Cambridge, MA: Harvard University Press, 1983.

Kerscher, Gottfried. *Architektur als Repräsentation: Spätmittelalterliche Palastbaukunst zwischen Pracht und zeremoniellen Voraussetzungen: Avignon, Mallorca, Kirchenstaat.* Tübingen-Berlin: Wasmuth, 2000.

———. "Privatraum und Zeremoniell im spätmittelalterlichen Papst- und Königspalast: Zu den Montefiascone-Darstellungen von Carlo Fontana und einem Grundriss des Papstpalastes von Avignon." *Römisches Jahrbuch der Bibliotheca*

Hertziana 26 (1990): 87–134.

Kettering, Sharon. "Patronage in Early Modern France." *French Historical Studies* 17 (1992): 839–62.

———. *Patrons, Brokers, and Clients in Seventeenth-Century France.* New York: Oxford University Press, 1986.

———. *Power and Reputation at the Court of Louis XIII: The Career of Charles D'Albert, Duc De Luynes (1578–1621).* Manchester: Manchester University Press, 2017.

Kiesel, Helmuth. *"Bei Hof, Bei Höll": Untersuchungen zur literarischen Hofkritik von Sebastian Brant bis Friedrich Schiller.* Tübingen: Niemeyer, 1979.

Klingensmith, Samuel John. *The Utility of Splendor: Ceremony, Social Life, and Architecture at the Court of Bavaria, 1600–1800.* Edited by Christian F. Otto and Mark Ashton. Chicago: University of Chicago Press, 1993.

Knecht, Robert J. *The French Renaissance Court, 1483–1589.* New Haven, CT: Yale University Press, 2008.

Köhler, Andrea. *Passing Time: An Essay on Waiting.* Foreword by Mark Lilla. Translated by Michael Eskin. New York: Upper West Side Philosophers, 2017.

Kölle, Brigitte, and Claudia Peppel. *Die Kunst des Wartens.* Berlin: Klaus Wagenbach, 2019.

Koselleck, Reinhart. *Futures Past: On the Semantics of Historical Time.* Translated by Keith Tribe. New York: Columbia University Press, 2004.

———. *Sediments of Time: On Possible Histories.* Translated by Sean Franzel and Stefan-Ludwig Hoffmann. Stanford, CA: Stanford University Press, 2018.

Kracauer, Siegfried. *The Mass Ornament: Weimar Essays.* Translated by Thomas Y. Levin. Cambridge, MA: Harvard University Press, 1995.

Kraft, Stephan. *Geschlossenheit und Offenheit der "Römischen Octavia" von Herzog Anton Ulrich: "Der Roman macht ahn die ewigkeit gedencken, den er nimbt kein endt."* Würzburg: Königshausen & Neumann, 2004.

Krajewski, Markus. *The Server: A Media History from the Present to the Baroque.* Translated by Ilinca Iurascu. New Haven, CT: Yale University Press, 2018.

Krauss, Werner. *Graciáns Lebenslehre.* Frankfurt am Main: Viktorio Klostermann, 1947.

Krückmann, Peter O., Johannes Erichsen, Kurt Grübel, and Cordula Mauss. *Die Eremitage in Bayreuth.* Munich: Bayerische Schlösserverwaltung, [2019].

Kühn, Margarete. *Schloss Charlottenburg.* Berlin: Deutscher Verein für Kunstwissenschaft, 1955.

Kwastek, Katja. *Camera: Gemalter und realer Raum der italienischen Frührenaissance.* Weimar: VDG, 2011.

Ladendorf, Heinz. "Das Vorzimmer des jungen Königs: Neuentdeckte Wandbilder im Stile Pesnes." *Die Kunst: Monatshefte für freie und angewandte Kunst* 71 (1935): 16–17.

Landwehr, Achim. *Die Geburt der Gegenwart: Eine Geschichte der Zeit im 17. Jahrhundert.* Frankfurt am Main: S. Fischer, 2014.

Lefebvre, Henri. *The Production of Space.* Translated by Donald Nicholson-Smith. Oxford: Blackwell, 1991.

Le Goff, Jacques. *Time, Work, and Culture.* Translated by Arthur Goldhammer. Chicago: University of Chicago Press, 1980.

Le Roux, Nicolas. *La faveur du roi: Mignons et courtisans au temps des derniers Valois.* Paris: Champ Vallon, 2001.

Liberman, E. G. "The Queue: Anamnesis, Diagnosis, Therapy." *Soviet Review* 9, no. 4 (1968–69): 12–16.

Luebke, David M. *Hometown Religion: Regimes of Coexistence in Early Modern Westphalia.* Charlottesville: University of Virginia Press, 2016.

Luhmann, Niklas. *Love as Passion: The Codification of Intimacy.* Translated by Jeremy Gaines and Doris L. Jones. Stanford, CA: Stanford University Press, 1998.

Massey, Dawn. "*Veritas filia Temporis*: Apocalyptic Polemics in the Drama of the English Reformation." *Comparative Drama* 32 (1998): 146–75.

Maurice, Klaus. *Von Uhren und Automaten: Das Messen der Zeit.* Munich: Prestel, 1968.

Maurice, Klaus, and Otto Mayr, eds. *The Clockwork Universe: German Clocks and Automata, 1550–1650.* Washington, DC: Smithsonian Institution, 1980.

Mayr, Otto. *Authority, Liberty, & Automatic Machinery in Early Modern Europe.* Baltimore: Johns Hopkins University Press, 1989.

McCormack, Derek P. *Refrains for Moving Bodies: Experience and Experiment in Affective Spaces.* Durham, NC: Duke University Press, 2013.

Milovanovic, Nicolas. *L'Antichambre du Grand Couvert: Fastes de la table et du décor à Versailles: Splendours of Table and Décor at Versailles.* Montreuil: Gourcuff Gradenigo, 2010.

Minkowski, Eugène. *Le temps vécu: Études phénoménologiques et psycho-pathologiques.* Paris: J. L. L. d'Artrey, 1933.

———. *Lived Time: Phenomenological and Psychopathological Studies.* Translated by Nancy Metzel. Evanston, IL: Northwestern University Press, 1970.

Mödersheim, Sabine. *"Domini Doctrina Coronat": Die geistliche Emblematik Daniel Cramers (1568–1637).* Frankfurt am Main: P. Lang, 1994.

Moxey, Keith. *Visual Time: The Image in History.* Durham, NC: Duke University Press, 2013.

Münster, Robert. *"Ich würde München gewis Ehre machen": Mozart und der Kurfürstliche Hof zu München.* Weißenhorn: Anton H. Konrad, 2002.

Museum im Schloss Wolfenbüttel, ed. *Hermann Korb und seine Zeit: 1656–1735: Barockes Bauen im Fürstentum Braunschweig-Wolfenbüttel.* Braunschweig: Appelhans, 2006.

Nagel, Alexander, and Christopher S. Wood. *Anachronic Renaissance.* New York: Zone, 2010.

Nazeri, Mehran Karimi [Sir Alfred Mehran], and Andrew Donkin. *The Terminal Man: The Extraordinary True Story of the Man Who Has Lived in an Airport Terminal for Sixteen Years.* London: Corgi, 2004.

Nevola, Fabrizio. "Home Shopping: Urbanism, Commerce, and Palace Design in Renaissance Italy." *Journal of the Society of Architectural Historians* 70 (2011): 153–73.

———. *Siena: Constructing the Renaissance City.* New Haven, CT: Yale University Press, 2007.

North, Helen F. *From Myth to Icon: Reflections of Greek Ethical Doctrine in Literature and Art.* Ithaca, NY: Cornell University Press, 1979.

———. *Sophrosyne: Self-Knowledge and Self-Restraint in Greek Literature.* Ithaca, NY: Cornell University Press, 1966.

Nowotny, Helga. *Time: The Modern and the Postmodern Experience.* Translated by Neville Plaice. Cambridge: Polity, 2005.

Ogle, Vanessa. *The Global Transformation of Time, 1870–1950.* Cambridge, MA: Harvard University Press, 2015.

Oßwald-Bargende, Sybille. *Die Mätresse, der Fürst und die Macht: Christina Wilhelmina von Grävenitz und die höfische Gesellschaft.* Frankfurt am Main: Campus, 2000.

Oursel, Hervé, and Julia Fritsch, eds. *Henri II et les arts: Actes du colloque international: École du Louvre et musée national de la Renaissance—Écouen. 25, 26 et 27 septembre 1997.* Paris: École du Louvre, 2003.

Pangerl, Irmgard, Martin Scheutz, and Thomas Winkelbauer, eds. *Der Wiener Hof im Spiegel der Zeremonialprotokolle (1652–1800): Eine Annäherung.* Innsbruck: StudienVerlag, 2007.

Panofsky, Erwin. *Studies in Iconology: Humanistic Themes in the Art of the Renaissance.* New York: Harper & Row, 1972.

Pardailhé-Galabrun, Annik. *The Birth of Intimacy: Privacy and Domestic Life in Early Modern Paris.* Translated by Jocelyn Phelps. Cambridge: Polity, 1991.

Paravicini, Werner, ed. *Zeremoniell und Raum.* Sigmaringen: Thorbecke, 1997.

Parker, Geoffrey. *Emperor: A New Life of Charles V.* New Haven, CT: Yale University Press, 2019.

———. *Imprudent King: A New Life of Philip II.* New Haven, CT: Yale University Press, 2014.

Pečar, Andreas. *Die Ökonomie der Ehre: Höfischer Adel am Kaiserhof Karls VI. (1711–1740).* Darmstadt: Wissenschaftliche Buchgesellschaft, 2003.

Persson, Fabian. *Women at the Early Modern Swedish Court: Power, Risk, and Opportunity.* Amsterdam: Amsterdam University Press, 2021.

Phillips, Margaret Mann. *The "Adages" of Erasmus: A Study with Translations*. Cambridge: Cambridge University Press, 1964.

Puff, Helmut, and Bernardo Zacka. "Architectures of Waiting: Helmut Puff and Bernardo Zacka in Conversation." *Contemporary Political Theory* 21 (2022): 1–18.

Quaeitzsch, Christian. *Residenz München*. Munich: Bayerische Schlösserverwaltung, 2014.

Ragotzky, Hedda, and Horst Wenzel, eds. *Höfische Repräsentation: Das Zeremoniell und Zeichen*. Tübingen: Niemeyer, 1990.

Ringel, Felix, *Back to the Postindustrial Future: An Ethnography of Germany's Fastest-Shrinking City*. New York: Berghahn, 2018.

——. "Can Time Be Tricked?" *Cambridge Journal of Anthropology* 34 (2016): 22–31.

Rollason, David, ed. *Princes of the Church: Bishops and Their Palaces*. London: Routledge, 2017.

Rosa, Hartmut. *Weltbeziehungen im Zeitalter der Beschleunigung: Umrisse einer neuen Gesellschaftskritik*. Frankfurt am Main: Suhrkamp, 2012.

Rosenberg, Daniel, and Anthony Grafton. *Cartographies of Time: A History of the Timeline*. Princeton, NJ: Princeton Architectural Press, 2010.

Rotter, Rebecca. "Waiting in the Asylum Determination Process: Just an Empty Interlude?" *Time & Society* 25 (2016): 80–101.

Rovelli, Carlo. *The Order of Time*. New York: Riverhead, 2018.

Rüdiger, Horst. "Göttin Gelegenheit, Gestaltwandel einer Allegorie," *Arcadia* 1 (1966): 121–66.

Rutschky, Michael. *Wartezeit: Ein Sittenbild*. Cologne: Kiepenheuer & Witsch, 1983.

Sampson, Kristin. "Conceptions of Temporality: Reconsidering Time in an Age of Impending Emergency." *Theoria* 86 (2020): 769–82.

Sauter, Michael J. "Clockwatchers and Stargazers: Time Discipline in Early Modern Berlin." *American Historical Review* 112 (2007): 685–709.

Sauzet, Robert, ed. *Henri III et son temps*. Paris: Librairie Philosophique J. Vrien, 1992.

Saxl, Fritz. "Veritas filia temporis." In *Philosophy and History: Essays Presented to Ernst Cassirer*, ed. Raymond Klibansky and H. H. Paton, 297–222. Oxford: Clarendon, 1936.

Schall, Jan, ed. *Tempus Fugit, Time Flies*. Kansas City, MO: Nelson-Atkins Museum of Art, 2000.

Schivelbusch, Wolfgang. *The Railway Journey: The Industrialization of Time and Space in the Nineteenth Century*. Translated by Anselm Hollo. Berkeley: University of California Press, 2014.

Schmitt, Carl. *Gespräch über die Macht und den Zugang zum Machthaber: Gespräch über den Neuen Raum*. Berlin: Akademie Verlag 1994.

Schulz-Dornburg, Ursula. *Architekturen des Wartens: Bushaltestellen in Armenien, Bahnhöfe der Hejaz-Bahn in Saudi-Arabien.* 2nd ed., rev. Cologne: König, 2007.

Schwartz, Barry. *Queuing and Waiting: Studies in the Social Organization of Access and Delay.* Chicago: University of Chicago Press, 1975.

———. "Waiting, Exchange, and Power: The Distribution of Time in Social Systems." *American Journal of Sociology* 79 (1974): 841–70.

Schweizer, Harold. *On Waiting.* New York: Routledge, 2008.

Seeger, Ulrike. *Schloss Ludwigsburg und die Formierung eines reichsfürstlichen Gestaltungsanspruchs.* Vienna: Böhlau, 2020.

———. *Stadtpalais und Belvedere des Prinzen Eugen: Entstehung, Gestalt, Funktion und Bedeutung* (Vienna: Böhlau, 2004).

Seelig, Lorenz. *Friedrich und Wilhelmine: Die Kunst am Bayreuther Hof 1732–1763.* Munich: Schnell und Steiner, 1982.

Smail, Daniel Lord, and Andrew Shryock. "History and the 'Pre.'" *American Historical Review* 118 (2013): 709–37.

Smith, Pauline M. *The Anti-courtier Trend in 16th C. French Literature.* Geneva: Droz, 1996.

Sombart, Werner. *Der Moderne Kapitalismus: Historisch-systematische Darstellung des gesamteuropäischen Wirtschaftslebens von seinen Anfängen bis zur Gegenwart.* Munich: Duncker & Humblot, 1924–28.

Spielman, John P. *The City and the Crown: Vienna and the Imperial Court, 1600–1740.* West Lafayette, IN: Purdue University Press, 1993.

———. *Leopold I of Austria.* New Brunswick, NJ: Rutgers University Press, 1977.

Standen, Edith A. "The Story of the Emperor in China: A Beauvais Tapestry Series." *Metropolitan Museum Journal* 11 (1976): 103–17.

Starn, Randolph, and Loren Partridge. *Arts of Power: Three Halls of State in Italy, 1300–1600.* Berkeley: University of California Press, 1992.

Steedman, Carolyn. *Landscape for a Good Woman: A Story of Two Lives.* New Brunswick, NJ: Rutgers University Press, 1987.

Stiftung Preußische Schlösser und Gärten Berlin-Brandenburg, eds. *Amtlicher Führer Schloss Charlottenburg.* 9th ed. Potsdam: Stiftung Preußische Schlösser und Gärten Berlin-Brandenburg, 2002.

Stollberg-Rilinger, Barbara. *Cultures of Decision-Making.* London: German Historical Institute, 2016.

Straub, Eberhard. *Repraesentatio maiestatis oder churbayerische Freudenfeste: Die höfischen Feste in der Münchner Residenz vom 16. bis zum Ende des 18. Jahrhunderts.* Munich: Stadtarchiv München, 1969.

Suden, Marina thom. *Schlösser in Berlin und Brandenburg und ihre bildliche Ausstattung im 18. Jahrhundert.* Petersberg: Imhof, 2013.

Tatlock, Lynne. *Willibald Alexis' Zeitroman "Das Haus Düsterweg" and the Vormärz.* Frankfurt am Main: Peter Lang, 1984.

Thompson, E. P. "Time, Work-Discipline, and Industrial Capitalism." *Past & Present* 38 (1967): 56–97.

Trachtenberg, Marvin. *Building-in-Time from Giotto to Alberti and Modern Oblivion.* New Haven, CT: Yale University Press, 2010.

Trexler, Richard. *Public Life in Renaissance Florence.* Ithaca, NY: Cornell University Press, 1992.

Trüby, Stephan. *Geschichte des Korridors.* Munich: Wilhelm Fink, 2018.

Van Landingham, Marta. *Transforming the State: King, Court and Political Culture in the Realms of Aragon (1213–1387).* Leiden: Brill, 2002.

Vanstone, W. H. *The Stature of Waiting.* Harrisburg, PA: Morehouse, 1982.

Vogl, Joseph. *On Tarrying.* Translated by Helmut Müller-Sievers. London: Seagull, 2011.

Wajcman, Judy. *Pressed for Time: The Acceleration of Life in Digital Capitalism.* Chicago: University of Chicago Press, 2015.

Walker, Mack. *Johann Jakob Moser and the Holy Roman Empire of the German Nation.* Chapel Hill: University of North Carolina Press, 1980.

Weddigen, Tristan, Sible de Blaauw, and Bram Kempers, eds. *Functions and Decorations: Art and Ritual at the Vatican Palace in the Middle Ages and the Renaissance.* Turnhout: Brepols, 2003.

Weiß, Stefan. *Die Versorgung des päpstlichen Hofes in Avignon mit Lebensmitteln (1316–1378): Studien zur Sozial- und Wirtschaftsgeschichte eines mittelalterlichen Hofes.* Berlin: Akademie, 2002.

Welch, Ellen R. *A Theater of Diplomacy: International Relations and the Performing Arts in Early Modern France.* Philadelphia: University of Pennsylvania Press, 2017.

West-Pavlov, Russell. *Temporalities.* London: Routledge, 2012.

White, Lynn, Jr. "The Iconography of 'Temperantia' and the Virtuousness of Technology," in *Action and Conviction in Early Modern Europe.* Edited by Theodore K. Rabb and Jerrold E. Seigel, 197–219. Princeton, NJ: Princeton University Press, 1969.

Wiesner-Hanks, Merry, ed. *Gendered Temporalities in the Early Modern World.* Amsterdam: Amsterdam University Press, 2018.

Williams, Raymond. *Marxism and Literature.* Oxford: Oxford University Press, 1977.

Wilson, W. Daniel. *Goethe, Männer, Knaben: Ansichten zur "Homosexualität."* Translated by Angela Steidele. Frankfurt am Main: Insel, 2012.

Winterling, Aloys. *Der Hof der Kurfürsten von Köln 1688–1794: Eine Fallstudie zur Bedeutung "absolutistischer" Hofhaltung.* Bonn: L. Röhrscheid, 1986.

Wishnitzer, Avner. *Reading Clocks, Alla Turca: Time and Society in Late Ottoman Turkey.* Chicago: University of Chicago Press, 2015.

Yandell, Cathy. *Carpe Corpus: Time and Gender in Early Modern France*. Newark: University of Delaware Press, 2000.

Zimmer, Oliver. "One Clock Fits All? Time and Imagined Communities in Nineteenth-Century Germany." *Central European History* 53 (2020): 48–70.

———. *Remaking the Rhythms of Life: German Communities in the Age of the Nation-State*. Oxford: Oxford University Press, 2019.

Index

acceleration, 1–2, 3

access: inequities of, 116–18, 133, 150–51, 153; to people, 13, 48, 66–67, 102, 104–5, 108–10; 121: to spaces, 55, 57–58, 61–62, 65–68, 182n62

affect. *See* emotion

agency, temporal, 19; of waiting, 9

Albert, Franz Joseph, 130

Alberti, Gottfried, 44

Alberti, Leon Battista, 193n178

Albrecht V, duke of Bavaria, 100

alertness, 3, 10, 12, 19, 22, 30, 37, 49, 147, 164n36

Alexander the Great, 77, 85, 90

Alexis, Willibald (pseudonym for Wilhelm Häring), 138–40

Altdorfer, Albrecht, 192n162

Amelot de la Houssaye, Abraham-Nicolas, 38–42; figure 6

amplification. *See* architecture and rhetoric

Anabaptist Kingdom, 30–31

antechamber: after 1800, 148–49; critiques, 66–67, 134, 140, 149–150, 152; defined, 54–55, 89, 93–94; emergence in Europe, 54–62, 64–69, 93–96; furnishings and iconography, 61, 68–96, 100; public forum, 52, 67–68, 85, 115, 118–19, 150: tales about the a., 99–102, 110–16; unrul-iness, 60, 85, 93, 100–102, 105, 130, 137–38, 148; women, 116–19; word history, 54, 55, 66, 149

anticipation, 30, 35, 44, 50, 62, 97, 148; and anxiousness, 100, 123, 138, 152. *See also* anxiety, future

Anton Ulrich, Duke of Braunschweig-Wolfenbüttel, 41; author of *The Roman Octavia*, 16, 44–50, 51

anxiety, 4, 22, 30, 48, 53, 84, 88, 97, 123, 128, 131, 139, 143, 153–54

Apollo, 86, 189n134, 192n158

apartment: defined: 61; 64–65, 67–68, 75, 84–86, 88–91, 93–95, 107–10, 116, 127

appartement double, 67, 69, 75, 85–86, 90, 116–18, 149, 203n77

Aragon, 57, 60, 179n25

architecture: early modern architects on the antechamber, 93–94; rhetoric and architecture, 89–90; symmetry, 116; time and architecture, 54, 57, 63, 86–87. *See also* antechamber

Aretino, Pietro, 85

Aristarkhova, Irina, 5

Artaxerxes, King of Persia, 77–8, 188n126; figure 13

Asia, 51, 61, 68, 119

Atkinson, Niall, 105

Cultural Memory | in the Present

*For a complete listing of titles in this series, visit the
Stanford University Press website, www.sup.org.*

Printed in the USA
CPSIA information can be obtained
at www.ICGtesting.com
JSHW021315250823
47230JS00001B/1